Painting by Numbers

◇◇◇

Painting by Numbers

Data-Driven Histories of Nineteenth-Century Art

◇◇◇

DIANA SEAVE GREENWALD

PRINCETON UNIVERSITY PRESS

PRINCETON AND OXFORD

Requests for permission to reproduce material from this work should be sent to permissions@press.princeton.edu
Published by Princeton University Press,
41 William Street, Princeton, New Jersey 08540
In the United Kingdom: Princeton University Press,
6 Oxford Street, Woodstock, Oxfordshire OX20 1TR

press.princeton.edu

Front cover illustrations (l to r): Figure 3.12 (detail); Claude Raguet Hirst, *The Bookworm's Table* (detail), 1890s. Brooklyn Museum, Designated Purchase Fund, 80.79; Figure 5.18 (detail); William Bouguereau, *Breton Brother and Sister* (detail), 1871. Metropolitan Museum of Art, Catharine Lorillard Wolfe Collection Bequest of Catharine Lorillard Wolfe, 1887, 87.15.32; Johan Joseph Zoffany, *The Drummond Family* (detail), ca. 1769. Yale Center for British Art, Paul Mellon Collection, B1977.14.86; Edgar Degas, *Sulking* (detail), ca. 1870. Metropolitan Museum of Art, H.O. Havemeyer Collection, Bequest of Mrs. H.O. Havemeyer, 1929, 29.100.43; Cecilia Beaux, *Man with Cat (Henry Sturgis Drinker)* (detail), 1898. Smithsonian American Art Museum, Bequest of Henry Ward Ranger through the National Academy of Design, 1952.10.1; and Robert S. Ducanson, *Landscape with Rainbow* (detail), 1859. Smithsonian American Art Museum, Gift of Leonard and Paula Granoff, 1983.95.160.

Library of Congress Cataloging-in-Publication Data
Names: Greenwald, Diana, 1989- author.
Title: Painting by numbers : data-driven histories of nineteenth-century art / Diana Seave Greenwald.
Description: Princeton : Princeton University Press, [2021] |
Includes bibliographical references and index.
Identifiers: LCCN 2020022664 (print) | LCCN 2020022665 (ebook) |
ISBN 9780691192451 (hardcover) | ISBN 9780691214948 (ebook)
Subjects: LCSH: Art—Economic aspects—History—19th century. | Art, Modern—19th century. | Art and society—History—19th century. | Art—Historiography—Methodology. | Economic history—Methodology.
Classification: LCC N8600 .G735 2021 (print) | LCC N8600 (ebook) | DDC 709.03/4—dc23
LC record available at https://lccn.loc.gov/2020022664
LC ebook record available at https://lccn.loc.gov/2020022665
British Library Cataloging-in-Publication Data is available

Design and composition by Julie Allred, BW&A Books, Inc.
This book has been composed in Spectral and Noto Sans

Printed on acid-free paper. ∞
Printed in the United States of America
10 9 8 7 6 5 4 3 2 1

For my family

Contents

◇◇◇

Painting by Numbers

◇◇◇

◇◇◇

What Is a Data-Driven
History of Art?

In the mid 1960s, the art historian Jules Prown was jeered. He was presenting new research at the annual meeting of the College Art Association, the principal professional art historical organization. Prown's first slide—which showed an IBM punch card, then representative of cutting-edge computing technology—prompted some colleagues to boo.[1] In his essay "The Art Historian and the Computer," Prown describes how he arrived at that presentation. He used a mainframe in the Yale University computer lab to examine the link between the socioeconomic backgrounds of American painter John Singleton Copley's sitters and their preferences in portraiture. Recounting this experience, Prown writes:

> At first consideration the art historian and the computer would seem to be eccentric companions. Art historians are concerned with qualitative discriminations that reveal themselves slowly, and at an unpredictable tempo, to the investigations of a trained mind and sensitive eye. The computer, on the other hand, deals with quantitative computations at an unvarying pace with incredible speed. Its monotonous, inflexible, unthinking efficiency sends a shudder down the spine of any self-respecting art historian.[2]

Yet as he discovered, these apparent enemies can work together.

Prown—famous for being a passionate advocate of formal analysis and close looking—described his impulse to use computers while preparing a monograph on Copley. Discussing the roughly 350 artworks that Copley created while he was working in North America, Prown writes that "certain questions c[a]me insistently to mind." These were mostly about the social makeup of Copley's clientele over time:

"Were Anglicans wealthier than Congregationalists, and if so, did Copley paint more Anglicans as he himself prospered?...Did merchants order bigger pictures than ministers or vice versa? Which group ordered more pastels?" For Prown, "it seemed quite clear that these questions and many similar ones about the patterns of Copley's patronage could be answered through a statistical analysis of his paintings and their subjects."[3] Statistical analyses *did* indeed indicate that certain kinds of patrons—defined by their occupations, political affiliations, and other social attributes—were more likely to purchase a work from Copley at different periods in the artist's career. Sitters of certain professions were also more likely to purchase particular sizes of works. With the help of a computer and statistics, Prown was able to see trends in Copley's career and oeuvre that were otherwise invisible. The quantitative view complemented the qualitative one.

At the end of his essay, Prown concluded: "On the basis of this experience... I am convinced that the computer can and will be used fruitfully for other studies in art history. The computer can be especially helpful for projects which require any kind of quantification."[4] Despite the fact that his colleagues dismissed this work at the College Art Association—after his presentation "a senior art historian berated [him] loudly in the aisle for [his] apostasy"—Prown made a prediction about the future of art historians and computers.[5] He said that art historians would happily adopt computing technology as an automated retrieval system for images and information, but they would resist its more complex statistical uses.[6] His prediction has generally proved true. This book, however, seeks to return to the complementary data-driven modes of inquiry that Prown first engaged with more than fifty years ago.

I trained as both an art historian and an economic historian. These two disciplines—like the art historian and the computer—may at first seem incompatible. The methodological foundations of art history are, as Prown describes, close looking and focused examination of select artists and works of art. The social sciences, including economics and economic history, are often quantitative and dependent on large datasets; the scale of social scientific evidence is orders of magnitude greater than the number of paintings art historians typically analyze. Furthermore, economic methods provide a zoomed-out view of history, where people, events, and historical change can be reduced to a collection of data points. How can one combine these two approaches? This book seeks to answer that question by presenting case studies that combine the macroscopic examination typical of economic history with the tightly focused analyses common in art history. I aim to show that these apparently incompatible approaches are, in fact, complementary. Data can better contextualize the stories of individual artists and objects; and paying close attention to the stories of these artists and their works can provide better insight into the individual choices and details that, in aggregate, become a general trend in the data.

In doing this, I hope to provide—as do Harrison and Cynthia White in their landmark book *Canvases and Careers: Institutional Change in the French Painting World* (1965)—a novel view of the nineteenth-century art world that sketches out

its structural contours without losing sight of the individual painters and objects that existed within those structures. The nineteenth-century art world is particularly well suited for this type of approach for three reasons: the large scale of artistic production during the period, the extent to which this production is documented in preserved exhibition catalogs and other written sources, and the large quantity of nineteenth-century artworks that have since faded into obscurity or been lost—and therefore have largely disappeared from art historical narratives.

While these usable traces of past cultural production exist for a range of geographical settings, this book focuses on France, the United States, and England. Nineteenth-century art exhibitions in these three countries often (although certainly not exclusively) took place in large art academies or other centralized venues. As described at length in chapter 2, exhibitions were well documented in these three countries—and this documentation was fairly easily converted into usable data. The availability of these data combined with my own area expertise in nineteenth-century American and French art—as well as my familiarity with the history of British art—led to the geographic focus presented here. Ultimately, the broad scope of this book reflects the large scale of the data available, which in turn reflects the enormity of nineteenth-century artistic production.

Nonetheless, amid the wide-ranging potential of these large datasets, it is necessary to identify specific research questions that can be addressed with computational methods. Therefore, while chapter 2 introduces the datasets and fully embraces their breadth, the subsequent three chapters are case studies that show how a computational approach can add new evidence and perspectives to what I have identified as recurring important topics in the study of nineteenth-century art related to industrialization, gender, and the history of empire. In particular, chapter 3 focuses on the impacts of industrialization on art in nineteenth-century France; chapter 4 examines the profound effects of gender on American art and artists; and chapter 5 charts how art exhibited in England showed (or omitted) evidence of the country's colonial expansion and enterprise.

Before delving into this new methodological approach and then the case studies, it is important to provide a couple of caveats. I am aware that the discipline of economics—and by extension economic history and the quantitative social sciences more generally—is not ideologically neutral. Economic theories and studies are often political tools. The discipline—beginning with the foundational work of Adam Smith—emerged at the same time as the contemporary capitalist system, and one of its core goals is to describe, understand, and predict how markets and people function in this system. For these and other reasons, art historians and other humanists may be resistant to an economic or quantitative approach to the history of art. Though this social science may, for some, evoke soulless data-driven analyses and capitalist agendas, I ask readers to be open to a reevaluation of modern economics and its value to the humanities. This book uses data, quantification, and economic theory as analytical tools that can address long-standing research questions in art history in totally new ways. Without these tools, it would be impossible

to gain these insights. However, I want to make clear that just using quantification and data do not provide some sort of objective truth. Correlations presented do not translate to definitive causation. Rather, they simply provide a different perspective and new kinds of evidence.

This may, to some, seem like a profound lack of skepticism about the ideological underpinnings of the methodologies that I deploy. Instead, I view it as pragmatism in the name of novel inquiry. Economists and social scientists have been analyzing large datasets for a century; as digitization and new computing technology make it possible to engage with art historical data, it is counterproductive to ignore this disciplinary expertise for ideological reasons. I hope to present convincing examples of the ways in which economic and data-driven approaches are multifaceted and helpful. I will show (rather than tell) those who may be skeptical of these methods that they are, in fact, valuable complements to the study of art history. Furthermore, they do not supplant the qualitative humanistic core of the discipline.

This book bridges art history and economic history in two principal ways. First, it applies quantitative methods and statistical analyses typical of the social sciences to art historical subject matter—similar to what Prown did. To do this, it relies primarily on three new datasets about hundreds of thousands of artworks shown in nineteenth-century France, England, and the United States. These datasets are crucial, as it would be impossible to forge a quantitative history of art without this kind of information. Furthermore, these kinds of large datasets can help art historians address a phenomenon that potentially compromises our research: sample bias. Second, it draws on economic theory that seeks to explain how and why people act in a certain way, both in market settings and in broader society. Art historians are expert at chronicling and analyzing detailed information about the lives and careers of the artists, collectors, dealers, and institutions we study. However, we rarely step back and generalize about commonalities in the actions of all these subjects and how they reflect broad patterns of behavior as elucidated by social scientific disciplines like economics.[7] Taking a cue from economics' generalizing impulse and drawing on its theoretical conclusions can yield valuable art historical insight.

This introduction begins by laying out several key concepts in economics that provide touchstones for creating a data-driven history of art. Following these descriptions, I provide a brief literature review of earlier interdisciplinary efforts that have combined quantitative analysis and art history. The scholarship reviewed is from both the social sciences and the humanities. The final section of this introduction describes what makes certain kinds of art historical research questions particularly suited to this kind of inquiry. In some ways, what this book presents can be described as digital humanities, because it relies on computing technology both to generate and to analyze datasets. However, I believe the analyses presented here go beyond the digital because they take on humanities subject matter with a social scientific approach. To clearly identify my methods as a distinct blend of elements from economics, art history, and the digital humanities, I have opted to refer to this work as a data-driven history of art.

Sample Bias: Understanding the Limits of Art Historical Knowledge

Sample bias, a term frequently used by social scientists, emerges when the group of people, objects, or other entities that a scholar analyzes is both limited and misrepresentative of the entire population that the scholar is interested in studying. A classic example comes from political polling. Prior to the 1936 US presidential election, the periodical *Literary Digest* conducted a poll. It sent straw vote ballots to more than ten million Americans, which represented almost 8 percent of the population. Participants were mostly selected using automobile registration and telephone listing information. Over two million ballots were returned (about 20 percent of the number distributed), and the magazine published the results without any adjustments to the data generated by the responses. The poll predicted that the Republican candidate, Alf Landon, would win in a landslide. The opposite happened. Democratic incumbent Franklin D. Roosevelt won with an overwhelming majority. How could *Literary Digest* reach such incorrect conclusions? The answer is, in part, sample bias. By selecting the recipients of the straw poll from lists of automobile and telephone owners, the poll captured a greater number of wealthy Republican-leaning voters than of the generally poorer Democratic supporters. There was also systematic bias in who was more likely to return completed ballots. As follow-up surveys by the polling firm Gallup showed, more Landon supporters returned their ballots than Roosevelt supporters. The editorial team at *Literary Digest* drew incorrect conclusions because the sample of information it was working with was limited and misrepresentative of the population of interest—it was biased.[8]

How does this concept relate to art? In art history, sample bias is subtler than the example of the *Literary Digest* poll. The sample of artworks that can be the subject of art historical study is necessarily limited. Artworks are damaged and lost; some pieces are not saleable and therefore never end up in a private collection, and certainly not a public one; museums have limited space and must be discriminating in what they choose to collect. The end result of this process is that only a limited number of artworks ever created will be preserved and available for study. A further narrowing of the sample occurs when disproportionate attention is given to particular artists whose work is well known and accessible—notably, those artists who are currently famous, have ended up in major museum collections, or are featured in typical art history survey courses.

Art historians therefore necessarily study a sample of the entire population of artworks. However, it is difficult to know the specific ways in which that sample may diverge from or reflect the historical population of artworks. First, the qualitative methods and close looking that are the fundamental components of art history demand that scholars limit their focus to a narrow sample of artworks. These approaches are designed for focused analyses, not population overviews. Second, there is limited information available about artworks that no longer exist, are unlocated, or have faded into obscurity. When the focus of a method of inquiry is, quite correctly, looking at the artwork, it is hard to account for artworks that one cannot see or study.

One contribution of this book is to provide new data about these forgotten artworks. It repurposes records of past cultural production—notably, historic exhibition catalogs—and reintegrates them into art historical consideration. The transcription, digitization, and statistical analysis of lists of artworks produced and displayed at institutions during the nineteenth and early twentieth centuries provide vast and previously untapped historical sources. As chapter 2 demonstrates, there were hundreds of thousands of works made and shown during the long nineteenth century in a handful of venues in France, the United States, and England alone. While these sources provide only trace records—mostly lists of artists, titles, dates, and media—these data nonetheless provide a new opportunity to compare careful histories focused on select artists and works of art to population-level trends in the nineteenth-century art world. It is suddenly possible to understand the ways in which the sample of art we study is ultimately a miniscule portion of what was produced and how this small sample may be biased.

An art historian reading this might, quite rightly, ask: So what? Sample bias is, of course, only a significant problem if it compromises the conclusions that a scholar makes. The problem with the *Literary Digest* poll was that the biased sample led the editors to reach the wrong conclusions. If it does not have these analytical consequences, sample bias—one could argue—is not necessarily a problem.

Imagine a scholar completing a narrow study on the career and aesthetic development of one artist with a well-documented oeuvre, such as Edgar Degas, a member of the Impressionists and now one of the best-known artists active in nineteenth-century France. The relevant population for studying Degas can be defined as all of the works—pastels, statues, paintings, and drawings—that the artist produced during his lifetime, as well as all of the traces of his communications and exhibition patterns that have survived the roughly one hundred years since his death. It is possible for a diligent scholar to see and engage with a very large proportion of this population of materials; sample bias should not, in theory, be a problem nor compromise that scholar's conclusions about Degas. Sample bias can, however, become a potential roadblock when one expands the focus beyond the narrowly defined scope of specific artists and artworks that can be deemed relevant to a scholarly project or research question.

Consider when art historians engage in studies that aim to place artworks in their broader socioeconomic context. Worthwhile and admirable efforts to draw conclusions about how visual culture reflects general trends in society and how social and economic changes in turn influence the production of visual culture can, potentially, be derailed by an unrepresentative sample. Chapter 3, which examines the production of rural genre painting and landscapes produced in nineteenth-century France, addresses this risk. This moment in the history of French art has long been fertile ground for social historians of art. These scholars were, in part, interested in how industrialization and urbanization influenced the production of artwork featuring rural subjects and its reception by audiences. New data sources

show that by focusing on the output of select superstars in this area—notably, Jean-François Millet—art historians have drawn incomplete conclusions about the causal relationship between modernization and depictions of rural life. They were working with incomplete art historical evidence. This is one possible art historical consequence of sample bias.

A data-driven macroscopic view of the nineteenth-century art world not only presents problems for social historians of art but can, in fact, also affect the scholar working exclusively on Degas and his oeuvre—including works such as figure 1.1. Of course, this scholar can, as described above, be confident that he or she has considered a sufficient proportion of the artist's output to support any conclusions about his artistic development. However, considering data about the vast amount of art produced throughout history that has since faded into obscurity provokes additional questions: Why did this scholar choose to work on Degas? What are the forces that have made Degas of interest to collectors, museums, and art historians? As historians of nineteenth-century French art know, Degas and his Impressionist colleagues were not the most famous artists of their own era. Instead, academic art—such as the work by William-Adolphe Bouguereau, in figure 1.2, which also features two young girls—was far more successful. Despite this success, Bouguereau and his colleagues are now mostly forgotten. Their works have been deaccessioned from major collections, and in art historical narratives they are often relegated to the role of conservative foils for the Impressionist heroes.[9]

This question—why scholars choose to study a particular sample of art and artists—has ramifications beyond just reconsidering Bouguereau and other now-obscure academic artists. Specifically, it can contribute to the work of feminist and other art historians who have critiqued the canon and its formation and dominance. Art historian Griselda Pollock writes in *Differencing the Canon* (1999):

> Tradition is the canon's "natural" face, and in this form cultural regulation participates in…social and political hegemony.…Tradition is, therefore, not merely what the past leaves us.…[It] cultivates its own inevitability by erasing the fact of its selectivity in regard to practices, meanings, gender, "races" and classes. What is thus obscured is the active process of exclusion or neglect operated by the present-day makers.[10]

Through the lens of social scientific sampling, the canon can be analyzed as a potentially biased sample. Furthermore, including quantitative methods and more data about the full population of artworks, rather than just works by select "geniuses," allows one to look behind the face of opaque tradition. Data can chart how systematic behaviors of actors in the art world have influenced the inherited art historical canon. Taking this zoomed-out view does not erode the importance of the ongoing scholarship that has reevaluated the canon from the specific points of view of women artists, artists of color, self-taught artists, and other marginalized groups. Instead, it aims to further support this work by providing systematic evidence of the

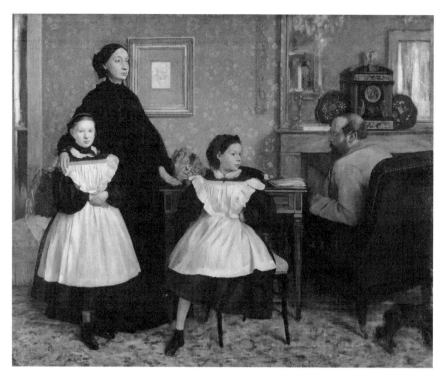

FIGURE 1.1 Edgar Degas, *The Bellelli Family*, 1858–1867, oil on canvas, 200 × 250 cm. Musée d'Orsay, Paris. © RMN-Grand Palais (Musée d'Orsay) / Gérard Blot.

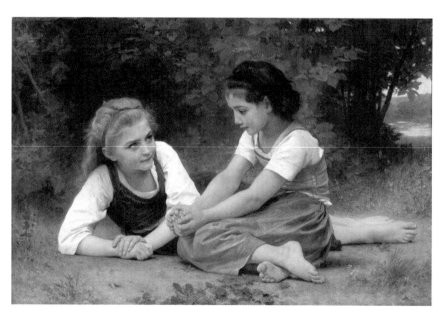

FIGURE 1.2 William-Adolphe Bouguereau, *The Nut Gatherers*, 1882, oil on canvas, 87.6 × 134 cm. Detroit Institute of Arts, Gift of Mrs. William E. Scripps.

historic, and ongoing, editing process that has been responsible for this marginalization. Chapter 4, in particular, compares data about women artists' contributions and participation in the nineteenth-century American world with their representation in a major American museum collection. These data help illuminate structural reasons why nineteenth-century women artists were limited to particular subject matter and media—subjects and media that have not been the focus of museum collecting.

Finally, trends that seem important and widespread in the sample of artists or works that are typically the focus of art historical scholarship may, in fact, be marginal in a larger population of art that was produced. Chapter 5 turns to the topic of images of the extractive and exploitative British Empire displayed in the metropole, by which I mean the territory of the present-day United Kingdom. The chapter charts and analyzes the depiction of sites and subjects under British imperial control displayed at London's Royal Academy between 1769 and 1915 and highlights a potential pitfall of sample bias. I assumed based on the extensive literature about art and empire that there would be many depictions of imperial subject matter on display throughout this period of British history. In fact, empire was barely depicted at the Royal Academy. The existing studies that explore British imperial visual culture focus primarily on a range of works on paper—humorous and popular prints, images created by explorers and the artists who accompanied them, as well as illustrations for travel guides and botanical handbooks. As described in chapter 5, very few of the works featured in existing studies about art and empire are oil paintings. Of course, the majority of works shown at the annual Royal Academy exhibition were oil paintings. Conclusions drawn about the content of one subset of nineteenth-century British artworks (works on paper) does not apply to another subset (oil on canvas).

The diverse range of constituent case studies included in this book suggest the far-reaching consequences of acknowledging sample bias in art history. Some readers may be tempted to simply throw their hands up. The inherited structure of art history dating back to Giorgio Vasari's first edition of *Lives of the Most Eminent Painters, Sculptors, and Architects* (1550)—which singles out artists he selected as most eminent—may make it seem like sample bias is inescapable in art history and impossible to discuss. The critiques put forth in this book are not designed to dismiss the foundations of art history. Instead, they are advocating for greater awareness of sample bias and the occasional integration of a macroscopic data-driven view that facilitates this awareness. Quantitative methods can allow scholars to better grasp the boundaries of what historical art production is included in our analyses and what is excluded. As art historians, we can—unlike the editors of *Literary Digest*—strive to learn if our samples of artistic evidence are biased. Finally, though this book leverages large datasets about major European and American arts venues—and case studies sometimes focus on relatively well-known rather than totally obscure artists—questioning and expanding the sample of art we study has the potential to systematically challenge the canon in ways impossible without quantification.

Econometrics: Using Data to Empirically Test Hypotheses

Of course, after gathering the data necessary to expand the art historical sample, there is suddenly potential for statistical testing well beyond gauging sample bias. One can again turn to Jules Prown's experience for an example. Remember, Prown asked specific questions about the relationship between Copley's clients' social backgrounds and the portraits they commissioned. Did Copley paint more Anglicans than Congregationalists, and was this because the former group was wealthier? Did merchants order bigger pictures than ministers? These questions represent hypotheses that Prown could statistically test using the art historical and biographical data he had gathered.

Alfred Marshall, considered a founding father of economics, called the discipline "an 'Organan,' ancient Greek for tool, not a body of truths but an 'engine of analysis' useful for discovering truths and, as the term implied, an implement that would never be perfected or completed but would always require improvement, adaptation, innovation."[11] In this spirit, the statistical testing of hypotheses is now integral to modern economics. This testing is generally called econometrics. As one economist wrote in an essay tracing the history of this subdiscipline: "The business of statistical inference is predicated upon the metaphysical notion that, underlying the apparent randomness and disorder of events that we observe in our universe, there is a set of regular and invariant structures.... In the sphere of social realities, statistical science has uncovered many regularities in the behavior of large aggregates of apparently self-willed individuals."[12]

The use of statistics to support social scientific research dates to the end of the nineteenth century and—it must be noted—was pioneered by scholars who were adherents of eugenics. While the attitudes of the founders of this branch of statistical analysis have (thankfully) been discredited, their statistical insights have survived. Most importantly, they created the idea of regression analysis, where one can measure the effects of one set of variables—referred to as explanatory variables—on another, called dependent variables. In Prown's research, the dependent variables were, roughly speaking, the number or size of portraits that Copley produced; the explanatory variables were the socioeconomic attributes of the sitters who commissioned those portraits, such as their religion or occupation. Prown wanted to measure whether those social attributes could explain any consistent patterns in the types and quantity of portraits that colonial Americans purchased from Copley. In an art historical setting, Prown was searching for "regularities in the behavior of large aggregates of apparently self-willed individuals." Integrating quantitative data into art historical research therefore not only corrects for sample bias but also facilitates this kind of hypothesis testing. He found, for example, that merchants were disproportionately represented among Copley's sitters, and that ministers favored quarter-length portraits. The frequency with which Anglicans or Congregationalists were depicted was correlated with the location where the sitters lived.[13]

Regression analysis is used and explained in chapter 3 and appendix D. However, the important point for framing a data-driven history of art is that the core

of statistical empirical analysis is testing and measuring the relationship between explanatory and dependent variables. While some scholars who work at the intersection of art and the social sciences use complex econometric methods—which have become more and more complex as computing power has exponentially increased—this book makes a more general argument for integrating a statistical or econometric perspective into art historical analyses. The use of regressions can be valuable—as I show in chapter 3—but even the simple inclusion of greater volumes of data considered within the analytical framework of explanatory and dependent variables opens new avenues of inquiry. It can reveal underlying patterns of behavior among participants in the historical art world and clarify certain social and economic structures that influence that behavior. However, just statistically observing patterns of behavior and identifying explanatory and dependent variables is not enough to reach a fulsome conclusion. Social scientists also need theory to help understand *why* people or organizations behave in a certain way.

Scarcity: How Resource Allocation Can Illuminate Art History

The word "scarcity" can evoke a variety of images, from gemstones whose value is a function of their rarity to the desolation of drought and famine. If a good is scarce, it means there is ultimately a limited amount of it and—in a market setting—demand might outstrip available supply, driving up prices. However, scarcity as an economic concept reaches far beyond the analysis of market supply and demand or the availability of natural resources. In 1932, the British economist Lionel Robbins proposed the following definition of his field of study: "Economics is the science which studies human behavior as a relationship between ends and scarce means which have alternative uses."[14] In short, economists begin with the concept that *all* resources are limited. Humans and the organizations they create—from national governments to companies to families—have limited time, attention spans, and financial resources. These resources are, ultimately, all scarce—even if some people and organizations are richer than others. People must decide how to allocate resources according to what they judge to be most important and valuable for their personal well-being or that of the organization they are helping to direct. Economists study this allocation, which is often idiosyncratic and irrational.

Perhaps one of the greatest misconceptions about economics is that the discipline does not allow for idiosyncrasy or irrationality. Irving Fisher, a pioneer of mathematical economics, concluded as early as 1906 that the concept of *homo economicus,* the perfectly rational economic man, was defunct. People are irrational. Furthermore, the sum total of seemingly rational behavior by individuals can result in negative outcomes for society generally. Fisher found that markets—and the social and institutional contexts in which they existed—were similarly compromised by irregularity and irrationality.[15] This critique has, in the intervening century, been fully integrated into economics. Economists study the successful, faulty, and simply quirky ways that resources are allocated. For example, one of the discipline's most

dynamic subfields is behavioral economics, which uses lessons from psychology to trace the specific ways people diverge from *homo economicus*.[16] In short, economists study the wide range of ways—both successful and problematic—that people cope with scarcity.

This book draws on ideas about the centrality of scarcity to analyze and explain patterns and trends in the art world. Artists and artistic institutions—like other humans and organizations—have limited time, money, space, and energy to expend on their activities. How people and institutions navigate these constraints can, in turn, have a profound impact on the works that artists produce or that an institution chooses to display. Specific literature reviews and information about these theories are provided in each chapter, but all of these insights benefit from the general economic insight that scarcity and resource allocation are fundamental to understanding human behavior.

Chapter 3 examines how the decision of budget-constrained French artists to live in affordable artists' colonies near Paris influenced which subjects they chose to depict. Chapter 4 draws on research in labor economics about professional women being pressed for time because of their domestic responsibilities; I argue that time constraints pushed nineteenth-century American women artists toward certain genres and artistic media. Finally, chapter 5 turns to the literature on what economists broadly call institutions—which include governments, laws, and social customs—to illuminate why British artists and arts venues in England used their limited time and space to display artworks showing the metropole more frequently than countries and territories exploited as part of the British overseas empire. To reiterate, these case studies will not and do not claim to provide definitive answers to questions about these topics. Instead, these chapters present a new methodological approach while contributing both novel evidence and new points of view to ongoing debates in the history of art.

The Novelty of the Data-Driven History of Art: A Literature Review

While I believe my methodologically blended approach to art history is novel, I am far from being the first to apply computational or economic methods to the history of art. Many people have experimented in this interdisciplinary space since, and even before, Prown's presentation in the 1960s. There are several active subfields—both within and outside of art history—to which this book is greatly indebted. These include cultural economics, cultural sociology, the social history of art, and the digital humanities, including digital art history.

Cultural economics is, simply, economics with a focus on subjects in arts and culture.[17] Traditionally, cultural economists have cast a wide net in the arts, ranging from classical music, to contemporary movies, to Old Master paintings. Often, though not exclusively, much of the research about the fine arts has focused on the art market. Many studies focus on the market during particular art historical periods—such as the sixteenth and seventeenth centuries in Holland, the Italian

Renaissance, and Europe during World War II.[18] Perhaps the best-known pioneering contributor to this area is John Michael Montias, who wrote several groundbreaking books about early modern Dutch art, particularly Vermeer, and established a database of seventeenth-century art inventories from the Netherlands.[19] Other cultural economists analyze the long-term performance of art as an asset in a global market and how the peculiarities of the art market affect this performance.[20] The handful of significant existing collaborations between art historians and economists fall into the first category of scholarship: studies of art markets in a particular art historical moment. Examples include art historian Christian Huemer's work with economists Kim Oosterlinck and Géraldine David, many collaborations between Neil de Marchi and Hans van Miegroet about early modern Europe, and Thomas Bayer and John Page's *The Development of the Art Market in England* (2011).[21]

This scholarship is important; the market is an essential motivator for artists' and other actors' behavior. However, focusing on art markets and price data has siloed the application of quantitative methods within the study of art history. Statistical methods can be used on data that is *not* about prices and to answer research questions that do *not* deal exclusively with the market. Of course, this book addresses the art market and dealers where they are relevant to the constituent case studies. However, it uses almost no market data.

Several scholars have deployed price data to answer research questions that are not about the art market. In these settings, auction data are typically used as a proxy for the quality of an artist's output over time. Economist David Galenson used prices in this way to trace two different career and creative trajectories for modern artists. In *Old Masters and Young Geniuses* (2007), Galenson shows that most artists fall into one of two categories: innovative artists, who formulate new ideas before placing them on canvas, and experimental artists, who work out their ideas progressively across a large body of work. Innovative artists' early career work is usually the most expensive on the market. For experimental artists, late career canvases—which tend to encapsulate how an artist's ideas have matured through years of development—are typically the most expensive.[22]

Some economists have also used auction prices to understand why artists clustered in certain artistic centers and how those working within a peer group are more likely to create work that demands high prices or is featured in major exhibitions. This phenomenon of visual artists in clusters producing higher-quality works—which has also been identified in other fields, such as music and literature—has been observed across time periods.[23] Economists John O'Hagan and Christiane Hellmanzik examined the migration and clustering patterns of famous artists for four periods (based on their dates of birth): Renaissance Italy, Europe in the first half of the nineteenth century, and Europe and North America for the periods 1850–1899 and 1900–1949. Florence and Rome dominated in Renaissance Italy; Paris and London witnessed a marked clustering of artists born in the first half of the nineteenth century. The French capital continued to dominate among artists born in the second half of the nineteenth century, while artists born around the world in

the first half of the twentieth century clustered in New York City.[24] This literature shows that an artist who lived and worked in one of these clusters is far more likely to have an enduring posthumous reputation. In general, economists attribute the positive outcomes in clusters to peer effects: the impact of working alongside and in competition with creative colleagues.

Of course, major art collectors, dealers, and institutions were usually located near these artistic clusters and can have a clear impact on the lasting reputation of an artist. Social scientists have not engaged extensively with the effects of these other art world actors on the success of artists working in clusters. However, in an article and then a book—*Etched in Memory: The Building and Survival of Artistic Reputation* (1990)—the sociologists Kurt and Gladys Lang explored how the behaviors and backgrounds of artists (primarily nineteenth- and early twentieth-century British and American etchers) during their lifetimes and the handling of their posthumous legacies has affected the durability of their fame.[25] More recently, Samuel Fraiberger and his coauthors have used a data science approach to show that early exposure to these core networks in the art world—including major museums—have a strong effect on lasting fame.[26]

The creation and survival of artistic reputation is also the subject of a handful of articles that have systematically tested the durability of expert opinion. In two 2003 articles, Victor Ginsburgh examines the fate of winners of classical music competitions, American movie awards, and international book prizes.[27] He concludes that positive expert opinions or awards given shortly after the production of a work are usually correlated with economic success. However, these pronouncements do not correlate with the long-term survival or acclaim of the work of art or the artist. In the visual arts, Kathryn Graddy specifically tested the correlation between quality rankings created by renowned seventeenth-century art critic Roger de Piles for artists active in his own period and the prices attained by those artists on the auction market over the subsequent three centuries. She found, contrary to Ginsburgh, that his highest-ranked artists attained both better financial returns on the market and more art historical acclaim.[28] One of the best collections of work featuring computational approaches to art history—the interdisciplinary volume *Partisan Canons* (2007), edited by Anna Brzyski—presents several studies of the durability of canonical status once an artist or artwork has achieved it.[29]

Within quantitative studies of art history, one of the most studied areas is the art of mid-nineteenth-century France. Tackled by both economists and sociologists, this period, which bridges the end of the dominance of the Paris Salon as an exhibition venue and the emergence of the Impressionists, has been a laboratory for computational analyses of art. The earliest contribution to this subfield was *Canvases and Careers: Institutional Change in the French Painting World* (1965). In this influential book, sociologist Harrison C. White and art historian Cynthia A. White examine the transition in late nineteenth-century France from a system of centralized state support for the visual arts to what they call the "dealer-critic" system, a decentralized market-based system for the exhibition and sale of contemporary art.

The Whites show that the Académie des beaux-arts (Academy of Fine Arts) was simply unable to absorb the growing numbers of painters as France's population—and particularly its urban population—grew rapidly throughout the nineteenth century. Furthermore, Paris became an international center for the arts, meaning that both large numbers of foreign artists and purchasers relocated or traveled to the city. This put further pressure on the academic system to accommodate the growing artistic activity in its orbit. Around this time, several entrepreneurs—most of whom had been dealers in art supplies or paper—began to sell work by contemporary artists. While a secondary market for Old Master works had existed since the eighteenth century, the emergence of art dealers selling work by living artists was a new phenomenon. However, these dealers needed a way to market and vouch for the value of the contemporary art they were selling. This, the Whites argue, is where art criticism became an essential part of the art world. The art market came to rely on both dealers' skills as salespeople and the opinions of public intellectuals—famous critics like the Frenchman Théophile Gautier and Englishman John Ruskin—who were qualified to judge the quality of art. The book concludes with a discussion of the Impressionists. Famously, the jury that managed submissions to the Salon consistently rejected the Impressionists' artworks. Under extreme financial pressure and excluded from the major exhibition venue of the day, the Impressionists began organizing their own group shows with the assistance of the art dealer Paul Durand-Ruel. This shift in exhibition practice represented a watershed moment in the history of art and the art market. It is the juncture at which the dealer-critic system began to ascend and the Salon and academic system—which had analogs all over Europe and even in the United States—began to falter.

Many scholars have followed the Whites' lead in exploring and explaining why the market for arts and culture changed so radically during the nineteenth century. Galenson and several coauthors have produced a number of papers in direct response to *Canvases and Careers.* For example, he and art historian Robert Jensen wrote a paper arguing that the fracturing of a centralized state-sponsored exhibition system in nineteenth-century France can be partially attributed to artists' entrepreneurial impulses to exhibit and sell in their own group shows.[30] In another article, Galenson and economist Bruce Weinberg argue that the new decentralized market-based system encouraged and rewarded innovation among artists and helped foster the advent of modern art.[31] More recently, two emerging scholars have published new studies on the nineteenth-century French art market and its international dimensions: Agnès Penot and Léa Saint-Raymond.[32] Saint-Raymond, in particular, is trained as both an art historian and economist, and has used econometrics and other quantitative methods extensively in her work.[33] One of her most recent contributions specifically challenges the Whites' characterization of the antagonism between the academic and the dealer-critic, as well as the time frame in which the former system collapsed.[34]

Harrison White and the Langs were sociologists. While their work overlaps with cultural economics, it is also related to another subfield that is relevant to this book:

cultural sociology. Though the Whites and Langs focused on the art market and artists' professional trajectories, many sociologists who have studied the arts have instead focused on cultural consumers. They examine how peoples' taste for arts and culture are formed and preserved. This kind of research into the tastes of art consumers—and their ability to accrue cultural capital—is not directly addressed by the case studies in this book but nonetheless deserves to be mentioned as another point of overlap between art and economics.

The originator of this line of inquiry was Pierre Bourdieu. The sociologist first published *Distinction: A Social Critique of the Judgment of Taste* in French in 1979. The book presents a combination of theory and empirical analysis. The theoretical framework is derived from his earlier work on *habitus*, people's education and upbringing, and the supporting empirical evidence comes from surveys of contemporary French people of different educational and socioeconomic backgrounds. Bourdieu begins his argument with the assertion that "there is an economy of cultural goods [with] a specific logic."[35] This logic is determined by the *habitus* of the participants in the cultural economy. He writes:

> In a sense, one can say that the capacity to see (*voir*) is a function of the knowledge (*savoir*).... A work of art has meaning and interest only for someone who possesses the cultural competence, that is the code into which it is encoded.... A beholder who lacks the specific code feels lost in a chaos of sounds and rhythms, colors and lines, without rhyme or reason.[36]

Because transacting in this cultural economy demands this encoding—namely, a certain *habitus*—Bourdieu concludes that class may be not only expressed but also defined and transmitted to future generations through the consumption of cultural goods. Finally, he argues that formulating class distinction on the basis of cultural tastes is particularly effective. While upwardly mobile people may be able to accumulate financial capital in one lifetime, cultural understanding is the product of "total, early, imperceptible learning, performed within the family from the earliest days of life and extended by a scholastic learning which presupposes and completes it.... Bourgeois families hand [this] down to their offspring as if it were an heirloom."[37] These conclusions have since been accepted as general theory that can help explain the cultural behaviors of elites, past and present. Sociologist Paul Dimaggio, for example, has published extensively on American arts institutions and their role in propagating elite cultural capital in the nineteenth century. Other notable contributors to this area include Sven Beckert, a historian of capitalism, and art historian Oscar Vázquez, who writes about nineteenth-century Spain.[38]

These contributions from across the social sciences are primarily—although not exclusively—relevant to this book as examples of the application of social scientific methods to topics from art history or the history of culture. However, the research questions central to the case studies in this book are drawn primarily from the social history of art. In the opening pages of *The Social History of Art* (1951), art historian Arnold Hauser discusses prehistoric cave paintings, interpreting from the

perspective of the economic setting in which they were created: "We know that it was the art of primitive hunters…who had to gather or capture their food rather than produce it themselves."[39] Throughout this multivolume, century-spanning study, Hauser continues to ask similar questions and to begin his answers with descriptions of contemporaneous social and economic conditions. Although Hauser published in the 1950s, the most robust and sustained efforts to write social histories of art emerged in the 1970s.

Inspired by Marxist theory, a group of scholars changed the discipline of art history by demonstrating that artworks and artists do not exist in a separate aesthetic sphere but must be understood in their social, economic, and political contexts. This approach has since had a far-reaching impact on the study of art history, and many scholars—even without a clear commitment to Marxist theory—now incorporate socioeconomic context into their analyses.[40] T. J. Clark, one of the founders of this new art historical methodology, wrote in the introduction to his groundbreaking book *Image of the People: Gustave Courbet and the 1848 Revolution* (1973): "If the social history of art has a specific field of study, it is…the processes of conversion and relation, which so much art history takes for granted. I want to discover what concrete transactions are hidden behind the mechanical image of reflection, to know *how* background becomes foreground."[41] As Clark goes on to elaborate, the "background" is social, economic, and political change that an artist, audiences, and patrons lived through as a work was being created and exhibited. He and other social historians of art, including Robert Herbert, Linda Nochlin, and Griselda Pollock— whose feminist critique of the canon was discussed earlier in this chapter—sought to understand how socioeconomic change affected the art world, particularly in nineteenth-century France. Notably, Lillian B. Miller and Alan Wallach were among the first to extend these questions to a nineteenth-century American setting, while Ann Bermingham and John Barrell were pioneers in applying the lens of the social history of art to the British setting.[42] Though more recent scholarship has distanced itself from the explicitly Marxist approaches of the founding contributions, providing and engaging with socioeconomic context—such as industrialization, changing transport connections, and scientific developments—is now standard for studies of nineteenth-century art. Some of the most compelling and well-known scholarship that has placed French, American, or British artwork in this context has been written by André Dombrowski, Jennifer Roberts, Andrew Hemingway, Tim Barringer, and Leo Costello—although this is *very* far from an exhaustive list.[43]

Though they differ by degree in their methods and areas of focus, founding social histories of art have several things in common. First, they are dedicated to the assumption that most works of art are formed in the crucible of interaction between different social groups, mostly defined along class or gender lines. Second, they criticize established art historical accounts for a failure to challenge received wisdom, traditional methods, and narrow definitions of the artistic canon. Finally, the founding social historians of art embraced empiricism as a way to combat what were perceived to be entrenched scholarly perspectives.[44] This book attempts to

build on the pioneering work of these scholars along all three of these axes: by placing art in a more complete socioeconomic context, by challenging received wisdom and narratives, and with a renewed dedication to empiricism. Furthermore, their specific contributions to certain topics—including the relationship between art and industrialization, the career attainment of women artists, and the relationship between empire and art—help to frame the questions addressed in case studies central to this book.

The final area of scholarship that is particularly relevant to this book is the comparatively young one of digital humanities, specifically, digital art history. What should be considered part of this subfield is up for debate. Does a digital image repository or a website that engages with digital storytelling, for example, count as digital art history? Or does the designation of an art historical inquiry as "digital" depend on using computational analytical methods rather than just using computer-dependent databases or technology to aggregate information? Various scholars have weighed in on this debate, and there is no firm conclusion.[45] Therefore, it is difficult to provide an up-to-date comprehensive literature review of this quickly growing and methodologically broad field.[46] A recent comprehensive questioning of the scope of the field, written by Nuria Rodríguez-Ortega, says of the breadth of the burgeoning scholarship: "One of our tasks should be to construct a representation of digital art history that reflects multiple and varied practices, distributed and pluralistic, encompassing practices that have been developed outside of hegemonic contexts that make possible different lines of research."[47] With respect to this diversity of digital approaches—and for the sake of a limited word count—the remainder of this literature review engages only with digital humanities and digital art history initiatives that work directly with quantitative and statistical analysis.

Some of the earliest contributions to the digital humanities came from literary studies and marshalled simple statistical presentations of data about cultural output: plotting trends over time. Scholars like Franco Moretti and Matthew Jockers described their graphing and mapping of trends in genre and subject matter as "distant reading" and "macroanalysis."[48] These kinds of methods have recently been applied to recapture otherwise overlooked histories, such as in the context of Kim Gallon's Black Press Research Collective, which examines the extensive media outlets that were produced by and for the American Black community.[49] Yet scholars within digital humanities have pushed against, revised, and refined Jockers's and Moretti's approaches—most notably, Stephen Ramsay.[50] Rodríguez-Ortega has written that these types of analyses engage with a "narrative based on technological progressivism" and can unquestioningly present computational analysis as the future of the discipline of art history. Claire Bishop, a scholar and theorist of contemporary art, has passionately argued that subordinating art history to the use of statistics and "distant viewing" (adapted from the term "distant reading") subjects the discipline to an ideologically charged neoliberal political agenda.[51] Needless to say, data-driven approaches remain controversial—and what can even be considered "data" in the digital humanities is still up for debate.

In response to this controversy, leading digital humanist Willard McCarty has, in particular, focused on how to reckon with the integration of computing into humanities research and reconcile techno-enthusiasm and techno-skepticism among scholars.[52] Addressing this divide from another perspective, feminist scholar and digital humanist Tara McPherson has argued for a much closer connection between the wide range of available computational approaches and what she refers to as "the theories and histories of difference" that the humanities have long engaged with.[53] This book will not settle these debates. Instead, it provides examples of scholarship that can, perhaps, be considered by those debating the future of digital humanities. Its focus on integrating methods and theories from the social sciences—particularly economics—to help humanities scholars reckon with large datasets is, I believe, a contribution of novel evidence to these ongoing deliberations.

Some art historians who have engaged with digital methods have emulated and built on Jockers's and Moretti's model of digital humanities work. Examples of these kinds of analyses include Anne Helmreich and Pamela Fletcher's research on the geographic distribution of art dealers and the movement of paintings marketed by the Goupil group of galleries, and the ongoing Artl@s exhibition mapping project led by Béatrice Joyeux-Prunel and Catherine Dossin.[54] Matthew Lincoln has used statistical analyses to study how social networks and geography influenced art production, notably, in the Low Countries during the sixteenth century.[55] Yet as Murtha Baca and Helmreich wrote in a review of the field of digital art history: "The driving force behind any research project should be the scholarly question, *not* a particular technology or tool. While new technologies can be alluring, the key point is to clarify the art-historical research questions at the core of the inquiry and then, once these are established, to determine if digital modes of analysis are well suited to pursuing these questions."[56]

A recent article by Paul Jaskot, a leading digital art historian, responds to this critique of the field by linking the computational potential of a digital history of art to persistent art historical research questions. Jaskot and I agree about certain themes in forging a data-driven history of art:

> Social art history at its most critical is not satisfied with a social context for art, but rather reverses this equation by arguing that an analysis of art, artist, and audience must tell us something structurally about society. It is these kinds of questions that engage in broader art-historical debates. When questions such as these rely on large bodies of evidence—which they often do if "society" is their focus of study—then the scale of the project is, in today's context, best suited for digital methods.... In sum...digital art history lets us address the tradition of the social history of art in new ways.[57]

He argues, in short, for the potential of the types of evidence and analyses that are central to digital art history to upend received wisdom about art history and—more broadly—about the society that produced the art we study. These methods are not only valuable for building on existing histories of art but essential for analytical

completeness. "We do this work not merely because we can—we do it because it is analytically the most rigorous."[58] Interestingly, his article also presents feminist critiques of the canon—like Pollock's—as a potential model for the productively disruptive effects of new methods in art history.[59] Key to Jaskot's insight—and the use of data in this book—is the question of scale. With data, the size of samples studied and the scale of evidence marshalled can be greater than ever before.[60] This can allow generalizing inquiries into art and social and economic context to be more robust than ever.

However, as Jaskot notes, there has been resistance to marshalling digital art history in this way. Art historians engaged in and methodologically indebted to the social history of art—with its roots in Marxist history and critiques—are sometimes wary of statistical and data-driven analyses. Quoting Franco Moretti, Jaskot writes: "This disjunction—perfectly mutual, as the indifference of Marxist criticism is only shaken by its occasional salvo against digital archives as an accessory to the corporate attack on the university[—]is puzzling, considering the vast social horizon which digital archives could open to historical materialism, and the critical depth which the latter could inject into [digital humanities]. It's a strange state of affairs; and it's not clear what, if anything, may eventually change it."[61] In short, the reputation of data and statistics as tools of capitalist agendas have impeded some scholars from recognizing their analytical potential.

Jaskot concludes his article by stating that he hopes the examples he provided will change this resistance. The case studies presented in this book, though framed as data-driven histories of art rather than digital art history, will hopefully further convince humanities scholars of the value of computational and quantitative methods. Furthermore, by demonstrating the ways in which economic analysis does *not* simply propagate one ideological position, but can provide guidance for complex data analysis, this book can—perhaps—help humanists be open to interdisciplinary work with the quantitative social sciences.

Why Data-Driven Histories of Nineteenth-Century Art?
The data-driven history of art that I present is a way to unite art and economic history while building on digital humanities work like Jaskot's. I try to make clear the value of computational and digital tools that can engage with the social history of art—but then go one step further. Rather than simply stop at quantitative work with digitization and the plotting and mapping of data, this book aims to show that one can engage with both the empirical quantitative methods of modern economics *and* its theories about the structural complexities of human behavior and institutions. I make an argument for the complementary power of economic history for art historical inquiry along both computational and theoretical axes. This is a new approach.

However, I want to make clear that not every research question in art history is well suited for this kind of methodology. The hypothetical scholar conducting a close study of the work of Edgar Degas, as discussed above, probably does not need

large datasets, statistics, or economic theory to guide him or her. However, when that scholar becomes interested in how Degas and his work fit into broader trends in the art world or—as in the case of the social history of art—broader trends in society, the data-driven history of art becomes useful. Economics and computational methods can allow that scholar to visualize these trends, understand the relationship between changing socioeconomic variables and the arts, or trace the ways that scarcity influenced Degas and his contemporaries' behavior. As Jaskot writes, "The scale of evidence and the methods central to much of social art history are the evidence and methods that complement or call out for digital art history."[62] The use of these methods is dependent on the scale of the evidence needed to answer the research question at hand—and this approach is best suited to large-scale evidence.

After talking about the advantages of zooming out to a quantitative bird's-eye view of art history, it is necessary to describe the costs and the counterpoint to this methodological opportunity of quantification. I do not want to overclaim: data does *not* provide simple objective truth. First, art historical data is not flawless. Cataloging a work of art is a profoundly human process; there is the possibility of error in the original recording of a work of art in an exhibition catalog, in the transcription of that catalog into other forms (analog and digital), and then in how it is categorized in a dataset. The data in this book, like the works of art they represent, are complex and sometimes imperfect. Second, behind each data point is a complex work of art that should not only be collapsed into a row in a spreadsheet. The issues of reducing an artwork to a series of attributes—such as artist, title, date—are discussed in greater detail in chapter 2. Ideally, the data-driven historian of art can provide analyses that oscillate as necessary between a focus on individual historical figures and close looking at select objects and general trends and behaviors clarified by quantitative methods and economic theory. In this way, one can place artworks in their most complete social, economic, and cultural contexts. The three case studies in this book provide examples of which kinds of art historical research questions are best suited to this approach. Furthermore, they demonstrate how analyses can move seamlessly between close examinations of individual works and artists and a more macroscopic view.

Nineteenth-century art has proven an ideal subject to test-drive this methodology. The creation and reception of works of art is remote enough that contemporary scholars need to rely on a select preserved sample to study. However, likely owing to the proliferation of cheap printing technologies and growing literacy rates, nineteenth-century arts venues had a growing interest in documenting art exhibitions.[63] This means there is ample source material listing works that were produced and exhibited but have either physically not survived or—along with their makers—simply faded into obscurity. This juxtaposition of an existing art historical canon of well-known and well-preserved masterpieces with available trace information that can be digitized and quantified presents the perfect opportunity to test scholars' existing hypotheses and assumptions. Furthermore, as described in the coming chapters, the nineteenth century was a time of rapid social and economic

change, much of which was attributable to industrialization. This dynamism creates a perfect laboratory for testing the effects of socioeconomic variables on art historical ones, in a way that is guided by an economic understanding of scarcity and structural constraint. Focusing on this period has allowed me to engage with research questions related to growing urbanization and changing transport connections, shifting opportunities available to women artists, and the context of colonial expansion and imperialism.

The use of a Degas scholar as an example throughout this introduction is not random. I do not study Degas in particular—and he is an artist who behaved in problematic ways and held problematic views of the world.[64] Yet he has created some of my favorite paintings, which, upon viewing, are much more complicated than their titles suggest. *The Bellelli Family* (1858–1867) [fig. 1.1] transports the viewer to the bourgeois world of an upper-class nineteenth-century European family. One could, perhaps, glean this much from the title. The red chalk drawing in the center of the wall, the large mirror, and items gathered on the marble mantel suggest the members of this household were among the consumers who formed part of the nineteenth-century cultural economy and are also all in keeping with a haute-bourgeois environment. The severe adult woman on the left side of the painting is draped in—or almost swallowed by—her black wardrobe. The smothering outfit and distance from her husband on the other side of the painting seem to allude to a tension in the household. The father and mother—Gennaro and Laura Bellelli, who was Degas's aunt—look in opposite directions, away from each other and from the viewer. While one of their daughters stands firmly at Laura's side, the other appears torn. Perched on a chair, her one visible foot points to her mother and sister, while her face is turned in the direction of Gennaro. Though the title tells us that Degas had painted a family, it does not indicate the extent to which he poetically presented a family coming apart at the seams. Primary sources indicate the Bellellis' homelife was unhappy, and Degas conveys this tension masterfully.[65] Part of the power of this painting is its ability to transmit human emotion across history.

Not only are distinct artworks behind each of the data points in this book, but in turn, complicated human stories about artists, subjects, and models are wrapped up in each work. Adding to the complexity of the *The Bellelli Family* is Degas's own complicated history—including his family's links to cotton and the institution of slavery in Louisiana, as well as his anti-Semitism and misogynistic views.[66] Each dataset represents a flattening—and obscuring—of these stories, both positive and problematic. Therefore, though I believe wholeheartedly in the value of data-driven art history, it is essential never to lose sight of the qualitative richness that underpins quantification. Ultimately, this book seeks to present new thought-provoking methods that walk this tightrope between quantitative and qualitative approaches. This is the beginning of a methodological conversation rather than any kind of final say.

◇◇◇

The Historical Data
of the Art World

Artists and art historians have—often inadvertently—created valuable datasets for decades. Exhibition checklists, catalogues raisonnés, finding aids to archival sources, and collections information generated by museums are all rich sources of data. However, art historians do not generally conceive of them as such. Instead, we are trained to treat these resources as simple lists of information. This book repurposes, digitizes, and reconceives of many of these kinds of common art historical sources to create novel datasets. Of the wide range of sources deployed in this book, information about historical exhibitions provides the largest datasets; these data are graphed in figures 2.1 and 2.2.

Figure 2.1 features data about exhibitions in France, England, and the United States. In a given year between the mid-eighteenth century and World War I, anywhere from a few hundred to more than 14,000 works were shown in the included venues. If this quantity of artwork exhibited annually seems large but comprehensible, the numbers become more overwhelming when considering their cumulative effect. Figure 2.2 uses the same data from figure 2.1 but presents the cumulative number of works shown. In total, hundreds of thousands of artworks were exhibited: a tsunami of art was produced and shown. Just this accounting of the amount of artistic production during this period is a new insight into the history of nineteenth-century art. Qualitative accounts suggest this scale—and works like the Whites' *Canvases and Careers* quantify it in a particular setting—but this book (and specifically this chapter) presents the most comprehensive enumeration to date.

In aggregate, these exhibition data represent a unique view of the transatlantic art world during the long nineteenth century. This view includes not only famous works often studied by art historians but all of the lost art, repeat showings, copies,

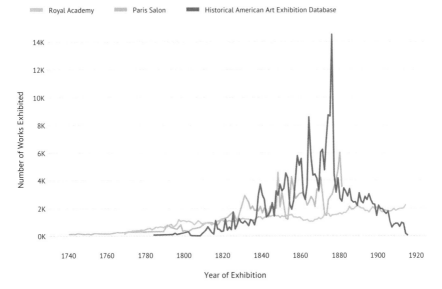

FIGURE 2.1 Number of Works Listed in Each Exhibition Dataset, 1740–1915 (N = 528,931).
Sources: Diana Seave Greenwald, Historical American Art Exhibition Database, see table 2.2;
Jon Whiteley, *The Subject Index to Paintings Exhibited at the Paris Salon, 1673–1881* (1993), Sackler
Library, University of Oxford; *Catalogues of the Paris Salon, 1673 to 1881*, 60 vols., ed. H. W. Janson
(New York: Garland, 1977); *Catalogs of the Exhibitions of the Royal Academy, 1769 to 1914*, https://
www.royalacademy.org.uk/art-artists/search/exhibition-catalogues; *The Royal Academy Summer
Exhibition: A Chronicle, 1769–2018*, ed. Mark Hallett, Sarah Victoria Turner, Jessica Feather, Baillie
Card, Tom Scutt, and Maisoon Rehani (London: Paul Mellon Centre for Studies in British Art, 2018),
https://chronicle250.com.

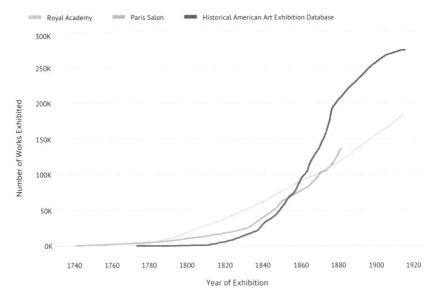

FIGURE 2.2 Cumulative Number of Works Listed in Each Exhibition Dataset, 1740–1915
(N = 528,931). Sources: See figure 2.1.

and generally less-accomplished work that formed part of the historical artistic landscape. The scale and raw nature of these data make them distinct from a museum's curated inventory or even an encyclopedia of active artists. By casting a wide net for this full but uneven population of works exhibited, these data are critical for combating the sample bias discussed in chapter 1. However, just because a dataset is large does not necessarily mean it is perfectly representative. The goal of this chapter is to introduce the three principal datasets central to the case studies presented in this book: the Whiteley Index to Paris Salon Painting,[1] the Historical American Art Exhibition Database (HAAExD), and the Royal Academy Exhibition Database. In doing so, it seeks to help readers understand what information one can and *cannot* glean from the data sources. As a result, this chapter does not seek to establish an overarching narrative about what these data mean or how they sketch out a complete history of nineteenth-century art; it is meant to be a thought-provoking overview.

Each section is dedicated to a given dataset and begins with a description of the underlying source material, its original purpose, and its content. With historical exhibition data, it is essential to understand the institutional history of the venue whose shows are chronicled. Exhibition rules, the presence of a jury, and the constitution of that jury all had significant effects on which artworks were shown or excluded from gallery walls. Juries or other committees also often had control over how artworks were arranged—how visible they were in dense Salon hangs, as seen in the background of figure 2.3, meaning whether they were at eye level or at the

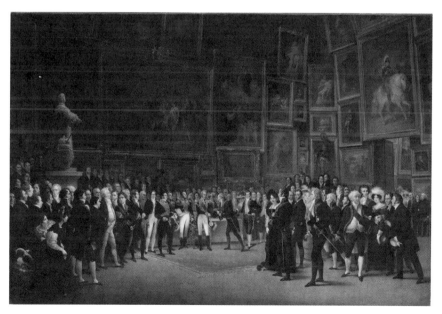

FIGURE 2.3 François-Joseph Heim, *Charles X Distributing Awards to Artists at the end of the Salon of 1824, in the Grand Salon at the Louvre*, 1824, oil on canvas, 173 × 256 cm. Musée du Louvre, Inv. 5313. Photo: Philippe Fuzeau.

top of the gallery walls, impossible to see. Unfortunately, decisions about placement and display are not extensively documented in the source materials underpinning the data, apart from occasional information about which room a work was displayed in. The dense gallery arrangements are, essentially, flattened and paintings' status is equalized. Juries often also awarded prizes to exhibitors, as shown in figure 2.3; in some cases, notably for the Paris Salon, winning a prize had a significant effect on one's ability to show regularly in the exhibition. These advantages are described generally, and some data about prizewinning are presented in chapter 3; however, information about prizes is not systematically recorded in the sources that underpin these datasets. Ultimately, these histories can help readers understand the ways in which these data are and are not representative of the full population of artworks produced in nineteenth-century France, America, and Britain—the ways the data may be biased. Generally, one must note that *all* of the included venues primarily exhibited paintings. Works on paper—notably, prints—are underrepresented in these datasets, given their popularity during this period.[2]

The case studies in chapters 3 to 5 delve into particular subsets of data tailored to narrower research questions. In contrast, the graphs and tables in this chapter engage with larger themes, such as the frequency with which political portraits were shown, the geographic distribution of contemporary art exhibitions, and the rate at which works submitted to juried exhibitions were rejected. This overview of the scale and scope of the data available highlights the potential for quantitative analysis to inform art historical research beyond the contributions of this book. Finally, these datasets are available for other scholars to use. Instructions for accessing data, as well as further information about how it was compiled, is in appendix A.

The Whiteley Index to Salon Painting

The Paris Salon was a national state-run art exhibition whose structure was inextricably linked to politics both in the art world and in France's government. It stood at the center of a constellation of state affairs, rival artistic styles, diverse critical reactions, and public reception. Usually administered by the Académie des beaux-arts, the Salon took place approximately every one to three years from the seventeenth century until the end of the nineteenth century.[3] By the nineteenth century, it was Europe's premier juried art exhibition and featured work by artists from around the world.[4] Between 1673 and 1881—the last year of the unitary Salon—over 150,000 works were shown.[5] For every exhibition, the organizers published an official catalog, called a *livret*, which recorded the title and maker of each work displayed.

Over the course of twenty years, Jon Whiteley—a curator at the University of Oxford's Ashmolean Museum—assembled a hard-copy index to every painting (and some drawings, depending on how the sections of the Salon were divided) listed in the livrets.[6] The index is officially titled *The Subject Index to Paintings Exhibited at the Paris Salon, 1673–1881*. Based on its French title, each work is tagged with one or more English keywords or "subject headings," as Whiteley calls them. Figure 2.4

Ploughing: 1795-242; 1796-27, 199; 1834-112; 1845-159; 1847-167; 1849-204; 1850-2136; 1855-4094; 1859-1546; 1865-1978; 1870-3123.

Sowing: 1850-2221; 1859-1425; 1873-1062; 1879-2444; 1880-595; 1881-116, 1823.

Harvesting: 1737-p. 9; 1739-p. 21; 1751-2; 1775-80; 1777-59; 1783-23; 1795-119; 1799-70; 1819-1627; 1827-825; 1831-1913, 2745, 2836; 1833-123, 465, 1108, 2274, 3181; 1834-848, 912; 1835-589, 1501; 1837-179, 340, 680, 1703; 1838-860, 1092, 1213, 1241; 1839-864, 968; 1840-613; 1841-340, 937, 1049; 1842-13; 1843-489; 1844-740, 1376, 1801; 1845-1512; 1846-240, 513, 1091; 1847-104, 333, 642, 652, 879, 1203, 1647; 1848-1664, 2680, 3794; 1849-1124, 1199; 1850-1378, 2746, 3035; 1852-309, 658; 1853-92, 174, 526, 586, 837, 963, 1149; 1855-3173, 3281, 3444; 1857-190, 349, 1222, 1592, 1698, 1967, 2149; 1859-467, 804, 1092, 1559, 1916, 2380, 2436, 2945, 2946, 2973, 3044; 1861-637, 833, 1057, 1077, 1685, 2785, 3043, 3056; 1863-27, 143, 154, 340, 668, 744, 1251, 1272, 1538; 1863R-441; 1864-157, 675, 1273, 2085; 1865-179, 417, 862, 1574; 1866-739, 1913; 1867-672, 849; 1868-745, 746, 748, 1543, 2418, 3087; 1869-942, 1467, 2003; 1872-182, 950, 1268; 1873-1131; 1874-395, 546, 1216, 2384, 2588; 1875-834, 1231, 1786, 2572, 2813; 1876-731, 751, 1003, 1125, 1720; 1877-160, 401, 722, 998, 1226, 1544, 1946, 2765, 3520; 1878-381, 601, 1640, 2430, 3488; 1879-4649; 1880-150, 288, 306, 463, 1672, 1752, 2016, 2708, 2751, 2787, 2923, 3263, 3407, 3606, 4504, 5310, 5980; 1881-882, 2271, 2332, 2569.

Gleaning: 1801-75; 1806-128; 1812-571; 1814-1351; 1824-433, 1509; 1831-1565; 1834-336; 1840-1518; 1842-649, 1308; 1849-320; 1850-2438; 1855-2541, 2628; 1857-1322, 1936, 2639; 1859-409; 1861-2135; 1863-748, 1350, 1669; 1864-356, 1406, 2375; 1865-385; 1866-1523, 2595; 1868-1705; 1870-1647; 1873-163; 1876-115; 1877-302; 1878-1331, 1898; 1879-1111, 1517; 1880-59, 1297; 1881-192, 336.

Wheat: 1850-41; 1853-744; 1855-2804; 1857-381; 1863R-446; 1864-1585; 1865-677, 1530; 1870-2334; 1873-1304; 1874-1052, 1366, 1411; 1875-2313; 1876-678; 1878-3940; 1881-2257.

Winnowing: 1808-270; 1819-392; 1845-1038; 1848-3341; 1855-3565; 1857-1550; 1861-1409, 2738; 1863-748; 1864-3257; 1866-605, 1188; 1867-587, 1214, 1326; 1868-730, 2121; 1869-932; 1870-2838, 3428; 1874-1052; 1876-1970; 1877-1857; 1878-730; 1879-2004, 2016, 3443; 1880-2161, 5067.

Sieving: 1855-2804.

Threshing: 1819-528; 1840-90; 1857-1695; 1876-678.

207

FIGURE 2.4 Page 207 from Jon Whiteley, *The Subject Index to Paintings Exhibited at the Paris Salon, 1673–1881* (1993), Sackler Library, University of Oxford.

presents an image of a page from the 908-page manuscript index. The subject headings are the words before each list of numbers. Each numerical entry includes the year of a painting's exhibition and its number in the livret. For example, painting number 1850-2221, categorized under the keyword "Sowing," is French artist Jean-François Millet's *The Sower* (fig. 2.5), the first version of which appeared on a livret page shown in figure 2.6.[7]

Whiteley's introduction to the index recounts the decades-long assembly of the work, including challenges posed by ambiguous titles. Titles are an imperfect way to identify paintings and their content; a basic and sometimes enigmatic written title cannot capture the experience of seeing a painting with one's own eyes and deciding how to categorize it.[8] Whiteley's solution to this ambiguity was to

FIGURE 2.5 Jean-François Millet, *The Sower*, 1850, oil on canvas, 101.6 × 82.6 cm. Museum of Fine Arts, Boston, Gift of Quincy Adams Shaw through Quincy Adams Shaw Jr. and Mrs. Marian Shaw Haughton 17.1485.

create thousands of subject headings. These keywords are dizzyingly precise. They range from "Girls with Poultry," to both "Cervantes' work" and "Cervantes' life," to "Jealousy," to the specific geographic location a painting depicts. When needed, multiple headings were applied to a work. Whiteley's decision to create ever more specific keywords makes data derived from his index especially detailed. Whiteley categorized works in chronological order, moving from the earliest Salons to the most recent. After completing this process, he reviewed all of his categorizations to reapportion earlier works to the more specific categories that he had created after tackling later Salons.[9] This makes his keywords both exceptionally detailed and consistent. I personally checked all of the works that he tagged as rural genre painting, which form a core portion of data analyzed in chapter 3, and he had a staggeringly precise error rate of .05 percent in tagging.

While the Salon may now be best known for routinely excluding the Impressionists from its galleries, distinctions between the sites of innovation and reaction in the nineteenth-century French art world were not, in fact, so clearly delineated. The Impressionists, for example, only chose to exhibit on their own under

184 PEINTURE.

Portrait de M^lle C...
Idem de M. R...
Idem de M^me E...
Idem du petit-fils de M^me E...
Idem de M^lle de Ch...
Idem de M. Ch...
Idem de M^me de Ch...

2220 — Planche contenant trois portraits à l'aquarelle :
Portrait de M. A. G...
Idem de M^lle D...
Idem du fils de M. R...

MILLET (JEAN-FRANÇOIS), 19, *rue Fontaine-Saint-Georges.*

2221 — Un semeur.

2222 — Des botteleurs.

MILON (ALEXIS-PIERRE), 19, *rue du Regard-Saint-Germain.*

2223 — Chaire de Saint-Etienne-du-Mont.

2224 — Intérieur de la même église.

MIRANI (E.-P.), 18, *passage des Petites-Écuries.*

2225 — Un fragment du bois de La Haye, en hiver.

MISBACH (CONSTANT), 34, *rue Neuve-Saint-Etienne-du-Mont.*

2226 — *Sainte Geneviève; tête d'étude.

MOENCH (CHARLES-VICTOR-FRÉDÉRIC), 54, *rue de la Ferme-des-Mathurins.* — M. 2^e cl. [EX].

2227 — Tête de Vierge.

2228 — Vue du Tréport.

2229 — Id. d.

MOLIN (AUGUSTE DE), 6, *rue Neuve-Breda.*

2229-1° — Vue du pont du Gard.

2229-2° — Un temps couvert (Arles).

FIGURE 2.6 Page 184 from *Explication des ouvrages de peinture, sculpture, architecture, gravure et lithographie des artistes vivants, exposés au palais national le 30 décembre 1850* (Paris: Vinchon, 1850).

professional and financial duress; their first preference was to exhibit at the Salon.[10] The Salon exhibition was, despite its current reputation, central to the dynamic nineteenth-century French art world. It attracted hundreds of thousands of spectators and inspired hundreds of critical reviews in the press. However, to understand what kind of artwork was included in or excluded from the Salon—and by extension the Whiteley Index—one must understand the history of the exhibition and its jury.

The Salon began as an exhibition of works by members of the Academy of Fine Arts. The history of the Salon therefore begins with the history of the Academy. While it existed in earlier rudimentary forms, the Academy of Fine Arts received royal sanction from Louis XIV in 1648. Historian Albert Boime writes that the original academy, then called the Académie royale de peinture et de sculpture, was "divided into three levels: *élèves, agréés* and *acadèmiciens*, corresponding to the corporation categories of apprentice, journeyman and master."[11] The seventeenth-century academic system remained largely intact throughout the eighteenth century. A jury of acadèmiciens determined which works submitted by members of the Academy were displayed at the Salon and another committee (sometimes composed of the same members, sometimes a different group) awarded prizes to the best submissions. The Salon functioned like this until the French Revolution.[12]

The Salon of 1791 abolished the jury system. The committee directing this Revolutionary Salon decreed that any artist—French or foreign, Academy affiliate or independent—had the right to exhibit work without having it reviewed by an admissions jury. The 1791 overhaul of the Salon began a conflict over its relative openness to different exhibitors that colored battles over the control of the exhibition for the remainder of its existence. After 1791, the jury system was reinstated and the central point of contention became the composition and decisions of the jury, rather than its existence.[13] There was constant debate over whether or not the jury should be appointed or elected, who should appoint or elect its members, and whether there was an appropriate balance of power between acadèmiciens, state officials, and *indépendants*, artists not affiliated with the Academy. Stakeholders also wrangled over the size of the Salons and how often they were held. Acadèmiciens tended to favor smaller and less frequent exhibitions, while independents preferred large annual events. Regular political regime change meant that the rules and regulations for the Salon were often revised to alternatively favor one of these camps or attempted to strike a compromise between them, the terms of which all sides usually condemned.[14] Further exacerbating this conflict, the reestablished Academy that emerged from the Revolutionary era was a smaller, more exclusive, and grayer institution than during the ancien régime. The average age of academicians increased dramatically.[15]

The Salon was therefore not a static institution. What emerges from its contested history is that the exhibition was part of a protracted tug-of-war over the control and character of fine arts in France. Studying those works only shown at the Salon is clearly a biased sample—but it is difficult to tell how it was specifically biased at any given time. Table 2.1 provides a summary of the different rules and balance of power between stakeholders during each regime covered by the Whiteley Index.

While the Salon was the most important fine arts event in France during most of the nineteenth century, several other venues existed for exhibiting contemporary art. These included Salon-like exhibitions in cities outside of Paris, exhibits at the growing number of private commercial galleries, and group shows—including the eight Impressionist exhibitions that took place between 1874 and 1886—that developed in response to the restrictiveness of the Salon. In 1863, in response to public outcry over the continued rejection of notable artists from the Salon, Napoleon III ordered a separate exhibition, deemed the Salon de Refusés, to display all rejected canvases. This schism is generally considered the beginning of the end of the Salon's dominance—the first major fracture in the concept of a single Salon. The satellite show included works that are now considered masterpieces of modern art, such as Édouard Manet's *Le déjeuner sur l'herbe* (1863).[16] Because the Salon des Refusés was conducted with official sanction, a livret was published. Therefore, the Whiteley Index *does* include information about the Salon des Refusés. However, it does not include data about venues outside of Paris or independent group exhibitions.

The erosion of the Salon's dominance gave way to what sociologists Harrison

and Cynthia White have described as the "dealer-critic" system. Starting in the late nineteenth century, dealers—rather than competitive exhibitions—became a primary conduit for bringing new art to the market.[17] For example, Paul Durand-Ruel, the Impressionists' dealer, was closely involved with the organization of shows for the group and individual members.[18] Under the pressure of this external competition and ongoing internal debates among organizers and participants, the unitary state-sponsored Salon came to an end in the first decade of the Third Republic (1870–1940). In 1879, education reformer Jules Ferry became the minister of public instruction, which also gave him control over fine arts policy. From this point forward, while the state commissioned many artists to decorate public buildings and create public monuments, it scaled back its role in organizing and sponsoring the Salon. Edmond Turquet, Ferry's undersecretary for fine arts, expanded the number of artists who could vote for jury members controlling admissions to the 1880 Salon, but packaged the jury reforms with policies allowing académiciens' work to be more easily accepted and hung in the best galleries.[19] The public, art critics, and artists condemned these reforms and their impact on the Salon. The outcry was so loud and universal that organizers cancelled the usual awards ceremony at the close of the exhibition. Finally, in January 1881, the government also announced that it was fully surrendering control of the Salon to a society of artists.[20] The artists responded promptly to the state's withdrawal. The Salon of 1881, the last one in the Whiteley Index, was run by the Société des Artistes Français. While the Salon run by the Société was the only Salon of 1881, soon a variety of large annual exhibitions—many of which used the name "Salon"—were mounted.

Figure 2.7 zooms in on one element of figure 2.1 and uses the Whiteley Index to plot the number of works shown at the Salon between 1740, when the exhibition became more regular, and 1881. This visualization alone provides novel information about the art world in eighteenth- and nineteenth-century France. First, the number of artworks on display generally increased over time, with marked increases immediately after the Revolution and then again from 1830 until the 1880s. The number of works exhibited was mostly stable during the ancien régime. The Revolution represents a clear break, when the number of works displayed began to increase dramatically. Significant volatility in exhibition size developed particularly after 1830. The dramatic swings in the number of works shown during the final fifty years of the sample indicate the inconsistency in Salon and jury policies under the July Monarchy, the Second Republic, the Second Empire, and finally the Third Republic. While scholars have described this institutional instability qualitatively, this graph confirms those observations quantitatively.[21]

These data, however, can be used to understand more than simply the number and frequency of paintings shown at the Salon. Whiteley's meticulous system of subject labeling also allows us to plot the relationship between French national politics and trends in subject matter. Figure 2.8 further explores the links between the Salon and national politics. It plots the frequency with which portraits of members of the French royal family—specifically, the House of Bourbon—and members of

TABLE 2.1 French Political Regimes and Their Salon Policies

DATES	REGIME	RULER(S)	NUMBER OF SALONS
~15th century–1789	Ancien Régime	Multiple, including Kings Louis XIV, Louis XV, Louis XVI	37
1790–1792	French Revolution	—	1
1792–1804	First French Republic	National Convention, Directory, Consulate (Napoleon)	8
1804–1814 (briefly 1815)	First Empire	Emperor Napoleon I	6
1815–1830	Constitutional Bourbon Restoration	Kings Louis XVIII (1814–1824) & Charles X (1824–1830)	5
1830–1848	Constitutional Orléanist Monarchy (July Monarchy)	King Louis-Philippe	17
1848–1852	Second Republic	Constitutional Assembly, President Louis-Napoleon Bonaparte	2
1852–1870	Second Empire	Emperor Napoleon III (Louis-Napoleon Bonaparte)	14*
1870–1940	Third Republic	Parliamentary Republic	11

*15 including the Salon de Refusés; one of these Salons was replaced by Exposition Universelle (1855).

Based on Patricia Mainardi, "Political Regimes, 1789–1870," in *The End of the Salon: Art and the State in the Early Third Republic* (Cambridge: Cambridge University Press, 2011), 34; *Catalogues of the Paris Salon, 1673 to 1881*, 60 vols., ed. H. W. Janson (New York: Garland, 1977); Albert Boime, "The Second Empire's Official Realism," in *The European Realist Tradition*, ed. Gabriel P. Weisberg (Bloomington: Indiana University Press, 1982), 31–123; Boime, *The Academy and French Painting in the Nineteenth Century* (London: Phaidon, 1971); Pierre Vaisse, "Reflections sur la fin du Salon official," in *Ce Salon à quoi tout se ramène: Le Salon de peinture et de sculpture, 1791–1890*, ed. James Kearns and Pierre Vaisse (Bern: Peter Lang, 2011), 117–38; Harriet Griffiths, "The Jury of the Paris Fine Arts Salon, 1831–1852" (PhD diss., University of Exeter, 2013).

The Salon began as an irregular show for the members of the Académie royale de peinture et de sculpture. It became an annual exhibition in 1737, with the jury system for selecting works to be shown instituted in 1748. Even after the establishment of the jury, only members of the Academy could exhibit.

Jury was abolished and Revolutionary Salon made open to all artists, amateur and professional, all nationalities.

In order to control the quality of work shown, the jury was reestablished. In 1798, the jury was composed of painters, sculptors, and architects nominated by the government.

In 1808, the national director of museums—Vivant Denon—reconfigured the jury to include both artists and amateurs selected by the government.

Louis XVIII's government adopted Denon's approach to appointing the jury, placing it under the control of the director of museums. A new appointed committee known as the "Conseil honoraire des Musées royaux" also served as Salon jury, which was roughly half high-ranking arts administration officials and half artists, most of whom were *acadèmiciens*.

Academics sat on the jury, and past prizewinners received privileged admission. However, the government also worked to provide support to independent artists.

Jury abolished for first Salon; jury reestablished but elected by artists for remaining exhibitions.

For first Salon, jury partially elected and partially appointed; for later Salons jury entirely appointed or mostly appointed; traditional exception that past prizewinners were automatically accepted was abolished.

Jury partially appointed by the government, partially elected by academics and past prizewinners; traditional exception for past prizewinners reestablished.

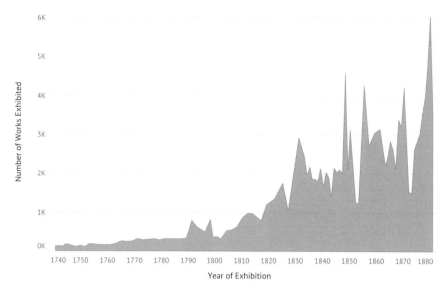

FIGURE 2.7 Number of Paintings Shown at the Paris Salon, 1740–1881 (N = 136,346). Source: Jon Whiteley, *The Subject Index to Paintings Exhibited at the Paris Salon, 1673–1881* (1993), Sackler Library, University of Oxford.

the Bonaparte family, including Napoleon I and Napoleon III, were shown at the Salon.[22] There is a spike in depictions of the Bourbons just before the Revolution. In this context, the many portraits of Louis XVI and his family shown just before 1789 seem like futile attempts to visually assert power that was slipping away. Under the always-tenuous Bourbon Restoration, dozens of portraits of the kings and their families were shown. There are also large quantities of depictions of Napoleon III before his downfall. For rulers, demand for portraits appears linked to a sense of instability. Furthermore, this assertion of political power through volume of portraiture is accompanied by an apparent suppression of images of competing dynasties. While the institutional volatility of the Salon on display in figure 2.7 hints at the effects state affairs had on the exhibition, figure 2.8 makes clear that politics and the Salon were inextricably tied to one another. Of course, these graphs are not meant to be a final pronouncement about the links between Salon painting and politics; instead they are examples of how quantification can contribute to topics of interest in art history.

Because its content is limited to the Salon, the Whiteley Index is not comprehensive in its coverage of the French art world. Nonetheless, both its scope and detail are unprecedented. It is exceptional to have easily digestible digital information available about tens of thousands of artworks all shown in one venue and indexed by one person.[23] Furthermore, the detail of keyword tagging deployed in the Whiteley Index is unique among the data sources in this book. These keywords allow for data-driven investigations into the content of hundreds of thousands of artworks, many of which have since been lost or faded into obscurity.

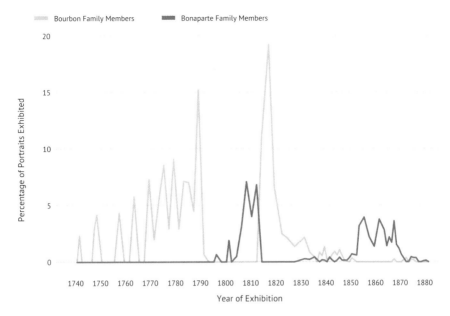

FIGURE 2.8 Percentage of Portraits Shown at the Paris Salon That Depicted Members of the House of Bourbon or the Bonaparte Family, 1740–1881 (N = 36,248). Source: See figure 2.7.

The Historical American Art Exhibition Database

The Paris Salon and the Académie des beaux-arts were central to the French art world until the end of the nineteenth century. The institutions of the nineteenth-century American art world were both younger and more scattered than their French counterparts. In a country without royal collections, major museums, or a central art academy, art institutions in the United States played a variety of roles. They were art schools, locations for contemporary art shows, and places for the exhibition of Old Master works and plaster casts of antique art. The Historical American Art Exhibition Database (HAAExD) unites information from indices to works shown in dozens of venues in seventy-two cities in twenty-two states between 1773 and 1914.

Reflecting this geographic diversity, data forming HAAExD have been collated from several sources rather than culled from one unified source.[24] The content of these component indices is also different from the Whiteley Index. Whiteley tagged the paintings listed in the Salon livrets with keywords. Most of the American sources are simply lists of all works shown in an exhibition venue over decades. Usually organized by artists' names, these indices provide information about the artists, dates of display, and titles of works. They often list the name of the collector who owned the work, as well as other miscellaneous details, such as medium and whether or not the work was for sale. Most of the works in the indices are paintings; this appears to be the default medium because it is explicitly noted when a work is a sculpture, photograph, drawing, or print.[25] Table 2.2 lists all the constituent indices and the number of works in each.

TABLE 2.2 Sources That Make Up the Historical American Art Exhibition Database

SOURCE OF DATA

Smithsonian's Pre-1877 Art Exhibition Catalogue Index (ed. James L. Yarnall and William H. Gerdts, 1986)

National Academy of Design Exhibition Record, 1826–1860 (ed. Mary Bartlett Cowdrey, 1943) & *National Academy of Design Exhibition Record, 1861–1900* (ed. Maria Naylor, 1973)

Annual Exhibition Record of Pennsylvania Academy of the Fine Arts, 1807–1870 (ed. Peter Hastings Falk, 1988) & *Annual Exhibition Record of Pennsylvania Academy of the Fine Arts, 1876–1913* (ed. Peter Hastings Falk, 1989)

Publications in California Art No. 7: Exhibition Record of the San Francisco Art Association, Mechanics' Institute, & California State Agricultural Society (ed. Ellen Halteman, 2000)

The Boston Athenaeum Art Exhibition Index, 1827–1874 (ed. Robert F. Perkins Jr. & William J. Gavin III, 1980)

American Academy of Fine Arts and American Art-Union, 1816–1852 (ed. Mary Bartlett Cowdrey, 1953)

Nineteenth-Century San Francisco Art Exhibition Catalogues: A Descriptive Checklist and Index (ed. Ellen Halteman, 1981)

TOTAL*

*After a more extensive double-checking of the sources, the numbers presented here differ slightly from those in Diana Seave Greenwald, "Painting by Numbers: Case Studies in the Economic History of Nineteenth-Century Landscape and Rural Genre Painting" (PhD diss., University of Oxford, 2018). They also differ from the number listed in the map for figure 2.9 because some works in the dataset from the Pre-1877 Art Exhibition Catalogue Index were missing clear state information or were from exhibitions in Canada.

DESCRIPTION OF DATASET	NUMBER OF WORKS	PERCENTAGE OF TOTAL WORKS
Wide range of exhibition catalogs from small galleries and American art institutions not indexed in the large venues listed below	135,227	48.9
Index to all works shown at the NAD. Exhibition rules changed over time, but shows were commonly used as a venue for members of the Academy to exhibit new work.	41,887	15.2
Index to all works shown at juried and nonjuried shows, and special exhibitions at PAFA. In this period, PAFA focused on contemporary American artists and on displaying art historically important works (from plaster casts to European contemporary) in Philadelphia.	39,310	14.2
Works exhibited at a mix of juried and not-juried shows in Northern California from the 1850s to 1915	37,165	13.4
Index to all works shown at the Boston Athenaeum, which was a hybrid library, museum, and exhibition space. Showed a mix of contemporary American art, medals, plaster casts, Old Masters, European contemporary.	11,148	4.0
The two major art institutions in antebellum New York. The American Academy showed work by "eminent" American artists, mostly Benjamin West and John Trumbull, and plaster casts. The Art-Union purchased and exhibited contemporary American art and then distributed the works by lottery.	6,289	2.3
Index to works shown at small galleries and single-artist shows in San Francisco during the nineteenth century. Complementary to *Publications in California Art No. 7.*	5,364	1.9
	276,390	100.0

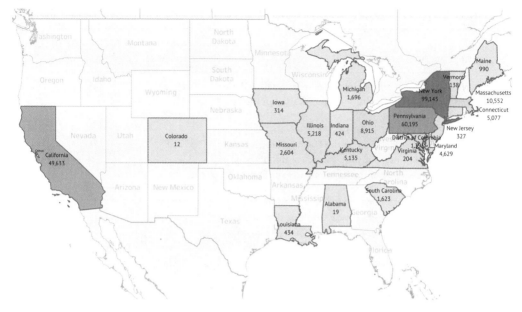

FIGURE 2.9 Number of Works Exhibited in Each State, 1773–1914 (N = 258,340). Source: Historical American Art Exhibition Database. © 2020 Mapbox © OpenStreetMap.

Figure 2.9 maps the number of works exhibited and recorded in the HAAExD that have a clear location in a US state. (For ease and legibility, I have used modern borders—but of course the locations of some institutions changed states mid-sample due to changing territorial borders.) The heavy concentration of works in the Northeast reflects the early history of arts institutions in the United States. Founded in Philadelphia in 1805, the Pennsylvania Academy of the Fine Arts (PAFA) was the first art museum and art school in the United States. The institution's stated mission was:

> to promote the cultivation of the Fine Arts...by introducing correct and elegant Copies, from works of the first Masters...and, by thus facilitating the access to such Standards, and also by occasionally conferring moderate but honorable premiums, and otherwise assisting the Studies and exciting the effort of the artists, gradually to unfold, enlighten and invigorate the talents of our Countrymen.[26]

PAFA's first exhibition, mounted in 1807, included a blend of plaster casts of famous works, Old Master paintings (of dubious origin), and contemporary art by American and British painters.[27] By the middle of the nineteenth century, the institution had established itself as central to the Philadelphian and American art scene. It boasted an active schedule that included an annual exhibition for contemporary artists, loan shows, and displays of its growing permanent collection.[28]

Though PAFA remained an important American arts institution, New York became the center of American artistic activity by the mid-nineteenth century. The founding of several arts institutions and galleries in the city contributed to this dominance.[29] The American Academy of Fine Arts was the first New York–based arts institution and school; it was officially incorporated in 1808 and active until 1841.[30] Though the American Academy had a major collection of sculptural casts and hosted several exhibitions of American art, stagnant patron-led leadership led to its collapse.[31] In its place, the artist-led National Academy of Design (NAD) was established in 1826. The NAD stands out from PAFA and other early northeastern arts institutions, such as the Boston Athenaeum, because of its focus on contemporary American art.[32] NAD exhibition rules codified in 1828 made it so that only "original works of living artists...never before exhibited by the Academy" could be shown—this meant neither copies nor repeat showings were allowed.[33] These strict rules were distinct from the other institutions included in HAAExD, which were generally open to both historic and contemporary artworks.

Just as political wrangling over the Salon and its jury affected which works were shown—and therefore included in the Whiteley Index—the rules and missions of the American institutions included in HAAExD had a profound impact on their exhibitions. Table 2.2 provides a brief summary of exhibition rules at each major venue included. Exhibition rules could significantly change the content of what was shown in a given venue. Compare, for example, data from the exhibition records for an 1850 show at the Boston Athenaeum and data from a show in the same year at the NAD. As mentioned, there was a rule in place at the National Academy that *only* original works of art that had never been previously exhibited at the Academy could be shown at its annual exhibition. There was no equivalent rule in Boston, where the exhibitions often included copies of Old Master paintings, works from the Athenaeum's permanent collection, and new original works.[34]

While the East Coast was the center of American artistic activity during the nineteenth century, figure 2.9 also shows that many works were exhibited in California. Golden State exhibition venues and art schools were created within a decade of the state's admission to the Union in 1850. A variety of institutions, including the San Francisco Art Association (est. 1871) and the Mechanics' Institute (est. 1854, also in San Francisco), educated the public about the arts and provided training for local artists.[35] By volume of works exhibited—which included contemporary American and European art, as well as copies and casts—the West Coast quickly caught up with the East.

In between the coasts, there were fewer works displayed, although thousands were shown in Ohio, Illinois, and Kentucky. The limited number of artworks shown in the middle of the country was linked to both smaller population size and the founding of fewer dedicated arts institutions. There are, to a certain extent, problems with data coverage. The major exhibition venues in the Northeast and California have indices dedicated to them; any coverage of the middle of the country comes from the Smithsonian's digital Pre-1877 Art Exhibition Catalogue Index. The goal

of this index was to capture exhibitions that occurred outside the confines of major academies. It includes smaller academies and arts associations, "artists' receptions" in studios, shows in commercial galleries, and charity exhibitions, such as the 1864 Metropolitan Sanitary Fair that laid the foundations for the establishment of the Metropolitan Museum of Art in 1870. It specifically does *not* index exhibitions in American institutions that had their own dedicated indices published. The Pre-1877 Art Exhibition Catalogue Index is therefore both the largest and most piecemeal constituent source in the HAAExD. The ad-hoc nature of this catchall index likely contributes to the relative invisibility of Midwestern and Southern arts institutions in these data.[36]

Analyzing HAAExD sheds light on the changing nature of American arts institutions. The evolving role of exhibitions at the Pennsylvania Academy of the Fine Arts provides a useful example. The two-volume index dedicated to PAFA—called *The Annual Exhibition Record*—lists the life dates of most artists who exhibited. These data allow one to record the changing mix of historical art—alleged Old Masters, copies after major works, casts—and contemporary art shown at the Academy. When graphed, these data provide insight into the changing role of arts academies in the United States. Beginning in 1811, the Academy hosted an annual exhibition. When planning the first annual exhibition, which came to be called simply the annual, the committee in charge of the event stated that "Paintings by American & living Artists shall always have a preference over those by European or Ancient Artists."[37] However, scholars have described how, in practice, the goals of the annual were fluid and "no rules held firmly at any time" in its early history.[38] For the first fifty years of its existence, the exhibition was a mix of contemporary American art, loaned European works (both contemporary and Old Master), and copies.[39]

Exhibitions of both historic and contemporary art complemented the annuals. The Pennsylvania Academy not only had a growing permanent collection but also housed a number of items on long-term loan from private collectors. Prior to 1864, the Academy's exhibition catalogs listed both the loaned and permanent collections on display with the list of works shown in the annual exhibition, so it is impossible to distinguish in the data between shows dedicated to contemporary art and other shows.[40]

There were significant institutional changes at PAFA starting in the 1870s. In 1876, Philadelphia hosted the Centennial Exhibition and the Academy moved into its new (and current) building. With the opening of the new building, several policy changes were made to the administration of exhibitions. An 1880 policy limited works by European artists shown at the annual to those submitted by the artists themselves. This meant that private collectors could no longer loan their European works to be shown. This policy was part of a general trend at PAFA to deemphasize private loans to exhibitions in favor of the display of contemporary works for sale by the artists.[41] The creation of specific prizes for Americans, residents of Philadelphia, or PAFA students further encouraged this focus on showcasing contemporary American art. Finally, a major institutional change occurred when the annual

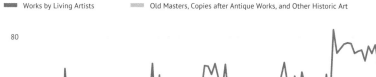

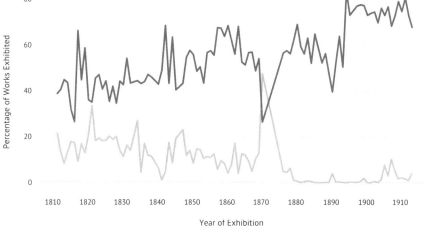

FIGURE 2.10 Percentage of Artworks Shown at the Pennsylvania Academy of the Fine Arts That Are Old Masters or Works by Living Artists, 1811–1913 (N = 39,128). Source: Historical American Art Exhibition Database.

exhibition officially became juried in 1885. Using listed data about artists' life dates to determine whether an artist was living or dead when his or her work was exhibited can quantitatively illuminate this transition, as seen in figure 2.10. From the 1870s forward, a clear majority of artwork displayed was by contemporary artists.[42]

Part of the shift in PAFA's institutional focus was also due to the growing prominence of American art museums dedicated to showing antiquities and European art. Prior to the founding of institutions like the Metropolitan Museum (founded 1870, opened 1872) and the Museum of Fine Arts in Boston (founded 1870, opened 1876), art academies fulfilled the dual role of showing contemporary art and mounting exhibitions of historical art, copies, and casts. As museums were established, academies could focus exclusively on their roles as schools for young artists and as exhibition venues for contemporary American art. While the Salon and academic venues faded in importance in France during the last quarter of the nineteenth century, academies remained central to the American art world until the early twentieth century. Not only did they provide an education, but their exhibitions remained a primary way for American artists to bring art to market. Though the dealer-critic system took hold in Paris, there were limited numbers of professional art dealers active in the United States prior to the twentieth century.[43] Furthermore, those dealers who did establish themselves in the United States often focused on importing European art.[44]

Finally, it is necessary to provide a caveat about the data quality of HAAExD. The Whiteley Index was carefully compiled and checked by one person, but the constituent data sources that form HAAExD come from indices created by many people and from diverse sources. The struggle that scholars faced in compiling these

No.	SUBJECTS.	POSSESSORS.	PAINTERS, &c.
148.	Miniature of a Lady,	- - - -	Henry Wenzler, jr.
149.	Miniature of a Gentleman,	- - - -	A. Agate, A.
150.	Miniature of A. Stodart, Esq.,	- - - -	J. J. Mapes, H.
151.	Miniature of James W. Wallack, Esq., Lessee of the National Theatre	J. W. Wallack, -	L. Bingham.
152.	S. P. Taylor, Organist of St. Paul's,	- - - -	G. W. Newcombe, A.
153.	Miniature of a Lady,	- - - -	Miss D. Vail.
154.	Miniature of a Child,	Jonathan Adden, Esq.,	C. H. Thomas.
155.	Miniature Portrait of a Lady,	- - - -	J. Vandyck.
156.	A Sketch,	- - - -	H. J. Morton, H.
157.	Engraving, Gen. Peter Gansevoort,	- - - -	J. F. E. Prud'homme, A.
158.	Engraving, Friar Puck, after Chapman, -	- - - -	J. F. E. Prud'homme, A.
159.	Portrait of a Child,	- - - -	Alvin Fisher.
160.	Scene from the Battery, with a Portrait of the Franklin, 74 guns,	For sale, - -	Thomas Thompson.
161.	Portrait of a Child,	Dr. A. S. Doane, -	J. G. Chapman, N. A.
162.	View near Interlachen, Canton of Berne, in Switzerland, -	Rob't. Livingston,Esq.,	M. Livingston.
163.	Portrait of a Gentleman,	- - - -	W. Creighton.
164.	Portrait of a Gentleman,	Theodore W. Porter, Esq., -	J. H. Shegogue.
165.	Portrait of a Dragoon, Staff Officer of the U. S. Army, - -	Thomas Snores, Esq.,	J. Stearns.
166.	Portrait of a Lady, -	- - - -	Thomas Thompson.
167.	Landscape, - -	For sale, -	S. V. Hunt.
168.	Drawing of the Rev. D. Follen, - -	- - - -	A Young Lady.
169.	Engraving, from W. S. Mount, - -	- - - -	R. Hinshelwood.
170.	Turkish Seaport, a pencil drawing, - -	S. H. Sexton, Esq., -	L. Bradley.
171.	Mansion of Sullivan Dorr, Esq., a pencil drawing, -	- - - -	J. A. Underwood.
172.	Engraving, an autumn evening on the Rondout Hill, - -	- - - -	J. Smillie, A.
173.	Profile in Wax, - -	J. Thomson, Esq., -	M. Morrison.
174.	Frame, with six Engravings on Wood, -	- - - -	J. A. Adams, A.
175.	Portrait of a Gentleman,	W. Creighton, -	J. M. Burbank.
176.	Tockwatton House, pencil drawing, - -	- - - -	J. A. Underwood,

FIGURE 2.11 Page 12 from National Academy of Design, *Catalogue of the Thirteenth Annual Exhibition* (New York: E. B. Clayton, 1838).

indices are frankly described by art historian, curator, and archivist Mary Bartlett Cowdrey, who compiled the component index *National Academy of Design Exhibition Record, 1826–1860* (1943).[45] She transcribed all of the information about titles, owners, and whether or not a work was for sale from the original National Academy exhibition catalogs—despite the fact that these catalogs "suffered severely from lack of editing and proofreading."[46] She needed to use research and interpretation to add artists' life dates. "It was necessary," she wrote, "to establish the identities of many lesser known figures in order to avoid confusion caused by errors in the original catalogues."[47] Figure 2.11 shows an example of one of the source catalogs, in this case from 1838. Assembling a digital database based on sources like Cowdrey's book added another level of complexity to capturing accurate information about historic exhibitions. The existing hard-copy indices were hand transcribed from a form like

FIGURE 2.12 Page 33 from *National Academy of Design Exhibition Record, 1826–1860*, vol. 1, ed. Mary Bartlett Cowdrey (New York: New-York Historical Society, 1943).

BIERSTADT, Albert (*continued*)
 1859 (*continued*)
 704. St. Peters and the Castle of St. Angelo—Sunset. *J. Hopkins.*
 757. The Arch of Octavius. *Boston Athenaeum.*
 783. Capri, Bay of Naples. *For sale.*
 1860 *Address:* 15 Tenth Street.
 547. Base of the Rocky Mountains. *For sale.*

BILLINGS, Edward T. (1824-1893)
 1858 *Address:* Worcester, Mass.
 494. A Gentleman.

BINGHAM, George Caleb (1811-1879)
 1840 *Address:* St. Louis.
 88. Group, Two Young Girls.
 96. Tam O'Shanter, from Burns. *For sale.*
 249. Landscape.
 257. Tam O'Shanter. *For sale.*
 293. Pennsylvania Farmer.
 303. Sleeping Child.
 1842 *Address:* Not given.
 166. Going to Market. *For sale.*
 1848 *Address:* Not given.
 226. The Stump Orator. *For sale.*

BINGHAM, Luther (active 1838-1839)
 1838 *Address:* 52½ Howard Street.
 151. Miniature of James W. Wallack, Esq., Lessee of the National Theatre. *J. W. Wallack.*

BININGER, W. B. (active 1840)
 1840 *Address:* Granite Buildings, Corner of Chambers Street and Broadway.
 81. Portrait of a Boy. *Sigr. Teraro.*
 86. Small Half Length of a Gentleman. *W. B. Bininger.*

BIRCH, Thomas (1779-1851)
 Honorary Member, Professional, 1833-1851.
 1832 *Address:* Philadelphia.
 81. Sea Piece. *Mr. Clover.*
 1833 *Address:* Philadelphia.
 127. Marine View.
 191. Sea Piece. *For sale.*
 199. Sea Piece. *For sale.*

[33]

figure 2.12—which shows a page from Cowdrey—into a spreadsheet like figure 2.13 in order to create a workable dataset. There are, inevitably, some errors in the data as a result of this extensive and multistep transcription and transformation.

Despite these caveats, the Historical American Art Exhibition Database creates an unprecedentedly comprehensive record of what hung on gallery walls across America during the long nineteenth century. It reveals an art world that, by quantity, was exceptionally vital for a relatively young country with young arts institutions. It also reveals that the parts of the country that dominate today's contemporary art scene—cities along the coasts—have been major clusters of artistic activity for more than a century. Like the Whiteley Index, HAAExD captures information about hundreds of thousands of works of art that have long faded from art historical notoriety and scholarly consideration.

artist_full_name	birth_date	death_date	active_start_date	active_end_date	membership	artist_residence	display_year	title
BIERSTADT, Albert	1830	1902			Honorary Member	New Bedford, Mass.	1859	St. Peters and the Castle of St. Angelo--Sunset
BIERSTADT, Albert	1830	1902			Honorary Member	New Bedford, Mass.	1859	The Arch of Octavius
BIERSTADT, Albert	1830	1902			Honorary Member	New Bedford, Mass.	1859	Capri, Bay of Naples
BIERSTADT, Albert	1830	1902			Honorary Member	15 Tenth Street	1860	Base of the Rocky Mountains
BILLINGS, Edward T.	1824	1893				Worcester, Mass.	1858	A Gentleman
BINGHAM, George Caleb	1811	1879				St. Louis	1840	Group, Two Young Girls
BINGHAM, George Caleb	1811	1879				St. Louis	1840	Tam O'Shanter, from Burns
BINGHAM, George Caleb	1811	1879				St. Louis	1840	Landscape
BINGHAM, George Caleb	1811	1879				St. Louis	1840	Tam O'Shanter
BINGHAM, George Caleb	1811	1879				St. Louis	1840	Pennsylvania Farmer
BINGHAM, George Caleb	1811	1879				St. Louis	1840	Sleeping Child
BINGHAM, George Caleb	1811	1879				Not given	1842	Going to Market
BINGHAM, George Caleb	1811	1879				Not given	1848	The Stump Orator
BINGHAM, Luther			1838	1839		52 1/2 Howard Street	1838	Miniature of James W. Wallack, Esq., Lessee of the National Theatre
BININGER, W. B.			1840	1840		Granite Buildings, Corner of Chambers Street and Broadway	1840	Portrait of a Boy
BININGER, W. B.			1840	1840		Granite Buildings, Corner of Chambers Street and Broadway	1840	Small Half Length of a Gentleman
BIRCH, Thomas	1779	1851			Honorary Member	Philadelphia	1832	Sea Piece
BIRCH, Thomas	1779	1851			Honorary Member	Philadelphia	1833	Marine View
BIRCH, Thomas	1779	1851			Honorary Member	Philadelphia	1833	Sea Piece
BIRCH, Thomas	1779	1851			Honorary Member	Philadelphia	1833	Sea Piece

FIGURE 2.13 Transcription of page 33 from *National Academy of Design Exhibition Record, 1826–1860*, vol. 1, ed. Mary Bartlett Cowdrey (New York: New-York Historical Society, 1943).

The Royal Academy Exhibition Database

Younger than its European counterparts but older than equivalent American institutions, the Royal Academy was founded in England in 1768.[48] The French academy was founded in the mid-seventeenth century, and many Italian cities—including Rome and Florence—had their own academies by the sixteenth century. Before the founding of the Royal Academy, there were several earlier British academies and associations that sought to provide education and exhibition opportunities for artists. Two of the most important were the St. Martin's Lane Academy, a teaching institution founded by artist William Hogarth in 1735, and the Society of Artists, an eighteenth-century collective of artists that organized regular exhibitions.[49] However, these somewhat decentralized and informal institutions lacked the standing and authority associated with an academy supported by the Crown.

The impetus to found the Academy had its roots in professional artists' dissatisfaction with the Society of Artists and in the initiative of Sir William Chambers, an architect who served as a tutor to King George III. Chambers and a small group of artists—many of whom were affiliated with the Society of Artists—met with the king in November 1768 to explain their plans for an institution backed (and, in case of emergency, financially guaranteed) by the sovereign. However, the Academy would be designed to fund itself with money raised from an annual exhibition. Roughly a week later, the group returned with the Instrument of Foundation, the document that laid out the structure, management, and mission of the Academy. King George III signed the Instrument on December 10, 1768, and the Royal Academy was born.[50]

The Instrument described an organization inspired by the model of the French academy and affiliated École des beaux-arts. The Royal Academy was designed as an institution that elevated notable artists and architects to privileged membership—these members were called royal academicians, resembling the French acadèmiciens. The Instrument also stipulated the organization of a regular exhibition for academi-

cians to show their work alongside pieces by nonacademic artists that had passed jury review. Finally, it created a free school for promising art students. While the initial members of the Royal Academy were appointed in a somewhat ad-hoc process, future academicians were elected to membership by existing members. There were two tiers of membership: first one would be elected an associate of the Royal Academy; after achieving this status, one could be elevated to that of a full academician, the number of whom was capped. Entrance fees charged to see the annual exhibition funded the schools of the Royal Academy.[51]

Data about the Royal Academy's annual exhibition, which was christened the Summer Exhibition at the end of the nineteenth century, provides snapshots of the contemporary art world in England from the eighteenth century to the present. Shortly after the Academy's founding, it quickly became the primary public venue for the display of British contemporary art. The first exhibition took place in Pall Mall in the spring of 1769. It featured 136 works, including history paintings, portraits, landscapes, sculptural busts, drawings, and architectural models by 54 artists, and 14,008 visitors attended.[52] By the nineteenth century, hundreds of thousands of visitors attended each exhibition in its successive homes in Somerset House, Trafalgar Square, and Burlington House (its current location). Today, roughly 200,000 people still attend the Summer Exhibition.[53]

Under the rules set forth in the Instrument, academicians were allowed to exhibit up to six works each year, which did not need to be submitted for jury review. The lower-ranked associate members also bypassed jury review. Nonacademic artists could exhibit only by submitting works for jury review, similar to processes at the Salon.[54] However, the structure of the jury—sometimes called the Selection Committee or the Hanging Committee—at the Royal Academy was stabler than for the Salon; it was always a group of academicians convened by the president of the Royal Academy, an artist or architect who had been elected to the position by the body of academicians.[55]

Also like the Salon, a catalog was published each year listing the works on view. Works for sale were explicitly and systematically marked with an asterisk. These catalogs form the basis of available data about the Summer Exhibition. *The Royal Academy Summer Exhibition: A Chronicle, 1769–2018* is an online publication by the Paul Mellon Centre for British Art. It provides exhaustive year-by-year descriptions of each of the 250 exhibitions that occurred between 1769 and 2018. The *Chronicle*'s mission is threefold: to provide searchable access to catalogs from the annual exhibitions, to compile and release data about each exhibition—such as submission and attendance figures—and to present a descriptive scholarly essay about each year of the exhibition.[56] According to the introduction to the publication, data were "gathered from the institutional records of the Academy, including the minutes of its Council, its Annual Reports, and the published catalogues of the Summer Exhibition, as well as published repositories of Summer Exhibition data such as Algernon Graves's *The Royal Academy of Arts: A Complete Dictionary of Contributors and their Work from its Foundation in 1769 to 1904*."[57] This expansive source makes it possible

to provide a quantitative overview of both the composition of individual exhibitions and long-run trends across the exhibition's history.

Figure 2.1 shows that the size of the annual Royal Academy exhibition increased over time, although the growth of exhibit size was much slower and steadier than that of the French Salon.[58] Despite this growth in the number of included works, the rejection rates of submissions to the annual exhibition—available from 1860—increased. Of course, acceptance rates were partly constrained by physical space available in the Academy's successive homes; however, all exhibitors were not treated equal. While academicians and associates could display without being judged by the jury, and therefore could *not* be rejected, participation in the exhibition seems to have become increasingly competitive for nonacademicians. Figure 2.14 plots rejection rates over the course of the century, which ultimately plateaued around 85 percent after 1895. To cope with the growing number of artists and their need to exhibit, as figure 2.15 shows, the *average* number of works per exhibitor decreased. However, nonacademic artists bore the brunt of this policy. Nonacademics were limited to one or two works per exhibition, while artists affiliated with the academy—a category that groups both associates and full academicians—continued to show between two and three pieces. Interestingly, the numbers of works per exhibition for academicians and nonacademics were closest in the 1860s. In 1863, the Royal Academy had, as in Paris, a "Salon des Refusés" in response to high rejection rates. As a result, in 1864 "there seems to have been an impetus towards modernization, or at least to greater fairness towards those not yet in the Academy's ranks."[59] Turning back to figure 2.15, in the years following this controversy there was a brief convergence of the number of works per exhibition shown by academicians and nonacademicians. Therefore, the graph—when considered in the context of this history—suggests that Academy leadership adapted institutional practices in response to complaints about the fairness of exhibition and membership selections. This ability to adapt, including to later calls for reform at other points in its history, has contributed to the organization's longevity.[60]

Nonetheless, just like in France, alternate venues for showing artwork developed in London alongside the Royal Academy exhibitions. Interestingly, however, individual academicians—rather than artists serially excluded, such as the Impressionists in France—were among the first to exhibit outside of the Academy. The founding president of the Royal Academy, Joshua Reynolds, advocated for a hierarchy of genres in which history painting was the apex of artistic achievement.[61] In the 1780s, the notable academician Thomas Gainsborough began to chafe against Reynolds's teachings as well as the decisions of the Hanging Committee. Though Gainsborough's work could not be rejected for display, his pieces could be functionally hidden from public view if placed in a poor location next to a doorway or "skyed" high on the wall amid a crowded hang making them impossible to see.[62] When his work began to suffer this treatment , he stopped exhibiting at the Royal Academy and instead showed in his own home.[63] In the early nineteenth century, the increasingly experimental J.M.W. Turner—who had been elected an associate

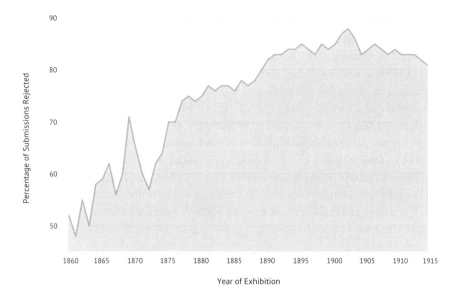

FIGURE 2.14 Rejection Rate of Submissions to the Royal Academy Annual Exhibition, 1860–1914 (N = 460,929). Source: *The Royal Academy Summer Exhibition: A Chronicle, 1769–2018*, ed. Mark Hallett, Sarah Victoria Turner, Jessica Feather, Baillie Card, Tom Scutt, and Maisoon Rehani (London: Paul Mellon Centre for Studies in British Art, 2018), https://chronicle250.com.

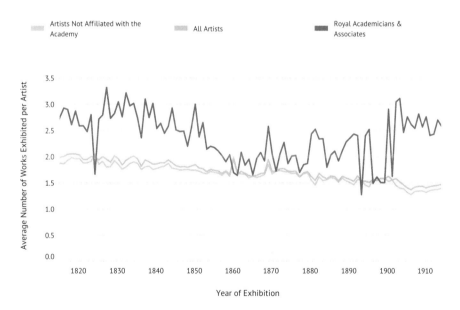

FIGURE 2.15 Average Number of Works per Artist Shown at the Royal Academy Annual Exhibition, 1815–1914. Source: See figure 2.14.

member of the Academy at just age twenty-four—also began to show works at a purpose-made gallery in his own home, although he simultaneously participated in the annual exhibitions at the Royal Academy.[64]

As in France and the United States, there was growing commercial dealer infrastructure in nineteenth-century England. Though it took place earlier in Britain, the commercial art world—as in the US—first emerged to import and sell foreign art, often Old Master paintings from the European continent.[65] As dealers focused on contemporary art established themselves in London, they continued to trade in the work of foreign artists and act as importers and exporters of art. However, they soon began to add British artists to their rosters.[66] Rather than antagonize the Royal Academy, dealers worked with and used the reputation of the institution to build their businesses and market British artists' works.[67] In the Victorian era, the independent Grosvenor Gallery (1877–1890), which was technically a commercial gallery but eschewed explicit signals of being a sales room in its exhibitions, became a leading venue for showing some of the most experimental artists active in London and on the European continent who had less success within the confines of academic systems. Exhibitors included James Abbott McNeill Whistler and Edward Burne-Jones.[68] Just as commercial dealers complemented the role of the Academy, other artists' associations also aimed to complement the annual exhibitions—often in the form of medium-specific shows. For example, in 1804, artists working in watercolor created what would become the Royal Watercolour Society. The still-extant society's regular exhibitions became a venue for showing a medium that was not the focal point of Royal Academy exhibitions.[69] Data culled from the Royal Academy's annual exhibitions do not, of course, include art shown in these alternative venues. A testament, however, to the continued centrality of the academic system is the fact that one of the artists who showed regularly at Grosvenor Gallery, John Everett Millais—a leader of the Pre-Raphaelites, a group of artists who worked outside of and in opposition to the Royal Academy—later went on to become a president of the Academy.[70]

Both by providing an arts education and recognizing successful artists and architects by electing them to membership, the Royal Academy has remained a central institution in the British art world since its founding. While the French academy ossified and the Salon fractured at the end of the nineteenth century—and historic American academies have faded in importance—the Royal Academy has adapted and endured. Through financial challenges, accusations of conservatism, and occasional political threats, it is still a thriving institution in the twenty-first century.[71] Returning to figure 2.1, the steady rise in the size of exhibitions and consistent rejection rates presented in figure 2.14—as compared to the volatile exponential increases in works shown in French and American venues—presage the Royal Academy's ability to carefully navigate the art world and steadily preserve its role in it.

Conclusion

The graphs presented in this chapter make clear that huge amounts of artwork were produced and exhibited in a variety of institutional and geographic settings over the long nineteenth century. Some readers may react to these figures with a sense of despair—how can art historians account for this veritable mountain of art in their scholarship? With this much art on display, sample bias may seem inevitable. Chapters 3, 4, and 5 demonstrate that bias is not an inevitability. Furthermore, they show that art historians do not need to engage with the *entire* population of art shown throughout history. This would be impossible. Instead, the key is to understand the scope of this population and clearly define the sample that is relevant to the historical moment or phenomenon under investigation. The most powerful quantitative art historical analyses are focused and therefore mitigate sample bias by guaranteeing the data deployed address a well-defined research question suited to quantitative approaches.

Data-driven art history is also at its best in conjunction with traditional qualitative methods, including archival research and formal analysis. Each data point in economics represents a human reality—people employed, families growing, wealth accrued or lost across generations. Real humans are aggregated to create digestible datasets. Therefore, aggregation, while valuable, can also obscure this humanity. Sometimes, economists and other social scientists lose sight of the individuals behind the numbers—and this is a detriment to the quality and real-world applicability of their work.[72] In art history, an analogous process can take place: the data-based reclamation of historical production is a compression of the individuality of each work. In datasets, one treats all art as simply a collection of basic attributes: artist, title, year of display, and so forth. This loss of the object can, if taken too far, be just as dangerous to the validity of scholarly conclusions as sample bias.

Consider the following example: Jean-François Millet's *The Gleaners* (1857) [fig. 2.16] and Jules Breton's *Calling In the Gleaners* (1859) [fig. 2.17] have similar titles. They were shown only one exhibition apart at the Paris Salon by male French artists originally from the countryside (from Normandy and Pas-de-Calais, respectively). Both works are tagged as "gleaning" in the Whiteley Index, and therefore appear almost identical in the Salon data. Yet the two canvases are radically different from each other when viewed.

Millet's painting depicts a lavender, powder blue, and pink sky shining over a golden wheat field; haystacks and a small village lie on the horizon. Three large female figures dominate this Georgic landscape. They collect the bits of wheat that the reapers have left behind after the harvest. Clad in clothing almost as rough as the broken wheat they are gathering, none of their heavy-boned bodies breaks the horizon line. A wide and beautiful scene stretches behind them, but they seem unaware of it or simply unconcerned. Instead, their faces—which are barely detailed but appear sunburned and windbitten—turn to the work at hand. The setting may be picturesque, but the women's labor is not. Traditionally, the poor engaged in

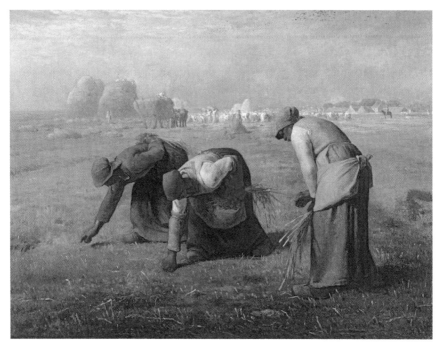

FIGURE 2.16 Jean-François Millet, *The Gleaners*, 1857, oil on canvas, 83.5 × 110 cm. Musée d'Orsay, Paris. Source: RMN (Musée d'Orsay) / Jean Schormans.

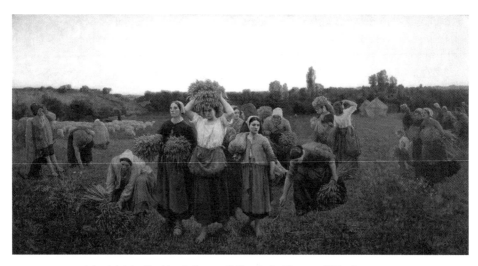

FIGURE 2.17 Jules Adolphe Aimé Louis Breton, *Calling In the Gleaners*, 1859, oil on canvas, 90 × 176 cm. Musée d'Orsay, Paris. Source: RMN (Musée d'Orsay) / Jean Schormans.

gleaning to supplement their own food supplies. Millet's figures evoke this need for subsistence—and at a moment when gleaning was a dying practice.[73]

While showing the same subsistence activity, Breton's *Gleaners* exist in a world of greater bounty than Millet's. Rather than place hunched and rough-hewn figures in the center of the painting, Breton features three vibrant young women. While they wear crude clothing similar to that of Millet's *Gleaners*, Breton's women have pale smooth skin and stand upright. The central figure has a pile of wheat on her head that appears far more bountiful than scraps. The other peasant women in the painting are arranged around this young woman, forming a wheat-topped pyramid. In stark contrast to Millet's work, one woman on the right-hand side of the Breton painting is, in fact, able to pause and turn to look at the warm sunset behind her.

Millet and Breton present radically different images of rural life. The lists of titles, artists' names, dates, and other text-based information convey none these visual differences. This rich contrast in depicting the same subject is made visible only by engaging with the objects behind the datasets. The remainder of this book, therefore, presents analyses that oscillate between focus on individual artworks and general trends made visible with the use of large datasets and statistics.

◇◇◇

Between City and Country

Industrialization and Images of Nature
at the Paris Salon

Reflecting on his arrival in the French capital from Normandy, Jean-François Millet supposedly wrote: "Paris, black, muddy, smoky...made the most painful and discouraging impression upon me....The immense crowd of horses and carriages crossing and pushing each other, the narrow streets, the air and smell of Paris seemed to choke my head and heart, and almost suffocated me."[1] The juxtaposition of this dark urban imagery with Millet's preferred choice of subject matter—peasants like those in *The Sower* (fig. 2.5) and *The Gleaners* (fig. 2.16)—is evocative. It implies that Millet's choice to depict rural subjects represents an escape from the city, just as the painter himself would ultimately decamp from the capital to a small village near the forest of Fontainebleau. Why begin this chapter with Millet's indictment of life in Paris? The artist's condemnation of urban life and choice to paint rural scenes are emblematic of foundational works in the social history of art, which focused on the relationship between mid-nineteenth-century French rural genre painting, urbanization, and industrialization—as well as the political upheaval that accompanied the country's economic development.[2] This case study analyzes this relationship between modernization and images of nature.

Painters like Millet and Gustave Courbet—whose earliest attention-grabbing works were rural scenes like *The Peasants of Flagey Returning from the Fair* (1849–1850), and *A Burial at Ornans* (1849–1850) [fig. 3.1]—became famous at the same time that France was undergoing major social and economic changes. The country was transforming from a collection of isolated rural localities into a more urban nation connected by railways and roads, a shared economy, and shared social customs.[3] Peasants, people living and working in small rural communities that were economically dependent on agricultural production, inhabited this changing world.[4] In

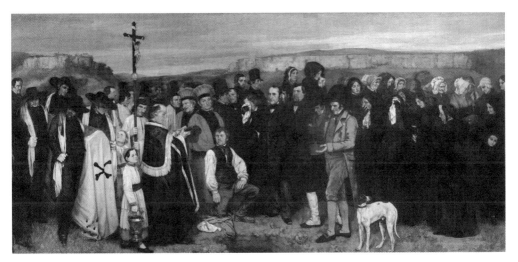

FIGURE 3.1 Gustave Courbet, *A Burial at Ornans*, 1849–1850, oil on canvas, 315 × 668 cm. Musée d'Orsay, Paris. Source: RMN (Musée d'Orsay) / Hervé Lewandowski.

1846, 76 percent of the French population was rural, but this number was starting to decline as the growing transport network allowed peasants to move from community to community, and often from the countryside to the city.[5] The coincident timing of the end of rural isolation, social upheaval linked to industrialization in the wake of the revolutions of 1848, and the emergence of notable artists creating rural genre paintings provided social historians of art with an ideal setting to examine links between socioeconomic change and the art world, and produce groundbreaking scholarship.

Millet in particular has been a focal point, as his life neatly maps onto these broader trends. Born in rural Normandy in 1814, for the first several years of his career he struggled as an artist in Paris, producing mainly portraits and mythological scenes. Around 1848 he began producing images of rural life and by 1849 settled in the village of Barbizon. These paintings were more successful than his earlier work and—guided by his friend, patron, and agent Alfred Sensier—a myth developed around the artist as the peasant painter depicting his fellow rural men and women.[6] Later, across the work of twentieth-century scholars including Robert Herbert, T. J. Clark, Linda Nochlin, Griselda Pollock, and Nicholas Green, Millet has emerged as a prominent representative of a recurring hypothesis: as France developed, images of rural life and landscape apparently increased in frequency, notoriety, and political importance.

Each of these scholars' arguments is distinct and nuanced—and the extent to which they deal with Millet varies. This nuance is addressed in appendix B, which provides a more extensive historiography of social historical studies of the peasant image and images of nature in French art, including more recent contributions. However, a quote from Herbert provides a succinct summary of a recurrent conclusion that emerges from this body of scholarship:

As the city grew ever larger, as its slums, its spectacular building campaigns, and its social upheaval became more prominent in France of the Second Empire, there was quite literally a need to bring landscape into the city. It entered quite directly in the growing number of landscapes, animal pictures and paintings of rural genre. These forms of painting constitute an urban phenomenon...Millet himself certainly found a measure of tranquility in the country around Barbizon, and he shared nostalgia for an untrammeled past.[7]

Herbert ultimately concluded that "the peasant was among the most important subjects [expressing artists'] attitudes toward the urban-industrial revolution."[8] In short, the socioeconomic changes affected the artistic ones.

Yet to date, art historians' abilities and tools to test this hypothesis have been limited. Reflecting on the foundations of the social history of art, Nochlin herself stated that something was left to be desired in the model of placing individual artists' works and opinions in conversation with broader socioeconomic trends:

> The difficult or thorny issue of mediation is, understandably, often side-stepped by the social history model, leaving a heap of historical or social data on one side of the equation and a detailed analysis of pictorial structure on the other, but never really suggesting how the one implicates the other, or whether, indeed there is really any mutual implication.[9]

Using quantitative methods, it is possible to get closer to isolating the points of "mediation"—what I understand as better-demonstrated causal relationships—that Nochlin felt were missing from the field. To attempt to better understand this mediation, this chapter engages with and tests this posited relationship between rural imagery and the industrialized city. It does so by combining new data about art with data that traces the multifaceted ways in which France modernized during the nineteenth century.

Nochlin was worried that the kinds of evidence—"pictorial structure" on the one side, social data on the other—were mismatched. By using information from the Whiteley Index, the art historical evidence can, for the first time, also be presented in the form of data. Furthermore, focusing on arguments about the relationship between industrialization and images of nature fulfills two goals: it represents a return to the foundations of the social history of art and it features an art historical hypothesis that can be fairly clearly distilled for the purposes of quantitative analysis and econometric testing. This distillation might be interpreted as an oversimplification of the literature about images of nature in nineteenth-century French art. However, as appendix B shows, I do not view scholars' past work as one-dimensional or uniform—and arguments about the relationships between the growth of cities and images of nature have become increasingly nuanced. Nicholas Green's *The Spectacle of Nature* (1990) is a particularly important contribution, as the appendix details. Ultimately, I have used the existing literature as a guide to determine variables to focus on and test. Some of my conclusions are surprising

and perhaps differ from those one might expect. My approach seeks to build on and contribute to the excellent long-standing scholarship in this area—it is not an effort to refute it.

First, as described below, the exhibition data show that rural genre paintings by artists who are often the primary focus of the social histories of nineteenth-century French art—such as Millet and Courbet—were rare. Rural genre painting constituted a very small percentage of works shown at the Paris Salon, topping out at no more than 4 percent in a given year. Therefore, focusing on artists like Millet and Courbet and their rural imagery potentially creates sample bias and an inaccurate perception that rural genre painting was ubiquitous during the mid-nineteenth century. In fact, rural genre paintings were so rare that this chapter also uses data about other images of the countryside—landscape painting—in order to create a dataset large enough for statistical analyses. This is not to say that volume is the only measure of significance. Critical reactions both good and bad, winning of official prizes (which is charted below), and the aesthetic and political impact of subject matter are all important measures of the significance of a work. However, looking at the volume of the display of rural imagery provides a quantifiable measure that contributes new information about the scale of this particular area of nineteenth-century French painting.

Second, using extensive social and economic data unpacks modernization into its clear constituent parts, such as changing transport, growing industry, and out-migration from rural communities. Rather than present modernization as fairly monolithic and generally anxiety-inducing, this approach helps clarify how phenomena like urbanization and the growth of the railroad specifically influenced artistic output. As demonstrated below, neither increasing urban population nor growing industrial employment share is associated with an increase in the images of nature on display at the Salon. Instead, the greatest impacts on artistic output were changes to transport and the founding of artists' colonies that allowed artists to have direct access to the countryside while remaining in Parisian professional networks. This growing connectedness of rural communities, and the affordability of living there, drove increases in the amount of rural genre and landscape painting produced and exhibited in nineteenth-century France. Structural links between Paris and the countryside—and artists' ability to move between the two—encouraged the depiction of natural imagery. This is one of the points of mediation and mutual implication that Nochlin sought out.

The remainder of this chapter is divided into three sections. The first provides an overview of the history of landscape and rural genre painting in nineteenth-century France, with a particular focus on its relationship to the Salon in order to understand how many of these kinds of works are captured by the Whiteley Index. The second section delves into statistical analyses of rural imagery at the Salon and its relationship to broader social and economic change. The final section presents an extensive quantitative and qualitative analysis of hundreds of letters written by Millet, whose work is most emblematic of images of rural France. This archival analysis

further demonstrates how changes to the French economy that facilitated artists' regular access to the countryside had a greater effect on the output of rural imagery than more abstract concerns about the ills of industrialization. Delving into Millet's archives yielded another surprise: I could not locate the original source for Millet's much-quoted statement about "Paris, black, muddy, smoky." Ultimately, the quote is attributed to "an undated autobiography" by Millet, which is only ever cited by the artist's friend Sensier, who has since been shown to have been an unreliable source.[10] Therefore, in this chapter, all assumptions and received narratives about any causal relationship between modernization and natural imagery are suspended. Instead, these narratives of links between city and country are hypotheses to be tested in a new way.

One final note about the methods used here and what they can and cannot tell us about the nineteenth-century French painting in particular and art history more generally. In 1974 T. J. Clark wrote in "The Conditions of Artistic Creation," which has since become a sort of manifesto for the social history of art: "We need *facts*—about patronage, about art dealing, about the status of the artist, the structure of artistic production—but we need to know what to ask of the material."[11] This chapter provides facts about the scope and structure of artistic production and how it relates to modernization. It sketches out some nuts-and-bolts relationships between industrialization and changes in the art world, particularly related to the daily lives and travel of artists. However, with the exception of the discussion of Millet's letters, it does not examine at length the idiosyncratic reasons *why* different individuals in the art world—audiences, critics, patrons, artists—responded to modernizing changes in France in particular ways. Other art historians have (and future art historians will) dig into these questions with the help of rich qualitative sources. My hope is that this chapter will help situate their findings with a macroscopic understanding of the ways in which the changing structures of the French economy and society changed the lived experiences of artists—and therefore the artworks they produced.

French Landscape and Rural Genre Painting: A Historical Overview

The history of French landscape and rural genre painting begins with the hierarchy of genres that existed in European academies beginning in the late seventeenth century. According to this hierarchy, the best and most important works were history paintings—large-format works primarily showing episodes from ancient history or the Bible. Portraiture was considered the second most accomplished form of painting, followed by genre paintings depicting everyday life, and landscape painting.[12] Still life occupied the lowest rung. This hierarchy of genres was reinforced by the École des beaux-arts, the state-sponsored school of fine arts primarily responsible for educating aspiring artists in France.[13] As discussed in chapter 2, the specific relationship between the École, the Académie des beaux-arts, and the Salon changed over time; however, in general, graduates of the École were more likely

to be successful Salon painters and académiciens. This meant they were also more likely to serve on the Salon jury and favor the admission of history painting and other "higher" genres.[14] There is no clear threshold for measuring when the pastoral figures in a landscape painting's foreground become large enough or central enough to make the work a rural genre painting. Similarly, it is unclear when the natural setting a painted peasant inhabits transforms from background to subject. Therefore, this brief historical introduction presents the histories of landscape and rural genre painting as intertwined.

Most French landscape painters in the eighteenth and early nineteenth centuries produced *paysages historiques* (historical landscapes), which focused on classical settings and endowed landscape with some of the importance of history painting. The most famous of this group, Pierre-Henri de Valenciennes, and his pupils exhibited regularly at the Salon.[15] Until the early nineteenth century, landscape painters generally chose to embrace historical settings in lieu of depicting contemporary landscapes or rural scenes.[16]

Beginning in the 1830s, however, a generation of landscape painters who rejected this preoccupation with imagined classical landscapes emerged. Instead, they turned to present and observable ones.[17] Two painters provide a direct link between the historical landscape tradition of Valenciennes and the developing interest in contemporary landscapes: Jean-Baptiste-Camille Corot and Théodore Rousseau. Both were born in Paris and both trained in academic studios. Corot studied with Achille Michallon and Jean-Victor Bertin—both Valenciennes pupils—while Rousseau trained with J. C. Remond.[18] Corot began to exhibit historical landscape paintings and Italian scenes at the Salon of 1827; Rousseau first exhibited a landscape in 1831.[19]

Under the July Monarchy, liberalizing changes were made to the makeup of the Salon jury (see table 2.1). These changes favored landscape and genre painters, making the Salon of 1831 an important exhibition in the history of artistic engagements with rural imagery. Landscape and rural genre paintings were more accepted by that year's jury, which was more open to "lower" genres. This was also the first exhibition in which a painting of contemporary peasants received widespread critical attention. Enthusiastic positive reviews greeted Louis Léopold Robert's *Arrival of the Harvesters in the Swamp of Pontins* (1830), and young artists copied it for years to come.[20] After Robert's success, several painters exhibiting at the Salon began to form reputations as painters of contemporary rural life. In the 1830s, the most notable were Philippe-Auguste Jeanron and Adolphe Leleux.[21] Importantly, none of these painters were members of the Académie des beaux-arts and, apart from Robert, they were not educated at the École des beaux-arts.

Around the time of this new success at the Salon, several landscape and rural genre painters began to form an artistic community around the Forest of Fontainebleau. The painters stayed in inexpensive local inns and spent days sketching the forest en plein air, first in the commune of Chailly and then in the village of Barbizon. Corot first traveled to Fontainebleau in 1822, Rousseau in 1833, and several other painters now considered to be part of the Barbizon School—such as

Narcisse-Virgile Diaz de la Peña and Charles-François Daubigny—were active in the area by the early 1840s. Courbet had visited by 1841.[22]

While the artistic community at Barbizon grew throughout the July Monarchy (1830–1848), its direct interaction with the Salon was limited. Corot exhibited frequently at the Salon throughout the 1830s and 1840s, but other Barbizon-affiliated artists were less successful. Rousseau's work was accepted for exhibition in 1831 and 1835 but was rejected several times from 1836 to 1841; he then stopped submitting works until the Second Republic (1848–1852).[23] Many other Barbizon painters, such as Diaz, Daubigny, Jules Dupré, and Paul Huet, were also consistently rejected and had to earn a living as porcelain painters or engravers.[24]

The exhibitions of the Second Republic were pivotal for rural genre and landscape painters, particularly those working beyond the purview of the Académie or École des beaux-arts. The structure of the Salon was overhauled yet again after the Revolution of 1848, including one year where the jury was abolished. For this and other reasons, landscape painters enjoyed new levels of success.[25] Millet—who joined the community of artists at Barbizon in 1849—showed *The Sower* (1850) [fig. 2.5], and Courbet displayed *After Dinner at Ornans* (1848), *The Peasants of Flagey Returning from the Fair* (1849–1850), and *A Burial at Ornans* (1849–1850) [fig. 3.1]. Rousseau received a state commission in 1848, exhibited work in the 1849 and 1850–1851 Salons, and received the Légion d'Honneur during this period.[26] Salon prizes were awarded to many emerging artists interested in contemporary landscapes and rural scenes. Crucially, receiving prizes guaranteed the continued presence of landscape and rural genre painting at the Salon because prizewinning artists could usually exhibit without facing jury review. Data about prizewinners is somewhat patchy during this period and needed to be culled both from the Salon exhibition catalogs and occasionally published lists of winners in the periodical *L'Artiste*. Identifying the genre in which a prizewinner worked involved intensive research; therefore, only data about what percentage of prizewinners were rural genre painters—rather than both rural genre and landscape painters—are presented in figure 3.2. Consistent with the trends described above, 1850–51 was a watershed year for prizes awarded to painters working in this area.

In 1852, President Louis-Napoléon Bonaparte became Emperor Napoleon III, and his administration subjected the Salon to various new policies. Scholars debate how much the imperial arts administration was able to control the fine arts and how responsive its policy was to the will of artists and public tastes.[27] However, during this period, exhibitions shifted toward the display and celebration of genre and landscape painting instead of history painting.[28] There were more genre and landscape paintings admitted for display, and rural genre painters who worked both within and outside of the Academy began to consistently win prizes.[29] This encouraging environment for landscape and rural genre continued into the Third Republic (1870–1940). By the 1870s, most of the founding Barbizon painters were elderly or had already passed away. Rousseau and Troyon both died in the 1860s, Corot and Millet died in 1875, Diaz in 1876, and Daubigny in 1878. Immediately and in the

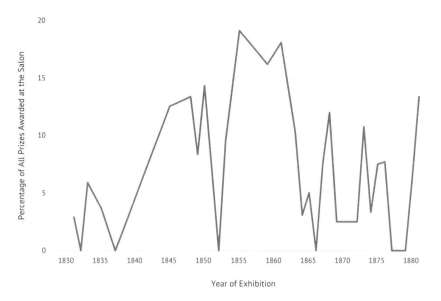

FIGURE 3.2 Percentage of Salon Prizes Awarded to Rural Genre Painters, 1831–1881 (N = 1,344). Sources: *L'Artiste* (1831–1881), http://gallica.bnf.fr/ark:/12148/cb343612621/date; and *Catalogues of the Paris Salon, 1673 to 1881*, 60 vols., ed. H. W. Janson (New York: Garland, 1977).

decades following their deaths, this founding generation was commemorated with hagiographic articles honoring their lives and work.[30] Having started out in relative obscurity during the July Monarchy, these artists died as celebrities. Younger rural genre and landscape painters working within the academic tradition—such as Jules Bastien-Lepage—also became famous during this period and did so without the resistance and struggle that their predecessors faced. Of course, this cozy environment was not extended to the Impressionists, who also produced landscape and rural genre paintings but—as described in chapter 2—were largely forced to exhibit outside of the Salon.

As also discussed in chapter 2, works on paper are a blind spot of the Whiteley Index, although occasionally drawings were grouped with paintings in the *livret* and are therefore indexed. Many images of rural life in contemporary France circulated in the form of illustrated books, prints, and photographs. One famous example is *Voyages pittoresques et romantiques dans l'ancienne France* (Picturesque and Romantic Travels in Old France), which was published between 1819 and 1878. This illustrated book series included many printed images of dramatic French landscapes punctuated with ruins and peasants, and it is cited throughout the scholarly literature on rural genre painting.[31] Millet was a prolific printmaker, and surveys of the peasant image have documented its presence in graphic works from the mid-nineteenth century forward.[32] In a catalog essay for a 1995 exhibition dedicated to the proliferation of prints featuring rural imagery, Herbert wrote of "the extraordinary prominence of peasants in French prints from the 1840s to the turn of the century," which he considered evidence that a "yearning for a rural world was a

prominent counterweight to the drastic alterations of society under the impact of the industrial revolution."[33] Unfortunately, there is no data to gauge just how common rural imagery was compared to other subjects of printmaking and photography in nineteenth-century France. There is not—or at least not yet—an equivalent to the Whiteley Index that captures this important area of artistic production. In the future, this kind of data source could be assembled, especially as more collections data and historical sources are digitized.

Peasants and Paysages at the Salon: A Statistical Examination

The first step to quantitively tracing links between depictions of rural life and nature in nineteenth-century France and socioeconomic change during that same period is to determine how many rural genre and landscape paintings were exhibited. Until now, there has not been quantitative evidence available to gauge whether there was indeed an increase in rural imagery during the nineteenth century and, if so, the magnitude of this increase. However, using data derived from the Whiteley Index, it is possible to track how the quantity of rural imagery changed over time in France's premier exhibition venue. This section begins with a series of graphs that display how many landscape and rural genre paintings were shown at the Salon over time. These graphs reveal a more modest increase in images of nature and rural life than the existing literature has implied. Then, using a statistical method called regression analysis, the remainder of this section combines data from the Whiteley Index with socioeconomic data about nineteenth-century France. This allows one to test whether the socioeconomic variables scholars have identified—such as political upheaval and urbanization—influenced changes in the amount of rural imagery on display at the Salon.

Digitizing and making use of the sprawling Whiteley Index, despite the problems discussed in chapter 2 about working with title data from a juried exhibition, corrects for ex post facto sample bias created by scholars' disproportionate focus on select artists. The entire population of paintings exhibited at the Salon rather than select extant paintings can be analyzed. These data analyses focus on the period from the July Monarchy (1830–1848) until the end of the unitary Salon in 1881. There are two reasons for this chronological focus. First, the existing literature focuses on this period in French art history. Second, it is difficult to get good social and economic data about France before the July Monarchy came to power. To place the artistic data in conversation with a complete suite of social and economic information, it is best to start any analysis in the mid-nineteenth century.

Figure 3.3 represents a first assessment of the assertion that there was a pronounced increase in rural imagery on display in industrializing nineteenth-century France. It shows the absolute number of rural genre and landscape paintings displayed at the Salon from 1831 to 1881. Though the number did not change significantly from year to year, there is certainly an upward trend in the quantity of rural genre paintings displayed. Landscape painting also trends upward, although the dramatic

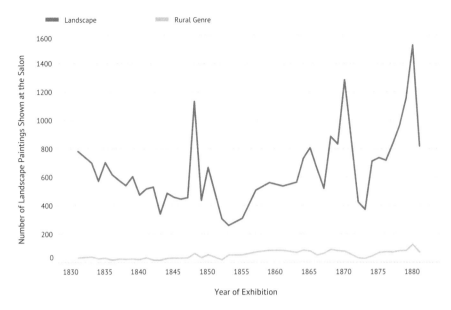

FIGURE 3.3 Number of Landscape and Rural Genre Paintings Displayed at the Salon, 1831–1881 (N = 30,419). Source: Jon Whiteley, *The Subject Index to Paintings Exhibited at the Paris Salon, 1673–1881* (1993), Sackler Library, University of Oxford.

swings in quantity reveal that almost the same number of landscapes were shown in 1881 as in 1831: 819 and 783, respectively. Over this period, however, the number of paintings shown at the Salon was increasing. Figure 3.4 shows the *percentage* of paintings displayed at the Salon that were rural genre and landscape paintings. As a percentage, the upward trend is more modest. Rural genre painting represented a small share of the paintings displayed at the Salon between 1831 and 1881. Even as each Salon included more total works over time, the percentage of rural genre paintings hovered around 2 percent. A notable spike occurred in the number of rural genre paintings at the Salon in the early years of the Second Empire; it more than doubled from just under 2 percent in the exhibition of 1850–1851 to over 4 percent in 1853. Over the next twenty years, this percentage declined unevenly back to the 2 percent level. Landscape paintings were far more common at the Salon than rural genre paintings, usually making up between 20 and 30 percent of all paintings displayed.

What aspects of rural life were shown in these rural genre paintings? Did artists depict a happy, idyllic family life or peasants hard at work? Figure 3.5 provides a breakdown of activities: work; home and family scenes; markets and fairs; pastorals and shepherds; coming and going (images of people on roads and traveling, often to fairs); festivities and relaxation.[34] One clear and stable trend emerges in this graph: the dominance of work as a theme in rural genre paintings. While most of the other categories oscillate between 5 and 15 percent of rural genre paintings, work as a theme is always more than 20 percent; by the end of the sample, it is over 35 percent.

Pastorals and images of shepherds—the second most common subcategory—is

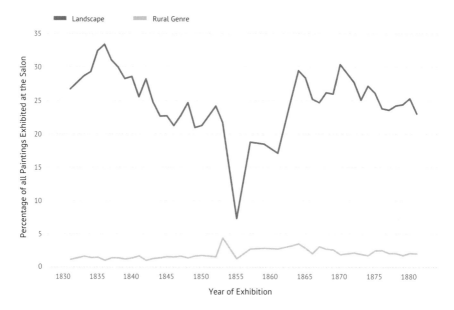

FIGURE 3.4 Percentage of Landscape and Rural Genre Paintings Displayed at the Salon, 1831–1881 (N = 114,455). Source: See figure 3.3.

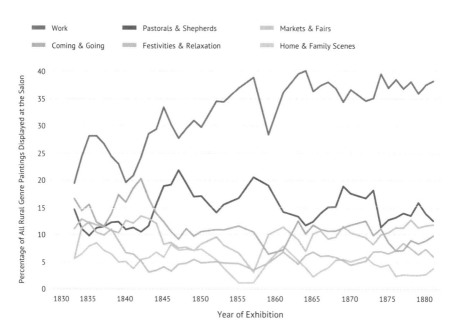

FIGURE 3.5 Subcategories of Rural Genre Painting, 1831–1881, Five-Year Rolling Averages (N = 2,286). Source: See figure 3.3.

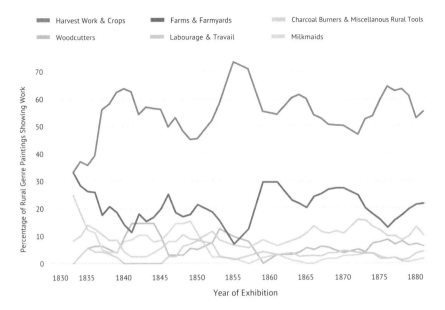

FIGURE 3.6 Kinds of Tasks Shown in Rural Genre Painting Depicting Work, 1831–1881, Five-Year Rolling Averages (N = 942). Source: See figure 3.3.

a distinct category for two reasons. First, the pastoral is a specific trope in French rural genre painting that dates to the seventeenth century. Several paintings (roughly 14 percent of rural genre paintings displayed in a given year) were explicitly labeled "pastoral" or "idyllic" based on their titles. Second, shepherds are a liminal case. While a painted *berger* or *pâtre* (words for shepherd) is potentially depicted performing agricultural work, he can also be shown behaving like his mythical predecessors: lounging, dreaming of lovers, and generally enjoying life. Is the shepherd working or relaxing? It is often impossible to answer that question with only a title. Of the few extant paintings in this category that could be located, about half depict shepherds at work and half depict them relaxing. Even if one could successfully subdivide this category into specific images of a relaxed idyllic past and a shepherd's more difficult present working life, this division would likely contribute to an already clear trend: the increase over time in the number of paintings tagged as "work." Figure 3.6 subdivides the paintings tagged as work in figure 3.5 into more specific tasks. Images of harvest work (such as gleaning and sowing) and of crops (anything tagged as depicting wheat, potatoes, etc.) are the two most common. Rural life is depicted most often as labor in the arable fields.

One problem with using data culled from an index dependent on titles is that some paintings depicting rural life may not have a title that is explicitly rural. Though a broad definition of "rural" was used to select the relevant Whiteley subject headings, listed in appendix C, there are rural images with titles that make no mention of their rural settings. The existing scholarly literature about rural genre painting suggests that two subjects in particular—religious piety and dedication to

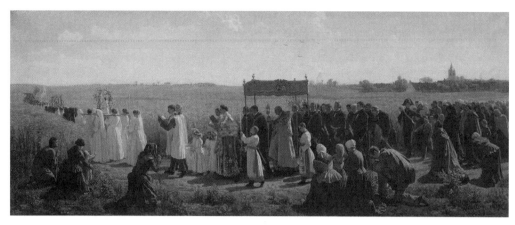

FIGURE 3.7 Jules Adolphe Aimé Louis Breton, *The Blessing of the Wheat in Artois*, 1857, oil on canvas, 130 × 320 cm. Musée des beaux-arts d'Arras.

family—were associated with rural life.[35] Nonetheless, there are relatively few paintings, such as Breton's *Blessing of the Wheat in Artois* (1857) [fig. 3.7], that are tagged in the index with both a religious and an explicitly rural tag.[36] Some famous rural genre paintings do not register as rural, according to the Whiteley Index, because their titles reference only religious rites, such as *A Burial at Ornans,* or family scenes. Léon-Augustin Lhermitte often painted peasant women with their children or families and titled these works "Motherhood" or "Family." Charting possibly related genres alongside rural genre painting can approximate their relationship to images of rural life. Figure 3.8 explores these potential relationships. Two striking facts emerge from this graph. First, the frequency with which rural genre painting and religious genre painting were displayed at the Salon appear linked. Second, there are almost no images of industry. Confirming what art historians—notably, Robert Herbert—have stated, factories, railroads, and other industrial phenomena are largely excluded from the Salon.[37]

This statistical overview provides new and rich information about the quantity of rural imagery in the French fine arts during the nineteenth century. However, the question remains: Are there correlations or causal links between these trends in the art world and changes to France's society and economy? Combining the full sample of rural genre and landscape paintings summarized by figures 3.3 and 3.4 with census and other data about nineteenth-century France facilitates the use of statistical tests to trace the interaction between social and economic change and artistic change. Using strategies from econometrics—the way economists statistically test their hypotheses—it is possible to gain quantitative insight into the relationship between art and broader socioeconomic change.

Table 3.1 provides summary statistics for most of the data (both artistic and socioeconomic) used throughout the remainder of this chapter. An important first step in understanding the relationship between different variables over time is to run statistical tests for correlation. When interpreting statistical correlations, it is

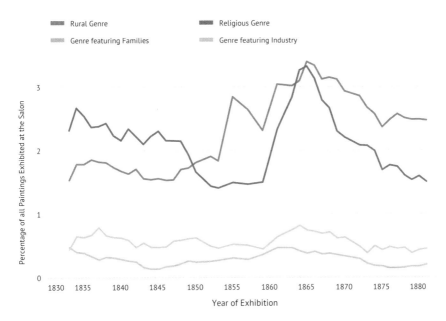

Rural Genre Religious Genre
Genre featuring Families Genre featuring Industry

FIGURE 3.8 Comparison of Different Subsets of Genre Painting, 1831–1881, Five-Year Rolling Averages (N = 114,455). Source: See figure 3.3.

important to look at the magnitude of a correlation, the direction of the correlation, and whether or not it is statistically significant. A technical definition of correlation is that it is a measure of the extent to which two variables move in tandem. This tandem movement can be either positive, meaning the variables move together in the same direction, or negative, meaning they move in opposite directions. In addition to knowing the direction of a correlation, one can also gauge how *often* two variables move in tandem by looking at the correlation coefficient. Correlation coefficients fall on a scale between 1 and -1. Two variables that always move in the same direction at the same time have a correlation coefficient of 1; they are perfectly positively correlated. Consider thunder and lightning, which almost always appear and disappear together—they are two variables that would have a correlation coefficient close to 1. Two variables that always move in the opposite direction at the same time are perfectly negatively correlated. Sunshine and rain can provide an illustrative example. Sunshine almost always disappears as rain appears and vice versa. They are highly negatively correlated. Variables that are *not at all correlated* have a correlation coefficient of 0.[38] Statistical significance is related to the chance that a result is not random. It is stated in degrees of certainty that the result provided by the statistical test is trustworthy and not spurious.

Table 3.2 presents the results of correlations between the percentage of landscape painting and rural genre painting shown at the Salon and national-level socioeconomic data. There are no statistically significant correlations between the output of landscape painting and any of the socioeconomic variables. (Remember, statistical significance is not about the size of the correlation coefficient but rather

TABLE 3.1 Descriptive Statistics of Panel Data about the Rural Imagery at the Paris Salon and French Social and Economic Change

DEPENDENT VARIABLES

Number of Salon Paintings that are Rural Genre Showing Select Department

Number of Salon Paintings that are Landscape Showing Select Department

EXPLANATORY VARIABLES

Number of Tourist Attractions in Department[1]

Number of Artists' Colonies in Department[2]

Number of Major Cities in Department & Neighboring Department[3]

Labor & Strike Activity in Department[4]

Average Price of Travel to Department from Paris[5]

Agricultural Employment Share[6]

[1] Information about the number of tourist attractions in a department comes from Paul Bouju et al., *Atlas historique de la France contemporaine, 1800–1965* (Paris: Armand Colin, 1996); and Karl Baedeker, *Paris and Its Environs*, 6th ed. (Leipzig, 1878). These combined sources provide three surveys (1838, 1869, 1878) of the number of tourist attractions in every department; this number is held constant between the years where updated information is provided; observations before 1838 are listed as missing.

[2] Information about rural artists' colonies and their dates of founding are from Nina Lübbren, *Rural Artists' Colonies in Europe, 1870–1910* (Manchester: Manchester University Press, 2001), and Robert L. Herbert, *Monet on the Normandy Coast: Tourism and Painting, 1867–1886* (New Haven: Yale University Press, 1994). The variable is a total number of colonies in a department; therefore, it is either always increasing or stable. It should be noted that 95 percent of French departments had no artist colony.

[3] Information about the number of cities in a department and neighboring departments comes from Georges Dupeux, *Atlas historique de l'urbanisation de la France* (Paris: Editions du Centre national de la recherche scientifique, 1981). This provides population information for cities every ten years. While the French census treated any community of more than 2,000 people as urban, I have designated a "major city" as 10,000 people or more. Numbers are held steady between the ten-year reporting of how many major cities were in or near a department.

OBSERVATIONS	MEAN	STANDARD DEVIATION	MINIMUM	MAXIMUM
3722	0.09	0.3532224	0	5
3722	3.95	9.058743	0	138
3722	0.803	1.471	0	13
3722	0.0892	0.438	0	3
3722	3.256	1.681	0	11
3722	0.137	0.905	0	26
2911	33.789	19.302	1.317	104.409
1860	0.5660525	0.1410244	0.018829	0.838372

[4] Charles Tilly and David K. Jordan, "Strikes and Labor Activity in France, 1830–1960" (Inter-university Consortium for Political and Social Research [distributor], 2012), https://doi.org/10.3886/ICPSR08421.v2. This is an annual database of strikes and labor activity, by department. The variable is simply an absolute annual number.

[5] Data about the average price of travel from Paris to another department is from Guillaume Daudin, Raphaël Franck, and Hillel Rapoport, "Costs of Travel within French Departments, 1840–80." Provided via email by G. Daudin, July 2014. Prices quoted every ten years; linear interpolation used between observations.

[6] Information from French census in "Social, Demographic, and Educational Data for France, 1801–1897" (Ann Arbor: Inter-university Consortium for Political and Social Research, Feb. 20, 2009), http://doi.org/10.3886/ICPSR00048.v1. Regular accounting of department-level agricultural employment share is only available from 1855 forward.

TABLE 3.2 Correlations Between the Percentage of Landscape and Rural Genre Paintings Shown at the Salon and Several Socioeconomic Variables

	Percentage of Landscape Paintings Shown at the Paris Salon	Percentage of Rural Genre Paintings Shown at the Paris Salon
National Average Price of Travel to and from Paris	-0.2285	-0.4723*
Strikes and Labor Activity	0.0091	0.0352
Share of French Population Employed in Agriculture	-0.2172	0.6706*
Percentage of French Population Living in an Urban Environment[1]	0.3608	0.0771

Note: These are Pearson correlation coefficients.

[1] A community was considered "urban" in the French census data if it had more than 2,000 inhabitants.

*Denotes statistically significant at the 0.05 level (i.e., 95 percent chance this is a nonrandom result).

Sources: See table 3.1.

based on whether or not a result is random; the results of the tests for statistical significance are indicated with an asterisk next to the coefficient.) However, there are a couple for rural genre painting. Specifically, a *decrease* in the cost of travel from Paris is correlated with greater amounts of rural genre painting. The correlation coefficient here is negative because as the price decreases, the amount of painting increases—the variables move in opposite directions. Agricultural employment share is *positively* correlated with an increase in the amount of rural genre painting displayed. The art historical literature suggests that *decreases* in rural population and agricultural employment should be associated with *increases* in paintings of rural genre painting—that as France became less rural and more urban, more artwork depicting rural settings appeared. The opposite effect emerges from the data.[39] There is no correlation between urbanization rates and the frequency of rural genre painting.

However, as the much-cited maxim states: correlation is not causation. Multivariate regression analysis, a basic tool used in econometrics, aims to test whether one variable—or a series of variables—influenced another variable, looking for causation rather than just correlation. Regressions distinguish between "explanatory variables" and "dependent variables" and then measure the effect of the explanatory variables on the dependent ones. It is easiest to explain regression analysis—and the

distinction between explanatory and dependent variables—with an example from outside of art history. Consider that both the number of days of sunshine and rain can explain how much wheat a farmer can grow in a given year. In a regression testing the effects of weather on crop yields, days of sunshine and inches of rainfall would be explanatory variables, while the amount of wheat the farmer grows is the dependent variable. Here, the explanatory variables are social and economic phenomena—such as the price of rail travel and the number of major cities in France—while the dependent variable is the number or proportion of paintings displayed at the Salon that were rural genre or landscape paintings.[40]

To learn from the regressions presented here and how to interpret them, one needs to roughly understand what a regression is and to be familiar with three general types: time-series, cross-sectional, and panel regressions. Time-series regressions measure changes in a single dependent variable over time. Returning to the farming example, a time-series regression would test the effects of sunshine and rain on the average yield of one particular wheat field over several years. Cross-sectional regressions test the effects of variables on multiple individuals at a single point in time: such as the effects of rain and sunshine on ten different wheat fields in one particular year. Panel regressions test the effects of variables on multiple individuals over time—like the effects of rain and sunshine on ten different wheat fields over a ten-year period. Panel regressions are, essentially, cross-sectional regressions through time.

It is possible to do time-series regressions with the available data about images of nature or rural life at the Salon and French socioeconomic markers. However, doing just time-series regressions with national numbers about social and economic change is problematic for two reasons. First, there were only forty-three Salons between 1831 and 1881; for mathematical and theoretical reasons, this small number of data points—called observations—makes it hard to reach meaningful statistical results. Second, economic development in France was highly piecemeal—and different parts of the country developed at different paces and in different ways, which can be obscured by national aggregations.[41] Panel regressions, however, address these problems.

There were approximately ninety departments (or administrative divisions) in France between 1831 and 1881, the period for which a full selection of relevant social and economic data is available. There are good social and economic data available at the department level throughout much of the nineteenth century, particularly after 1840. Using departmental data, the number of observations can be multiplied by up to a factor of 89, for each of the 89 departments included. (I exclude Corsica, which does not have consistent data available.) These data are then combined with information from titles about the location of each painting's subject. Figure 3.9 shows how many rural genre and landscape paintings were tagged with an identifiable location in France over time. It shows a large proportion of landscapes were explicitly named as images of France between 1831 and 1881.[42] While this strategy increases the number of overall observations, it increases them more successfully

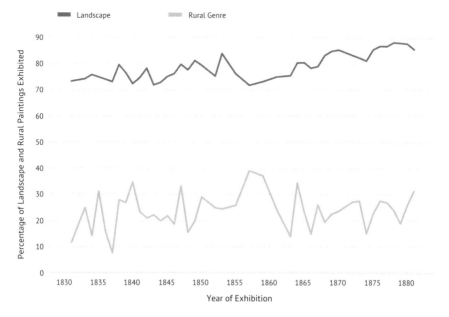

FIGURE 3.9 Percentage of Landscape and Rural Genre Paintings of Identified Locations in France (N = 30,419). Source: See figure 3.3.

for landscape painting than for rural genre painting. There are only around 500 rural genre paintings with French geographic tags, while there are four times as many landscapes identified with a specific department. The small number of geographically identified rural genre paintings means regression results where rural genre painting is the dependent variable are less robust than those where landscape painting is the dependent variable.[43]

Each department had a socioeconomic and artistic profile linked to its transport connections, the presence of artists' colonies, the structure of its economy, and its population's propensity to be involved in labor unrest. These attributes can be linked to questions about paintings' connections to modernizing trends. For example, if a conservative Salon jury was nervous about labor unrest in general, they may have avoided accepting images of departments that had recent labor troubles. If the primary reason for more interest in (and images of) rural settings was greater contact with the countryside facilitated by better transport, then paintings of departments with more rail connections should be more common.

Regression results are typically presented in numerical tables. Full regression tables, an explanation for interested readers who are new to interpreting regressions, and a discussion of the nuances of the statistical results are available in appendix D. However, for the sake of general legibility, table 3.3 provides a summary—in words rather than numbers—of the results of the regressions.

The first clear result is that the advent of artists' colonies had a greater effect on the depiction of a department than any other variable measured. Although the results are slightly more complicated for rural genre painting than for landscape,

the presence of an artists' colony generally had a positive effect on the likelihood of a department's depiction. Artists' colonies provided several amenities to artists. In *Rural Artists' Colonies in Europe, 1870–1910* (2001), art historian Nina Lübbren provides an overview of rural artists' colonies active across Europe and the social and artistic dynamics that attracted artists to these communities. They usually had a low cost of living and were (often, although not always) home to locals amenable to having artists in their village. The artists also provided one another with instruction, support, and inspiration. Colonies were therefore infrastructure that simultaneously allowed artists to come into greater contact with a rural environment and encouraged the production of more work.[44] Unsurprisingly, when artists have easier access to painting en plein air in the countryside, they produce more images of nature and rural life.

This finding about the importance of rural artists' colonies links to economic findings about the advantages artists and other creative workers gain from working in clusters, defined as groups of people in a close geographic proximity. Economists have long observed that firms and workers in the same industry tend to cluster together—and firms and workers within clusters are more productive than those outside of them. This is particularly true of high-skill creative industries.[45] In recent years, economists and economic historians have explored how visual artists, musicians, and writers cluster together. As in other industries, artists tend to produce more work when they are in a cluster. Economic research has also shown, using proxies like auction prices, that artists also tend to create higher-quality work when they are in a cluster.[46]

The economic research about clustering and creativity has, to date, primarily focused on groups of artists in urban centers like Paris and New York. The finding that the presence of artist colonies drove greater numbers of depictions of a given place reinforces the findings that clustering increases the quantity of artists' output. These findings, however, also suggest something new: clusters in certain areas can influence not only the quantity and quality of art but also its *content*.

Rural artist colonies were seasonal or satellite clusters of artists that, ultimately, were dependent on the infrastructure and networks of a nearby major cluster: in this case, Paris. The existence of these smaller communities depended on the ability of members to have access to the Parisian art world. The statistically measured effect of travel prices between a department and Paris reinforces this point about accessibility. In general, the more accessible the countryside became by rail, the more often it was depicted—both because train travel allowed artists to live in these colonies either full-time or seasonally and because it facilitated sketching trips or other excursions that exposed urban artists to rural subject matter. In the regressions, the effect of the price of travel on depiction is recorded as negative because the explanatory variable is an index of the cost of rail travel from Paris to an outlying department. As the price of travel increased, the number of paintings of that location decreased; inversely, as the cost of travel decreased, depictions increased. Figures 3.10 and 3.11 show this trend for one of the included departments, specifically,

TABLE 3.3 Qualitative Overview of Regression Results Presented in Appendix D

EXPLANATORY VARIABLES	EFFECT ON LANDSCAPE PAINTING
Number of Artist Colonies in Department	Strong positive effect across all models
Average Price of Travel from Paris to Department	Clear negative effect, suggesting initially lower prices mean more paintings; however, influence of changes in price over time is negligible.
Number of Major Cities (Pop. > 10,000) in Department and Neighboring Departments	Fewer paintings of traditionally urban places; changes in level of urbanization over time has a negligible effect.
Number of Tourist Attractions in the Department	Long-standing tourist attractions have no effect; addition of new tourist attractions over the course of the century has a strong positive effect on number of depictions of the department (see body of text for further explanation)
Percentage of Workforce of Department Employed in Agriculture (only available from 1855)	Departments with a historically larger share of their workforce employed in agriculture are less depicted. Changes in agricultural employment share have no effect. However, this shorter sample makes results less robust. Lags have no clear effect. (See Appendix D.)
Strikes and Labor Activity in Department	Departments that have a legacy of more strikes and labor activity are more likely to be depicted, but changes in this activity over time has no effect on rate of depiction. Effect slightly more pronounced with lags (see appendix D for explanation).

Calvados in Normandy. Interestingly, the role of the railway in facilitating the growth of artists' colonies is mentioned as something of an afterthought toward the end of Lübbren's book: "The establishment of a network of artists' colonies across Europe was dependent on an equally extensive network of railway lines."[47] These results make it absolutely clear that artists' colonies were dependent on the railroad.

Digging further into the regression results presented in appendix D, there are a couple of important caveats to this relationship between accessibility—via artist colonies and rail connections—and depictions of rural life. The pattern of regression coefficients that measure the effects of explanatory variables suggest that artist colonies and rail connections had the greatest effect when they were established earlier in the nineteenth century. The legacy of access influenced artistic depictions of a certain location more than new or changing access to that location.

Strong positive effect across most models. When controlling for year, the effect becomes negative. See body of text for explanation.

Unlike landscape, no clear effect. Slightly positive and significant when controlling for differences between years and departments with dummy variables (see appendix D). This suggests that while initial low prices may have been associated with greater depiction, a price increase for travel midsample may have resulted in a slight increase in frequency of rural genre depiction.

No clear effect

Long-standing tourist attractions have no effect; addition of new tourist attractions over the course of the century has a strong positive effect on number of depictions of the department; lags have no clear effect.

No detectable effect

Weak effect. However, paintings of departments with strikes and labor activity in the same year as the Salon less likely to be depicted; effect is stronger in models without lags (see appendix D for explanation).

For different reasons, a legacy effect also exists for the links between artists' colonies and the output of rural genre painting. Colonies that produced large amounts of rural genre painting for the Salon—such as Barbizon and nearby Chailly-en-Bière—were all founded in the 1820s and 1830s. They are stable throughout the period examined.[48] Newer colonies, such as those founded on the Normandy coast often focused on the creation of landscape painting. The artists who worked in these newer colonies produced fewer rural genre paintings, and avant-garde artists like the Impressionists who gathered together in these places often did not exhibit at the Salon.[49] This distinction between different "generations" of artist colonies is evident in the statistical results.

Several other tested explanatory variables deserve particular attention. The presence of a tourist attraction in a department sometimes had an effect on artistic

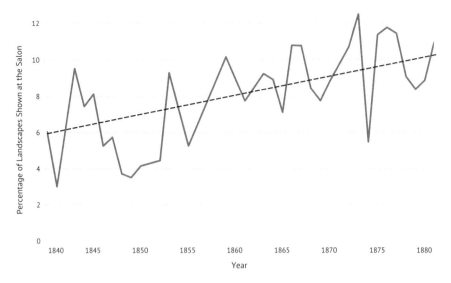

FIGURE 3.10 Percentage of Landscape Paintings Depicting Calvados, 1840–1880, with trend line (N = 28,133). Source: See figure 3.3.

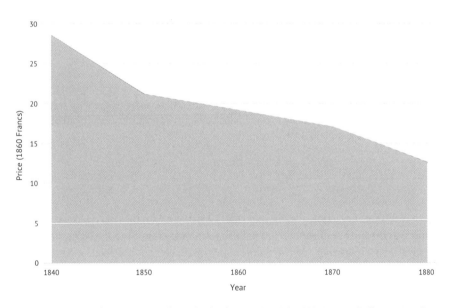

FIGURE 3.11 Price of One-Way Travel to Calvados from Paris, 1840–1880. Source: Guillaume Daudin, Raphaël Franck, and Hillel Rapoport, "Costs of Travel within French Departments, 1840–80." Provided via email by G. Daudin, July 2014. Prices quoted every ten years; linear interpolation used between observations.

depictions of that department. However, this variable is only statistically significant when a new tourist attraction appeared in the middle of the nineteenth century. This pattern of statistical significance suggests that the presence of a long-standing seaside resort or mountain spa did not encourage depictions of landscape or rural genre painting. Rather, the founding of *new* tourist attractions is associated with an increase in the depiction of a place in both rural genre and landscape painting. This correlation between new tourist attractions and images of rural life makes sense in the context of trends in nineteenth-century French tourism. As the century progressed, tourism in "authentic" French rural destinations—like Brittany, where traditional ways of life and dress remained intact until the twentieth century—became increasingly popular.[50] These destinations renowned for their authenticity similarly attracted artists in search of rural subjects.

Urbanization, strikes, and labor activity[51]—central to hypotheses in the social history of art about the links between rural imagery and socioeconomic change—have no consistent effect in the regressions where rural genre painting is the dependent variable. For landscape painting, the effect of strikes and labor activity is significant only under a handful of statistical conditions, which are discussed in greater detail in appendix D. When the effect is measurable and statistically significant, it is negative. Artists may have chosen *not* to depict departments with track records of unrest; juries surprisingly do not seem sensitive to this unrest. However, this negative effect among artists is limited and inconsistent.

While not definitive proof of causal relationships, these regressions suggest two conclusions. First, variables linked to accessing the countryside, such as artist colonies and cost of travel, affect the number of depictions of the countryside. The ability to work in a collegial environment in a rural setting not too far from Paris seems to have more greatly affected the frequency of depicting rural environments than did broad changes in the French economy and society. Second, urbanization rates, declining agricultural employment share, and political unrest and strikes—the socioeconomic factors that studies of well-known rural genre painters have tended to focus on—do *not* have consistent or strong effects in these regressions. However, to further understand these statistical results, one must draw on more qualitative evidence.

Jean-François Millet: Peasant or Parisian Painter?

Millet was born in 1814 in the hamlet of Gruchy, Normandy, and was the eldest son and second child of a peasant family. The Millets were not, however, impoverished. Jean-François's mother "came from so prosperous a peasant family that they were considered gentry in the area" and his father had the time to become "a gifted organist and calligrapher."[52] Millet attended school, and his family encouraged his preparation for one of the liberal professions; he learned Latin and read Dante, Shakespeare, Hugo, and Virgil. His parents also encouraged his interest in art and later supported his artistic studies in the nearby city of Cherbourg.[53] In 1837, Millet received a scholarship from the city of Cherbourg to study at the École

des beaux-arts. Despite having a portrait accepted for display in the Salon of 1840, Millet did not flourish during his early years in Paris.[54] Between 1840 and 1845, he moved back and forth between Normandy and the capital before settling definitively in the Paris region.[55] He traveled to Gruchy for the last time for his mother's funeral in 1853; it was his first visit to the village in nine years.[56] Millet's family was religious, but he was not. This seems to have created tension around the painter's personal life. His first wife died in 1843, and in 1845 he began a relationship with domestic worker Catherine Lemaire. The two lived together and had several children but did not obtain a civil marriage until 1853; they were not married in the Catholic church until the year of his death, 1875.[57]

A turning point in Millet's career occurred in 1848 when he showed a rural genre painting—*The Winnower*—at the Salon for the first time. *The Sower* (1850) [fig. 2.5], his next submission, was also successful. In these works, Millet found an artistic niche that resonated with groups of critics and collectors and even brought him a state commission from the Second Republic. Also around this time, Millet became acquainted with the group of artists who lived and worked in the village of Barbizon on the edge of the forest of Fontainebleau, about thirty-five miles from the center of Paris. He became particularly close to Théodore Rousseau, a leader of the group. Millet moved to the village in 1849 and lived there for the rest of his life, painting primarily rural subjects. He exhibited regularly at the Salon and other exhibition venues, including the Exhibitions Universelles in 1855 and 1867, and in galleries run by private dealers.[58] Though his work still provoked mixed critical reactions— particularly through the 1850s—he continued to gain in notoriety and reputation through the Second Empire. He often struggled financially, but he was generally a successful professional artist until his death in 1875. The artist's reputation as a "peasant painter" helped to transform *The Gleaners* (1857) [fig. 2.16] and *The Angelus* (1857–1859) into beloved French national icons after his death.[59]

The story of the peasant painter Jean-François Millet has been integral to the art historical narrative that links rural imagery to urbanization and industrialization. In particular, existing scholarship has pulled out select quotes from the artist that highlight either his love of nature or his dislike for the city. For example, Millet wrote in a letter to his friend and agent Sensier, "The gayest thing I know is the calm, the silence which one enjoys so deliciously either in the forests or in the cultivated places."[60] This quote appears again and again, along with the unlocated journal entry about "Paris, black, muddy, smoky" mentioned in the introduction to this chapter.[61] However, moving beyond these few select—and sometimes dubious—quotes, a different picture of the consummate peasant painter emerges. He apparently moved consistently and easily between the city and the country, which is in line with the statistical analysis that points to the growing accessibility of the countryside influencing the creation of rural genre and landscape painting.

A collection of 604 Millet letters were given to the Louvre in 1927, part of a gift known as the Legs Moreau-Nélaton, and they are currently preserved in the Louvre's department of drawings and manuscripts. This collection represents the

largest concentration of preserved letters written by Millet.[62] Each item in the Moreau-Nélaton collection is indexed in the Louvre's *Inventaire du département des arts graphiques*, complete with Moreau-Nélaton's short description of the subject of each letter.[63] Web-scraping[64] information about the Millet letters from the *Inventaire* provided a dataset that reports the date, recipient, and a brief description of the content of each letter. Emulating the Whiteley Index, I used keywords to categorize Moreau-Nélaton's descriptions of the Millet letters.[65] Table 3.4 shows how the letters were categorized and divided, and what percentage of the letters fell into that category (letters could be double-tagged).

This survey of Millet's letters demonstrates several things about his opinions. First, his primary concerns were ordinary: money, health, and the well-being of his family. He also frequently mentions travel to and from Paris in order to participate in the Parisian art world. Among the most discussed topics in these letters are specific places—grouped together under "Geography"—including mentions of the goings-on in these locales and Millet's travel to and from them. By far the most frequently mentioned place is Paris. On average, he mentions it in approximately 30 percent of his letters each year—and it only fades from frequent mention in the final three years of his life. The letters most often mention Paris in terms of professional activity. Millet travels there regularly in service of selling or marketing paintings, organizing his participation in an exhibition, or meeting other artists and patrons. Thus, Paris and its importance to his professional success loom large in his correspondence. Barbizon is the second most mentioned location in Millet's letters, although it appears far less frequently than the city. The village is mentioned in one of the two letters from 1848 that are preserved in the Moreau-Nélaton donation. After that spike, the artist colony is mentioned in only about 10 percent of letters. These mentions are frequently about travel to and from the village, real estate, or village politics. The final identifiable location in Millet's letters is his native Normandy. This category includes both mentions of Normandy as a region and specific Norman locations like Cherbourg and his home hamlet, Gruchy. In almost half of the years for which letters are available, Millet does not mention his home region. Only in 1871, four years before the artist's death, was the region mentioned in a maximum of 15 percent of his letters.

The most discussed topics in Millet's letters are professional activity and money, including asking for emergency financial support from his agent and friend Alfred Sensier, discussing commissions and sales, or simply describing how hard he must work to eke out a living. Unsurprisingly, Millet's letters also discuss his artwork, its progress and exhibition, and the activities of his colleagues. On average, Millet discusses works of art (most often his own) in an average of 40 percent of his letters throughout the sample. Théodore Rousseau—his close friend, neighbor, mentor, and patron—is the colleague mentioned most frequently in Millet's letters: around 10 percent each year until a spike in discussion after Rousseau's death in 1867— more than all other artists combined.[66] However, to fully grasp Millet's opinions and concerns, it is necessary to read the material behind the data. In particular, one

TABLE 3.4 Frequency with Which Select Keywords Appear
in Jean-François Millet's Letters

CATEGORY	KEYWORDS IN FRENCH	PERCENTAGE OF TOTAL LETTERS THAT MENTION TERM
Geography		
Paris	"Paris"	30%
Barbizon	"Barbizon"	4.50%
Normandy and Home Village	"Normandie," "village natal," "Gréville," "Cherbourg"	1%
Business Affairs		
Alfred Sensier (Millet's agent)	"Sensier" (but not "Mme. Sensier")	12.27%
Money and Business Concerns	"argent," "les sous," "des sous," "francs," "dettes," "versement," "prix," "vente," "financière," "contrat"	14.59%
Dealers and Agents, Other than Sensier	"Stevens," "Beugniet," "Brame," "Durand-Ruel," "Blanc"	10.61%
Patrons	"Feydeau," "Hartmann," "Tesse," "Robaut," "Couturier," "M. Mame," "M. Thomas," "Forget," "Forges," "M. Granet," "Bruyas," "Bischoff-sheim," "De Knyff"	9.95%
Work	"travailler," "travaille," "travail"	8.79%
Artworks, Artists, Exhibitions		
Artworks	"dessin," "tableau," "tableaux," "gravure," "eau forte," "panneaux décoratifs," "crayon," "pastel," "esquisses"	33.33%
Théodore Rousseau	"Rousseau" (but not "Mme. Rousseau")	12.11%
Other Barbizon Artists (besides Rousseau)	"Diaz," "Dupré," "Jacque," "Jacques," "Bodmer"	4.48%
Non-Barbizon Artists	"Delacroix," "Courbet," Gérôme," "Meissonier," "Puvis de Chavannes"	1.66%
Exhibitions (in general, usually referring to the Salon)	"exposition," "expositions," "exposer"	7.46%

continues

CATEGORY	KEYWORDS IN FRENCH	PERCENTAGE OF TOTAL LETTERS THAT MENTION TERM
Family and Well-being		
Illness	"migraine," "douleur," "malade," "maladie," "dents," "médicin," "inflammation"	10.61%
Family	"ma femme," "fille," "garçon," "naissance," "enfant," "famille," "fils," "frère," "soeur," "mère"	9.78%
"News"	"nouvelles"	8.96%

must understand the context in which the artist made his much-cited comments about the beauty of Barbizon and his affinity for peasants as subjects.

As detailed above, there are a handful of Millet quotes repeated throughout studies of the artist. Many of the most cited—including where the artist describes "silence which one enjoys so deliciously either in the forests or in the cultivated places"[67]—appear in a February 1851 letter to Sensier. Because this letter is in the Moreau-Nélaton collection at the Louvre, it is possible to read and analyze the complete document rather than only select excerpts. Below is a transcription of the letter in its entirety; ellipses are used when it was impossible to discern with confidence what Millet had written. The French is available in appendix E.

Saturday,

My dear Sensier,

Yesterday, on Friday, I received the oil colors that you sent me and the draft painting that was with them.
 Here are the titles of the three paintings for the sale in question:
 1. Woman carding linen
 2. Peasants going to work in the fields
 3. Gatherers of wood in the forest
 I don't know that one can print a word about the Gatherers . . . or in whatever you want. Know only that the painting is composed of a man binding a stick and two women, one cutting branches and the other holding a bundle of wood. Voilà.
 As soon as the frames are done, tell me so I have the time to see them without the paintings in them and retouch them if needed.
 There is only you to describe them by their titles, in my works in progress there are neither naked women nor mythological subjects: I want to position

myself before anything else as a...that I do not understand why no one defends the fact that I would not want to be forced to do it; but in the end the beginnings go better with my temperament because I swear at the risk of speaking even more...that it is the human side, the frankly human that touches me most in art & if I could do whatever I want or at least try the result I would not do anything that is not the result of impressions received by the aspect of nature, whether in landscapes or in figures and it is never the joyous part that appears to me; I don't know if it is there, I never saw it. That which I...gay, is the calm and silence that one enjoys so deliciously either in the forest or in the cultivated places, whether ploughable or not, you will admit that it is always very dreamy & a sad reverie while delicious, you are seated below the trees, experiencing all the well-being, all the tranquility that one can enjoy, you see a poor figure break out from a small trail, loaded with a bundle of wood, the unexpected and always shocking nature of the figure recalls instantly the sad human condition, the fatigue that always gives an impression analogous to that which La Fontaine describes in the fable of the woodcutter. What pleasure has he had since he has been in the world? Is there a poorer man in the...?

In the cultivated places, and sometimes in certain regions that are barely plough-able, you see figures digging, shoveling. You see them stand up from time to time...and, as one says, wipe their brow with the back of their hand, and eat by the sweat of their brow. Is it there the happy frolicsome work that certain people want us to believe in[?] It is however here that I find the real humanity, the great...I will stop myself here because I could eventually bother you with this. I have to excuse myself, I know all...without having learned...of my impressions sometimes, I let myself go without noticing, I won't start again.

Ah, now that I am thinking about it, send me from time to time your wonderful letters with the seal of the ministry, the one in red wax, in fact with all the possible embellishments. If you saw the respect with which the postman hands me these letters! Cap in hand, which does not usually happen, and then he tells me with the most...air: it's the ministry! It makes me appear in the best of manners. It gives me some credit because a letter with the cachet of the ministry is obviously from the minister, it really is something...that beautiful envelope.

[Karl] Bodmer has still not returned to Barbizon. Neither has [Charles] Jacque.

Do you think I have a chance at getting an order from the ministry? Do you know if Jacque's commission has worked?

Handshakes,
JF Millet

[PS] Have Rousseau's paintings made a splash and been successful?[68]

From reading the letter in its entirety, one learns several things. Millet's letter is not only about his opinions of Barbizon, its forests, and residents. His philosophical interlude about human nature and his appreciation for both wild nature and "cultivated places" ("les endroits labourés") are sandwiched between two more banal topics. First, he writes about the receipt of supplies, the challenges of preparing paintings to be framed, and a list of paintings to be sold. This is the daily business of being a professional artist. After describing that he finds the "real, big humanity" ("la vrai humanité, la grande") in the people who "wipe their brow with the back of their hand, and eat by the sweat of their brow ("s'essuyant le front avec le revers de la main, tu mangeais ton pain a [sic] la sueur de ton front"), he discusses envelopes. Sensier's full-time job then was as chef du secrétariat for the ministry of the interior.[69] Apparently, he could send letters on official stationery with official seals. The concluding paragraph to Millet's letter begins, "Ah, now that I am thinking about it, send me from time to time your wonderful letters with the seal of the ministry, the one in red wax, in fact with all the possible embellishments." For the next few sentences, Millet expresses that he is pleased with the official status and letterhead of his friend. The letter concludes with news about the whereabouts of two artists (Charles Jacque and Karl Bodmer) and questions about the success of Théodore Rousseau's and Jacque's recent paintings.

The structure of this letter and the topics it addresses provide a useful and compact example for considering Millet's correspondence in general. The beginning is typical of the majority of the letters included in the Moreau-Nélaton donation. Millet most often discusses business related to the creation and sale of his work—including brief trips to Paris—and asks his interlocutors for financial help, materials, and professional advice. The end of the letter is also symptomatic of another common thread in the artist's writing: gossip and stories about family and mutual acquaintances. Millet's fixation on his friend's position at the ministry and questions about goings-on in the art world echo his comments and concerns in other letters when he asks for *nouvelles.*

Nonetheless, amid these quotidian topics is a deliberate statement of Millet's opinion of the countryside and a winding explanation of why he chooses to paint peasants. He talks about his clear affinity for the forest and agricultural fields and about his belief that the people who inhabit these places are more human and real than any other potential artistic subject. This reality is linked to their fate of working hard for their entire lives ("Quel plaisir a-t-il eu depuis qu'il est au monde?"). In this letter, Millet states one thing about his opinions of modern life and simultaneously implies a contrary opinion. He describes a clear preference for painting and living among the rural landscapes and people in his adopted hometown of Barbizon. Yet he actively works with his Paris-based agent to sell his work in the city and describes how impressed he is by the fact that Sensier is a prestigious bureaucrat working in the capital. By volume of topic included in his correspondence, he acts and transacts as a modern painter and entrepreneur more often than he states his preference for a world of peasants and virgin forests.

Until now, scholars have largely privileged Millet's rare explicit statements about his opinions over his actions or descriptions of the banalities of professional life as an artist.[70] In general, the corpus of Millet's letters in the Moreau-Nélaton collection gives the impression of the easy coexistence between the artist's life in Barbizon and his need to regularly go to the city to attend to his career. Below, an 1859 letter to Théodore Rousseau (a French transcription of which is also available in appendix E) provides another typical example of the content of Millet's correspondence:

Barbizon Thursday,

My dear Rousseau, I do not have any kind of frame that will work for Etienne's painting, this is delaying me enormously. So if you can quickly quickly send me the frame that he left at your place you would be doing me a big favor. Big and small migraines have besieged me this month so that I have had only a quarter of my time. I assure you that I am demolished, both physically and morally. You were right my dear Rousseau life is truly sad & and there are only few places where one can find refuge. One ends up understanding those who sighed after a place of refreshment, light & peace. One understands also how Dante made some of his characters describe the time that they spent on earth as "the time of my debt." Tell that to Mme Rousseau: what I wholeheartedly wish her is to be well and that there is a little bit of selfishness on my part in this wish, in the sense that I have a terrible need to be a little bit scolded & shaken when I go to Paris one of these days & she can do it better than anyone. It's just that I am experiencing a real need. My wife seems to act in a manner more...she wishes her simply to be as well as...

Sensier seems furious with the Exhibition. Yes, I must try to go once I am in Paris. I want to go at the same time as Sensier, who was just here for Easter. I don't know if we'll go Monday evening or Tuesday morning, that will be how he wishes...my dear Rousseau. I did "Coco's" commission...

Handshakes,
J. F. Millet[71]

Writing to his fellow artist, Millet discusses his work, health, general low morale, and plans to travel to Paris to attend an exhibition—likely the Salon—with Sensier. Millet's everyday network and concerns include both Barbizon and Paris, where Rousseau was when he received this letter. Barbizon and Paris are not two opposing forces in the artist's life; rather, they have a symbiotic relationship. Millet could not earn his living and remain in his professional networks of dealers, artists, and exhibition venues without easy access to Paris. His ability to be a successful artist in the countryside thus depended on regular travel to the city.

Conclusion

This chapter has revealed that there was only a modest increase in the amount of rural imagery shown at the Paris Salon over the course of the nineteenth century. Of the variables tested, the founding of artists' colonies had the greatest effect on rural imagery's appearance at the Salon. The ability to spend time away from the city with other artists—though not too far to preclude an easy return to Paris for business or personal purposes—significantly affected the artistic output of the period. Furthermore, increases in the depiction of a location were directly related to the decrease in travel prices from Paris to that location, indicating that easy access to the countryside influenced the creation of more images of rural scenes. Even Millet, despite his reputation as a peasant painter, was firmly enmeshed within a Parisian orbit, as his correspondence demonstrates. Therefore, what could be viewed as one of the advantages, rather than an ill, of modernization drove increases in rural genre and landscape painting: a relatively easy commute to and from one's community of choice. This kind of nuts-and-bolts finding about the effects of modernization is a common conclusion of analyses in economic history. Often, modernization had its greatest effect on people by simply making life more convenient.

FIGURE 3.12 Camille Pissarro, *The River Oise near Pontoise*, 1873, oil on canvas, 46 × 55.7 cm. Clark Art Institute, Williamstown, MA, acquired by Sterling and Francine Clark, 1945, 1955.554, image courtesy of the Clark Art Institute.

Perhaps the ways in which city and country—industry and rural life—could coexist in modernizing mid-nineteenth-century France is best summarized by a painting. Impressionist Camille Pissarro also painted rural subject matter throughout his career, although peasants and rural landscapes were just one kind of content he produced. Pissarro, whose interest in peasants was partly motivated by his anarchist-communist political views, has often been compared to Millet and he owned works by the elder artist.[72] Like Millet, Pissarro also lived outside of Paris, specifically in the towns of Pontoise and Louvenciennes, which are approximately nineteen and fifteen miles from the capital, respectively.

In 1873, he painted *The River Oise near Pontoise* (fig. 3.12). The jewel-like canvas shows what is, at first glance, a pastoral scene. Blue sky peeks through clouds in the upper left-hand corner of the canvas, and what appears to be a wild-flower dotted riverbank appears in the bottom right. The river cuts through this scene; perfectly still, the water's surface reflects the mix of buildings and trees on the far bank across from where the viewer is situated. The buildings are, it turns out, a factory nestled into the bucolic environment. The collection of gabled and lean-to roofs could be mistaken for a large farm, but what seem to be four smokestacks—three of which are emitting smoke or steam—betray the fact that this is an industrial scene. The smoke and steam may be polluting but they also fade into the otherwise scenic broken clouds. Industry and a rural scene merge, the modernizing France presented as part of a pastoral. City and country are not antagonistic but integrated into one another. In its easy representation of industry and rural life coexisting, Pissarro's painting is a fitting analogy for the relationship between artists, rural life, and the modernization of France. Progressively, artists were able to exist simultaneously in both the city and the country, in rural and industrial France. This binding together of seemingly antagonistic environments helped provide artists with access to rural subject matter, driving growth in the number of rural genre painting and landscapes produced and displayed.

◇◇◇

Why Have There Been
No Great Women Artists?

Artistic Labor and Time-Constraint
in Nineteenth-Century America

The Guerrilla Girls, an anonymous feminist artist collective founded in 1985, call attention to systematic gender and race discrimination in the art world by creating posters and handbills that feature a mix of dark humor, politics, and statistics.[1] One of their best-known posters (fig. 4.1) features a send-up of French artist Jean-Auguste-Dominique Ingres's *Odalisque* (1814). In it, the Guerrilla Girls, who had collected data on the representation of women in major museum collections, posed a clear question: Do women have to be naked to get into the Metropolitan Museum of Art? The answer appeared to be "yes"—the collective concluded that 5 percent of artists in the Met's Modern Art section were women, while 85 percent of the nudes on display were *of* women.

FIGURE 4.1 Guerrilla Girls, *Do Women Have to Be Naked to Get into the Met. Museum?* 1989 Copyright © Guerrilla Girls, courtesy guerrillagirls.com.

This 5 percent figure provokes myriad questions. Do fewer women than men make art professionally? If so, has this been true both historically and at present? In economic terms, this could be explained by supply and demand. If there is a lack of supply, what are the practical barriers that block women from making art? Or is this underrepresentation explained by a lack of demand for the works women produce? Does discrimination by collectors, gallerists, and curators stop women from getting their fair share of wall space in major museums?

This chapter uses statistics to examine the experiences of women in the art world. Central to this examination is exhibition data from one of the principal art academies in the nineteenth-century United States—the National Academy of Design—and collections data from the Metropolitan Museum of Art, the nation's leading museum since the nineteenth century. Pairing data about the participation of women in important nineteenth-century Academy exhibitions with statistics about what has been preserved in an important museum makes it possible to consider the extent to which there is either a correlation or a disconnect between the amount of artwork created by women in the nineteenth century and how much of this output makes it into museum collections.

Analyses of these data reveal that women participated in nineteenth-century American exhibitions at much higher rates than they are represented in museum collections of nineteenth-century American art. The current scholarly literature treats this disconnect as the product of sexist cultural and institutional norms during the nineteenth century.[2] Recent commentary has also focused on curatorial choices that have kept women out of museums' permanent collections and exhibitions.[3] Without denying the effects of both historic and current sexism, this chapter proposes other structural factors that limited nineteenth-century women artists' attainment in their own lifetimes and posthumously.

Before proceeding, it is essential to note that the use of the word "woman" in this context refers to cis-gendered women. This choice is not to deny the fluidity of gender nor to edit out transgender women from history. Instead, this study is tethered to the fact that nineteenth-century data conform to a nineteenth-century concept of gender: that it reflects biological sex. Using this data therefore engages with a distinctly non-twenty-first-century idea of womanhood.[4] Parts of the chapter discuss individual artists who subverted nineteenth-century gender expectations by painting under traditionally male first names and engaging in romantic relationships with other women. However, the term "woman" and its permutations are generally used here as shorthand for someone who was born biologically female and presented as such throughout their adult life. Furthermore, I am keenly aware that gender is just one element of artists' lived experience and focus on it can sometimes obfuscate issues of class or race.[5] The vast majority of nineteenth-century women artists included in this dataset were white and often (though not always) came from privileged backgrounds; this limits the range of experiences captured. While acknowledging these problems with the data, this chapter aims to highlight

labor market dynamics that affect women across class and racial divides. This is not to say lived experience is uniform, but rather data-driven approaches can help highlight some potential common denominators across demographic groups.

Focusing on these artistic career paths in the past illuminates the current barriers that exist for women in the art world. When studying the nineteenth or early twentieth century, it can be easy to think that the flagrant sexism of that period disappeared decades ago—and therefore that the study of nineteenth-century women artists constitutes the study of mostly bygone discrimination. Now that the social and cultural landscape has changed, one might think it is just a matter of time before the inequities of the past are resolved in the future. In contrast, this chapter shows through a mix of economic theory, quantitative evidence, and archival sources that certain structural barriers faced by nineteenth-century women artists closely resemble those faced by women artists today.

Labor economists have been studying women and their professional experiences for decades. This is because rates of women's job participation have been changing since the 1890s, while the proportions of men engaged in full-time employment have mostly remained steady.[6] Particularly since the 1990s, economists have generated a significant literature that seeks to understand how women's career trajectories are affected by marital status, spousal income level, and the decision to have children.[7] Though this literature tends to focus on the careers of women in business, law, medicine, and academia, the general conclusions that it reaches about women's labor market experiences also apply to women artists.

Besides explicit legally sanctioned gender discrimination, two factors have historically kept women—especially married women—out of the labor force.[8] The first is the labor of caring for a household and children. Having a career has traditionally been incompatible with domestic responsibilities. Second, social pressures have forced women to wed young and abandon employment after marriage, and certainly after motherhood. These social pressures and conceptions of gender norms have fueled outright discrimination against women in many professional fields.[9] Yet even in the twenty-first century, gender pay and achievement gaps persist despite laws addressing workplace discrimination and women's matching—and now actually surpassing—the educational attainment of their male peers.

Economists have attributed a large part of this persistent inequality to one factor: time. Women do not have enough time, and they have never had enough time. Even without children, women in heterosexual couples shoulder greater domestic burdens than their male partners.[10] These added burdens hamper women's (and, more acutely, mothers') professional achievement. Economist Claudia Goldin, a leading authority in this field, has shown that women fall behind in jobs with significant time demands. Furthermore, women succeed the least in jobs that demand ample time spent with colleagues or clients—and therefore with a schedule beyond the worker's control. Today, the highest-paying careers in major law firms, big banks, and prestigious consulting firms make these demands on workers; as a result, women tend to

seek employment—usually lower-paying employment—elsewhere, especially as they marry and start families.[11]

How do insights about today's female lawyers and bankers apply to nineteenth-century women artists? Being an artist, particularly in the nineteenth century, has all the hallmarks of a profession in which it is difficult for a woman to succeed. First, making art is time intensive. Though artists are self-employed and theoretically in charge of setting their own hours, the total number of hours it takes to create a work is generally inflexible, and having long uninterrupted hours in the studio improves an artist's output.[12] Furthermore, the most time-intensive and time-inflexible works of art—such as landscapes that demand months of traveling and then months of studio time, large-format history paintings, or portraits of important people requiring multiple sittings—have traditionally been the most prestigious. It is these works that dominate textbooks and museum walls, not the small-format still life or watercolor that can easily be paused and returned to over multiple interrupted sessions. Finally, the marketing activities required for a nineteenth-century American artist were particularly inflexible. Most artists did not have dedicated dealers and were responsible not only for creating work but for selling it as well, either directly or through intermediaries like art unions. This market structure, which existed both in Europe and in the United States through at least the middle of the nineteenth century (see chapter 2), made it necessary for artists to spend a lot of time with their patrons and maintain social networks with potential collectors.[13] These marketing practices are analogous to the client-facing time demands that continue to make certain professions undesirable for women today.

Framed by the economic findings about the relationship between inflexible time demands and women's professional success, the remainder of this chapter is divided into six sections. The first provides a brief literature review of quantitative art historical studies of women artists. The second introduces the history of women's engagement with nineteenth-century arts institutions and focuses particularly on the two institutions—the National Academy of Design (NAD) and the Metropolitan Museum of Art—whose data provides the quantitative evidence analyzed in this chapter. The third presents a statistical overview of women's participation at the NAD and the extent to which this participation is reflected in the Met's holdings. The fourth uses economic theory to interpret these quantitative findings, while the fifth uses this same economic theory to frame a qualitative case study about Lilly Martin Spencer, one of the most successful female painters in nineteenth-century America. Tellingly, Spencer wrote to her mother in 1852: "I wish I had studied landscape more when I was at home, for they sell quicker than any other kind of painting. I am extremely backward in it—principaly [sic] from not being able to afford time to make studies from nature."[14] The last section provides a coda to the historical focus of the chapter by exploring how time constraints related to domestic responsibilities continue to drive inequities in the art world today.

Quantification and the Study of Women Artists: A Literature Review

Studies of women artists have been produced since the nineteenth century. These include Elizabeth Fries Ellet's *Women Artists in All Ages and Countries* (1859) and Ellen Creathorne Clayton's *English Female Artists* (1876). These works conform to a biographical approach. In the mode of scholarship established by Vasari's sixteenth-century compendium *Lives of the Most Eminent Painters, Sculptors, and Architects,* they are roughly chronological accounts of select "geniuses" and their output. This monographic approach to art history dominated the discipline in general, including the study of women artists, until scholars pioneered the social history of art in the 1970s. As discussed in chapters 1 and 3, this new scholarship argued that most artworks are formed in the crucible of interactions between different social groups, and advocated for enlarging the artistic canon.[15] Of the many areas of art history altered by the social history of art, the study of gender was particularly affected.

A watershed moment came with the publication of Linda Nochlin's "Why Have There Been No Great Women Artists?" (1971). The essay critiques the use of a monographic approach to better integrate women artists into the history of art. She writes, "To dig up examples of worthy or insufficiently appreciated women artists throughout history" is overlooking the root of the problems of women's participation in the art world, both historically and in the present.[16] Instead, Nochlin argues for an institutional approach to the study of women artists:

> If there actually were large numbers of "hidden" great women artists, or if there really should be different standards for women's art as opposed to men's—and one can't have it both ways—then what are feminists fighting for? If women have in fact achieved the same status as men in the arts, then the status quo is fine as it is.... But in actuality, as we all know, things as they are and as they have been, in the arts as in a hundred other areas, are stultifying, oppressive, and discouraging to all those, women among them, who did not have the good fortune to be born white, preferably middle class and, above all, male.[17]

This is followed by an enjoinder to art historians to study the structures and effects of the institutions that both historically and presently limit women artists' ability to succeed. Nochlin continues:

> It is no accident that the crucial question of the conditions *generally* productive of great art has so rarely been investigated, or that attempts to investigate such general problems have, until fairly recently, been dismissed as unscholarly, too broad, or the province of some other discipline, like sociology. To encourage a dispassionate, impersonal, sociological, and institutionally oriented approach would reveal the entire romantic, elitist, individual-glorifying, and monograph-producing substructure upon which the profession of art history is based, and which has only recently been called into question by a group of younger dissidents [the social historians of art].[18]

Of course, I am far from the first to respond to Nochlin's call to action. Many studies published since 1971 have examined how institutions—a term that, in the social sciences, encompasses governmental structures, laws, schools, and well-established cultural behaviors[19]—affect women artists. Nochlin, Griselda Pollock, and Carol Duncan, all feminist scholars and social historians of art, are among the most prominent contributors to this field. Building on their work, many scholars have sought to situate individual women artists or schools of artists in their broader socioeconomic context. The most helpful for my purposes here have been Laura Prieto's *At Home in the Studio* (2001), Kirsten Swinth's *Painting Professionals* (2001), and Melissa Dabakis's *A Sisterhood of Sculptors* (2014). These studies pay particular attention to how women artists had to adapt their career paths and professional personas because of their gender.

Still, most studies of women artists have not engaged with Nochlin's recommendation to use "dispassionate [and] sociological" approaches. The subfield has taken a theoretical turn closely linked to groundbreaking work about gender that emerged in the fields of critical theory and philosophy.[20] This work has provided essential critiques of art historical practice, feminism, and assumed gender norms. However, when numbers appear in studies of women artists, they are typically mentioned briefly or relegated to an appendix. For example, Swinth's introduction begins with a meditation on census numbers from the end of the nineteenth century: "Nearly 11,000 women artists, sculptors and teachers of art practiced their profession according to the 1890 census, rising stunningly from the 414 women counted in the same category just twenty years before."[21] These numbers are then supplemented by several tables about women exhibitors at different academies from 1880 to 1890, but these appear in an appendix and are referenced sparingly throughout the text.[22] Generally, quantitative information is used only to frame qualitative examinations of cultural factors affecting American women artists.

There are a handful of histories of women artists that feature extended engagements with quantitative methods. One of the earliest examples is a 1978 article by historian Jean Gordon. Gordon aimed to respond to Nochlin's seminal essay by counting the number of women included in an authoritative dictionary of American artists. However, she ultimately uses uneven quantitative evidence, moving without warning between absolute numbers and percentages throughout the piece, which supports a general arithmetic narrative of women facing an uphill battle in attaining artistic success.[23] Two sociologists—Gladys Engel Lang and Kurt Lang— published the only book that has taken a partially quantitative approach to the study of nineteenth-century women artists and their long-term success: *Etched in Memory: The Building and Survival of Artistic Reputation* (1990) drew on a statistical sample of 286 British and American artists who made etchings. The sample of artists was equally divided between men and women. Using both qualitative and quantitative evidence about these etchers, the Langs examine not only how artists of both genders established their reputations within their own time but also how being a

woman negatively affects posthumous reputation.[24] This chapter contributes to this limited quantitative literature by engaging with new data sources and asking new kinds of questions of supporting qualitative evidence.

A Brief Overview of Nineteenth-Century Women Artists' Engagements with the Art World

The National Academy of Design and the Metropolitan Museum of Art are central to the quantitative component of this chapter for several reasons. Perhaps most importantly, there are high-quality accessible data available about each institution. Adding to this practical advantage, there are also historical reasons that combining information from these two institutions creates an illustrative case study. First, both were based in New York and helped to make the city the center of the American art world.[25] Second, the two institutions' histories are intertwined. Members of the National Academy participated in the founding of the museum and many of their works form the core of the Met's American art collection.[26] Pairing these institutions allows one to study a pipeline of artworks from initial display to preservation in a major collection.

The National Academy of Design was not New York's first art academy. That title goes to the American Academy of the Fine Arts, which was officially incorporated in 1808.[27] However, unlike the still-extant Boston Athenaeum (est. 1807) and Pennsylvania Academy of the Fine Arts (est. 1805), the American Academy suffered from stagnant leadership. Ultimately, several New York artists founded the National Academy of Design in 1825 to protest the older non-artist-led institution.[28] Modeled on European academies, the NAD was organized into three classes of membership: academicians, associates, and honorary members. There were also clear rules for promotion: "From the Associates alone, the vacancies in the body of Academicians were to be filled. Active members were to be residents of New York City and vicinity. Honorary Members were of two classes: nonresident professional artists, who on becoming resident were admitted as Academicians; and amateurs, patrons of the arts, and distinguished members of other professions."[29]

The NAD sought to encourage the education of art students. Along with the founding of a school, the institution's annual exhibitions were an extension of this mission.[30] While the first annual exhibition was mounted in 1826, codified exhibition rules were only created in 1829. The most important of these rules for data analyzed in this chapter are that "Works of Living Artists only, and such as have *never before* been exhibited *by the Academy*, will be received." This excluded copies after other works and repeat showings; however, artists could submit works across media, including paintings, sculptures, works on paper, and architectural designs.[31] Until the 1870s, there was no formalized jury selecting works to be displayed at the annual exhibition.[32] Instead, as a commentator wrote in the *United States Magazine and Democratic Review* in 1847: "The Annual Exhibitions of the Academy of Design

are not prize exhibitions of pictures which come up to a certain fixed standard, high or low, nor exhibitions of the works of members of the Academy, but of all pictures sent by living artists…[they give] both the artist and the public the opportunity of comparing the works of one painter with those of another."[33] In its early years, the only attempts to limit submissions were encouragements such as NAD president Asher Durand's 1846 enjoinder that there be "propriety of limiting the number of works presented by each contributor for exhibition—say to eight or thereabouts."[34]

During its first decades, the NAD had to coexist not only with the elder American Academy but also with a younger organization: the American Art-Union, which purchased and distributed works by contemporary American artists to its members.[35] Though the two institutions shared a common goal of fostering American artistic talent, there was tension between them.[36] However, the Art-Union came to an abrupt end in 1852 when it was declared an illegal lottery and shut down.[37] In the years following the closing of the Art-Union, the National Academy of Design solidified its role as the premier New York institution supporting contemporary American art. In 1865, the organization moved to new premises on 23rd street in Manhattan and began to question its rules and processes for managing the annual exhibition. A decisive constitutional amendment passed in 1869 established the Hanging Committee, a jury of three academicians elected by the membership and charged with selecting the works for the exhibition and how they would be displayed.[38] No one could serve on the jury two years in a row.[39] From 1869 forward, the works exhibited—and therefore the data analyzed here—were curated by a group of academicians.[40]

A handful of women artists have been linked to the National Academy since its earliest years. Miniaturist Ann Hall became the first woman to be named an associate in 1827 and a full academician in 1833.[41] American art academies accepted women students earlier than their European counterparts, likely to increase the number of students who could pay tuition and shore up the academies' finances.[42] The Pennsylvania Academy of the Fine Arts began to admit women as students to its school in 1844, and the school of the National Academy followed suit in 1846.[43] Despite this early inclusiveness among the student body, women's appointment to membership as associates or academicians of the NAD remained anemic. From 1825 to 1900, there were eleven female associate members, four honorary members—including Lilly Martin Spencer, whose letters and works are analyzed later in this chapter—and Hall remained the only full academician. In all, less than 6 percent of members elected between 1825 and 1953 were women.[44] Women were also excluded from life-drawing classes offered at the Academy—which involved nude models—until the establishment of a separate ladies' life-drawing class in 1871, similar to what was created at other American art academies, notably in Philadelphia (fig. 4.2).[45]

Qualitative studies demonstrate that despite attending classes at the same institutions, the treatment of men and women within those institutions and in the broader art world was unequal. Only some teachers "took lady pupils," and classes

FIGURE 4.2 Alice Barber Stephens, *The Women's Life Class*, 1879, oil on cardboard (grisaille). Pennsylvania Academy of the Fine Arts, Philadelphia.

for women were held irregularly.[46] Furthermore, while male artists often worked alongside one another and shared ideas in each other's studio spaces, similar collegial relationships were less likely to develop across gender lines.[47] These dynamics excluded women artists from social and professional networks that helped male artists exchange ideas, gain patronage, and successfully navigate the art market.[48] Social clubs like the Century Association, founded in 1847, were specifically designed as a meeting place for artists and patrons. However, the Century and related clubs, such as the Union League, were open to only men until the late twentieth century.[49] Professional development and networking happened not only at the NAD but in these informal and gender-segregated spaces.[50] Understanding this fact, women created their own networks and associations to support one another. The Women's National Art Association, which Laura Prieto describes as "the first major American women's art club," was founded in Philadelphia in 1866; the Ladies' Art Association started in New York in the following year; and Sorosis, a club also started in New York for women in the arts, was created in 1868.[51] As the century progressed, more clubs for women artists and their supporters appeared throughout the country.[52] Perhaps the apex of women-specific arts initiatives were the Woman's Pavilion at the 1876 Centennial Exhibition and the Woman's Building at the World's

Columbia Exposition in 1893, where both wealthy and socially connected female patrons and professional women artists worked together to organize showcases of women artists' work.[53] However, these parallel female networks remained divided from the centers of financial and institutional power in the art world. Furthermore, they remained open almost exclusively to white women.[54]

This gender division is clear in the genesis of one of the most important American art institutions: the Metropolitan Museum of Art. The impetus for founding the Met had its roots in the Metropolitan Art Fair, an 1864 exhibition and auction organized for the benefit of the United States Sanitary Commission.[55] That event demonstrated New Yorkers' growing interest in art and demand for regular exhibitions. The organizers—most of whom were members of the all-male Union League Club—became founders and trustees of the Metropolitan Museum of Art. The idea for the museum took form within the club, and the Union League's art committee was asked to draft a proposal for the founding of a major museum in New York City. This seven-man committee included five artists, a publisher, and an art dealer—all of the artists were academicians or associates of the National Academy of Design.[56]

Built on the recommendations of this committee, the first board of trustees for the new museum was elected in January 1870. While mostly composed of businessmen, city officials, and the wealthy men who spearheaded the project, four of the twenty-seven members were artists: John F. Kensett, Frederic E. Church, Eastman Johnson, and J.Q.A. Ward. All four were academicians. Starting with this initial participation, members of the National Academy continued to be involved in the management of the museum. During their lifetimes and posthumously, academicians' works were frequently added to the Met's collections of nineteenth-century American art. As an early feeder for the Met's collection of American art, the comparison between the full population of works shown at the National Academy and the subset of works preserved in the museum is instructive. The next section highlights the extent to which the gender composition of the Met's collection mirrors or diverges from the content of the annual exhibitions of the National Academy of Design and interrogates what drove any divergence.

Quantifying Women's Representation at the National Academy of Design and the Metropolitan Museum of Art

Chapter 2 describes how many art historical datasets featured in this book were generated by transcribing hard-copy indices to series of art exhibitions that took place. It goes into detail about the transcription of the two publications central to this chapter: the *National Academy of Design Exhibition Record, 1826–1860* (1943) and the *National Academy of Design Exhibition Record, 1861–1900* (1973). For my purposes here, I added a variable about each artist's gender to the dataset. To do this, I used an online program that assigns the probability with which a first name is associated with a certain gender. The process of using first names to determine gender is not perfect. Nonetheless, the program uses data across multiple languages to estimate

the probability that a first name is typically used by a man or a woman.[57] The program also uses a gendered salutation like Mr. or Miss, when included, to determine a person's gender. While these data may capture most women artists, some are difficult to count. Consider the example of the tromp l'oeil still life painter Claude Raguet Hirst. Born Claudine, she went by Claude—a man's name—for her entire professional career.[58] Though she was sometimes listed as "Miss Claude Hirst," marking her as a woman, she also appeared as Claude Hirst with no salutation. In this latter case, viewers unfamiliar with her identity likely would have assumed she was a man. Crucially, the computer program used to determine the gender of an artist will also assume she is a man named Claude. While some manual checking and correction was possible, lesser-known cases of women painting under a male first name have inevitably been misclassified as men. Furthermore, 3,725 works were by artists who showed as "An Amateur," under initials that could not be identified with a full name, or other opaque names.[59] In this dataset, these cases are listed as "gender undetermined." However, it would not be surprising if a significant number of the works anonymously exhibited or exhibited by artists with unidentified initials were women.

The American Wing of the Metropolitan Museum, which houses works from the seventeenth to the early twentieth century across media, makes all of their collections data public. The department also collects decorative arts, which may include more women artists, but the works included in the data analyzed here are limited to fine arts.[60] Working with museum data serves two purposes. First, it allows one to compare the number of works by nineteenth-century women artists that are included in a major public collection to the number of works that were produced by nineteenth-century women. Second, museum objects are extant and have been cataloged. This means that one can confirm the genre of works by looking at them and, unlike in most exhibition data, there is clear information about the medium. Keeping the different historical contexts and data constraints in mind, one can proceed to a quantitative and economic analysis of nineteenth-century American women artists' contemporary participation and subsequent preservation in museum collections.

While women's participation was initially very low at the NAD, it exploded after the Civil War. Figure 4.3 shows the number of works by women displayed at the National Academy over time. Between 1865 and the 1890s women, who went through the same jury review as their male counterparts, were routinely the makers of between 15 and 20 percent of works displayed—three times the antebellum number. Aggregating over time across the full dataset, women produced 12 percent of all works displayed. The exclusion of women from classes at the NAD—or any formal art or design academy in the nineteenth century—seems to have kept participation in the annual exhibitions low until their admission in the mid-1840s.[61] As is the case with women's education and training in other fields, it appears to have taken time for the first classes of female students to mature into the first cohort of professional female artists.[62] The subsequent decline in participation in the last five years covered by the data, from 1895 to 1900, may be partially a result of the

TABLE 4.1 Frequency of Gender of Makers of Different Kinds of Fine Artworks in the Metropolitan Museum of Art's American Wing

	PERCENTAGE OF WORKS BY FEMALE ARTISTS	PERCENTAGE OF WORKS BY MALE ARTISTS	GENDER OF MAKER UNKNOWN
All Fine Arts (N = 5,906)	6.33	85.68	7.99
Still Life Paintings (N = 105)	23.81	76.19	0

Note: While this data could be web scraped off of their public-facing website, American Wing curator Betsy Kornhauser and collections manager Leela Outcalt provided me with a clean data file exported from TMS, the collections database system the Met and many museums use. To assign gender of artist, I initially used the online tool Gender API (Gender-API.com) and then checked gender categorizations manually.

creation of alternative exhibition venues, such as private galleries and competing more progressive art academies, in New York and around the US. Some of these new associations, such as the Ladies' Art Association, were specifically founded by women for women.[63] The National Academy did not elect a woman to full membership between Ann Hall's election in 1833 and Mary Cassatt's election in 1909; it was not a particularly hospitable environment and women seem to have sought opportunity elsewhere when available—either in other art schools and academies, such as PAFA, or by training and conducting careers abroad.[64] Table 4.1 provides an overview of the gender of makers of fine arts included in the American Wing's collection: only 6 percent of the artworks are by women. This is half as many as the percentage of works by women that were shown at the National Academy of Design, a frequent exhibition venue for many of the nineteenth-century American artists whose work the Met collects.[65]

What drives this disconnect between the number of women producing works in the nineteenth century and their representation in present-day museum collections? The remainder of this chapter attempts to answer that question. Targeted keyword searches of the titles of artworks in the NAD dataset allows one to identify, with a reasonable degree of confidence, the genre of the work of art shown. A list of the searched-for keywords is presented in appendix F. Of all the traditional categories of painting—history painting, portraiture, landscape, genre painting, and still life—the last is typically most associated with women artists. This is also considered the lowest prestige type of painting.[66] Figure 4.4 shows the number of works displayed at the National Academy identified as still life using these keywords. Similar to the number of works by women, still life makes up a small proportion of works shown in the antebellum period and grows in frequency—topping out at around 17 percent—after the Civil War. The next graph (fig. 4.5) looks at the gender of makers of still life over time. No more than 10 percent of works by men in a given year

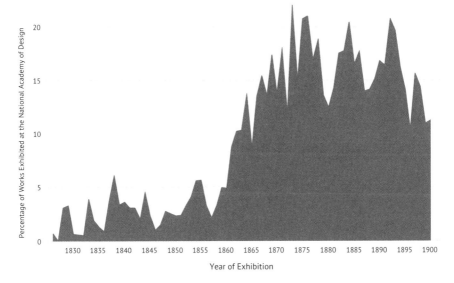

FIGURE 4.3 Percentage of Paintings Exhibited at the National Academy by Women Artists, 1826–1900 (N = 41,887). Sources: *National Academy of Design Exhibition Record, 1826–1860*, 2 vols., ed. Mary Bartlett Cowdrey (New York: New-York Historical Society, 1943); *National Academy of Design Exhibition Record, 1861–1900*, ed. Maria Naylor (New York: Kennedy, 1973) and Markus Perl, Gender API, Gender-API.com.

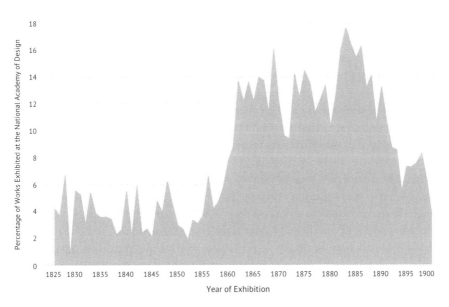

FIGURE 4.4 Percentage of Paintings Exhibited at the National Academy Identified as Still Lifes, 1826–1900 (N = 41,887). Sources: See figure 4.3.

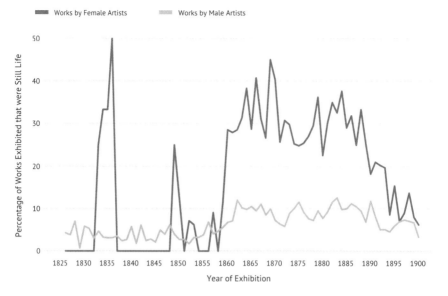

Legend: ■■■ Works by Female Artists ■■■ Works by Male Artists

Y-axis: Percentage of Works Exhibited that were Still Life

X-axis: Year of Exhibition

FIGURE 4.5 Percentage of Artists Exhibiting Still Life Paintings at the National Academy, Divided by Identifiable Gender, 1826–1900 (N = 38,893). Sources: See figure 4.3 and Markus Perl, Gender API, Gender-API.com.

were still life paintings, while the genre routinely represented one-third or more of works by women.[67] Women are also well represented among still life paintings in the Met's collection (see table 4.1), which could be identified by reading every title in the collection and double-checking by looking at images of photographed works. However, overall, still life is a rarity among the fine arts holdings of the American Wing: only 1.8 percent of works. Therefore, a genre in which women are disproportionately active is one that is also disproportionately *under*collected relative to its nineteenth-century display and production.

The importance of time—or rather lack of time—as a factor shaping women's artistic production is brought into focus by data about medium from the Metropolitan Museum's detailed collections data. An important attribute of still life paintings is that they are typically smaller than works of other genres and can be finished over multiple interrupted sessions. They can be completed by an artist who is pressed for time. These collections data suggest that women artists were more active in media that were smaller in scale and faster to work with than oil on canvas. Figure 4.6 shows the breakdown of what is called "object type" in the collections data for fine arts in the American Wing made by male artists. While drawings and pastels dominate, oil paintings are a clear second; men made almost no miniatures included in the collection. Figure 4.7 shows the same data for women artists. Miniatures dominate, followed closely by drawings and pastels; watercolors are the third most common and oils are fourth. Smaller, faster media are far more common among works by women artists in this sample than their male counterparts.[68] Unfortunately, these faster media are also more light-sensitive; works on paper and miniatures can only

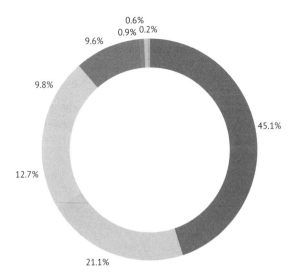

FIGURE 4.6 "Object Type" of Works by Male Artists in the American Wing, Metropolitan Museum of Art, as of August 2018 (N = 5,058). Source: Collection data provided in clean spreadsheet format by Leela Outcalt, Senior Collections Manager, via email on August 22, 2018.

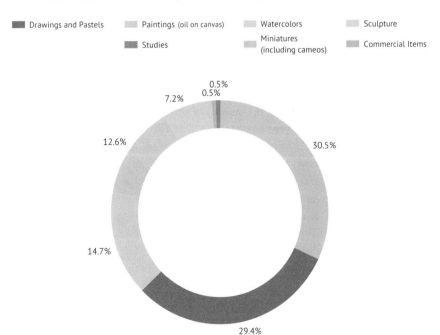

FIGURE 4.7 "Object Type" of Works by Female Artists in the American Wing, Metropolitan Museum of Art, as of August 2018 (N = 357). Source: See figure 4.6.

be displayed for several months at a time. The time constraints during nineteenth-century women artists' lifetimes translate to time constraints on the exposure of their work to audiences in the present day.

Unfortunately, there is no equivalent information about the works for the NAD that one can use to fully understand how the Met's collecting differs or is representative of women's activity across media. Watercolor had, as the nineteenth-century American artist John La Farge summarized, long been "a pretty material for lady amateurs to use in flower-painting or vase-decorating."[69] However, this feminized "lesser" medium—along with other works on paper like pastel and etching—became more prestigious as the nineteenth century progressed. Works on paper were elevated in part by dedicated medium-specific male-artist-led associations. In particular, male artists recognized the use of the medium to smooth their incomes between big-ticket sales of oils.[70] A future project could identify the media across the NAD dataset to compare how the gender breakdown of watercolorists changed over time, although this will involve extensive manual review of the data.

Why Are Women Underrepresented? A Labor Economics View

When seen through the lens of time constraint, these data align with general accounts of artistic process in the nineteenth century and take on more meaning for the achievement of women artists. Consider the time and travel demands placed on nineteenth-century American landscape painters, who often traveled to the distant places they painted. In *The Painted Sketch* (1998), Eleanor Harvey describes the lengthy process of creating a landscape painting in nineteenth-century America. Artists went on extended sketching trips and then spent months in the studio to create a large-scale and highly finished work.[71] Apart from the presence of social barriers that limited women's ability to join all-male Western survey parties or make trips to other rugged landscapes, the months of travel followed by months of work on large-scale oil paintings were incompatible with the time demands of domestic responsibility.[72] This was the case for the landscape painter Mary Swinton Legaré, whose mother accompanied her on trips to the Hudson River Valley and Blue Ridge Mountains. However, after she moved to Iowa and married in 1849, Legaré's career ended. As Prieto writes at the conclusion of her description of this landscape painter's experience, "The demands of domesticity overrode the possibilities for [her] continued artistic production."[73] The handful of nineteenth-century American women who successfully produced landscapes, such as Mary Nimmo Moran (the wife of famous American landscape painter Thomas Moran), did not specialize in oil paintings but rather in works on paper, mostly etchings and lithographs.[74]

Even oil portraits, which for nonitinerant painters did not demand extensive travel, were time inflexible. Daniel Huntington was a leading portraitist in nineteenth-century America and served as president of the National Academy.[75] Throughout his career, his correspondence describes scheduling problems related to making portraits of notable people that demanded sittings and delivery on the

client's timetable.[76] In one letter to a friend in 1875, Huntington declared: "To stop the crowd of portraits I have determined to *raise my prices* [his emphasis]—I have no leisure to do anything else and it will not do."[77] If Huntington—a man from a well-off family who was in an apparently happy marriage with his stay-at-home wife, Harriet Sophia Richards Huntington—found the time demands of portraiture grating, an active career as portraitist seems incompatible with the domestic obligations often facing women artists.[78]

Compounding time demands related to the more prestigious genres were the space constraints women also faced. A woman's leasing her own studio space could have been considered inappropriate.[79] Furthermore, maintaining a studio demanded access to money to pay a lease at a time when women's financial independence—particularly married women's financial independence—was limited and radically different depending on a woman's class, race, and home state.[80] Yet women artists recognized studios were essential to artistic practice. Cecilia Beaux, a successful nineteenth-century artist, wrote "A studio, even a poor one, is indispensable for *recueillement* [contemplation], even if little gets done in it."[81] The kinds of artworks that are easier to complete across interrupted sessions or in limited amounts of time—still life paintings, watercolors, and miniatures—are the same ones that because of size and media could be completed in a domestic space rather than a dedicated studio.

Finally, marketing artworks to patrons and collectors demanded both time *and* space. Many of the art dealers active in the United States in the nineteenth century focused on importing and selling European art.[82] In his diary, artist Jervis McEntee discusses this lack of commercial representation for American artists and the need to cultivate dealers' interest. Describing a meeting with dealer Gustav Reichard in the 1870s, McEntee "gave some reasons [to Reichard] why we [American artists] thought it worthwhile for someone to deal in the best American Art. He seems a prudent pleasant man but I do not think would be able to do much. We are more and more impressed with the fact that we shall ultimately have to get some dealers to interest themselves in our work or we shall sink out of sight."[83] Instead, artists were forced to network and market on their own. Therefore, spaces like the Tenth Street Studio Building—which housed studios for Church, Sanford Gifford, and other famous (male) artists—were sites not only for work but also for hosting receptions where resident artists could show and sell new pieces.[84] Furthermore, these receptions and events that allowed artists to cultivate commercial relationships were mostly evening events and dinners, which were often not open to women. A painting by Charles Yardley Turner, *A Saturday Evening at the Century Association* (1894) [fig. 4.8], illustrates one of these evenings. Bearded and mustachioed Caucasian men fill two rooms of the club, which are decorated with paintings in gilded frames. They are gathered in groups, apparently chatting and laughing over drinks and cigars—they are, to use a twenty-first-century term, networking.[85]

There are several examples of nineteenth-century women artists circumventing these time, space, and social constraints. A common strategy was to leave the United

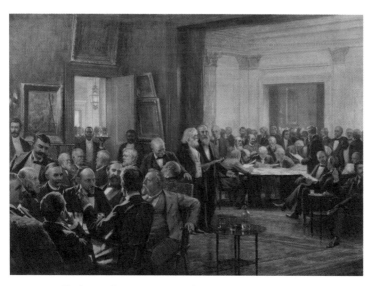

FIGURE 4.8 Charles Yardley Turner, *A Saturday Evening at the Century Association*, 1894, oil on canvas, 65.72 × 91.12 cm. Century Association, New York. Photograph by John Bigelow Taylor. Courtesy Century Association, New York.

States and join communities of either foreign artists or fellow expatriate American artists. The most famous example of an American woman expatriate artist is Mary Cassatt, who completed most of her artistic training in France and subsequently lived there for most of her life. Cassatt also remained unmarried, which seems to have been a deliberate choice in order to preserve her career.[86] This ability to work and live abroad from a young age—she moved to Paris in her early twenties—was facilitated by her family's financial resources and social connections.[87] While thriving professionally in France was dependent on her wealth and class back home in the United States, another group of expatriate American women artists from a variety of backgrounds were able to succeed in Europe by creating their own supportive communities. An example was the group of American women sculptors active in Rome in the nineteenth century, who often lived together in households of two or more. Many of these women were involved in what were considered to be "romantic friendships" at the time.[88] These female collective households served a supportive purpose for women of all sexual orientations, allowing for the sharing of domestic responsibility and therefore creating an environment that fostered artistic practice.[89]

With this qualitative knowledge about nineteenth-century art practice as well as theories from labor economics about women's time constraints, one can see that the data in figures 4.5 to 4.7 support a narrative that women were active in genres and media that allowed them to create the most work in the least amount of time, across short working sessions. Unfortunately, those same genres and media that are quicker to work in are also the ones that have traditionally been neglected in museum collections, including the Metropolitan Museum, as shown in table 4.1.

To support these general findings, the next section turns to one of the most successful nineteenth-century woman artists who did not leave the United States. Lilly Martin Spencer seemingly bucked the trend of time-constrained women artists working in watercolors. She painted primarily in oil and focused on genre painting. A close examination of her oeuvre and correspondence preserved in the Archives of American Art provides evidence of how she confronted and coped with the time demands of her professional and domestic life.

Lilly Martin Spencer: Artist, Wife, Mother

Angélique Marie Martin was born in Exeter, England, in 1822. Known as Lilly, she was the eldest daughter of French parents living in England. Gilles Marie Martin and Angélique Perrine LePetit Martin taught French; in America her father continued in this profession. After immigrating to New York when Lilly was a child, the family ultimately settled in Marietta, Ohio.[90] The Martins had moved to Ohio in order to join or create a Fourierist commune. In addition to following the socialist principles of Fourierism, they were passionate advocates for other social justice issues, such as women's equality and abolition.[91] Therefore, Spencer grew up in a progressive and intellectual household. Her parents apparently encouraged her artistic ambitions from an early age, and there are hagiographic stories about adolescent Lilly drawing on the walls of the family home in rural Ohio and transforming it into a local attraction.[92] She held her first solo exhibition in Marietta in 1841 at the age of eighteen in order to raise money for her future artistic education. The strength of this show and its positive reviews in the local press attracted the attention of Nicholas Longworth, a wealthy Cincinnati resident.[93] Longworth offered to sponsor the young artist's education by sending her to the East Coast to study with the leading history painters John Trumbull and Washington Allston. She declined Longworth's offer of patronage, which came with certain conditions about her training, and instead moved to Cincinnati with her father. Despite another offer of patronage from Longworth—this time to sponsor travel and training in Europe—Lilly remained in Cincinnati and studied with local artists. During this time, she produced a variety of works, including Shakespearian scenes and a powerful self-portrait (fig. 4.9).[94]

In the summer of 1844, she married Benjamin Rush Spencer, an Irish immigrant who worked in the cloth trade and as a tailor.[95] A letter to Lilly Martin Spencer from a Mr. W. A. Adams, apparently a family friend, makes clear that marriage posed a risk to her career. He wrote in the postscript: "I am glad to hear you determine to stick to painting, you can do what you please in the art, by application and practice. I was fearful matrimony would put an end to painting—I hope not."[96] As it turned out, painting would remain Spencer's occupation and she became the primary breadwinner for her new family. The Spencers moved to New York in 1848 to further her artistic career and ultimately settled in Newark, New Jersey.[97] By 1852, her husband seems to have become a full-time stay-at-home spouse who helped with domestic

FIGURE 4.9 Lilly Martin Spencer, *Self-Portrait*, c. 1840, oil on canvas. Ohio History Collection, Columbus, H24656.

responsibilities and also served as Spencer's studio assistant.[98] The couple had thirteen children, seven of whom survived to maturity.[99]

In her progressive upbringing and domestic arrangement, Spencer was atypical for her period. She was also the most famous American woman artist of the mid-nineteenth century. In general, the existing literature about her has been dedicated to determining the extent to which she and her work conformed to bourgeois conservative ideals or were subtly subversive. Authors have found evidence for both these viewpoints in Spencer's letters and formal analyses of her best-known works.[100] In general, her letters illustrate that a progressive family life could nurture her professional ambition and facilitate her career but did not protect her from the significant time demands and professional repercussions of motherhood.

Among the preserved correspondence, there are nearly one hundred very frank letters written to her parents, and occasionally her siblings, between her move to Cincinnati in 1841 and her mother's death in 1866.[101] Though the complete transcription and quantitative analysis of keywords in these letters was beyond the scope of data generation for this chapter, it is still possible to identify themes in the letters.[102]

Though much of the literature on Spencer has been dedicated to determining how progressive or conservative she was, she is fairly silent on the subject.[103] Her

own scant commentary on the feminist movement—of which her mother was a fervent adherent—is telling. Seemingly referring to a women's rights convention, she writes: "I am very glad that you found the convention so satisfactory to your expectations. You ask me, dear Mother, if there is anything of the kind going on here. I do not really know, dearest Mother; not that I am not interest[ed] in it I assure you but because I am so extremely busy—both in mind and body, trying to improve my painting, that I can scarcely find time to even think of anything else, except what Ben reads now and then in the papers."[104] Spencer does not seem to be intentionally apolitical or dismissive of her parents' progressive causes; she simply does not have the time to take them on.

By 1848, after moving to the East Coast and having her first child (referred to as "the little stranger"), time constraint becomes a recurring theme in the artist's correspondence. Starting in 1847, Spencer begins most of her letters to her parents with apologies like "Every day I have been trying to write but have absolutely not found the time."[105] Often, she elaborates about the demands on her time, as in one letter written shortly after her arrival in New York City: "We got your letter only this morning, dearest dearest parents and to our mortification we found it had been there two or three weeks—and we had been utterly unable to go to the post office— being two or three miles from the post office, and both the children been taken severely sick with chicken pox, and my being obliged to finish a picture for the Art Union, and having a great many persons calling to see us."[106] From 1848 forward, almost every letter includes an apology for not writing because of how busy she is due to professional and domestic responsibilities. Lamenting her lack of time is perhaps only second in frequency to lamenting her lack of money. Often, she links the two. A letter sent home in 1850 reads: "I hope Father will not think that I forgot the picture I promised him. I will try to do it as soon as I possibly can. I have several pictures to finish, which I have already commenced and which I must have done by a certain time, that I have not been able yet to do your picture, but just as soon as I get a little over this press of work, which after all [requires] more labor, a great deal [more], than payment...I will be able to do it."[107]

In general, she describes her work as fetching lower prices than she thinks it deserves and certainly less than her labor merits. In the midst of noting that in New York City there is a "perfect swarm of painters...and very very good ones," she writes, "It takes me so much longer to finish a picture than it used to for I am endeavoring by conscientious application to improve myself in every picture I do, but still I get very little more for them than I used to."[108] Part of her ability to compete with a "swarm" of painters was hampered by her gendered exclusion from professional networks. There were clear commercial consequences to Spencer's domestic demands and her gender. Not only did they disrupt her ability to paint, but they also disrupted her ability to sell her artwork. The letters and diaries of other successful (male) American artists who were her contemporaries—like Huntington and McEntee—describe many hours and evenings spent with patrons in settings such as the Century Association, Union League Club, and receptions of the Tenth

Street Studio Building.[109] These social connections did not mean that male artists were immune from financial and professional anxieties. McEntee, whose diary is full of complaints and worries, writes in 1878: "It seems a sad conclusion that after twenty years in New York during which I had won some distinction to find myself today actually unable to pay my rent and my living."[110] Yet these male artists had chances to use their social networks to support their financial well-being.[111]

These options were not accessible to Spencer, even though she was nationally famous by 1850, receiving multiple requests for her autograph by 1858, and featured in Elizabeth Ellet's *Women Artists in All Ages and Countries* in 1859.[112] Instead, she describes having to hurriedly sell her works directly at auction or to art unions, such as the American Art-Union and the Cosmopolitan Art Association.[113] She was also briefly represented by the dealer William Schaus, who seems to have arranged for lithographic reproductions of her work to be made and sold.[114] However, this arrangement generated less money than she had hoped, and did not inspire as many commissions as she felt she needed.[115]

Motherhood seems to have presented the most significant barriers to Spencer's ability to work. In the summer of 1852, eight years into her marriage and mother to three boys, Spencer writes: "We [she and her husband Benjamin] are very happy dear dear Mother and we help each other like clock work—we are contented and willing to wait and I think that after a while we will get over our hard times... Charley our little funny Charley's a baby... I think he would amuse you both so much. Our little Ben reads pretty well, and our Angelo begins to read his ABC[s] and he is so funny at it."[116] However, as time goes on and she continues to get pregnant and give birth to more children, which she calls "being sick," the combination of professional and domestic pressures become greater. She writes in 1859: "Another thing, I have not been in good health all summer, for reasons which you may guess, but thank goodness I am quite well now, and have a dear dear little daughter and I hope that though it of course increases our work when apparently we least can afford it, still I know we will get through it all."[117]

While time constraints are explicitly addressed in her letters, they also seem to inform her artwork. The exhibition *Lilly Martin Spencer: The Joys of Sentiment* (1973) at the National Collection of Fine Arts (now the Smithsonian American Art Museum) in Washington, DC is the only major retrospective of her work to date. The catalog includes a comprehensive list of Spencer's pieces. The coauthors combed the archival record and public and private collections for extant and unlocated works by Spencer. In all, they list 483 works—although 81 of these are individually cataloged sketchbook pages. An analysis of these works is presented in figures 4.10 and 4.11. Most of Spencer's works recorded in this catalog are unlocated and therefore dimensions and medium are unavailable. Unfortunately, only a handful of the works that were unlocated in the 1970s have since resurfaced in public collections or at auction, so only limited additional information was added to the catalog entries.[118]

An interesting pattern emerges when Spencer's extant output is divided by decade: she apparently created more than 50 percent of her known works in the

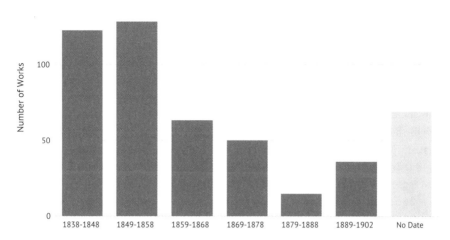

FIGURE 4.10 Number of Known Works Produced by Lilly Martin Spencer, by decade (N = 483). Many of the dates included in the catalog are approximate; an average of approximate dates was taken to assign one year to each piece. However, the choice to divide production into decades allows a range of dates to apply to each work. Source: Robin Bolton-Smith and William H. Truettner, *Lilly Martin Spencer (1822–1902): The Joys of Sentiment* (Washington, DC: Smithsonian Institution Press, 1973).

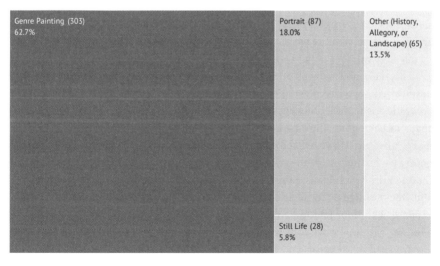

FIGURE 4.11 Types of Known Works by Lilly Martin Spencer, c. 1838–1902 (N = 483). Estimated based on title when painting not extant. Source: See figure 4.10.

first twenty years of her career, from 1838 to 1858. Part of this observed drop-off in productivity may be due to a patchier archival record later in her life. Furthermore, existing scholarship attributes a decline of production to her work falling out of fashion after the 1860s.[119] Even accounting for holes in the record and declining market demand, the downtick in the number of surviving works in the later years is striking, as shown in figure 4.10. From 1859 to 1868 she produced far fewer works— about half as many per decade as she had between 1838 and 1858. One possible reason could be the number of children she had by the 1860s. While the exact date of the birth of each of her children is fuzzy, genealogical and archival sources suggest that she had four surviving children from 1845 to 1855 and another three from 1859 to 1867. It is telling that in 1859 she wrote to her parents that the birth of a daughter "increases our work when…we least can afford it."[120] A drop-off in productivity may be linked to the cumulative demands of caring for five children. At one point, she describes hiring (or attempting to hire) a maid to help her with the domestic responsibilities. "I did not feel as if we could afford yet to keep a girl [a maid]…but I found that every day I did less and less in painting." However, in the same letter, Spencer complains about the uselessness of hired help and it seems that she and her husband continued to do the domestic work themselves.[121]

Although many of Spencer's works are unlocated, the catalog lists their titles. As with the National Academy data, it is possible to use titles to estimate whether a Spencer work was a genre painting, portrait, still life, landscape, or a history painting. Known as a genre painter, most of Spencer's works are, unsurprisingly, genre scenes; in contrast to other women artists, she completed relatively few still lifes (see fig. 4.11).[122] However, she made small-scale paintings. Oils with known dimensions were, on average, only 25 by 19 inches.[123] Of the works with a known medium, Spencer produced more works on paper than oils—although this number is skewed by the large number of her works that are unlocated.[124]

The scale and subject of Spencer's paintings may be linked to the fact that despite being a well-known professional painter, she often worked within her own domestic space. After moving to Newark, she told her mother about a new studio space in her home. She first describes spending months fixing the new house to make it livable. However, she writes that after selling "every picture I had, it was necessary for me to try to paint up something to show, this I could not do until the room in which I was going to paint in, could be fixed—this was no small job, and would oblige us to incur again another imperative and heavy and unexpected expense. The floor had to be fixed, there was no ceiling overhead…the immense window was almost without paint or glass in it—but to it we went and at last all was finished in the room, and I can work in it."[125] Given that her painting space was within her own home, it is unsurprising that her husband and children frequently served as her models.[126] Spencer's own family was a convenient subject able to be depicted within a domestic space over many interrupted sessions. With the importance of domestic time constraints in mind, one can return to formal analyses of Spencer's work—often seen as showing saccharine subject matter—with fresh eyes.

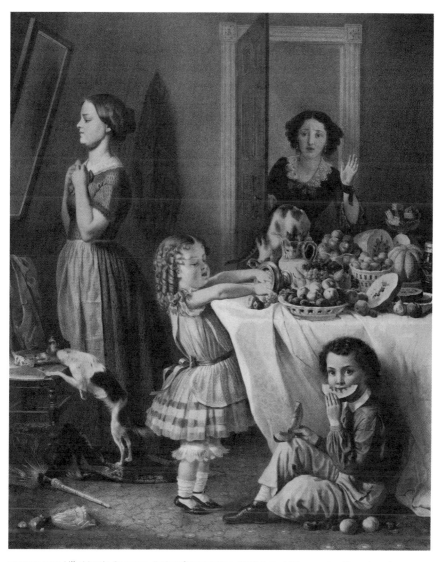

FIGURE 4.12 Lilly Martin Spencer, *Fruits of Temptation*, 1857, tinted lithograph with watercolor, 20 × 17 in. Printed by Jean Baptiste Adolphe Lafosse, published by Goupil, New York. Collection of the author. Shown without border.

Works like *Fruits of Temptation* (1857) [fig. 4.12] are an obvious expression of the domestic frustration Spencer experienced. However, the lens of time constraint also allows for reinterpretation of more canonical works like *The War Spirit at Home; or Celebrating the Victory at Vicksburg* (1866) [fig. 4.13]. Previous formal analyses of the work have examined it as a balancing act between the private and public sphere, the realm of historical events and that of domesticity.[127] While not disregarding these tensions between public and private life, this canvas can also be understood as a masterful translation of traditional subject matter, such as still life and the

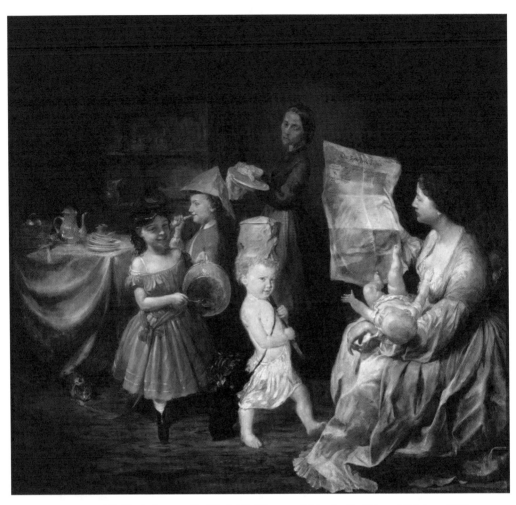

FIGURE 4.13 Lilly Martin Spencer, *The War Spirit at Home; or Celebrating the Victory at Vicksburg,* 1866, oil on canvas, 76.2 × 83.19 cm. Newark Museum, 44.177.

Madonna and child, into a domestic setting where Spencer could paint the models and props at hand: her children and the chaos left in their wake.

The War Spirit at Home contains what can be divided into three separate scenes. The left third of the canvas contains some of the elements of a still life: a tea or coffee pot and plates stacked on a table. There is even an expressive cat peeking out from under the dramatically draped tablecloth. Yet these elements are not artfully arranged. The tablecloth seems to be pulled haphazardly, moving the pile of used plates perilously close to the table's edge. The bread basket is not overflowing and bountiful; instead, only crusts remain from a morning meal. This is still life by chance, a byproduct of daily life, rather than careful display. Still life often features fruit and other food on the verge of decline, carefully skating the line between ripe

and rotten.[128] In contrast, Spencer's still life vignette dispenses with any sense of climax. In a normal household, food is consumed as needed before it rots.

The cat emerging from under the draped tablecloth physically connects the still life in the left third of the canvas to the boisterous genre scene at its center. Its tiny white paw tries to trap a trailing red ribbon, which happens to be the tail end of a sash wrapped around a smiling little girl's dress. The girl also wears a Union soldier's hat and has transformed part of the still life table setting—a pot or serving dish and a spoon—into a drum. The improvised percussion provides the marching rhythm for her and her two brothers. Donning paper hats, playing a toy bugle and holding a stick as if it were a flagpole or rifle, the boys complete the playful military parade. With rosy chubby cheeks, the playing children create another discrete scene; they are an oblivious happy genre scene unto themselves. This painting, however, also shows us the resources that support this happiness, such as the meal they have just consumed and the maid who stands in the background, cleaning up after them.

The maid is partly obscured by deep shadows, but small highlights show her angular features and allow the viewer to see her eyes, which look down and to the right of the canvas toward the final scene. Following the maid's gaze, we see what could be a baroque Madonna and child. Clothed in a voluminous turquoise silk dressing gown and wearing a delicate pearl earring, the mother figure is easily identified as the lady of the house. A pudgy baby is spread out on her wide lap. At first glance, the mother and child are assembled almost like a pietà. However, the infant is clearly thriving, with his or her limbs moving in every direction. While the baby is full of dynamism, the mother just barely holds her child in place with a lazily arched left wrist. The languor of her left hand is further emphasized by the energy and vigor with which the baby's left hand reaches upwards. Instead of focusing on the baby, the mother's firm grasp is on a partially legible copy of the *New York Times*. While the dense front-page text below the masthead is difficult to make out, a highlighted square of text seems to approximate: "VICKSBURG. VICTORY!", resembling the paper's front page on July 8, 1863 (fig. 4.14). This is a reference to a critical Union victory. Her grip on the paper and engagement with the war news physically resist the infant who has its hand on her breast and who kicks the bottom of the broadsheet. The maid looks at this scene—Madonna and child interrupted by reading—intently. It is unclear whether she is keeping watch in case the baby wriggles off the mother's lap or if she is reading the verso of the paper.

Other analyses of this work have identified the children as Spencer's own and the mother figure as a self-portrait.[129] Despite this identification, it would be a mistake to read strict biography into this image or imply that it is merely a scene plucked from Spencer's own life. Instead, one can focus on the fact that each of these subjects was easily accessible for Spencer: piles of plates, rambunctious children playing, and a woman attempting to read amid her parenting responsibilities. These direct life experiences and observable subject matter are combined and transmuted into a coherent composition. The depicted household is generally rendered more elegant than Spencer's likely was by the mother's luxurious dressing

FIGURE 4.14 Front page of the *New York Times*, July 8, 1863.
Source: https://timesmachine.nytimes.com/timesmachine/1863/07/08/issue.html.

gown and the presence of a domestic worker. Despite the apparent wealth, domestic demands and distractions transfuse the scene: a dirty breakfast table that needs to be cleaned, children filling and straining the physical boundaries of the home with their numbers and energy, and babies needing to be held and—as the infant's hand on the mother's breast suggests—fed. All a mother can do in this setting is eke out a moment to read or, in Spencer's case, work.

Conclusion

The broader quantitative view presented in this chapter is not intended to diminish the many cultural and social struggles women faced but rather to reveal some of the structural barriers to women artists' professional attainment that have existed for

centuries. The time demands of domestic work and childcare have been persistent barriers to women artists' attainment. Furthermore, these barriers continue to limit women's posthumous attainment; because time constraints often led women to work in less prestigious genres and media, they are less likely to be collected and exhibited in major museums. Not only are they less present in museums, but they are most present in light-sensitive media that can spend limited time on display.

Looking at the subjects that nineteenth-century women artists portrayed and the media in which they were active through the lens of time constraint also allows one to draw a clear line between past and present structural barriers to gender equity in the arts. Several recent articles in the popular press have probed questions about the effects of domestic responsibility and motherhood on artists. The article "You Can Be a Mother and Still Be a Successful Artist" on the arts website Artsy compiled interviews with several contemporary female artists about balancing motherhood and their artistic career. While these women highlighted historical resistance in the art world—particularly by art dealers—to a female artist's decision to have children, they say the barriers now are primarily logistical. They need "a partner who shoulders 50 percent of the parenting, a dealer who is supportive of his or her artist's choice to raise children, and a studio setup that is flexible enough for the initial disruption of a new baby and the transition into a new schedule."[130] This fits Goldin's description of a working life that favors women's attainment, and some evidence suggests careers in the arts may be some of the best at offering this flexibility.[131] Yet a career in the arts is different from being an artist. A long-form 2019 article that also appeared on Artsy examined why women artists' careers stagnate more than men's. It concludes that for women in particular parenthood and caregiving "unquestionably demands time that previously might have gone to the self-promotion and networking that is often critical to career advancement in the relationship-driven art industry. In a [2011 survey] of 138 artists, half of the respondents said childcare responsibilities had hindered their career...the majority of artists who said that were women."[132] One of the artists interviewed for the piece, Natalia Nakazawa, and another female artist friend help each other keep up:

> To save on childcare and support each other's careers, they trade babysitting duties when they need to go out at night and network. [Wanda] Gala, [the other artist], drops off her son with Nakazawa if she has to work all night on an installation, or she'll watch Nakazawa's three-year-old son while she goes to an opening. "Let's face it, the whole art world is based on evening events," [Nakazawa] said.

While Nakazawa and Gala found a solution that works for them, these kinds of time demands—despite some possibility for flexible working within the studio—represent a stubborn impediment to women's artistic achievement, just as they did in the nineteenth century.

Art dealers can, of course, take on many of the unpredictable client-facing time pressures of marketing artworks. However, women artists are generally less

represented by galleries than their male peers. In 2015, curator and writer Maura Reilly published "Taking the Measure of Sexism: Facts, Figures and Fixes," an extensive quantitative survey of women's participation and representation in the art world, in *ARTnews*. She writes that contemporary women artists still lag behind their male peers in terms of representation in museum collections despite the fact that "women represen[t] more than 60 percent of the students in art programs in the United States."[133] As in the nineteenth century, there seems to be a pipeline problem for women artists transitioning from arts education—including shows open to students, like at the NAD—into representation in permanent collections. Reilly's research also showed that women made up only 30 percent of the artists represented by galleries in New York, Los Angeles, and London.[134] A 2017 study of galleries showing at Art Basel in Miami found similar numbers.[135] These trends have been further analyzed in a series called "Women's Place in the Art World," which launched in 2019 on *artnetNews*.[136] The insights in this chapter about women being time-poor indicate that lack of commercial representation is particularly crippling to women artists' attainment.

By using data and statistics—guided by theory from labor economics—to describe these dynamics in the nineteenth century, it becomes possible to compare women's historical attainment to their present attainment. Continuity in evidence reveals a somewhat depressing continuity in barriers to success. In the opening paragraphs of *A Room of One's Own* (1929), Virginia Woolf wrote, "A woman must have money and a room of her own if she is to write fiction."[137] Woolf's revolutionary arguments about the necessary conditions of women's creative labor can be extended to other activities, including fine arts. And while her opening lines emphasize space, this chapter argues that *time* to work is just as important. Woolf wrote, "I will only pause here one moment to draw your attention to the great part which must be played in that future so far as women are concerned by physical conditions. The book has somehow to be adapted to the body, and at a venture one would say that women's books should be shorter, more concentrated, than those of men, and framed so that they do not need long hours of steady and uninterrupted work. For interruptions there will always be."[138] This nearly century-old sentiment is echoed in the statement that contemporary artist Lenka Clayton wrote to accompany her work *An Artist Residency in Motherhood* (2012):

> I will undergo this self-imposed artist residency in order to fully experience and explore the fragmented focus, nap-length studio time, limited movement and resources and general upheaval that parenthood brings and allow it to shape the direction of my work, rather than try to work "despite it." This website will document my attempts. Let's see.[139]

From Spencer, to Woolf, to Clayton, this chapter suggests that time has long been—and will likely continue to be—a scarce resource for women artists.

◇◇◇

Implied But Not Shown

Empire at the Royal Academy

In 1913, the total population of the British Empire was 412 million people—ten times the population of Britain itself.[1] The British controlled roughly one-quarter of the world's land surface and served as global gatekeepers of the oceans.[2] Considering the sheer scale of the imperial enterprise, the introduction to the popular history book *The Rise and Fall of the British Empire* (1994) boldly states: "Possession of an empire profoundly influenced the ways in which the British thought of themselves and the rest of the world."[3] Though Lawrence James's bestselling work is not academic, this statement succinctly summarizes an assumption that underpins much of the scholarly literature about art and empire: the empire *must* have had a profound effect on art and visual culture, both around the globe and in Britain.

Sharing this assumption, I began to look for information about the depiction of empire in data I gathered about works of art displayed at the Summer Exhibitions—first called the Annual Exhibitions—of the Royal Academy. As described in chapter 2, the Royal Academy and its juried annual exhibitions have been a central element of the contemporary British art world since 1769. Royal academicians and associates could participate in the show without facing jury review: artists not affiliated with the Academy could submit works to a jury for consideration and inclusion in the exhibition. The recent publication of the online resource *The Royal Academy Summer Exhibition: A Chronicle, 1769–2018* provided easy access to scans of the published catalogs corresponding to each exhibition. Transcribing these catalogs provided a rich new data source, complete with painting titles that could be categorized and then analyzed. Specifically, I gathered data from the founding of the Royal Academy in 1769 to 1914, the year that Britain entered World War I—although the exhibition was held prior to Britain's entry into the conflict. In terms of the relationship between the Royal Academy and the British Empire, 1914 is also

an apt capstone year. At that exhibition, architects publicly debuted ambitious plans for new government buildings to be constructed in New Delhi, where the imperial Indian capital had recently been established, replacing Calcutta.[4]

Empire is, of course, no longer understood as the simple monolithic rule of the metropole over colonies. Empire took different forms in different places, and colonized subjects resisted imperial power in myriad ways. Yet to establish a baseline for understanding the ways in which images of empire may have appeared in paintings at the Royal Academy, I used the blunt instrument of geographic signifiers of metropolitan and colonial settings. This strategy is imperfect but informative. As discussed in chapter 3, volume of depiction is not the only measure of significance of a category of works shown, but charting these frequencies is a way to start grappling with this vast subject of inquiry.[5] A combination of computational and analog strategies (described in appendix G) allowed me to identify geographic locations listed in works' titles—almost three thousand potential places in total. This process was applied to *all* works—primarily paintings—not limited to a specific genre. Therefore, landscapes, history paintings, portraits, and still lifes were all tagged if they included the name of a geographically identified site. I then sorted these tags as best as possible into their present-day countries. Once the present-day country was identified, I added a variable to the data noting whether that country had ever been part of the British Empire.

This geographic strategy based on titles clearly leaves out certain visual evidence of imperial subjects. This evidence would include images that are Orientalist in appearance but not in title, decorative arts extracted from or inspired by overseas territories included in an interior scene, and the depiction of unnamed people of color. These other kinds of visual evidence of empire on display at the Royal Academy are addressed later in this chapter—as are questions about the extent to which the Royal Academy is a venue where one should even expect to see images of empire—but this strategy was a best first step to establish a numerical baseline. On completing all the necessary preparatory work, I graphed the data and expected to see abundant depictions of empire. I found the opposite.

Explicitly named images of empire barely appear at the Royal Academy. Figure 5.1 shows the absolute number of depictions of identified locations, categorized by their present-day countries. It becomes immediately clear that the British Empire is, comparatively, far less depicted than the metropole. England is shown more than ten thousand times. Italy appears more than two thousand times, and France more than one thousand. To cast the broadest possible net, I consider a country "in empire" even if the painting was made before or after a country was colonized by the British. Ireland is the most frequently depicted colony at 526; next is Egypt, with 380 depictions, followed closely by India, with 347. In a dataset of over 184,000 works, the Empire rarely appears. To contextualize these and other findings presented in this chapter, table 5.1 provides descriptive statistics and figure 5.2 graphs how often any geographic site was named in the Royal Academy data, by decade.

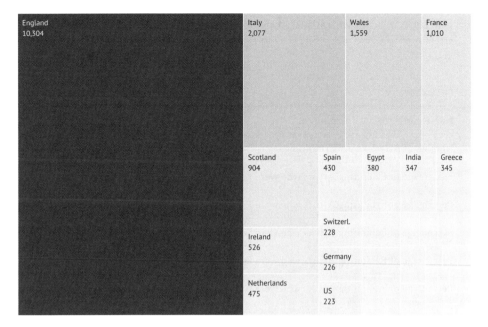

FIGURE 5.1 Number of Depictions of Named Countries Shown at the Royal Academy, Based on Titles, 1769–1914. Sources: *Catalogs of the Exhibitions of the Royal Academy, 1769 to 1914*, https://www.royal academy.org.uk/art-artists/search/exhibition-catalogues; *The Royal Academy Summer Exhibition: A Chronicle, 1769–2018*, ed. Mark Hallett, Sarah Victoria Turner, Jessica Feather, Baillie Card, Tom Scutt, and Maisoon Rehani (London: Paul Mellon Centre for Studies in British Art, 2018), https://chronicle250.com.

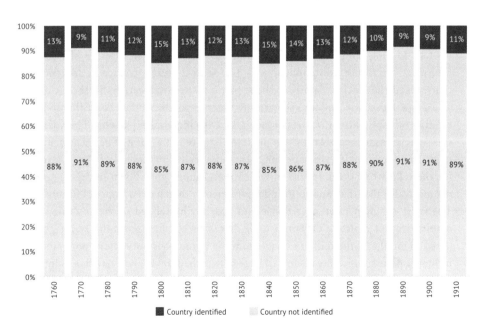

FIGURE 5.2 Percentage of Works Shown at the Royal Academy with an Identified Location, Grouped by Decade, 1769–1914 (N = 184,203). Sources: See figure 5.1.

TABLE 5.1 Descriptive Statistics about Royal Academy Data, 1769–1914

CATEGORY	AVERAGE NUMBER OR PERCENTAGE (rounded to the nearest whole number or hundredth)
Number of Artists per Exhibition	721
Number of Artworks per Exhibition	1265
Percentage of Exhibiting Artists who were Painters	77.41
Percentage of Exhibiting Artists who were Printmakers	2.84
Percentage of Exhibiting Artists who were Sculptors	8.27
Percentage of Exhibiting Artists who were Draughtsmen	0.24
Percentage of Exhibiting Artists who were Architects	10.96
Percentage of Artworks with Identified Geographic Locations	11.94

Source: Data provided on the individual exhibition year pages of *The Royal Academy Summer Exhibition: A Chronicle, 1769–2018*, ed. Mark Hallett, Sarah Victoria Turner, Jessica Feather, Baillie Card, Tom Scutt, and Maisoon Rehani (London: Paul Mellon Centre for Studies in British Art, 2018), https://chronicle250.com.

Considering the relatively few clearly identifiable sites in titles, as shown in figure 5.2 and discussed in appendix G, I tried to capture evidence of depictions that evoked the British Empire without naming specific locations in their titles. Therefore, I also searched for keywords (listed in appendix G) that, according to the existing scholarly literature, were associated with imperial expansion. The goal of this search was to locate works that depicted empire in the form of genre or history painting but whose titles did not link them to a specific imperial place. Yet a search for these keywords—the results of which are grouped and shown in figure 5.3— demonstrates that they appear even less frequently than named imperial locations. The most common references that could possibly be related to the extension of empire are not typically Orientalist (e.g., Arab or Muslim) but military imagery. (Keep in mind that the military imagery in this figure does not include portraits of military officers, which are discussed later in this chapter.) However, without simultaneously looking for geographic referents, it is difficult to know from this top-down view which battles, naval images, or depictions of the army are being shown— and to what extent they are linked to imperial expansion. Later in this chapter I engage with specific images of armies deployed—and defeated—throughout the

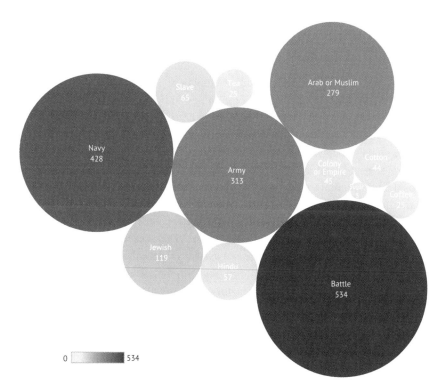

FIGURE 5.3 Keywords in Titles That Might Signify References to Empire in Works Shown at the Royal Academy, 1769–1914 (N = 1,939). Sources: See figure 5.1.

empire. However, in the context of this overview, if one wants to assume *all* images with a military keyword in their title or are somehow linked to empire, they still total only 1,275 works of the more than 180,000 works shown.

Considering both the countries depicted as well as the keywords in figure 5.3, there is an apparent erasure or denial of empire in British fine arts at the height of imperial power and expansion. This erasure was, for me, both unexpected and thought-provoking. If empire was rarely specifically named and depicted, how *did* it appear on the walls of the Royal Academy, if at all? This chapter seeks to answer that question using a blend of data-driven methods dependent on information gleaned from paintings' titles and qualitative analyses of select paintings and artists, as well as discussions of settings beyond the Royal Academy where imperial imagery appeared.

To better understand what at first examination appears to be an erasure of empire within the Royal Academy, this chapter turns to the concept of economic institutions, which include laws, governments, and ingrained societal structures and customs. Economists can classify institutions as either inclusive or extractive and have studied the effects of both types of social and governmental structures

on economic development and well-being. I argue that the exclusion of imperial subject matter from works displayed at the Royal Academy paralleled the ways in which colonies and colonial subjects were excluded from the inclusive political and economic institutions that started developing in Britain in the eighteenth century. In essence, keeping depictions of colonies and colonial residents outside of the most prestigious British art venue visually erased evidence of the exclusionary institutions that governed the empire. Simultaneously, the flourishing of portraiture and images of upwardly mobile Britons and the landscapes in which they lived both depicted and reinforced increasingly stable and inclusive metropolitan social, political, and economic structures. This flourishing of portraits of wealthy people and their metropolitan properties can be interpreted as evidence of empire and its transfer of resources from the colonies to the metropole.

This chapter is divided into several sections. The next section summarizes, as succinctly as possible, the parts of the extensive literature about art and empire that inform and relate to this analysis of Royal Academy data. The third section provides a brief introduction to the economic history literature about institutions, while the fourth provides more quantitative and qualitative information about which locations around the world were most depicted at the Royal Academy and why they may have been shown. After this quantitative overview, the chapter turns to a narrower analysis of images of India and the ways in which they conformed or diverged from the aesthetic ideal of the picturesque, which was developed and applied to the English landscape during this period. The concluding sections turn to the flourishing of portraiture in the mid-nineteenth century and how this was likely symptomatic of the development of inclusive metropolitan institutions.

Art and Empire: A Brief Literature Review

In his first discourse delivered at the opening of the Royal Academy in 1769, founding president Sir Joshua Reynolds stated, "It is, indeed, difficult to give any other reason why an empire like that of Britain should so long have wanted an ornament so suitable to its greatness…[except that] elegance and refinement [are] the last effect of opulence and power."[6] Several years later, William Blake—the imaginative British poet, artist, and six-time Academy exhibitor—wrote in the margins of his personal copy of Reynolds's *Discourses*, "Empire Follows Art, and not vice versa as Englishmen suppose."[7] From the earliest days of the Royal Academy, people in its orbit recognized a relationship existed between the growth of British arts and the British Empire—although Reynolds and Blake disagreed whether empire fuels art or art facilitates empire.

In the two hundred years since Reynolds and Blake made their comments, theories about the relationship between art and empire have proliferated and evolved. Sumathi Ramaswamy, citing the two artists' comments, effectively summarized the ways in which theoretical approaches to this topic have developed:

Empire and art...are mutually constituted and entwined, both in the colonies and in the metropole. Furthermore, the extraordinary movements of images across neatly laid borders and geopolitical boundaries...challenge theories that conceive of the West and the East, the colonizer and colonized, the center and the periphery, as Manichean oppositions locked in perpetual struggles of domination on the one hand and subordination or resistance on the other.[8]

In short, neither Reynolds nor Blake is wrong: the relationship between art and empire is multifaceted and multidirectional—there is no one hegemonic British Empire and the experience of each colony and colonized person was distinct. This analysis of the cultural feedback loop between colonizers and the colonized has its origins in literary theory, beginning with foundational works like Edward Saïd's *Orientalism* (1979), his later *Culture and Imperialism* (1993), and Gayatri Chakravorty Spivak's "Can the Subaltern Speak?" (1988).[9]

While the original theories used to analyze the relationship between art and empire may be easily traced to a handful of sources, their applications are wide-ranging and spread across various edited volumes, exhibition catalogs, and case studies. The number of these contributions is daunting even when one narrows the focus to art and the British Empire rather than art and empire more generally. Tim Barringer, Geoffrey Quilley, and Douglas Fordham, editors of *Art and the British Empire* (2007), wrote in the introduction to that volume, "Despite the centrality and importance of the subject, no attempt has yet been made at a full-scale narrative history of art and the British empire."[10] This statement remains true more than a decade later. The literature consists primarily of a proliferation of richly detailed case studies about select artists, commodities, geographies, and even pigments.

This simultaneous diffuseness and richness of the subfield has made it difficult to identify the elements of the literature that are most applicable to this chapter.[11] Contributions that have most informed my analyses are Beth Fowkes Tobin's *Picturing Imperial Power: Colonial Subjects in Eighteenth-Century British Painting* (1999); Kay Dian Kriz's *Slavery, Sugar, and the Culture of Refinement: Picturing the British West Indies* (2008); Quilley's *Empire to Nation: Art, History and the Visualization of Maritime Britain, 1768–1829* (2011); and Natasha Eaton's *Colour, Art and Empire: Visual Culture and the Nomadism of Representation* (2013).[12] I single out these four works because they focus on the interactions between British visual culture and its colonial economic practice. In particular, they describe how in art and visual culture the extractive and brutal nature of empire was transformed into something more palatable. Tobin, who focuses on the eighteenth century, writes that "for colonialism to have functioned successfully as a form of extraction, Britain had to incorporate colonies—their resources, in particular, but also their people—into a British economic and political framework with Britain at the center."[13] Therefore, she writes, the paintings she studies "perform ideological work, in part, by portraying imperialism in such a

way that the appropriation of land, resources, labor, and culture is transformed into something that is aesthetically pleasing and morally satisfying."[14]

Quilley, whose focus is maritime imagery from the mid-eighteenth to the early nineteenth century, takes this argument one step further. He demonstrates throughout his book that during this period a decisive shift occurred in both the arts and politics, from an interest in promoting and highlighting the multifaceted parts of the empire to conceiving of empire as something that serves to bolster and protect the home nation. He writes:

> The shift from "empire" to "nation" was a shift also in the image of the sea, whereby its representation as the conduit to the commercial empire was increasingly displaced by its image as defensive barrier for the nation. This is not to say that imperial imagery disappears from British art after the Napoleonic Wars, far from it. With the expansion of British imperial dominion during the nineteenth century, cognate visual material proliferated in abundance. However, this was increasingly assigned to a specialist category, associated with scientific and geographical documentation, and regarded as having greater relevance to recently established institutions such as the Royal Geographical Society than to the Royal Academy.[15]

While describing how imperial holdings were subsumed by the nation—in terms of economic extraction, political domination, and visual culture—Quilley's analysis also resonates with the quantitative evidence in figures 5.1, 5.2, and 5.3: few images of empire were on display at the Royal Academy. However, this observation in the introduction to his book is not explored at length. Rather than focus on measuring the extent to which imperial imagery appears in a given venue, Quilley's chapters are thematic and pull together sketches produced by artists on scientific and military voyages around the world, oil paintings, and popular prints. In contrast, this chapter dwells on and interrogates the observation that Quilley makes in passing about the visualization—or omission—of empire at the Royal Academy.

A survey of the kinds of artworks and visual culture that are central to scholarship about art and the British Empire anecdotally reinforces the quantitative finding that the empire was relatively absent at the Summer Exhibition. Illustrations and sketches from scientific and military expeditions—as well as prints, including both topographical and satirical images—are central to this literature, which deals with relatively few oil paintings and sculptures.[16] Scholars of art and empire have long argued for including a wide range of visual culture in studies of empire. For example, Tobin writes, "Cultural production, which includes 'high' art as well as more popular, mundane, or 'trivial' forms of visual and verbal expression, is crucial to the process of meaning-making and is, as such, a form of social practice."[17] Though the data about the Royal Academy deals with a more limited range of media, it dramatically expands the *number* of works under consideration. Working with this larger sample of artworks from the Royal Academy is just a first step in quantitative approaches to the study of art and empire. Potential data sources about prints are available and can

be systematically integrated into future analyses. Paintings and sculpture should not be the only media considered when studying this topic—and I hope these other data sources, described later in this chapter, will facilitate more expansive future quantitative analyses of depictions of empire in British visual culture.

Based on the data available, this chapter is firmly focused on goings-on within the metropole. It does not tell the story of those who lived and suffered under British imperial rule. In the introduction to her book, Tobin summarizes the problem with many academic studies of empire: "Too often the colonial peripheries are seen as significant only in relation to the urban centers of Europe; as a result, old imperialist hierarchies between core and periphery are reinstated in the name of 'radical' intellectual work, and it is business as usual within departments of literature, history, and art."[18] She describes how this process risks making the history of empire into what Frantz Fanon called "colonialist historiography."[19] Nonetheless, I hope that demonstrating the ways in which empire systematically appeared in—or rather was edited out of—the heart of contemporary British art is still a valuable addition to the literature. Ideally, the development of further datasets or the tapping of other data sources about art and empire will highlight other voices and decentering narratives. Though dealing with different historical moments and phenomena, there are examples of digital humanities initiatives that use data-driven methods to recapture the cultural contributions of traditionally marginalized groups and less-studied geographies. Some of the most effective works in this area are Kim Gallon's studies of the history of Black newspapers in the United States and Artl@s's global approach and documentation of exhibitions specifically created as platforms for women artists.[20] Similarly, decentering datasets can be developed for the nineteenth century and put in conversation with data about major European venues, like the Royal Academy.

Institutions and Empire: A Brief Literature Review
The economics literature I use as a lens for examining depictions of empire at the Royal Academy specifically aims to describe and clarify systematic differences in government and law in Britain itself versus in its overseas empire. Douglass North and Barry Weingast's 1989 article "Constitutions and Commitment: The Evolution of Institutions Governing Public Choice in Seventeenth-Century England"[21] is one of the most cited works of economic history. The article focuses on the economic impact of the Glorious Revolution of 1688, when King James II of England was deposed by a group of English Parliamentarians, his own daughter Mary, and her Dutch husband William, prince of Orange. North and Weingast argue that the Glorious Revolution marked the creation of a true constitutional monarchy, where both the monarch and state expenditures were subject to parliamentary control. This change in the balance of power represented a clear alteration in what economists refer to generally as institutions, formally defined as systems of established and prevalent rules that structure social interactions. Institutions range from laws and

government to respect for commercial contracts, to accepted manners in public interactions.[22] The Glorious Revolution, according to North and Weingast, inspired confidence in English institutions, particularly in their unprecedentedly stable protection of property rights. This confidence in the quality of institutions translated to greater financial investment in Britain and, therefore, to faster and more extensive economic development.

This landmark article, which contributed to North's winning the Nobel Prize in Economics in 1993, has become a touchstone for broader arguments about the importance of institutions for economic development, both historically and currently. In particular, economists have examined the way that not just stable institutions, but *inclusive* economic institutions, are essential to economic development. As economist Daron Acemoglu and political scientist James Robinson wrote in their much-cited book *Why Nations Fail: The Origins of Power, Prosperity, and Poverty* (2012):

> Inclusive economic institutions…are those that allow and encourage participation by the great mass of people in economic activities that make best use of their talents and skills and that enable individuals to make the choices they wish. To be inclusive, economic institutions must feature secure private property, an unbiased system of law, and a provision of public services that provides a level playing field in which people can exchange and contract; it also must permit the entry of new businesses and allow people to choose their careers.[23]

Concrete examples of what economists consider to be inclusive institutions are robust property rights extended to a broad swath of citizens rather than just a small elite, contracts that protect both parties entering into them, and court systems with due process that cannot be manipulated with bribes or other corruption. At later stages of development, inclusive institutions provide for extension of the franchise to all citizens to vote in fair and free elections, and equal access to public services, such as education and healthcare.

This is not to say that inclusive institutions are perfect or perfectly equitable. To be clear, the bar for what is considered an inclusive economic institution in this theoretical literature would absolutely not reach the bar of twenty-first-century cultural definitions of inclusion, which are typically mentioned alongside diversity and equity as social or organizational values. In the twenty-first century, inclusion involves empowering individuals regardless of social background, race, disability status, and other attributes. Therefore, the threshold for labeling historical institutions as "inclusive" in arguments made by North, Acemoglu, and others would not hold by today's standards.

Instead, basic stability and equity in the legal system accompanied by property protections can be considered inclusion in a historical setting. A country in which *all* people (not just a political elite or an ethnic minority) cannot be arbitrarily thrown into jail and cannot have their property—intellectual and otherwise—seized

without warning would be considered home to inclusive institutions in the eighteenth century. Extension of the franchise to allow all citizens to vote is another critical historic step. Eighteenth- and nineteenth-century Britain is often cited as the earliest adopter of inclusive institutions after its embrace of constitutional monarchy, establishment of a stable justice system and property protections, and then the relatively early extension of the franchise with parliamentary acts in 1832, 1867, and 1884.[24] Economists consider property rights particularly important for the innovation that fueled agricultural improvements and industrialization, because people could reap the financial rewards of their new ideas. As Acemoglu and Robinson write, "These foundations decisively changed incentives for people and impelled the engines of prosperity, paving the way for the Industrial Revolution."[25] Inclusive institutions encouraged innovation, industrialization, and the creation of unprecedented amounts of wealth in Britain that was more equally distributed among Britons than ever before.[26]

Again, this does not mean that eighteenth- and nineteenth-century Britain was equitable by modern standards. Class division was rife and economic and political elites still wielded power. The British working classes, as has been well documented in studies since Marx, were subjected to inhumane labor conditions during the nineteenth century.[27] Slavery existed in the metropole until 1772 and the enslaving and trading of people was legal in the overseas empire until the Slave Trade Act of 1807. Even after the passage of this act, the British continued to enslave people in certain territories until the passage of the Slavery Abolition Act in 1833.[28] However, starting from the top, with checks on the power of the monarch in the Glorious Revolution, Britain—relative to other European countries during the same period—had law and governmental systems that were more stable and equitable within the metropole. It was in the context of this relative flourishing of inclusive economic institutions that the Royal Academy was founded and began hosting its annual exhibition.

Acemoglu and Robinson also define institutions that are the opposite of inclusive. Called *extractive*, these institutions are "designed to extract incomes and wealth from one subset of society to benefit a different subset."[29] Extractive political and economic institutions work together to "concentrate power in the hands of a narrow elite and place few constraints on the exercise of this power…[and then allow] this elite to extract resources from the rest of the society."[30] Though the British working classes certainly struggled during the Industrial Revolution, legal protections and the capacity for upward mobility through work and innovation was much better for Britons—implicitly, white Britons—living in the metropole than for imperial subjects. Acemoglu and Robinson use a British colony as an exceptionally clear example of extractive political and economic institutions:

> In 1680 the English government conducted a census of the population of its West Indian colony of Barbados. The census revealed that of the total population on the island of around 60,000, almost 39,000 were African slaves

who were the property of the remaining one-third of the population. Indeed, they were mostly the property of the largest 175 sugar planters, who also owned most of the land. These large planters had secure and well-enforced property rights over their land and even over their slaves. If one planter wanted to sell slaves to another, he could do so and expect a court to enforce such a sale or any other contract he wrote. Why? Of the forty judges and justices of the peace on the island, twenty-nine of them were large planters. Also, the eight most senior military officials were all large planters. Despite well-defined, secure, and enforced property rights and contracts for the island's elite, Barbados did not have inclusive economic institutions, since two-thirds of the population were slaves with no access to education or economic opportunities, and no ability or incentive to use their talents or skills. Inclusive economic institutions require secure property rights and economic opportunities not just for the elite but for a broad cross-section of society.[31]

While Barbados in 1680 may be a particularly egregious example of extractive institutions dependent on enslaving two-thirds of the island's population, British imperial strategy throughout its existence—even after the abolition of slavery—was inherently extractive.

At the outset of the expansion of the British Empire in the late seventeenth and eighteenth centuries, mercantilism—a belief that there were limited economic resources in the world and that controlling more territory was akin to controlling more resources—was the prevailing economic worldview. Under this regime, the British Empire was a protectionist system focused on dominating the supply and trade in commodities.[32] These commodities were extracted and either directly sent to Britain or traded for money that would then be sent to the metropole. A different kind of extractive policy emerged in the nineteenth century when the industrializing British embraced free trade. Under this system, metropole-periphery links were established between Britain's factories and raw-material-producing colonies. The colonies also served as export markets for British manufactured goods.[33] Such extractive structures were typical of European imperial powers.

Though formulated as economic theory, applying the lens of the contrast between extractive colonial institutions and inclusive metropolitan ones can help to explain why empire was rarely shown at the Royal Academy. Engaging with the concept of institutions can clarify the ways in which empire was depicted and elucidate why there was such significant home bias in the creation and exhibition of images of the British Isles. Whether consciously or not, the galleries of the Royal Academy seem to have been reserved for showing and celebrating the beneficiaries of metropolitan-inclusive institutions rather than drawing attention to overseas territories subjected to extractive institutions.

Images of Empire: A Further Quantitative and Qualitative Examination

This section examines in more detail the depictions and omissions of empire at the Royal Academy. The analyses pinpoint three reasons for the relative paucity of imperial imagery in this setting—or rather three reasons in addition to Quilley's observation that depictions of empire were often placed in the category of scientific illustration rather than fine arts. The first reason is purely practical: large distances separated London from many parts of the British Empire. Accordingly, lack of easy transport to many imperial territories limited how many artists traveled to those places and then depicted them. The second reason is political. Artists' ability to travel throughout the empire was limited not only by physical distance but also by political considerations that affected artists' access to a given territory or, perhaps, generated demand for images of certain places. The number of depictions of certain colonies seems to be sensitive over time to the level of British intervention in that territory. The third reason, I argue, is that the British subjected their empire to extractive institutions that were in direct conflict with the inclusive institutions blossoming in the metropole during the eighteenth and nineteenth centuries—and this fundamental conflict made explicit images of empire inappropriate subject matter for the Royal Academy.

Figure 5.1 provides an introductory overview to the locations named, grouped into present-day countries, in titles of paintings shown at the Summer Exhibition. Figures 5.4 and 5.5 map a selection of the named locations and color-code them based on which were part of the British Empire between 1769 and 1914. For clarity, only countries named more than three times are included. The maps are divided into two figures—one showing just Europe (including Turkey and Russia) and one showing a global view. It is immediately clear that a European bias exists in terms of which locations are most depicted. Countries outside Europe that were colonies seem comparatively more depicted than their nonimperial counterparts, but generally they are less depicted than European nations. As a reminder, I consider a country to be "in empire" even if a painting was made either before or after a country came under British imperial control or influence.

Leaving aside, for the moment, the disproportionately large focus on depicting the present-day United Kingdom, several practical and art historical reasons account for the frequent depiction of continental Europe. As demonstrated in chapter 3, ease of transport can influence artists' choices about which places to depict. European nations were physically closer to Britain and easier to access than any imperial territory besides Ireland. Transport within these nations was also made simpler by railway and road systems, which were often much more developed in Europe than on other continents.[34] Furthermore, British artists who traveled to France, and particularly Italy, were following in the well-worn footsteps of fellow artists and travelers. Though the image of the Grand Tour of Europe may be most associated with wealthy British (and then American) tourists, artists often completed their own pilgrimages to Italy and France to copy from classical sculpture and the Old Masters, or to sketch exceptional architecture and landscapes en plein air.[35]

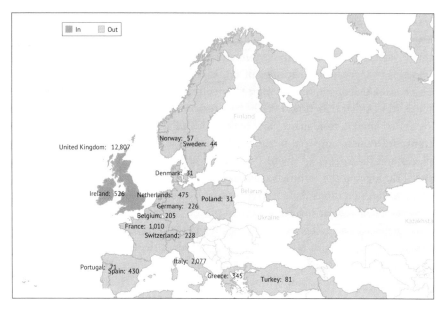

FIGURE 5.4 Detail Map of Depictions of European Countries Shown at the Royal Academy, Divided by British Imperial Status, 1769–1914 (N = 18,648). Sources: See figure 5.1. © 2020 Mapbox © OpenStreetMap.

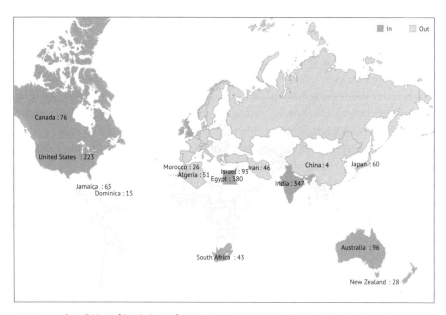

FIGURE 5.5 Detail Map of Depictions of Non-European Countries Shown at the Royal Academy, Divided by British Imperial Status, 1769–1914 (N = 1,675). Sources: See figure 5.1. © 2020 Mapbox © OpenStreetMap.

Countries outside Europe were shown far less frequently than their European counterparts given the barriers presented by vast global distances prior to the development of reliable transoceanic steam shipping in the 1870s. As art historian Jennifer Roberts eloquently describes in *Transporting Visions: The Movement of Images in Early America* (2014):

> The limits of community—civic, economic, domestic—were shaped and tested by distance.... In our own age of synchronous communication, it can be difficult to imagine the profundity of the geographic and temporal separations at issue here.... [Eighteenth- and nineteenth-century artists] lived in a world governed by absolute, intractable separations that we now associate only with interstellar distances.[36]

Roberts highlights an important but simple reality: time and distance between where an artwork was produced—or where the on-site preparatory sketches were completed—and where it was displayed were fundamentally different two centuries ago. Acknowledging and engaging with the past structural constraints of communication corrects for an unconscious but biased assumption among contemporary scholars that the logistics of long-distance travel represent neutral context rather than an important artistic influence. While Roberts goes on to use distance as a lens for formal analyses of late-eighteenth and early nineteenth-century American art, her point is also an important practical reminder when comparing the frequency of depiction of global sites. In short, the farther the distance between London and a given location, the less often one should expect that location to be depicted. While some paintings could have been based on written accounts of a distant locale, nineteenth-century artists—as described in chapter 3—tended to paint what they could observe directly.

This focus on direct observation, particularly for landscape painting, was important in Britain. As discussed later in this chapter with reference to the concept of the picturesque, a dedication to painting directly from nature first emerged in the late eighteenth century and became more pronounced in the early nineteenth century—especially in the landscapes of Thomas Gainsborough. It reached an apex in the writing of art critic John Ruskin and the work of the Pre-Raphaelite Brotherhood.[37] Ruskin occupied a central position in the nineteenth-century British art world and concluded the first volume of *Modern Painters* (1843–1860) with the exhortation that young artists should "go to nature with all singleness of heart, and walk with her laboriously and trustingly, having no other thoughts but how best to penetrate her meaning, and remember her instruction, rejecting nothing, selecting nothing, and scorning nothing."[38] The critic thought anything less than verisimilitude was an artistic failing. These theoretical factors further pushed British artists to engage with what they could directly observe, and portraying English landscapes effectively became a point of national pride—both as a credit to the development of the fine arts in Britain and as a way of celebrating the country's physical characteristics.[39]

Looking just at countries in Africa and Asia, colonial status does appear to have some effect on the frequency of depiction. One can compare, for example, the

FIGURE 5.6 J.M.W. Turner, *Peace—Burial at Sea*, 1842, oil on canvas, 87 × 86.7 cm. Tate, London.

number of depictions of Egyptian versus Moroccan locations. Morocco was perhaps the most accessible African nation from Europe during the nineteenth century. Ships traveled regularly between the United Kingdom and the British territory of Gibraltar, at the tip of the Iberian Peninsula.[40] From Gibraltar, it is only about nine miles by boat to the coast of Morocco. Several British artists traveled to and painted Morocco in the early 1800s; however, by 1830 France was the primary European power in North Africa and the region was considered French artistic territory—British depictions of Morocco dropped off.[41] In contrast, Egypt—a site of British intervention since the end of the eighteenth century and then formally controlled by them from 1882 to 1922—is far more depicted at the Royal Academy. Imperial involvement, and the commercial and political pathways it created, produced transportation and tourist routes for artists to follow.

This network was on display in J.M.W. Turner's famous painting *Peace—Burial at Sea* (1842) [fig. 5.6], which shows the burial of his friend the painter David Wilkie. Wilkie had traveled to Syria, present-day Israel and Palestine, and Egypt in search of new subject matter and fell ill and died on the return journey.[42] Art historian Nicholas Tromans writes in *The Lure of the East: British Orientalist Painting* (2008) that the ship featured was "the first stage of the Overland Route to India, sailing from Southampton to Alexandria (passengers and mail then continued by canal to the Nile, then overland to Suez and on to India via the Red Sea). The presence of the faithfully depicted [steamer] in Turner's picture thus reminds us of the power of British steam to develop Mediterranean tourism, and of the importance of Egypt for communications between Britain and its foremost imperial possession, India."[43]

Therefore, though Egypt and India may have been physically just as far from England as many other countries featured in figure 5.5, these transportation and tourist routes seem to have made them, in practical terms, easier to access. Though Turner's painting was done from imagination, many artists—like Wilkie—traveled along key imperial routes in order to directly observe subjects and scenes in Egypt and other destinations in North Africa and the Levant.[44]

Such infrastructure was particularly important for British artists who were traveling even farther afield. Despite its distance from England, India or Indian subject matter is shown 347 times. While this number lags significantly behind European nations, it makes India the second most depicted country outside Europe, only appearing less frequently than Egypt. Tromans writes, "Despite its centrality to British Identity, few professional artists made it to India, and fewer still to Persia (Iran), Afghanistan or Mesopotamia (Iraq), let alone Arabia, all of which were, so far as British power politics were concerned, within the sphere of influence of British India."[45] Figure 5.5 confirms this for most of the countries on Tromans's lists. However, locations in India were depicted—whether from direct observation or based on visual material like sketches and prints that were sent back to Britain—fairly often when considering the subcontinent's distance from London.

Figures 5.4 and 5.5 show the total number of depictions of different locations during a 145-year period. Such aggregation can, however, obscure how the growth of the British Empire *over time* may have affected how many imperial depictions were displayed in the metropole. Figure 5.7, in contrast, shows number of depictions over time divided into three categories: the British Isles (England, Wales, and Scotland), countries that were ever part of the British Empire (including the present-day Republic of Ireland and Northern Ireland), and countries that were not part of Britain or its empire. Though significant volatility appears from year to year, a consistent pattern exists and is evident in this graph grouped by decade: the British Isles are *always* most shown. They are followed by parts of the world that are *not* in the British Empire (mostly driven by continental European nations), and then the empire.

One can zoom in on the depictions of empire to see whether changes occurred in relation to political upheaval or imperial expansion. Figure 5.8 plots the five most frequently depicted countries that were ever colonies between 1769 and 1914. The number of depictions of each country is presented as a percentage of all works of art shown, grouped by decade.[46] Presenting the information in ten-year increments helps with legibility because of extensive year-to-year volatility.

The two most infrequently depicted colonies in this group are Jamaica and Australia. Though the share of depictions of Jamaica is uneven over time, it is comparatively more represented in the eighteenth century and first half of the nineteenth century. This overlaps with the period when the sugar trade—of which plantations in Jamaica were a critical component—represented up to 5 percent of annual British gross domestic product. Thousands of enslaved people worked in grueling conditions on these plantations.[47] Artists also traveled along these trade routes, as Sarah

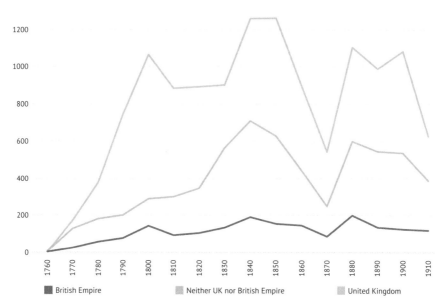

FIGURE 5.7 Number of Depictions of Named Countries Shown at the Royal Academy, Divided by British Imperial Status and Grouped by Decade, 1769–1914 (N = 21,739). Sources: See figure 5.1.

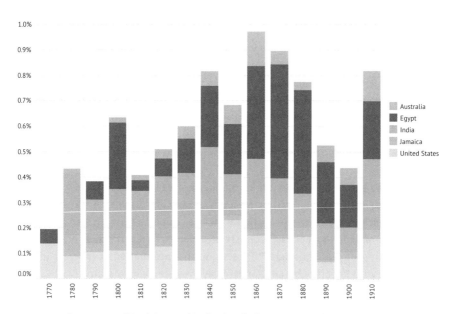

FIGURE 5.8 Percentage of Total Geographically Identified Depictions at the Royal Academy That Feature Australia, Egypt, India, Jamaica, and the United States, Grouped by Decade, 1769–1914 (N = 21,739). Sources: See figure 5.1.

Thomas recently documented in her book *Witnessing Slavery: Art and Travel in the Age of Abolition* (2019).[48] After the end of slavery in 1834, Jamaica and the Caribbean's centrality to the imperial economic system began to decline.[49] Sugar cultivation, refining, and export were less profitable without forced human labor.[50] Seeming to correspond with this decline in economic importance for the empire, the number of depictions of Jamaica declines significantly after the 1840s. The frequency pattern for the depiction of Australia is the inverse of that of Jamaica. Likely owing to its status as a penal colony, depictions of Australia are barely shown in the eighteenth and early nineteenth centuries. Representations of the antipodean landscape begin to appear more after the 1830s, as settlement by the British expanded on the continent, with the 1860s and then the early 1910s as high-water marks.[51]

Interestingly, the United States—or the Thirteen Colonies prior to the late 1770s—was frequently depicted from 1769 to 1779 (shown on the graph as "1770"). After the American Revolution, the US was understandably depicted less. However, it does not completely disappear from exhibitions at the Royal Academy. The US was always shown more than Canada, which, as figure 5.5 shows, was far less frequently depicted despite remaining loyal to the British. An individual case study could be dedicated to each of these countries—and hopefully these analyses will support the work of scholars focused on depictions of these specific parts of the empire. However, to make the scope of this chapter more manageable, I focus on depictions of two countries: Egypt and India.

Examining the depictions over time of the most frequently shown colony—Egypt—highlights the effects of two factors: the ability of artists to access the places they depicted and, to a certain extent, political change. Notably, throughout this period, many depictions that mention Egypt in their title were biblical scenes from both the Old and New Testaments.[52] This consistent flow of biblical imagery—which some scholars have argued is part of European Orientalist projections of the Middle East—buoys the presence of "Egypt" in the titles of works shown at the Royal Academy throughout the period examined.[53] Nonetheless, two clear spikes in depictions of Egypt appeared: one between 1800 and 1809, the other between 1860 and 1889.

The first increase occurred around the same time as battles between the French and British for control of Egypt during the Napoleonic Wars. Napoleon set out to conquer Egypt in 1798 but was ultimately defeated by an allied force of British and Ottoman troops in 1801. The British army remained in the country until 1807 when it was clear the troops would be unable to gain control of Egyptian territory. Muhammed 'Ali, who was appointed as the governor of the territory by Ottoman officials in 1805 and came to be known as the Pasha of Egypt, eventually consolidated his power and ruled until 1848.[54] This first period of sustained British presence in Egypt was accompanied by an increase in depictions of Egypt. The works exhibited were often battle scenes, or topographical images based on studies by officers stationed there. These works have titles such as *The landing of the British army in Egypt under the command of General Abercomby, Admiral Lord Keith commanding*

the Fleet (1804), by the maritime painter Nicholas Pocock, and *Antique capitals, from sketches at Alexandria, by Col. Turner* (1804), by P. B. Cotes, an artist who has faded into obscurity.

In 1839, the Ottoman government began its liberalizing *Tanzimat* campaign, making it easier for Europeans to access and visit Egypt and other Middle Eastern territories under Turkish control or influence.[55] Compounding this effect of political reform, steam shipping made accessing Egypt easier than ever before. The ship shown in Turner's painting of his friend David Wilkie's burial at sea belonged to the Peninsular and Oriental Steam Navigation Company. Founded in the 1830s, the company began by running steamships from Britain to the Iberian Peninsula. Eventually, the company received a contract to carry mail throughout the British Empire and ran steamers capable of reaching Egypt, India, China, and Indonesia. Traveling to Egypt by steamer was the first stage in connections to the further reaches of Asia, and the regular P&O services carried not only letters but also tourists—including painters—who disembarked at Alexandria.[56] By 1869, transport routes were well enough established that the British travel company Thomas Cook and Son had started leading package tours to Egypt.[57] Throughout this period, British influence in Egypt continued to grow,[58] and ultimately, the British invaded and occupied the country from 1882 to 1922.[59]

The second increase in imagery, from 1860 to 1889, had a different tenor than the mix of military, topographical, and biblical scenes earlier in the century, though works in each of these categories continued to be shown. Instead, genre scenes were far more common later in the century. These genre scenes set in Egypt are generally considered to be Orientalist paintings. Typically, they are exoticized depictions of daily life in these foreign countries, such as scenes of souks and markets, harems, and places of worship. Scholars credit growing direct access to Egypt and other North African countries—as well as publications about the region—with fueling the production of this kind of painting.[60] The existing literature cites the 1840s as "the Orientalist moment" in British art; however, a pronounced surge in depictions of Egypt—a preferred Orientalist subject—does not occur at the Royal Academy until the 1860s.

Among the most frequent Orientalist exhibitors during this period was John Frederick Lewis (1804–1876), who lived in Cairo from 1841 to 1851. After his return to England, he exhibited richly detailed exotic genre paintings of Egyptian subject matter. He became an associate of the Royal Academy in 1859 and a full member in 1865.[61] His painting *The Midday Meal at Cairo* (1875) [fig. 5.9] was displayed as number 187 at the Royal Academy in 1876.[62] With "Cairo" explicitly in the title, this work is clearly identifiable as an image of a place that, at one time, was under the influence of the British Empire. The painting is set in a complex architectural space that is typical of a traditional Islamic home.[63] The top right corner is dominated by a richly detailed wooden window screen, and the balcony central to the scene features hand-carved balustrades, a nook covered with elaborate turquoise tiles, and tall thin columns with capitals typical of Islamic architecture.[64] In an open-air

FIGURE 5.9 John Frederick Lewis, *The Midday Meal at Cairo*, 1875, oil on canvas, 88 × 114 cm. Private Collection © Christie's Images/Bridgeman Images.

setting surrounded by invading pigeons, men with turbans and beards sit on cushions to eat from a table full of luscious fruits. Two boys and one tall man stand to the left of the dining party; one holds a jug and inclines his head, suggesting he is serving the diners. The title of the painting identifies the meal as the picture's focus, but colors, detail, and bustle cover the entire canvas. From the activity in the courtyard to the birds flying through the different spaces, the entire composition radiates with energy. Lewis's focus on specific exotic detail and use of a jewel-like palette was typical of his work, and typical of Orientalism more generally. Indeed, of all the British imperial territories, Egypt appears to be the one that—based on titles and works I am able to locate—was most frequently depicted in an Orientalist mode.[65] Nonetheless, the images discussed here represent a tiny minority of works shown in the Royal Academy from 1769 to 1915. Images of Egypt represent at most 0.5 percent of works exhibited in a ten-year period.

In his analysis of maritime imagery, Quilley describes a decisive "shift from 'empire' to 'nation'" where national imagery displaced imperial imagery in British fine arts.[66] However, based on the data presented in figures 5.1, 5.4, 5.5, and other graphs throughout this chapter, there was never an extensive amount of imperial imagery to displace. Its depiction at the Royal Academy remained, for the most part, at a constant low level throughout imperial growth.

From Picturesque Stability to Institutions in Retreat: Images of India

Though depicted less than Egypt, India loomed larger in the British imperial economy and consciousness. India was under British control from 1757 to 1947, first under the jurisdiction of the East India Company and later—after the Indian Rebellion of 1857—under the direct government control of the British Raj.[67] Controlling the subcontinent was key to Britain's global trade, and allowed it dominate the regions around the Indian Ocean.[68] In 1877, the British prime minister, Benjamin Disraeli, even had "Empress of India" added to Queen Victoria's titles. No other imperial holding was bound to Britain in this way.[69] Figure 5.8 demonstrates how, despite its great physical distance from London, India was depicted in paintings shown at the Royal Academy from the earliest days of the annual exhibitions—well before the use of long-distance steamships or the opening of the Suez Canal in 1869, both of which significantly shortened the journey from England to South Asia.[70] While India was consistently depicted between the 1780s and 1840s, a dip occurred during the 1850s. The rate of depiction rebounded from the 1860s to the 1880s before declining again until the final years covered by the dataset.

This section turns to formal analyses of a handful of works from these two periods. First, it examines the work of Thomas Daniell, who, along with his nephew William Daniell, traveled to India and stayed there for ten years. After returning to England, he showed dozens of images of the subcontinent at the Royal Academy. Second, this section looks at paintings of the Indian Rebellion of 1857 by the military painter George Jones.

I argue that both Daniell and Jones visually grapple with the institutional incompatibility of the systems of rule applied at home in Britain and in the colonies, such as India. Daniell applies aesthetic models developed in relationship to English landscapes—specifically, the picturesque—to his Indian subjects, attempting to visually draw stronger links between Britain and the subcontinent. Jones, in contrast, shows the violent consequences of the imperial enterprise, although he shows this violence being perpetrated almost exclusively on white British settlers, rather than on the Indian people. Unlike Daniell, Jones does not attempt to reconcile the incompatibility of British institutions and imperial ones. However, far more common than either Daniell's application of an English picturesque lens to the Indian landscape or Jones's depiction of the violent instability of imperialism was another artistic approach to empire: simply *not showing it*. Once again, these paintings are representative of a tiny population of imperial subjects on display at the Royal Academy.

Many of the depictions of Indian sites in the eighteenth and early nineteenth centuries were done by a handful of artists who had traveled to the subcontinent. Specifically, William Hodges (1744-1797) showed at least twelve Indian subjects between 1778 and 1794, and Thomas and William Daniell showed a combined 138 paintings of Indian subjects at the Royal Academy after returning to England. The Daniells left England in April 1785 and arrived in China in August 1785. They stayed there for several months before arriving in Calcutta, India, which became their

home base, sometime in late 1785 or early 1786.[71] While abroad, they made their living creating paintings and prints, most of which were for the British community in Calcutta. This local demand—in addition to the logistical difficulties of transport between the subcontinent and Britain—contributed to relatively few images of India being placed on display at the Royal Academy. After eight years, they left India in 1793.[72] Upon returning to England, they spent much of the rest of their careers depicting—both in prints and in oil on canvas—Indian subjects and the other places they had traveled on their way to and from Calcutta.

Douglas Fordham includes a detailed discussion of the Daniells' productions in print (particularly illustrated books) in *Aquatint Worlds: Travel, Print, and Empire* (2019), but there is less recent scholarship available about their oil paintings. Table 5.2 lists the total number of depictions of different present-day countries shown by each Daniell at the Royal Academy. Thomas exhibited these works between 1795 and 1828, while William exhibited between 1795 and 1838.[73] Maurice Shellim, a medical doctor who wrote the first (and apparently still the only) monograph dedicated solely to the Daniells, determined their route from England based on inscribed sketches.[74] They traveled via "Gravesend, Madeira, the Cape of Good Hope, Java Head, Angere Point, Macao, and finally Canton…after which they embarked on a…coastal vessel for Calcutta."[75] Shellim notes that the pair produced a series of prints based on this voyage and their many excursions around the subcontinent. These travels also correspond to the output of oils they produced once back in London. The fact that Thomas and William principally painted places they had visited in person does not point to the accuracy of their images—but rather their choice of subject matter speaks to the importance of direct access to a location for its frequency of depiction.

The Daniells' works engage with a mode of landscape painting that had been developed with specific reference to the English countryside and was taking hold in late eighteenth- and early nineteenth-century Britain: the picturesque. This aesthetic sought to establish a compromise between the philosophical concepts of the sublime and the beautiful and was addressed by philosophers like Edmund Burke and Immanuel Kant.[76] In eighteenth-century England, the picturesque in the visual arts flourished with the theories and practice of William Gilpin (1724–1804). Gilpin was a clergyman, aesthetic theorist, plein air sketching advocate, and avid fan of the landscape painter Claude Lorrain (1600–1682). He presented the picturesque as an aesthetic that combined elements of both the sublime and the beautiful by integrating visual elements that evoked the sublime—such as distant towering mountains or architectural structures turned into ruins by the force of time—with supposedly beautiful elements, including calm bodies of water or sunny fields.[77] This picturesque model was applied extensively to the English landscape—including English estates—in depictions by both Gilpin and other artists, as well as through direct landscaping carried out by landscape architects like William Kent and Capability Brown.

Two examples of picturesque depictions of English sites come from John Constable's many depictions of the Malvern Hall estate, including *Malvern Hall, Warwickshire* (1809) [fig. 5.10] and *Malvern Hall, Warwickshire* (1820–1821) [fig. 5.11], which

TABLE 5.2 Countries Featured in Canvases Exhibited by the Daniells at the Royal Academy

COUNTRY	DEPICTIONS BY THOMAS DANIELL	DEPICTIONS BY WILLIAM DANIELL
China	0	2
England	23	51
France	0	2
India	87	51
Indonesia	0	2
No Clear Location	12	11
Oman	3	2
Portugal (including the island of St. Helena)	0	2
Scotland	0	24
South Africa	0	2
Spain (including one marine of the Bay of Biscay, which could also be considered France)	0	2
Sri Lanka	0	7
Wales	0	8

Source: Maurice Shellim, *Oil Paintings of India and the East by Thomas Daniell, 1749–1840, and William Daniell, 1769–1837* (London: Inchcape & Co. in conjunction with Spink & Son, 1979), appendixes II and III. Oddly, three of the five depictions of Oman were not captured in the geographic keyword search of the Royal Academy data. This is an example of where more manual checking of the large RA dataset could be helpful. (See Appendix A and Appendix G.)

was likely shown as number 219 at the 1822 exhibition and is therefore included in the data analyzed throughout this chapter.[78] Sometimes Constable painted Malvern Hall and its grounds at the specific request of its owner, Henry Griswolde Lewis— for whom Constable completed several projects, including portraits—and sometimes he seems to have painted the grounds just for his own interest during his time as a guest staying at the estate.[79]

The earlier of the two paintings (fig. 5.10) uses the distant image of the house, either at dusk or sunrise, as a fulcrum around which the composition turns. Sitting on the horizon line, the house is the central point of reference for recognizing the reflections in the pond in the middle ground of the painting. The house also divides two clumps of trees that have a height and density that suggest they are

FIGURE 5.10 John Constable, *Malvern Hall, Warwickshire*, 1809, oil on canvas, 51.4 × 76.8 cm. Tate, London.

FIGURE 5.11 John Constable, *Malvern Hall, Warwickshire*, 1820–1821, oil on canvas, 97.2 × 73 cm. Yale Center for British Art, New Haven, CT.

old—perhaps the landscaped remnants of an old forest. The scale of the land sur-
rounding the house, which almost looks like a small cottage from the distance Con-
stable has chosen, is impressive and suggests the imposing grandeur of nature. Yet
the calm and manicured grounds hew more closely to the balanced beautiful part of
a picturesque aesthetic. The later picture (fig. 5.11), from 1820–1821, presents a very
different view of the property. Constable has zoomed in on the house to display its
impressive façade, complete with columns and classical statues placed as sentinels.
As in the earlier painting, the architectural structure is framed by trees. However,
the focus is now on two enormous trees with hanging branches and foliage, once
again suggesting the impressiveness of the nature in which this home is placed. An
ornate gate is visible through the branches of the tree on the right-hand side of the
canvas—indicating a property line, a cue that this is an image of an improved and
constructed British estate.

In her social history of British landscape painting—titled *Landscape and Ideol-
ogy: The English Rustic Tradition, 1740–1860* (1986)—Ann Bermingham demonstrates
that the picturesque reached its peak popularity when applied to "working agrarian
land and those who worked it before and after it became scenery."[80] In short, the
picturesque co-occurs with the industrialization of Britain, which began with the
agricultural revolution. Bermingham, whose work focuses particularly on the land-
scapes of Thomas Gainsborough and Constable, summarizes her thesis at the outset
of her book. Focusing on enclosure—when British plots of land were combined to
be made larger and placed under individual rather than common management—
she writes: "The emergence of [picturesque] rustic landscape painting as a major
genre in England at the end of the eighteenth century coincided with the acceler-
ated enclosure of the English countryside. Beginning with the assumption that the
parallelism of these events is not an accident but rather a manifestation of profound
social change, this study attempts to illuminate the relationship between the aes-
thetics of the painted landscape and the economics of the enclosed one."[81] Andrew
Hemingway and Stephen Daniels have also contributed to this literature and have
argued that picturesque landscapes became vehicles for expressing a national pride
in industrializing Britain. Not only was landscape painting a response to changes in
Britain's socioeconomic makeup; it was a celebration of them.[82]

Bermingham and John Barrell, who also published on the topic of enclosure
and British landscape painting, view the socioeconomic changes that were co-
occurring with the taste for the picturesque as negative developments for England.[83]
Both express concern about the plight of the English rural poor under this chang-
ing economic system and engage with a tradition beginning with Marx's *Capital*
that draws a line between enclosure, rural depopulation, and the emergence and
suffering of the nineteenth-century British working class. Applying the language
of economic institutions, both scholars would likely view enclosure as extractive
rather than inclusive. The same is likely true of Hemingway, whose scholarship
builds on early Marxian approaches to art history. While the changes that enclo-
sure fomented within the English countryside were difficult and not every Briton's

quality of life improved, there is a consensus among economic historians that enclosure was—in fact—an essential early development in the emergence of early property rights within Britain. The clear ownership and innovative application of new farming strategies to enclosed land improved crop yields, fed more people, and allowed for labor and talent to be deployed into other areas of the economy. Therefore, in the long run, evidence shows that policies like enclosure created greater wealth that was more evenly distributed across the British population than in any earlier period.[84]

Though it runs counter to traditional Marxian arguments, economists view enclosure as a building block of the inclusive institutions developing in England during the eighteenth century. Drawing on Bermingham's and Barrell's research alongside the economic history literature that identifies enclosure as part of the development of inclusive institutions, I propose a slightly different interpretation of the picturesque. I believe this aesthetic and its application to the English landscape were at their peak popularity as *inclusive* institutions took hold in the British Isles. Ultimately, these depictions celebrated a Britain that was developing in inclusive ways totally distinct from its empire governed in maximally extractive ways.

A standard of the picturesque landscape aesthetic that Bermingham describes is conveying the passage of time. A painter could convey time in a number of ways, including with old trees, eroded landscapes, and architectural ruins. She writes, "The picturesque allowed for, depended on, and was finally undone by time and its changes. Gilpin, too, acknowledged the crucial role of time in determining the picturesque, even suggesting that the painter prematurely age the objects of his or her vision to secure a picturesque effect. Bermingham then quotes the theorist's assessment of new architecture in a landscape: "Should we wish to give [elegant architecture] picturesque beauty, we must use the mallet instead of the chisel: we must beat down one half of it, deface the other, and throw the mutilated members around in heaps. In short, from a smooth building, we must turn it into a rough ruin."[85] Though Gilpin was talking about the English landscape, this picturesque featuring of ruins also appears in images of India.

Looking more closely at the Daniells' work reveals a tension between exotic subject matter and the picturesque. Figure 5.12 shows *Ruins of the Naurattan, Sasaram, Bihar* (1811), a painting Thomas Daniell exhibited at the Royal Academy. The title does not immediately match known ruins near the city of Sasaram in India's Bihar state; therefore, it is difficult to gauge the documentary accuracy of Daniell's depiction. However, like Constable's images of Malvern Hall, this canvas features architecture framed by dramatic trees. A massive banyan tree dominates the right half of the canvas and dwarfs the ruins that are purportedly the subject of the painting. The hanging vines and mountains in the distance also conform to picturesque conventions. Barrell describes the integration of the rural poor into picturesque English scenes, where they function as props. Following this convention of integrating rural dwellers into the landscape, Daniell places what seems to be a local goat-herding family in the left-hand side of *Ruins of the Naurattan, Sasaram*. Apart

FIGURE 5.12 Thomas Daniell, *Ruins of the Naurattan, Sasaram, Bihar*, 1811, oil on canvas, 97.9 × 136.2 cm. Yale Center for British Art, New Haven, CT.

from the exoticized ruin at its center, skin color and dress of the rural family, and type of tree featured, the Daniell canvas is strikingly similar to picturesque images of Britain created in the same period.[86]

The picturesque is a flexible aesthetic that has been analyzed in reference to British landscapes and travel.[87] Romita Ray, Jill Casid, and Sarah Thomas have explored how a picturesque lens has been applied to arts depicting the British Empire, specifically, to India and the Caribbean; I am far from the first to suggest British artists applied this particular aesthetic to imperial territories.[88] However, the particular brand of picturesque landscape painting in oil—not in prints or other ephemeral media—and its striking resemblance to the way metropolitan land and *properties* were depicted at the same time seems to equate development in the empire with development in England. This transplanted picturesque view reflects the position of the early imperial project in India: attempting to settle on the subcontinent and link it to British institutions. While imperial settlement may have been inherently extractive, Daniell—who by 1811 was living and painting in England—applies an aesthetic to the Indian landscape that visually suggests similarities between India and England, their development, and the institutions governing them. Casid eloquently makes a similar point, although without citing the literature about economics, for visual culture and written descriptions representing the Caribbean (particularly Jamaica) in her book *Sowing Empire: Landscape and Colonization:* the picturesque was deployed to suggest that colonies could and should be fully integrated into the British Empire.[89]

The irony, of course, is that the colonies would not be governed in the same way as the metropole. The empire would never have the same more equitable institutions—and this picturesque aesthetic that implies similarities between Britain and its colonies disappears from the Royal Academy over time. Early in the direct rule of the British Raj, a spike in depictions of India occurred—specifically, during the 1860s. More artists generated these works than just the small group of painters who made it to the subcontinent at the end of the eighteenth century. Many of the artists who created the works had likely never traveled to India. Recall from figures 5.4 and 5.5 that the subcontinent was generally far less shown than more accessible places. Therefore, it is not surprising that of the handful of depictions produced, a significant number were done at a distance and demanded that the artists imagine their subjects with or without the help of sketches and photographs. Among this group are genre scenes with titles such as *An Indian Girl* (by T. Roods, shown in 1859, unlocated) and many portraits and medals created to show or commemorate both British colonial officials and Indians working with the British.

In 1857, the Indian Rebellion attempted to overthrow British rule, and some paintings were created as a direct response to this uprising. For example, Henry Hugh Armstead's sculpture titled *The Defence of the Residency at Hyderabad* (exhibited 1862, unlocated) likely depicted an event in which residents of Hyderabad tried to storm the Residency, the local political office representing the British government.[90] One of the most notable depictions of the rebellion was a pair of large oil paintings by George Jones shown in 1869. Jones was a veteran and senior member of the Royal Academy best known for painting military scenes.[91] He seems to have never traveled to the subcontinent.[92] His ambitious 1869 works were *Cawnpore, the Passage of the Ganges at Cawnpore on the 29th and 30th November 1857* and *Lucknow: Evening. The Sufferers Besieged at Lucknow, Rescued by General Lord Clyde; November* (fig. 5.13); both canvases are now at the Tate. Jones showed not only these two works in 1869 but also preparatory sketches in earlier exhibitions. Rather than depicting fighting or British triumph—as one might expect of a military painter—the works show the evacuation from two cities where British forces were under extended siege.

Lucknow: Evening is a large painting, 109 by 208 centimeters. The skyline recognizably belongs to the city of Lucknow, which is located in Uttar Pradesh in northern India. At the time, the city was ruled by the nawabi dynasty, a group of rulers who were Shia Muslims and loyal to the Mughal emperor, but whose subjects were mostly Hindu. To affirm their faith and power, the nawabi rulers conducted an ambitious building program of both religious and secular buildings.[93] In Jones's painting, the minarets and palace towers created during this construction campaign are outlined against the sky. One can also discern the silhouettes of a third architectural layer: the British Residency and other structures added to the Lucknow skyline under the aegis of the British East India Company.[94]

During the 1857 rebellion, several thousand British, European, and Indian soldiers—along with their families—took refuge in the area around the Lucknow Residency. They were trapped there for roughly six months, between June and November,

FIGURE 5.13 George Jones, *Lucknow: Evening. The Sufferers Besieged at Lucknow, Rescued by General Lord Clyde; November,* 1869, oil on canvas, 109.2 × 208.3 cm. Tate, London.

before being evacuated to Calcutta.[95] After the evacuation, many accounts were published of the experience within the Residency, where conditions were crowded and squalid, and many people died from disease, shelling, and gunfire. Often, the authors of these accounts were the wives of soldiers or colonial officials. Lydia Murdoch, a historian who has studied these accounts and how they reverberated through the British press and popular culture, describes how the stories of death and disease "revealed not only the violence at the heart of the imperial project but also the ultimate instability of British domestic life and identity within the imperial context."[96]

Completed ten years after this incident and by an artist who likely never traveled to Lucknow or anywhere else on the subcontinent, Jones's *Lucknow: Evening* emphasizes the instability of the British presence in India. Though set in a large landscape, the most dynamic parts of the painting are the vignettes of human interactions at the front of the column of people leaving the city. The cast of characters participating in this exodus is decidedly white and British—apart from the turbaned men carrying portable beds, presumably for the sick who are unable to walk. The scene of a mass of people on the march may recall triumphant images of military columns going into battle; however, this scene features only a handful of soldiers escorting mostly women and children. Echoing the firsthand accounts in the memoirs of those who had been in the Lucknow Residency, the focus of this painting is on how British settlements—British institutions—were disturbed and displaced. This focus shows, as Murdoch wrote, the inherent conflict between "the

FIGURE 5.14 Elizabeth Thompson Butler (Lady Butler), *Remnants of an Army*, 1879, oil on canvas, 132.1 × 233.7 cm. Tate, London.

violence at the heart of the imperial project" and the increasingly stable social and economic institutions that the British were actively building at home—and that would be extended to *white* Britons living on the subcontinent.

This violence was particularly obvious during and in the wake of the revolts of 1857, not only at Lucknow but also during the bloodier Kanpur (Cawnpore) Massacre.[97] Other famous paintings that retrospectively looked at the violent defeat of British imperial forces also appeared at the Royal Academy, notably, Elizabeth Thompson Butler's *The Remnants of an Army: Jellalabad, January 13, 1842*, now better known as *Remnants of an Army* (fig. 5.14), which was displayed at the Summer Exhibition in 1879 as number 582.[98] The scene is set in present-day Jalalabad, Afghanistan (and, as far as I have been able to detect, one of only two *named* images of Afghanistan identified in the Royal Academy data) near the present-day Pakistani border—and therefore on the edge of nineteenth-century British India. It shows Dr. William Brydon, a survivor of the bloody retreat from Kabul of the British Army of the Indus during the First Anglo-Afghan War (1839–1842).[99] Painted in the midst of the Second Anglo-Afghan War (1878–1880), the canvas shows Brydon and his horse completely exhausted. It is painted largely in a range of browns and tans, capturing the desert climate around Jalalabad, although with cool purple, pink, and blue highlights used to show mountains from the Hindu Kush range in the distance. The tan colors Brydon wears give the impression that he is fading into the landscape; the doctor and his horse appear within the center of a U-shaped bend in the path and a slightly elevated bluff along what is probably the Kabul River, as if they are surrounded by a swirl of arid land. This—like Jones's works—is an image of imperial failure rather than imperial triumph.

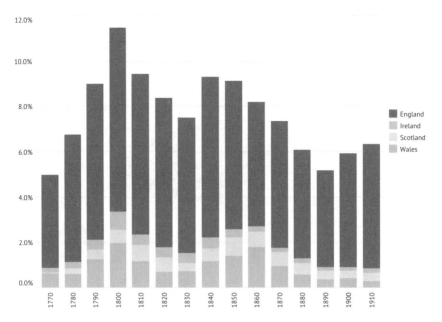

FIGURE 5.15 Percentage of Total Depictions at the Royal Academy That Feature England, Ireland, Scotland, and Wales, 1769–1914 (N = 21,739). Sources: See figure 5.1.

The fundamental incompatibility between the imperial project and British institutions developed in the metropole is on display in Jones's and Thompson's paintings. Whereas Daniell attempted to apply the same picturesque aesthetic to Indian subject matter as was applied to English scenes, Jones has abandoned this effort. Tellingly, no landscape painters replaced the Daniells to create picturesque images of India for the Royal Academy that aesthetically equated the subcontinent to the metropole. Perhaps, after the Daniells, the next comprehensive effort to present an image of the subcontinent that equated its institutions and governance with those that existed in Britain were the architectural plans presented at the 1914 exhibition for New Delhi government buildings.[100]

However, as described earlier in this chapter, the most common artistic strategy related to the empire was, quite simply, not to show it at all. This erasure is made even clearer by figure 5.15, which presents the same information for the paintings of the United Kingdom and Ireland as figure 5.8 presents for the empire.[101] Works— of all genres, including landscape, history painting, and portraiture—that list an identifiable British (or Irish) site in their titles routinely make up 5 percent or more of all works shown at the Royal Academy. While this number may seem small, it is *much* greater than the number of depictions of Britain's overseas colonies. In other words, a clear home bias exists—painters depicted the metropole far more often than any part of the empire.

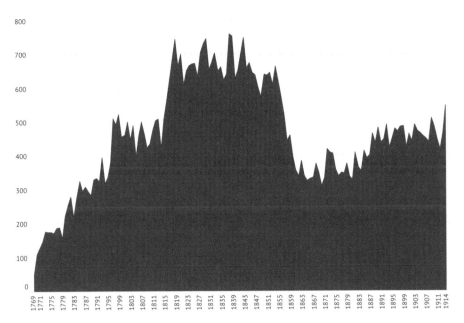

FIGURE 5.16 Number of Portraits Shown at the Royal Academy, 1769–1914 (N = 31,804). Sources: See figure 5.1.

Portraiture in the Context of Inclusive and Exclusive Institutions

Digging further into figure 5.15, the vast majority of identifiable British sites depicted were, in fact, English sites. The visual focus was not just on the British Isles but also on England in particular. Many of these sites were not images of a particular wild landscape or natural feature but rather a view of someone's land. A view on display at the Royal Academy may be picturesque, but it is likely also identified as belonging to a particular person who not only has wealth but also benefits from the secure property rights typical of inclusive institutions. John Constable's later *Malvern Hall, Warwickshire* (fig. 5.11), examined above, is just one example of these works. In showing these English estates, the images on display at the Royal Academy celebrate—at least implicitly—stable British institutions while editing out images of the extractive institutions that were transferring wealth from the empire to the metropole. Complementing this focus on estates, another genre flourished as extractive imperial institutions and inclusive metropolitan institutions simultaneously grew and solidified: portraiture.[102]

Figure 5.16 shows the flourishing of portraiture from the beginning of the Royal Academy through the 1850s, at which point portraits declined precipitously and, in general, the Summer Exhibitions came to be dominated by genre painting—although not genre painting featuring the empire.[103] In *Portraiture* (2004), art historian Shearer West writes, "Although rulers and other powerful individuals characteristically commissioned portraits, portraiture was also the province of lower ranks of society. The middle classes—as we now know them—used portraiture to help them project a

distinct identity; this level of society became most closely associated with portraiture in the modern period."[104] One can further break down the trend shown in figure 5.16 by category of sitter, which provides some quantitative evidence to support West's statement about the importance of nonrulers as patrons and subjects of portraiture in the late eighteenth and nineteenth centuries.

Based on titles and the use of certain honorifics—such as different dukedoms and "sir" or "lady"—one can track the shifting social makeup of portrait subjects. Figure 5.17 shows the ballooning of one category over the first half of the nineteenth century: people elevated to the lower levels of the peerage (such as a knighthood or baronetcy) and a growing number of members of parliament who were *not* hereditary peers. Swiss-born artist Henry Fuseli (1741–1825), who was a professor of painting at the Royal Academy Schools, complained about this new population of portrait subjects.[105] In one lecture, he stated:

> Since liberty and commerce have more levelled the ranks of society, and more equally diffused opulence, private importance has been increased… and hence portrait-painting, which formerly was the exclusive property of princes, or a tribute to beauty, prowess, genius, talent, and distinguished character, is now become a kind of family calendar, engrossed by the mutual charities of parents, children, brothers, nephews, cousins and relatives of all [kinds].[106]

Though Fuseli was complaining about the flood of portraits, his description of forces that "levelled the ranks of society, and more equally diffused opulence," is in fact a description of more inclusive economic institutions that allowed more Britons to earn and thrive.[107] Fuseli's lament is a real-time account of the positive end result of the inclusive economic institutions developing in England. Furthermore, the artist identified the taste for portraiture as directly related to this leveling. The data seem to confirm Fuseli's statement. Figure 5.17 shows not only a growing number of images that, based on their titles, seemingly portray newly rich or ennobled people but also a paucity of images depicting the royal family. As North and Weingast described in their landmark article about institutions and the Glorious Revolution, before 1688 the English monarchy was an unchecked and extractive institution. The political changes that checked the monarch's power were the first steps in establishing inclusive institutions in Britain. The fact that relatively few images of the royal family were exhibited at the Royal Academy seems to reinforce the findings about depictions of empire: artists were more likely to show the beneficiaries of inclusive institutions rather than depict anything related to extractive ones, which included the monarchy, despite new parliamentary checks. Fascinatingly, British monarchs appeared far less frequently in oil on canvas than non-constitutional monarchs and other nondemocratic leaders were displayed at the Paris Salon (see fig. 2.8).[108]

Of course, these images of the beneficiaries of England's inclusive institutions obscured the ways in which extractive imperial institutions fueled the metropole's

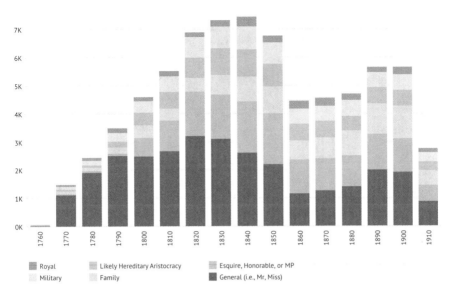

FIGURE 5.17 Types of Sitters Featured in Portraits Shown at the Royal Academy, 1769–1914 (N = 31,804). This number is higher than total portraits, because about 10% of portraits are tagged with multiple categories graphed here. Sources: See figure 5.1.

increasingly secure wealth. This obfuscation is on full display in a portrait that is often cited in the scholarly literature about art and the British Empire: Johannes Zoffany's *The Family of Sir William Young* (c. 1767–1769) [fig. 5.18].[109] Few details in the painting are explicitly imperial. The family members of Sir William, who is sitting in the center holding a cello, are all wearing clothing made of rich satin and lace. They are shown in nostalgic "Van Dyck costume" (named for the portraitist Anthony Van Dyck) that hearkens back to the Tudor and Stuart era from the end of the fifteenth century to the early eighteenth century. This costume choice implies a connection between this newly rich man and the English ruling class of an earlier era.[110]

Arranged across the foreground of a landscape and stone staircase, the family members grip musical instruments or flowers and are accompanied by dogs and horses. The whole scene indicates ease, opulence, and refinement. The only figure who suggests the source of the wealth supporting this idyllic scene is the young Black man on the left-hand side of the painting. Surrounded by Young's sons and next to the boys' horse, the young man seems to occupy a liminal space between the boys and animals. His dark skin tone echoed in and echoing the horse's coat presents a stark contrast to the pale and blonde Young boys. His hand firmly holds up the youngest son, suggesting his role is one of service and support. The name of this man was John Brook. He was a servant—likely a slave—brought by the Young family to England from the Caribbean.[111] Young made his fortune as a sugar planter and colonial politician, eventually becoming the governor of Dominica.[112] The wealth

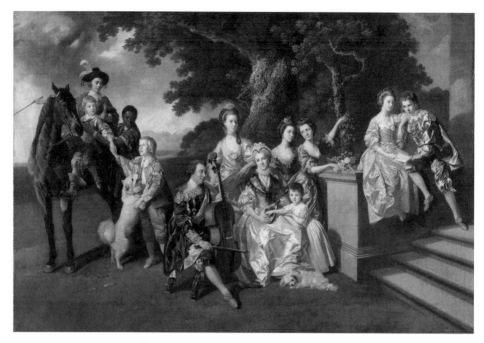

FIGURE 5.18 Johannes Zoffany, *The Family of Sir William Young*, c. 1767–1769, oil on canvas, 114.3 cm × 167.8 cm. Walker Art Gallery, Liverpool.

that supported the commissioning of this family portrait and the opulent lifestyle it depicts are not the product of ancient English wealth that the Van Dyck dress references. Instead, the Young family fortune and Sir William's 1771 elevation to a baronetcy are a recent product of colonial expansion and industrializing agriculture dependent on slave labor. The Young family's close ties to the Caribbean colonies are alluded to by the presence of the Black figure, but not emphasized. Only with knowledge of the sitters' biographies can Zoffany's group portrait be read as an imperial picture. Otherwise, most evidence of an imperial connection is omitted— and this connection is completely invisible in the title of the piece.

Zoffany's portrait is ultimately a depiction and celebration of inclusive British institutions accessible to white British families. Sir William, the son of a doctor and planter working in the Caribbean, was upwardly mobile, both socially and economically. His acquisition of Delaford Manor in Iver, Buckinghamshire, and appointment as the first Baronet of North Dean marked his inclusion in the aristocracy despite his not being aristocratic from birth. Though it may at first glance appear staid and rigid, the British aristocracy was inclusive in this way—making sure that wealth, aristocratic titles, and landownership continued to be correlated, even if it meant incorporating new members.[113] Portraits like Zoffany's commemorated people who were upwardly mobile and successful through inclusive British institutions, even when their success was dependent on extractive colonial institutions.

Conclusion

At first, the visual omission of empire from the Royal Academy is surprising. Imperial holdings constituted much of the wealth and territory that made Britain a global power in the eighteenth and nineteenth centuries—and Reynolds even referenced the empire in his 1769 founding lecture at the Royal Academy. Yet upon further reflection, the editing or removal of the empire from the visual landscape of the Royal Academy makes sense. The British subjected the metropole and the colonies to fundamentally different kinds of institutions. Metropolitan institutions were designed to be secure and relatively inclusive: to protect property, foster innovation, and create wealth. The frequent depiction of England and its notable citizens is a reflection of this security. The extensive estates, innovators, and wealthy were not only protected by British institutions but further bolstered by being preserved in the prestigious media of oil on canvas, marble, and bronze. This preservation created a permanent visual record of the products of increasingly entrenched inclusive institutions.

Extractive colonial institutions were designed to transfer resources and wealth to the metropole. Brutal and fundamentally unequal, these systems were not to be celebrated. As Reynolds's opening statement about empire and ornament suggests, art is a consequence of wealth and power that may be generated in the empire but is then decidedly transferred home to Britain. These policies and the places from which labor and resources were forcibly removed did not need to be celebrated or reaffirmed in painting and sculpture. Instead, far more ephemeral visual material on paper, including prints, photographs, and watercolors, were often produced in imperial contexts and used as vehicles for conveying information and opinions about the British Empire, its geography, and its inhabitants.[114] I have not yet developed a dataset about prints depicting empire, but such a dataset should be possible to create from sources like the declarations of engraved plates made to the Printsellers' Association in London and catalogs raisonnés of individual printmakers' works, such as those of the satirist James Gillray, who often dealt with empire, or the prints created by the Daniells and other artists who depicted India.[115] Just as the solidity of works at the Royal Academy may have affirmed the stability of British institutions at home, the ephemerality of prints and other paper depictions of empire may mirror the extractive instability of imperial institutions abroad.

Perhaps a fitting analogy for the relationship of empire to the Royal Academy comes from the home of Frederic, Lord Leighton (1830–1896), who served as president of the academy from 1878 until his death. Of the sixty-five works Leighton showed at the Summer Exhibitions, only two have tangential (and later) links to the British Empire: *Interior of the Grand Mosque, Damascus* (1875) and *The Star of Bethlehem* (1862), an Orientalist and a New Testament scene, respectively.[116] Otherwise, the artist mostly exhibited paintings showing scenes from the lives of great Renaissance artists and classical themes.[117] Therefore, just 3 percent of Leighton's paintings shown at the Royal Academy annual exhibitions were imperial by the metrics used throughout this chapter. Yet someone visiting Leighton House, the artist's

FIGURE 5.19 The Arab Hall,
Leighton House Museum, built
by George Aitchison (1825–1910)
between 1866 and 1895; Ken-
sington & Chelsea, London.
Photo courtesy of Bridgeman
Images.

custom-built home and studio in Holland Park, London, would almost immediately be confronted by a dramatic imperial image: the Arab Hall (fig. 5.19). This opulent room, designed for Leighton by the architect George Aitchison (1825–1910), integrates objects and architectural elements from around the world—including from Egypt, Syria, Iran, and Pakistan, all places that would fall under imperial influence or direct control.[118] In other words, Leighton put empire on display, just not at the Royal Academy.

Ultimately, the data-driven analysis presented in this chapter is just a first step in quantitatively measuring how often, where, when—and why—the empire appeared in British visual culture. With additional datasets, it could be possible to trace and chart where empire was depicted beyond the galleries of the Royal Academy. My goal here is not to provide definitive answers about the relationship between art and empire but rather to offer new evidence and a novel blended quantitative and qualitative approach in service of addressing existing research questions and provoking new ones.

CHAPTER 6

Conclusion

H aving presented these constituent case studies focused on specific geogra-
phies, themes, and research questions, this conclusion turns to some general
takeaways from a data-driven history of art and its place in the discipline of art
history. To do this, it takes a brief detour into philosophy. From Plato to Kant and
Adorno, many scholars have taken on the field of aesthetics. They have proposed
standards and tests by which one can define art and judge its quality.[1] Of these
efforts, the most useful for the purposes of this book is David Hume's 1757 essay
"Of the Standard of Taste." The philosopher writes that "it is natural for us to seek
a Standard of Taste; a rule by which the various sentiments of men may be recon-
ciled."[2] In seeking this standard, Hume methodically discredits a wide range of the-
ories for how to best assess the essential quality of works of art, literature, and other
cultural production. He describes how taste can be imperfect and fickle, and there-
fore, truly great art can only be proven by its survival of "the continual revolutions
of manners and customs."[3] In essence, only an ongoing test of time can determine
the true value of a work of art. Hume writes:

> A real genius, the longer his works endure, and the more wide they are
> spread, the more sincere is the admiration which he meets with. Envy and
> jealousy...may diminish the [initial] applause [a work receives].... But when
> these obstructions are removed, the beauties, which are naturally fitted to
> excite agreeable sentiments, immediately display their energy and while the
> world endures, they maintain their authority over the minds of men.[4]

In the process of identifying these works of genius, other works are necessarily—to
use Hume's words—"thrown aside."[5]

The inherited structure of art history dating back to Vasari has meant that the
discipline has traditionally dealt with the works of "real geniuses." There have been

153

many valid critiques of the concept of genius—and how it can be biased in terms of gender, class, and ethnicity. Some of the most notable critics to pick apart this term are the social historians of art whose work is referenced throughout this book, such as Linda Nochlin and Griselda Pollock.[6] Other scholars have used computational methods to examine the persistence of canons and the practicalities of their formation and maintenance. Anna Brzyski—editor of *Partisan Canons* (2007), which featured many quantitative approaches to the study of art history and the canon—efficiently summarized these issues:

> In most universities and colleges, survey courses still consist mainly of great masters, although the word "genius" has been banned from our lexicon. While it would seem that many art historians would like to distance themselves from the survey textbook's litany of canonical artists, those "greats" still receive the greatest bulk of scholarly interest, as any survey of recent art historic bibliography will readily demonstrate. Likewise, museums clearly understand the economic advantages of blockbuster exhibitions drawing on the canonical standards. Although they certainly embark on noncanonical projects, they also provide us with a steady diet of Impressionist and Post-Impressionist shows because they know what will garner most attention and, in the end, attract the largest crowds.[7]

Brzyski and her fellow contributors go on to more specifically interrogate this persistence of the canon, and the practicalities—like access to a work in a public collection or at least the availability of reproductions of it—that continue its dominance.[8] The volume highlights how these practicalities keep a decidedly Western canon of art in place and limit the members of that canon to a familiar cast of characters. Yet despite these critiques of the concept of genius and of the canon, little systematic effort has been made to define what is *not* genius as embodied by the artworks that have *not* survived or have faded into such obscurity that no images of them are readily available.

The data presented throughout this book make clear how large this population of works is. From vast numbers of artworks produced in a given era or geographical setting, only a small number overcome Hume's test of time and are deemed masterpieces or even worthy of preservation. A tiny percentage of cultural output makes it into museums, textbooks, and scholarly publications. Furthermore, records are scant for those works of art that did not make the cut into an institution or major publication. They are often confined to a line of text in historic exhibition or auction catalogs, diminished for posterity to nothing but a listing in a dusty brochure. The most important contribution of this book is to reengage with this scant evidence—with the art thrown aside.

I have used quantitative methods to repurpose records of thrown-aside cultural production and reintegrate them into art historical consideration. The transcription, digitization, and statistical analysis of lists of hundreds of thousands

of artworks produced and displayed during the long nineteenth century provide vast and previously untapped historical sources. Inevitably, many if not most of the works recorded in these lists were not masterpieces—they should not have survived Hume's test of time. However, they were part of the artistic landscape that constitutes the historical and visual context for the masterpieces with which art history is traditionally concerned. Engaging with these artworks, then, immediately provides a more complete art historical context; it corrects for sample bias.

In many ways, the culling process that separates works that survive the test of time from those that do not is invisible. In Hume's formulation, this reversal of fortunes—for example, those of the academics and the Impressionists discussed in chapter 1—can be interpreted as part of a progressive process in which short-term fashions give way to the long-term collective selection of great art. However, in this view, the forces that identify genius are neutral. And while art historians may not explicitly echo this point of view, their continued focus on a limited cast of art historical characters implies what Hume states: the great art will naturally rise to the top. It will then enter the best museum collections, where it can be studied by scholars.

What this book has also sought to point out is that this separation of the artistic wheat from the chaff consists of the accrued contributions of generations of actors in the art world—artists, juries, collectors, dealers, curators, and others. These people rarely record their motives or leave complete archival records of why certain decisions were made to create, exhibit, acquire, or deaccession a given work of art. As economics teaches us, humans and the organizations they create have limited time, attention spans, and financial resources. These resources are, ultimately, all scarce. People must decide how to allocate resources according to what they judge to be most important and valuable for their personal well-being or that of the organization for which they are responsible. Whether it is a French painter who chooses to live in (and paint) the countryside in part because of its affordability, the woman artist who works in watercolors because her time is scarce, or the British institution most interested in granting limited wall space to status-granting portraits, these contemporaneous decisions were often idiosyncratic. Yet in aggregate they have an effect on the formulation of an artistic canon—the creation of sample that may be biased.

Drawing on available artistic data about a larger population of artworks is a first step in the detection of patterns in the effects of all these accrued decisions on the creation, preservation, and fame of artworks. With these datasets and some guidance from the social sciences about how to productively analyze them, it is possible to glimpse the structural constraints that formed the decisions and behaviors of artists and other actors. A bird's-eye view of the historical art world emerges. This view ultimately better contextualizes the works that have survived Hume's test of time. Furthermore, it provides insight into structures that determined and continue to determine artworks' lasting fame.

The patterns examined throughout this book—the relationship between images of nature and industrialization (chapter 3), the factors that influence the success of

women artists (chapter 4), or charting elements of the relationship between art and empire (chapter 5)—are glimpses from this higher vantage point. There are myriad other topics yet to be discovered, especially as computing technology gets more powerful and accessible and more sources are digitized. With these new tools, it becomes possible to answer art historical research questions, both long-standing and brand new, in novel ways. The principles laid out in this book—sample bias, the econometric concepts of dependent and explanatory variables, and the constraints of scarcity—are key to understanding which factors can and should be examined with quantitative evidence and from a data-driven perspective. However, a potential next direction is to turn this novel analytical lens to today's art institutions and decision makers. How does sample bias or scarcity continue to perpetuate scholarly and institutional focus on select artists and works? How can data-driven methods like econometrics help to answer these questions? These are future avenues of inquiry to be tackled.

Yet as this book has attempted to show and describe, data-driven analyses must not lose sight of the artworks and human stories behind each data point. In the 1960s, Jules Prown—once again prophetic in his comments—described the challenges of navigating this tension between individuality and aggregation. In the "The Art Historian and the Computer," he quoted a colleague to summarize the difficulties of integrating quantitative analysis into the study of art history: "What have the humanities and computers to say to each other? Are they not strangers, perhaps enemies, at heart? By definition the humanities should be concerned with quality and with individual man, computers with things in quantity or men in the mass."[9] A close view of particular artworks and artists will *always* be necessary for art historical scholarship. However, it is valuable to also consider the macroscopic view of artistic trends, as revealed by data-driven methods of research. By providing analyses that oscillate between a focus on individual artworks and on general trends made visible with statistics, we can place art in more complete socioeconomic and cultural contexts.[10]

It is not always easy to strike a balance between qualitative and quantitative; however, I believe it is worth striving for.

APPENDIX A

Further Information about Compilation of
and Access to Data Sources

The large datasets that support this research are all freely available at www.artsandecon .com. This website also includes the edited data and code that support the graphs, tables, and statistical tests cited in the book. I have done my best to check each dataset. However, with hundreds of thousands of data points, there are inevitably errors in the transcriptions and categorizations. If you use these datasets and find errors, please send a message to the email listed on the site to report them. I will try to update the data regularly to fix any identified issues.

As alluded to in chapter 2, assembling these datasets was a years-long process. The journey began my first year as a master's candidate in economic and social history at Oxford, when my college advisor suggested I take a look at an unpublished finding aid to all of the paintings ever shown at the Paris Salon. This was the Whiteley Index. Though it was suggested that I use the index to find landscape paintings—I was broadly interested in links between landscape painting and socioeconomic change, which I had tackled in an American setting for my undergraduate senior thesis—I immediately recognized it as an invaluable data source. I was taking a quantitative methods class at the time, which required us to do statistical and econometric testing with historical data. Based on the uniformity of the formatting, I also suspected that the index could be easily scanned and then transformed into digestible spreadsheets. Quantitative approaches to the study of landscape and rural genre painting displayed at the Salon became the focus of my master's thesis—and now the core of chapter 3. Using grants available from my Oxford college, I paid a freelancer

via the outsourcing platform Upwork.com (called oDesk.com at the time) to use optical character recognition to transform the hard-copy index into spreadsheets. From there, I manually transcribed and checked the titles of every work classified as rural genre painting in order to check Whiteley's error rate and to try to track down paintings tagged in this way.

Based on the strength of my master's work, I was encouraged to apply for a doctorate. In working on the Whiteley Index, I realized that there were other indices and datasets published about art in the United States. Some were hard copy and some were digitized. Therefore, for my doctorate I proposed to turn these sources into digestible datasets and, as with my master's thesis, use these new datasets to answer questions about the social and economic history of art. Although the transcription of the Whiteley Index was easy to automate, this was not the case for the American indices. One was digital and able to be web scraped (the Smithsonian Pre-1877 Exhibition Database) but all the others would have to transcribed by hand—which would take *years* to do on my own.

At this point, I began to use funding from a series of residential predoctoral fellow-ships as well as funds secured from Oxford to offset money I spent on outsourcing large portions of the transcription and error checking of the data. I knew it was possible to outsource this task because economists and economic historians routinely hire freelancers—often freelancers overseas— to generate usable data in this way. I have worked with several freelancers around the world that I located via Upwork.com. Aijo de

Bien and his staff in the Philippines, Sedat Cankaya in Turkey, and Geeta Sharma in India have all worked with me since 2015 to help make these datasets—the foundations of this book—a reality. Without their help, and the financial support of the institutions and fellowships mentioned in the acknowledgments, I could not have generated the data and used the methods that are the heart of this book's contribution. I highlight this not only to give credit where it is due but to help readers understand the financial resources and labor that supports this kind of work.

Though my doctoral dissertation focused on France and the United States, more information was made available about Britain—specifically, the Royal Academy—shortly after my thesis defense in the summer of 2017. Therefore, with the encouragement of my editor at Princeton, I worked with the same freelancers once more to transcribe information from the online resource *The Royal Academy Summer Exhibition: A Chronicle, 1769—2018* to form a third large dataset. Once again, the ability to secure generous fellowships (this time postdoctoral) allowed me to offset the costs of transcription. This work is expensive; I have been fortunate to work with institutions that paid well and I have also taken advantage of options like free housing with family and friends to lower my costs of living. The ability to afford to pay for transcription work so I could focus on data analysis and writing is a privilege.

I also owe an enormous debt to the scholars who assembled the sources—both hard copy and digital—that support my datasets. While their contributions are discussed in chapter 2, I want to reiterate my thanks for their hard work. When using this data, please cite not only this book and the digital versions of the datasets provided on the website but also the original sources on which they rely. My work stands on the shoulders of the careful scholars who created the underlying indices and resources.

My hope is that releasing these data will inspire other scholars and students interested in the data-driven history of art, or the related subfields of digital and computational art history. In this way, rather than redoing and recreating the enormous work of assembling these indices and making them digital, a new generation of scholars can harness this data to fuel exciting art historical research. Furthermore, describing the process of creating new digestible datasets will allow scholars considering engaging in this work to understand the necessary upfront investment in data transcription that facilitates this kind of research.

Finally, in the very last stages of my research I worked with Carlos Capella, another freelancer I located via Upwork.com, to improve the design of my graphs. During my doctoral work, I learned to analyze and visualize data in a program called Stata that is frequently used by economists and other social scientists. While Stata is a powerful tool for statistical analysis, it does not create the most aesthetically pleasing graphs. (Readers can see examples of Stata graphs in my earlier publications in the *Economic History Review* and *American Art*.) When I was working on an article that appeared in the *Archives of American Art Journal*, the editors asked if their designers could redesign my Stata graphs. Going through that redesign, and seeing the final product, made me realize how much more effective my graphs were when they had a cleaner design. Accordingly, in 2019 I learned how to graph in Tableau—a data visualization software. However, I remain a relative novice with the software. Carlos, an expert in Tableau, helped me transform the graphs I had created in Stata into the more compelling versions printed in this book.

A Brief Historiography of the Study of Jean-François Millet and the Relationship between City and Country in Nineteenth-Century French Rural Genre Painting

This appendix presents the results of extensive reading of footnotes and tracing of sources to track down where, in art history, theories about the relationship between nineteenth-century French rural genre painting and industrialization first emerged. It does not focus on broader Marxian theoretical sources from other disciplines and geographies, such as Raymond Williams's *The Country and the City* (1973). Instead, it primarily presents an examination of the modern study of the peasant image in nineteenth-century French art, which began with the study of Jean-Francois Millet in the 1960s. From there, it broadened to Gustave Courbet's Realist images of rural France and expanded to include other less-renowned artists who engaged with this topic, as well as studies of visual culture like books and popular prints depicting rural life. Due to this somewhat narrow focus (and word-count limits), this historiography is neither as exhaustive nor as nuanced as it could be.[1] However, it provides some further context about the emergence of the hypotheses and explanatory variables that chapter 3 aims to test.

Modern scholarship on Millet—and advocacy for the importance of his work and rural genre painting in the history of art—began with several publications by Robert Herbert, who would go on to become one of the founding social historians of art. Over eight years he published five works about French rural genre painting that had a particular focus on Millet: the landmark exhibition catalog *Barbizon Revisited* (1962), two articles published in the *Burlington Magazine* that same year, a 1966 article in the periodical

Museum Studies, and an essay that appeared in *Artforum* in 1970.[2] Considered together, Herbert's works develop a clear thesis about Millet and then rural genre painting more generally—that rural imagery served as an antidote to the perceived ills of the city. In the earliest of these publications, Herbert asserts that "art was a century-long protest against industrialization. The Gothic and Greek revivals, like Barbizon art, were a way of pulling the mantle of the past over the ugly present."[3]

Over the following four scholarly articles, Herbert further probed this theory about the links between Barbizon art and modernization, described as "the incredible expansion of cities, the new urban populations increasingly tied to the new industry."[4] He simultaneously sought to bolster Millet's artistic reputation. "Millet Revisited—I" begins, "Given the enormous impact of Millet upon the last half of the nineteenth century, he is clearly worth studying if only as an object-lesson in the history of taste."[5] After lamenting Millet's relegation to museum basements, Herbert describes how this neglect is the product of the artist's inaccurate late nineteenth-century public image as a pious and unrefined peasant painter. Only by breaking this "myth" can Millet's art be given its rightful place in the canon; therefore, Herbert spends the next portion of the article describing all the ways Millet disliked peasants in general, abandoned his own rural family, and was, in fact, among the most learned of the Barbizon painters.[6] Despite this long description of how Millet distanced himself from his own rural roots, Herbert declares: "Hence [the

artist's] taste for the Bible and for the Greco-Roman bucolic poets, because he found in the peasant of Barbizon, out of reaction against the Industrial Revolution, the past surviving into the present, this past which he wished to hug to his breast as his safeguard and salvation."[7] For Herbert, Millet was someone who simultaneously rejected his own peasant pedigree while feeling "nostalgia for a preindustrial era…[like that] of Ruskin and Delacroix."[8]

This personal arc—from dissatisfied peasant to learned artist to champion of a preindustrial past—is further elaborated in "Millet Reconsidered" (1966). The article asserts a need to break down the myth that "Millet's art…reflected his life."[9] Yet the impulse for Herbert's interpretation of Millet's art comes from what he saw as the artist's "almost morbid dislike of the city."[10] Herbert quotes two 1851 letters (also quoted in "Millet Revisited—I") in which Millet states how beautiful he finds the Forest of Fontainebleau and Barbizon, writing, for example: "The gayest thing I know is the calm, the silence which one enjoys so deliciously either in the forests or in the cultivated places."[11] These kinds of statements considered alongside the artist's relocation from Paris to Barbizon in 1849 provide the biographic starting point for Herbert's interpretation of Millet as anti-city—and then form the foundations of the application of this antiurban interpretation to the Barbizon School in general.

He generalizes this argument in the later articles by citing broad demographic statistics—mostly about the growth of Paris and its environs—and political upheaval linked to industrialization. "As the city grew ever larger, as its slums, its spectacular building campaigns, and its social upheaval became more prominent in France of the Second Empire, there was quite literally a need to bring landscape into the city. It entered quite directly in the growing number of landscapes, animal pictures and paintings of rural genre. These forms of painting constitute an urban phenomenon… Millet himself certainly found a measure of tranquility in the country around Barbizon, and he shared nostalgia for an untrammeled past."[12] He ultimately writes, "the peasant was among the most important subjects [expressing artists] attitudes toward the urban-industrial revolution."[13] Though stating that this theory is generally applicable to nineteenth-century France, Herbert chooses to focus almost exclusively on Millet because "he has been known as 'the peasant painter' since the 1850s and any interpretation of peasant art would have to be measured against his work."[14]

Many of the arguments about Millet in these later essays are similar to what Herbert first wrote in 1962. But in the 1970 article, he makes one significant addition to the evidence cited and omits one significant portion of past arguments. The addition is Millet's recollection of his initial arrival in Paris from Normandy in the 1830s: "Paris, black, muddy, smoky…made the most painful and discouraging impression upon me.… The immense crowd of horses and carriages crossing and pushing each other, the narrow streets, the air and smell of Paris seemed to choke my head and heart, and almost suffocated me. I was seized with an uncontrollable fit of sobbing."[15] The omission is also linked to Millet's relationship to the city and his peasant roots. In his earlier publications, Herbert had argued that many of the sources about Millet and his peasant-like innocence cannot be trusted. In an attempt to establish the painter as a canonical professional painter, Herbert emphasizes Millet's dissatisfaction with his early peasant life and his development into a sophisticated artist. The somewhat awkward evolution from dissatisfied peasant to erudite artist, and then to modern champion of a preindustrial past is eliminated from the later scholarship. Instead, a simple narrative emerges: Millet's images of countryside represent a negative reaction to the growth of the city. This narrative is then applied to Barbizon art and even some of the Impressionists' rural imagery.

Herbert's scholarship—and his thesis about the relationship between industrialization and rural genre painting—went on to influence a generation of social art historians writing about nineteenth-century French

rural genre and landscape painting. For example, Linda Nochlin dedicates a section in her landmark *Realism* (1971), which covers multiple geographies in the nineteenth century, to the peasant image. She writes, "It may seem odd, or even paradoxical, that the demands for contemporaneity in art and literature in the years around the middle of the nineteenth century were answered by artists who themselves so frequently chose to escape from the harsh realities of urban industrialism to the peace and eternal verities of the countryside, or that the time-honored labor of the peasant should be more frequently treated than the mechanical activities of the factory hand."[16] She attributes part of this interest to the reality that most of the labor force in France remained rural—so there was limited exposure to factory labor and limited ability to depict it—but also concludes: "On the other hand, the choice of the image of the peasant to embody contemporary labor was also a function of Realist myth. For while it is true that the peasant still accounted for the largest proportion of the working force in Europe, nevertheless, he and his life, his habits and customs, were already beginning to be recognized as part of a vanishing reality."[17] Perhaps unsurprisingly, the footnotes throughout this section cite Herbert's *Barbizon Revisited*.[18]

Nochlin situated her discussion of the peasant image in the context of the Revolutions of 1848; her analysis of works by Millet, Courbet, and Jules Breton appear after a discussion of images of barricades.[19] However, she moves relatively quickly from this probing of labor as an issue in the 1848 Revolution in France forward in time into the Second Empire, and even the Third Republic—eventually jumping across the channel to consider British art of the same period. In contrast, T. J. Clark lingered on 1848 and the brief Second Republic. In 1973, he published two foundational social histories of art—*Image of the People* and *The Absolute Bourgeois: Artists and Politics in France, 1848–1851*. With five works, Herbert is the most cited scholar in Clark's bibliography; Nochlin is a close second, with four.[20] Therefore, unsurprisingly, the theme of rural genre

painting as reaction to industrialization that was developed in Herbert's and Nochlin's earlier work emerges in Clark's books. And, as Herbert himself wrote in a review of Clark's scholarship years later, the two books had a significant impact on the history of art: "Among scholars open to new ideas, they presented such a penetrating and well-documented analysis that they immediately reoriented the history of mid-century and Barbizon art. Clark's introductory chapter to *Image of the People* ... circulated in photocopies among students, historians, and critics in Great Britain and the United States, and became the touchstone for heady discussions of art's relation to history and society."[21]

The Absolute Bourgeois, which includes chapters on Millet, Honoré Daumier, Eugène Delacroix, and Charles Baudelaire, focuses on political readings of the works studied. *Image of the People*, which centers on Courbet, is Clark's explicitly declared attempt to create a social history of art.[22] However, the social and political readings are ultimately intertwined. Clark insists that *la question sociale*—the question of the People's social well-being—was central to the political discourse of the period. Where Herbert's peasants are a representation of a nostalgic yearning for a preindustrial past, in Clark's formulation they become potential political actors who can threaten revolution, particularly if they decide to leave their fields and move to Paris.

Clark's final conclusions are sometimes hard to pin down amid eloquent descriptions and formal analysis of select canvases, and suggestions of connections between works, their makers, and broader social change. As Herbert wrote in a reflective review of Clark's *Farewell to an Idea* (1999), which represents a long meditation on the art historian's scholarship: "Social art history, [Clark] wrote, should treat art neither as the 'reflection' of society nor as 'background,' and should not depend upon intuited analogies between subject and form. It should instead concentrate on the modes and conventions of representation in specific pictures by specific artists. Only through these could one hope to 'explain the connecting links

between artistic form, the available systems of visual representation, the current theories of art, other ideologies, social classes, and more general historical structures and processes.'"[23] What emerges from Clark's process is not a clearly stated theory about concrete and generalizable links between art and society—as Herbert provides—but rather evocations of these links.

One conclusion of Clark's work is his argument that it is necessary to look at mid-nineteenth-century painting through the lens of a question that he posits bourgeois French people were consistently asking themselves in the wake of 1848: "Were the People savages or heroes? When they manned the barricades, were they serfs fighting their masters' battles?...Or were they Barbarians storming the city?"[24] In the context of these politically charged questions about the role of the People, Clark argues that depictions of common men and women took on strong political meanings.[25] While Clark applies this lens to the work of Millet and other artists in *The Absolute Bourgeois,* his theories become clearest across several chapters of *Image of the People* that focus on the paintings Courbet produced during the Second Republic. At this time, the artist was working primarily in his hometown of Ornans in the Franche-Comté. The largest and most well-known of these paintings is his massive *Burial at Ornans.* Displayed at the Salon of 1850–51, *Burial at Ornans* provoked strong critical reactions "from admiration to outrage, and even the attitudes of hostility (which did predominate) were most often marked by reservations, genuine puzzlement, distress and an obvious effort to understand the incomprehensible."[26] Clark argues that the Parisian press and public reacted this way because Courbet had painted in the context of a countryside funeral a range of classes and types who were recognizably urban.[27] It was the juxtaposition of what was considered to be an urban phenomenon—class division—and a rural setting that was most unsettling. Clark writes about reactions to the *Burial:*

Anger was common to the Left and Right: nobody wanted the massive, ironic

representation of a rural bourgeoisie. The Left—or rather, its artistic spokesmen in Paris—wanted a glorification of the simple rural life, or perhaps a straightforward portrayal of its hardships....The Right and Centre wanted a preservation of the rural myth.[28]

Regarding this "rural myth" in the context of contemporary art criticism, Clark writes:

The [proper] painter of rural life portrays precisely and only what is alien to the town, what "we should be looking for" in the fields. Millet's peasant is acceptable because he is distinctly other; his primitive grossness will not be altered by his stay in Paris, and we, it is implied, have little to fear from it. He will stay a countryman, even in the city...he will not become a proletarian.[29]

Though Clark was discussing a narrow period in French history and a limited number of artists, this conclusion—that acceptable images of the countryside portray rural life as wholly distinct from city life and immune from the class conflict, politics, and violence of an urban setting—has become a cornerstone of study of French rural genre painting generally.

Contributors who have since built upon and responded to this theory include Albert Boime, Griselda Pollock, Madeleine Fidell-Beaufort, Richard and Caroline Brettell, Simon Kelly, and Gabriel P. Weisberg, among others.[30] Of the relatively recent contributions to the literature, one particularly important gathering of work is the edited volume *Soil and Stone: Impressionism, Urbanism, Environment* (2003), which includes several essays analyzing the work, lives, and careers of the rural genre painters that are the primary focus of chapter 3.[31]

For the purposes of this book, I would like to highlight Christopher Parsons and Neil McWilliam's 1983 article about Alfred Sensier, Nicholas Green's *The Spectacle of Nature: Landscape and Bourgeois Culture in Nineteenth Century France* (1990), and Bradley Fratello's 2003 article in *Art Bulletin* that traces the long-term fame of Millet's works.

Parsons, McWilliam, and Fratello have specifically dug into the sources of the myths around Millet's peasant background, while Green developed a more nuanced theory of the relationship between city and country in nineteenth-century France that has implications for the study of landscape and rural genre painting.

Though their work is separated by two decades, Parsons and McWilliam and Fratello make clear that some sources of information that supported the original social histories of rural genre painting—notably, of Millet—should be regarded with skepticism. In particular, Sensier's biography of Millet is suspect and should be read as a marketing document. The agent greatly exaggerated Millet's peasant roots, opinions, and behaviors as part of broader marketing campaigns to sell his work, as well as that of other Barbizon artists. As Parsons and McWilliam conclude, "Above all, however, [Sensier's] relationship with Millet himself highlights a fundamental duplicity seemingly at odds with the simple peasant virtues [he] was to eulogise at such length."[32] Fratello also interrogates Sensier's work, and specifically traces how Millet's paintings became French icons over time—and therefore immune from more critical analyses of stories told about their creator.[33] Taken together, these contributions demand that scholars challenge the rural myths that surround the Norman painter and his Barbizon colleagues.

Although Millet and Barbizon artists appear in Green's book, they are not its core focus. Instead, Green uses Foucauldian theory and evidence such as plans for urban development and guidebooks to trace how Parisians developed a "metropolitan gaze," a particular set of beliefs in how urban society should be organized and extended. He asserts that nature was central in this process: "In early to mid-nineteenth-century France nature [played] a significant role in the securing and maintenance of a certain kind of bourgeois hegemony."[34] In Clark's and Herbert's scholarship, the countryside and its inhabitants are understood primarily as opposite to the city. Green modifies this

assertion. He argues that nature—and, more broadly, open space—was progressively integrated into the worldview of urban dwellers as something other to the city, echoing earlier scholarship. However, he asserts that the development of "nature" as a cultural concept is in fact *dependent* on modernizing cities.[35] City and country depend on one another for their definition, and so there can be slippage in the delineation between the two spaces.

Green applies this lens to Barbizon in one five-page section of *Spectacle of Nature*. He writes that, beginning in the 1820s, "Villages round the forest began to operate as an extension of the Parisian studio or *atelier*. Instead of painting in the *atelier*, artists sought their models in the open air. Yet they brought with them all the baggage of rising urban professionals."[36] Part of this baggage was commercial interest and finding ways in which their careers could be supported by their time in village, with some artists even becoming local entrepreneurs. However, Green writes, the artists sought to deny this commercialization of Barbizon and the Forest of Fontainebleau while simultaneously cultivating it. "If the painters transformed what they perceived to be valuable in the village, they also set themselves up as staunch defenders of the primitivism of the forest against the depredations of commercial interests, whether tourist trippers or the planting of pines."[37] Via a different route, Green recognizes points acknowledged by Parsons and McWilliam: that there is significant mythmaking involved when modern artists and their agents present painters either as defenders of natural and rural space or, in the case of Millet, as peasants themselves. Despite their own clear simultaneous entanglements with both the city and country, the artists worked to try to define the country in clear opposition to the industrializing city.

Green's approach to the relationship between city and country is more nuanced than his predecessors', and his conclusions about the ways in which rural genre painters were inextricably tied to Paris are reinforced by the findings of chapter 3 in this

book. However, the takeaway from Green's work that I want to emphasize is that he is ultimately interested in the same variables that earlier social histories of art highlight as important drivers of the creation and consumption of images of nature. These include industrialization, urbanization rates, and the growth of transport networks (particularly trains). Green is also notably interested in growing tourism from Paris, a theme Herbert, too, has addressed in his scholarship.[38] While scholars have had different interpretations of the impact of any one of these variables on artists and their audiences, the corps of variables of interest has remained fairly constant since Herbert's first 1962 publication about Millet. Ultimately, it is this inherited list of variables of interest whose effects are tested in chapter 3. While the focus of this appendix has been to trace the development of theses about the relationship between industrialization and images of nature—and Millet's centrality to them—the goal of chapter 3 is to contribute to a broader ongoing conversation about the relationship between art and socioeconomic change by testing these consistent variables of interest.

APPENDIX C

Subject Headings in the Whiteley Index Identified as Rural, Industrial, Religious, and Family Tags

Below is an alphabetical list of all of Whiteley's tags that I determined to be "rural," "industrial," "religious," and "family" genre paintings. Whiteley created a separate section for genre painting, and these tags are within that section. He also grouped many of these tags himself, although I made some slight changes to these groupings. When looking at these lists, it is clear that some areas have more applicable tags than others—there are, for example, far more rural tags than industrial ones. This is a function of Whiteley's own indexing of titles he observed and categorized in the *livrets*

(see chapter 2). However, sometimes even when there are relatively few tags—as for family genre—one tag can be applied to *many* paintings. There are, for example, 542 genre paintings tagged with "Mothers" listed in the index.

Similarly, Whiteley separately identified landscape painting in a dedicated section of the index. When landscapes were views of large cities (such as Lyon or Bordeaux), these relatively few paintings were excluded from the total and departmental counts of landscapes.

Rural Genre Painting Tags

Apple picking and cider making
Beetroot
Bird catchers
Burning and gathering seaweed
Charcoal burners
Colza
Cutting and carrying grass
Excavating sand and gravel
Faggot gatherers
Fairs
Farm and farmyards
Festivities
Foragers
Forest wardens
Gamekeepers
Girls keeping watch over poultry
Gleaning
Going to or coming from the market
Going to or returning from the fair

Growing, picking and pressing grapes
Harvesting
Haymaking
Hemp
Herding goats and cattle
Hoe
Hops
Idylls
Inspector of woods and water
Le retour des champs [the return to the fields]
Markets
Milk, milking, milkmaids
Oil press
Olive picking
Other crops
Other scenes of rural life
Peasants leaving for the fields or for the town
Peasants returning home
Planting potatoes
Ploughing

Potato picking
Poste aux choux [a dinghy carrying goods]
Rural police
Scarecrows
Scything
Sheep shearing
Shepherds and pastoral subjects
Sieving
Sowing
Threshing
Tossing the hay
Trussing
Unspecified crops
Water carriers
Weeding
Wells
Wheat
Winnowing
Woodcutters
Wool-washing

Industrial Genre Painting Tags

Businessmen
Capitalists
Chimney-sweeps
Demolition
Forges
Foundries
Kilns
La grève (assuming it is "the strike")
Le peuple (The People)
Limited company
Mines, factories and workshops
Omnibus horses and omnibuses
Out of work
Printers
Proletariat
Road makers and roadmenders
Stonebreakers, stonecutters and quarries
Tanyards
The telegraph
Trains
Vocation
Work
Workers

Religious Genre Painting Tags

Abbots
Absolution
Acts of blessing and holy water
All Saints
All Souls
The Angelus
Ave Maria
Baptism
Benedictines
Capucins
Cardinals
Carmelites
Carthusians
Chaplain
Christmas
Coming from church
Communion
Confession
Confirmation
Convents and cloisters
Corpus Christi
Curés
Dominicans
Easter
Extreme unction
The feast of the Assumption
Franciscans
Funeral customs
Going to church
Grace
The holy bread
Lent
Marriage and married couples
Mass
Missionaries
Monks in other orders
Monks in unspecified orders
The month of Mary
Nuns
The Office (a Catholic prayer)
Ordination
Other religious subjects
Other scenes of Breton piety
Palm Sunday
The Pardon in Brittany
Parish priests
Penitence and remorse
Piety
Pilgrims
Pleas for intercession
Prayer
Preaching
Processions
Protestants
Puritans
Relics and reliquaries
Religious instruction
Rosaries
Sacred music
Sacred offering
Saint Valentine's Day
Sisters of Charity
Sunday
Tombs
Trappists
Vespers

Family Genre Painting Tags*

Brothers and sisters
Family Scenes
Fathers
Godmothers
Grandfathers
Grandmothers
Happy Families
Mothers
Old Age
Old Men
Old Women
Unhappy Families

*Children are excluded from this category because there are dozens of children-specific tags. Often children are classified as doing an activity, like going to school. It was hard to isolate what was family-specific or not.

Full Regression Tables, How to Read Regression Tables, and Further Discussion of Results

The main results from the regression analysis are presented in tables D.1–D.4. For readers who are new to regression analysis and would like to learn more about it, this appendix explains how to interpret regression results.

Each of the first seven rows of the regression tables represents a different explanatory variable, while each numbered column represents a different "model"—a set of conditions—under which the effects of the explanatory variables are being tested. The numbers in the cells that *are not* in parentheses are the "regression coefficients." Regression coefficients represent the "influence of that particular explanatory variable on the dependent variable while the influence of all other variables is held constant."[1] The larger the coefficient, the bigger the effect. If it is a positive number, the variable had a positive effect on, in this case, the number of landscape or rural genre paintings that depicted a given department. If it is negative, it had a negative effect on the number of depictions.

These coefficients are only valid if they are "statistically significant." The numbers in parentheses under each regression coefficient are the results of a t-test for statistical significance; the larger numbers indicate more statistically significant results. Results are statistically significant if there is a strong chance that they are not random. One asterisk means there is only a 10 percent chance the result is random; two asterisks mean there is only a 5 percent chance the result is random, and three asterisks indicate there is a 1 percent chance or less that the result is random.[2]

On the left-hand side of the regression one can also see two rows that read "Department Dummies" and "Year Dummies." A "dummy variable" is a variable that is either a "1" for "Yes" or "0" for "No." In econometrics, dummy variables are frequently used to control for effects that have not been explicitly identified in the explanatory variables being tested. The "Department Dummies" are a "1" assigned to each department—this controls for the intrinsic individual differences across departments. These differences include things like variations in climate and main agricultural activity between, for example, Finistère and Pas-de-Calais. The "Year Dummies" assign a 1 for all observations from a given year. There are as many year dummies as there are years in the sample. For example, all information from 1846 is assigned a "1" for the 1846 year dummy; observations from all other years are assigned a "0" for the 1846 year dummy. While the department dummies control for intrinsic differences across departments, the year dummies do the same thing for individual years controlling for national factors affecting all departments that change from year to year. These could, for example, include differences in the national economic situation or national population size in 1845 versus 1873.

Departmental dummies are cross-sectional dummies. Adding cross-sectional dummies allows one to isolate effects *over* time. In contrast, adding year dummies, which are time-series dummies, allows one to pinpoint the effects of differences between departments in the cross-section. (See chapter 3 for an explanation of cross-

sectional and time-series data.) Using both kinds of dummies together functions as a sort of safety net—they control for differences and important variables that one has not anticipated or cannot measure with the specific explanatory variables available.

The addition of dummy variables constitutes a significant change to the model. Therefore, it is best to present regression results with types of dummy variables added one by one. In all four tables (D.1–D.4), the first four columns (1–4) test all the variables *except* for the percentage of the work force engaged in agriculture, which is only available from 1855, and therefore limits the sample tested. Columns 5–8 test all the variables over the shorter time period for which agricultural employment share is available. Across these two groups of four columns, the dummy variables are added progressively. Columns 1 and 5 have no dummy variables, 2 and 6 only year dummies, 3 and 7 only department dummies, and 4 and 8 both year and department dummies. Presented this way, one can see the effects of the selected explanatory variables when controlling for different unobservable conditions.

The final three rows of the table—"N," "r2," and "F"—provide information about the model's effectiveness as a whole. "N" is the total number of observations (dependent variable data points) tested; "r2" is a percentage score for how well the explanatory variables explain the behavior of the dependent variable; and "F" is the result of the test for the statistical significance of the whole model. Every model presented here is statistically significant. With this key to reading regression tables in mind, it is possible to dig into more of the interpretive nuance of these statistical results.

To facilitate interpretation of the regression results, it is helpful to divide explanatory variables into supply-side and demand-side effects.[3] Of course, the Salon data are not price data from contemporary auctions or dealer records—it is not a market of buyers and sellers. Instead, the exhibition stood at the center of a constellation of political, intellectual, and aesthetic pressures. How

can one identify supply and demand in this complex system? Suppliers were the artists who had submitted their works for exhibition. The jury—those who decide which works to admit—was the primary component of demand, although it responded to significant public and political pressures. Some variables are easily characterized as either supply- or demand-side. For example, the increasing number of artists' colonies is clearly supply-side. These communities providing a creative infrastructure in the countryside had a direct effect on artists and a limited effect on the Salon jury. In the context of nineteenth-century France, however, most social and economic variables could affect cultural production from both sides of the interaction between supply and demand.

Consider the growth of the railways, which in this project is measured by the price of rail travel between each *département* and Paris.[4] The most basic assumption is that the railway is a supply-side variable, because it allowed artists to access and paint the countryside. However, an argument can also be made that the railway shaped demand. First, in an abstract way, the growth of the railway may have influenced the public's and jury members' feelings—either positively or negatively—about the modernization of France. Second, more concretely, if the railway connected a rural region to Paris or another major city, not only rural genre and landscape painters could travel to that newly connected region, but jury members and art audiences as well. People may have demanded images of where they have traveled to or perhaps the places from which they emigrated.[5] Finally, returning briefly to the supply side, a number of painters—including Millet, Breton, and Courbet—were among the emigrants who moved from newly connected regions to the capital. Thus, it is difficult to determine how the railway may have affected cultural output and the strength of that effect.

To resolve this conundrum, one can use what is called a time lag. Artists frequently did not paint and display paintings in the same year; instead, it could take several

months or years to complete a work suffi-ciently large and polished for display at the Salon. A time lag in econometrics is when one intentionally mismatches data from a given year, in this case pairing exhibition data from, for example, 1853 with social data from 1852, rather than 1853. Why do this? The lag better recreates the social and eco-nomic environment in which the artists were actually working on a painting, assuming the artist spent time in 1852 working on a canvas shown in 1853. If the lagged social variables help to recreate the artists' creative context, what does analyzing the variables without lags accomplish? It recreates the context in which the admissions jury, which usually made its decisions within one year, accepted paintings. Using lags, one can disaggregate the effects of social variables on supply (artists) and demand (jurors and the pressures they faced). Tables D.1 and D.2 present regressions *without* lags; tables D.3 and D.4 use lags. In general, lagged results were not significantly different from regres-sions in which explanatory variables were not lagged. There is one notable exception to this characterization: labor unrest, which had a greater effect in the lagged model. This difference is discussed below.

Full statistical results for the models without lags are presented in tables D.1 and D.2; standard errors are clustered at the department level to control for hetero-scedasticity.[6] The first clear result is that the advent of artists' colonies had a greater effect on the depiction of a department than any other variable measured. Although the results are slightly more complicated for rural genre painting than for landscape, the presence of an artists' colony generally had a positive effect on likelihood of a depart-ment's depiction. Artists' colonies provided several amenities to artists. They often had a low cost of living and were home to locals amenable to having artists in their village. The artists also provided one another with instruction, support, and inspiration. As discussed in chapter 3, colonies were infra-structure that simultaneously allowed artists to come into greater contact with a rural environment and encouraged the production

of more canvases.[7] If more artists could have easier access to painting en plein air in the countryside, they would produce more images of nature and rural life. Furthermore, as has been demonstrated for other clusters of artists, working within a group could improve the quality of art an artist made.[8] Higher-quality works created in a collabora-tive setting may have been more likely to be accepted by the Salon jury. These findings are consistent with earlier research about clusters of artists in urban settings.

The effect of travel prices between a department and Paris reinforces the first point about accessibility: the more accessible the countryside became by rail, the more often it was depicted. The effect is recorded as negative because the independent variable is an index of the cost of rail travel from Paris to an outlying department. As the price of travel increased, the number of paint-ings of that location decreased; inversely, as the cost of travel decreased, depictions increased.

The addition of year and department dummy variables significantly altered the results of these panel regressions. The results for "Average Price of Travel from Paris to Department" in table D.1 illustrate this. Before the addition of any dummies, its effect is statistically significant and negative. This effect remains consistent after the addition of year dummies. However, it changes when one adds department dummies; its effect becomes positive and no longer statistically significant. This pattern of dilution indicates that a variable has clear cross-sectional effects on the production of paintings—effects the departmental dummies then eliminate. This is evidence that the variable has a stable, long-term impact across departments, though it does not explain variations over time. For this variable, it means that departments with more affordable train access were depicted more often. However, departments where the price of travel changed significantly within the time of the sample (i.e., during the mid-nineteenth century) were not necessar-ily more frequently the subjects of landscape paintings because of this recent change.

The legacy of access—and not changing access—has a clearer influence on artistic output. Other variables follow this pattern of having a statistically significant effect prior to the addition of departmental dummies and then losing significance or changing direction (or both) once the departmental dummies are added. This is true, for example, for the share of a department's workforce employed in agriculture.

The presence of tourist attractions is only significant, and is positive, once department dummies are added. This pattern of coefficients suggests that it is not the presence of a longstanding seaside resort or mountain spa town that encourages depiction in landscape or rural genre painting but rather the addition of new tourist attractions over time. A quick survey of the types of tourist attractions developing in the second half of the nineteenth century demonstrates why this is true. As the century progressed, tourism in "authentic" French rural destinations—like Brittany, where traditional ways of life and dress remained intact until the twentieth century—became increasingly popular.[9]

As with tourist attractions, one has to look beyond simply the presence of an artist colony to what kind of artists' colony was present to understand some results. A survey of artists' colonies active during the nineteenth century indicates why new artists' colonies added during the sample had a negative effect on rural genre painting but a positive one on landscape painting. Colonies that produced large amounts of rural genre painting for the Salon—such as Barbizon, Pont-Aven, and other villages in

Finistère—were all founded in the 1820s and '30s. They are stable throughout the sample.[10] Newer colonies, such as those founded on the Normandy coast, were more avant-garde and often focused on the creation of landscape painting. The artists who worked in these new colonies rarely produced rural genre paintings and often did not exhibit at the Salon at all. Thus, the sign becomes negative, indicating the new colonies did not produce much, if any, rural genre painting displayed at the Salon.[11]

Urbanization and strikes and labor activity[12]—central parts of art historians' hypotheses about the links between rural imagery and socioeconomic change—have no consistent effect in the panels where rural genre painting is the dependent variable. For landscape painting, the effect of strikes and labor activity is significant only in the lagged model before fixed effects. The coefficient is negative, indicating artists chose not to depict departments with track records of unrest, just as art historians have suggested. This negative effect is not, however, robust across models.

While not definitive proof of causal relationships, these regressions suggest variables linked to accessing the countryside—such as artist colonies and cost of travel—affect the number of depictions of the countryside. The ability to work in a collegial environment in a rural setting not too far from Paris seems to have more greatly affected the frequency of depicting rural environments than did broad changes in the French economy or abstract concerns about the ills of modernization.

TABLE D.1 Factors Influencing the Number of Landscape Paintings Shown at the Salon Depicting a Department, 1831–1880

VARIABLES	(1)	(2)	(3)	(4)	(5)	(6)	(7)	(8)
Number of Artist Colonies in the Department	12.913***	12.778***	6.396***	6.019***	12.876***	12.847***	5.670***	5.186***
	(48.25)	(47.78)	(3.02)	(3.23)	(38.51)	(38.13)	(4.67)	(4.54)
Average Price of Travel from Paris to Department	-0.058***	-0.071***	0.007	0.075	-0.087***	-0.089***	0.017	0.143
	(-8.39)	(-9.60)	(0.36)	(1.15)	(-6.45)	(-6.44)	(0.45)	(1.65)
Number of Major Cities (Pop. > 10,000) in Department and Neighboring Departments	-0.107	-0.100	0.087	-0.144	-0.219**	-0.209**	0.032	-0.095
	(-1.47)	(-1.38)	(0.53)	(-0.70)	(-2.09)	(-1.97)	(0.26)	(-0.58)
Number of Tourist Attractions in the Department	0.100	0.163**	0.869***	0.764**	0.011	0.034	0.915***	0.911***
	(1.27)	(2.01)	(3.33)	(2.28)	(0.11)	(0.32)	(4.58)	(4.49)
Strikes and Labor Activity in Department	-0.117	-0.148	0.106	0.080	-0.189	-0.223	0.215	0.205
	(-0.86)	(-1.08)	(1.39)	(1.12)	(-0.99)	(-1.16)	(1.43)	(1.30)
Percentage of Workforce of Department Employed in Agriculture (only available from 1855)	—	—	—	—	-3.412**	-3.306**	-10.074	-8.493
	—	—	—	—	(-2.37)	(-2.28)	(-1.30)	(-1.12)
Total Number of Paintings Shown at the Salon (control for changing size of exhibition)	0.001***	0.001***	0.001***	0.002***	0.002***	0.002***	0.002***	0.002***
	(10.65)	(6.92)	(4.23)	(3.55)	(10.49)	(7.68)	(4.60)	(3.42)
Department Dummies (Yes/No?)	No	No	Yes	Yes	No	No	Yes	Yes
Year Dummies (Yes/No?)	No	Yes	No	Yes	No	Yes	No	Yes
N	2878	2878	2878	2878	1666	1666	1666	1666
r2	0.56	0.57	0.26	0.29	0.60	0.60	0.23	0.24
F	601.41	101.01	18.18	16.96	353.53	98.48	25.37	15.45

* significant at α = 0.10, ** significant at α = 0.05, *** significant at α = 0.01; standard errors clustered at the department level.

TABLE D.2 Factors Influencing the Number of Rural Genre Paintings Shown at the Salon Depicting a Department, 1831–1880

VARIABLES	(1)	(2)	(3)	(4)	(5)	(6)	(7)	(8)
Number of Artist Colonies in the Department	0.246***	0.248***	0.027	0.009	0.277***	0.272***	-0.715***	-0.695***
	(15.03)	(15.10)	(0.36)	(0.15)	(13.07)	(12.87)	(-4.66)	(-4.23)
Average Price of Travel from Paris to Department	-0.000	0.000	0.000	0.004*	-0.000	-0.001	0.005*	-0.005
	(-0.24)	(0.22)	(0.12)	(1.87)	(-0.43)	(-1.25)	(1.71)	(-1.04)
Number of Major Cities (Pop. > 10,000) in Department and Neighboring Departments	0.001	0.002	0.005	0.008	0.002	0.006	-0.009	0.006
	(0.13)	(0.47)	(0.52)	(0.89)	(0.25)	(0.84)	(-0.59)	(0.38)
Number of Tourist Attractions in the Department	0.001	0.002	0.032***	0.035***	-0.003	0.002	0.063***	0.071***
	(0.24)	(0.46)	(3.82)	(3.77)	(-0.52)	(0.25)	(5.89)	(5.73)
Strikes and Labor Activity in Department	-0.011	-0.012	-0.006	-0.007	-0.014	-0.016	-0.005	-0.006
	(-1.32)	(-1.40)	(-0.86)	(-1.00)	(-1.14)	(-1.33)	(-0.69)	(-0.84)
Percentage of Workforce of Department Employed in Agriculture (only available from 1855)	—	—	—	—	0.022	0.059	-0.384	-0.488
					(0.24)	(0.64)	(-1.15)	(-1.41)
Total Number of Paintings Shown at the Salon (control for changing size of exhibition)	0.000***	0.000***	0.000***	0.000**	0.000**	0.000***	0.000**	0.000**
	(3.81)	(2.58)	(2.83)	(2.17)	(2.41)	(3.05)	(2.57)	(2.15)
Department Dummies (Yes/No?)	No	No	Yes	Yes	No	No	Yes	Yes
Year Dummies (Yes/No?)	No	Yes	No	Yes	No	Yes	No	Yes
N	2878	2878	2878	2878	1666	1666	1666	1666
r2	0.10	0.12	0.02	0.05	0.12	0.15	0.08	0.10
F	53.01	10.40	6.70	4.70	33.81	11.13	6.63	5.22

* significant at $\alpha = 0.10$, ** significant at $\alpha = 0.05$, *** significant at $\alpha = 0.01$; standard errors clustered at the department level.

TABLE D.3 Factors Influencing the Number of Landscape Paintings Shown at the Salon Depicting a Department, 1831–1880, All Explanatory Variables Lagged 2 Years

VARIABLES	(1)	(2)	(3)	(4)	(5)	(6)	(7)	(8)
Number of Artist Colonies in the Department	14.214***	14.194***	8.060***	7.388***	14.007***	14.033***	8.105***	7.353**
	(47.43)	(48.11)	(3.27)	(3.65)	(38.09)	(38.90)	(3.06)	(3.19)
Average Price of Travel from Paris to Department	-0.071***	-0.073***	-0.034*	0.102*	-0.098***	-0.095***	-0.040	0.207*
	(-9.00)	(-8.64)	(-1.92)	(1.67)	(-6.63)	(-6.41)	(-1.10)	(1.96)
Number of Major Cities (Pop. > 10,000) in Department and Neighboring Departments	-0.073	-0.091	0.206	-0.173	-0.217*	-0.236**	0.116	-0.348
	(-0.88)	(-1.12)	(1.22)	(-0.81)	(-1.88)	(-2.07)	(0.76)	(-1.50)
Number of Tourist Attractions in the Department	0.124	0.122	0.918***	0.761**	0.072	0.048	0.794***	0.712**
	(1.37)	(1.33)	(3.84)	(2.57)	(0.62)	(0.41)	(3.05)	(2.81)
Strikes and Labor Activity in Department	-0.330**	-0.316**	-0.075	-0.075	-0.488**	-0.457**	-0.061	-0.007
	(-2.21)	(-2.14)	(-0.89)	(-0.80)	(-2.42)	(-2.28)	(-0.94)	(-0.10)
Percentage of Workforce of Department Employed in Agriculture (only available from 1855)	—	—	—	—	-3.289**	-3.559**	-7.053	-6.338
	—	—	—	—	(-2.07)	(-2.28)	(-1.07)	(-1.02)
Total Number of Paintings Shown at the Salon (control for changing size of exhibition)	0.000**	0.000	0.000***	-0.006***	0.001**	0.000	0.001***	-0.006**
	(2.57)	(1.55)	(3.09)	(-4.64)	(2.39)	(0.54)	(3.25)	(-4.59)
Department Dummies (Yes/No?)	No	No	Yes	Yes	No	No	Yes	Yes
Year Dummies (Yes/No?)	No	Yes	No	Yes	No	Yes	No	Yes
N	2441	2441	2441	2441	1498	1498	1498	1498
r2	0.58	0.60	0.23	0.33	0.61	0.63	0.14	0.26
F	555.25	113.30	19.95	10.33	328.07	108.30	12.46	13.24

* significant at α = 0.10, ** significant at α = 0.05, *** significant at α = 0.01; standard errors clustered at the department level.

TABLE D.4 Factors Influencing the Number of Rural Genre Paintings Shown at the Salon Depicting a Department, 1831–1880, All Explanatory Variables Lagged 2 Years

VARIABLES	(1)	(2)	(3)	(4)	(5)	(6)	(7)	(8)
Number of Artist Colonies in the Department	0.271***	0.272***	0.079	0.068	0.293***	0.289***	-0.250***	-0.223**
	(15.49)	(15.57)	(1.14)	(1.18)	(13.36)	(13.27)	(-3.02)	(-2.46)
Average Price of Travel from Paris to Department	-0.000	-0.000	-0.000	0.003	-0.000	-0.001	0.005*	-0.007
	(-0.85)	(-0.48)	(-0.36)	(1.49)	(-0.53)	(-1.21)	(1.88)	(-1.48)
Number of Major Cities (Pop. > 10,000) in Department and Neighboring Departments	0.006	0.007	0.009	0.015	0.010	0.013*	-0.003	0.011
	(1.24)	(1.55)	(0.82)	(1.36)	(1.40)	(1.85)	(-0.19)	(0.65)
Number of Tourist Attractions in the Department	0.008	0.009	0.038***	0.041***	0.005	0.009	0.058***	0.064***
	(1.49)	(1.62)	(3.48)	(3.63)	(0.78)	(1.29)	(5.25)	(5.53)
Strikes and Labor Activity in Department	-0.002	0.001	0.005	0.008	0.001	0.003	0.009	0.013
	(-0.24)	(0.06)	(0.76)	(1.25)	(0.05)	(0.23)	(0.96)	(1.28)
Percentage of Workforce of Department Employed in Agriculture (only available from 1855)	—	—	—	—	0.019	0.051	-0.336	-0.464
					(0.20)	(0.54)	(-1.21)	(-1.57)
Total Number of Paintings Shown at the Salon (control for changing size of exhibition)	0.000***	0.000	0.000***	-0.000	0.000*	0.000*	0.000**	-0.000
	(3.64)	(0.22)	(3.51)	(-1.35)	(1.66)	(1.84)	(2.48)	(-1.39)
Department Dummies (Yes/No?)	No	No	Yes	Yes	No	No	Yes	Yes
Year Dummies (Yes/No?)	No	Yes	No	Yes	No	Yes	No	Yes
N	2528	2528	2528	2528	1498	1498	1498	1498
r2	0.13	0.15	0.03	0.06	0.15	0.17	0.02	0.05
F	60.50	13.02	8.52	7.74	37.93	13.46	4.87	4.03

* significant at α = 0.10, ** significant at α = 0.05, *** significant at α = 0.01; standard errors clustered at the department level to control for heteroscedasticity.

French Transcription of Letters
Written by Jean-François Millet

Some awkward phrasings, idiosyncratic spellings, and grammatical mistakes made by the author are preserved here in order to be maximally faithful to the original text.

Jean-François Millet to Alfred Sensier, February 1851, Cote BSb12L9, Réserve des autographes, Cabinet des dessins, Musée du Louvre, Paris.

Samedi

Mon Cher Sensier,

J'ai reçu hier vendredi les couleurs huile que vous m'envoyez et le tableau ébauché qui y était joint.

Voici les titres des trois tableaux pour la vente en question:

1. Femme broyant du lin
2. Paysan & paysanne allant travailler dans les champs
3. Ramasseurs de bois dans la forêt

Je ne sais si un mot de Ramasseurs peut s'imprimer, si…vous mettez.

Paysan et paysannes [es…en…ou] en que vous voudrez. Sachez seulement que le tableau se compose d'un homme liant un fagot et de deux femmes, l'une coupant des branches et l'autre tenant un buisson de bois. Voilà.

Dès que les bordures seront faites dites le moi afin que j'aye le temps de voir sans tableaux dedans et au besoin les retoucher.

Il n'y a comme vous pour les décrire par les titres, dans mes tableaux en train, ni femmes nues, ni sujets mythologiques : je veux me poser avant autre chose que en… que je n'entends pas qu'on me défende mais que je ne voudrais pas être forcé de faire; mais enfin les prémices vont mieux à mon tempérament car je vous avouerai au risque de parler pour encore plus… que c'est le côté humain, franchement humain qui me touche le plus en art & si je pourais faire ce que je voudrais ou tout au moins le tenter je ne ferais rien qui ne fait le résultat des impressions reçues par l'aspect de la nature soit en paysages soit en figures et ce n'est jamais le côté joyeux qui m'appraît; je ne sais pas s'il est, je ne l'ai jamais vu. Ce que je…de gai, c'est ce calme et ce silence dont on jouit si délicieusement ou dans les forêts ou dans les endroits labourés, qu'ils soyent labourables ou non, vous m'avouerez que c'est toujours très rêveur & d'une rêverie triste bien que délicieuse, vous êtes assis sous les arbres éprouvant tout le bien être, toute la tranquillité dont on puisse jouir, vous voyez déboucher d'un petit sentier une pauvre figure chargée de fagot, la façon inattendue et toujours frappante dans une figure vous apparaît vous rapporte instantanément à la triste condition humaine, la fatigue cela donne toujours une impression analogue à celle que La Fontaine exprima dans la Fable du Bûcheron. Quel plaisir a-t-il eu depuis qu'il est au monde? Est-il un plus pauvre homme en la…?

Dans les endroits labourés, quoique quelquefois dans certains pays peu labourables, vous voyez des figures bêchant, piochant. Vous en voyez un de temps en temps se redressant…comme on dit, et s'essuyant le front avec le revers de la main, tu mangeais ton pain à la sueur de ton front. Est-il là ce travail gai, folâtre, auxquels certains gens voudraient nous faire croire. C'est cependant là que se trouve pour moi la vrai humanité, la grande…Je m'arrête là car je pourrais

bien vous embêter à la fin. Il faut me pardonner, je sais tout…sans avoir acquis…de mes impressions parfois, je me suis laissé aller sans m'en apercevoir, je ne recommencerai plus.

Ah tant que j'y pense, envoyez moi de temps en temps vos belles lettres avec le cachet du ministère, le cachet en cire rouge, enfin tous les enjolivements possibles. Si vous voyiez avec quel respect le facteur me remet ces lettres là! La casquette à la main, ce qui n'appartient habituellement, puis me disant de l'air le plus…: c'est le ministère ! Cela me pose de la plus belle façon. C'est du crédit car pour une lettre portant le cachet du ministère et tout naturellement du ministre, c'est quelque chose…belle enveloppe de lettres.

[Karl] Bodmer n'est pas encore de retour à Barbizon, [Charles] Jacque non plus.

Croyez-vous que j'ai quelque chance d'avoir une commande du ministère?

Savez-vous si celle de Jacque marche un peu?

Poignées de mains,
JF Millet

Les tableaux de Rousseau produisent-ils un grand effet, ont-ils beaucoup de succès?

Jean-François Millet to Théodore Rousseau, April 1859, Cote BSb12L156, Réserve des autographes, Cabinet des dessins, Musée du Louvre, Paris.

Barbizon Jeudi

Mon cher Rousseau, je n'ai de bordure d'aucune espèce pour travailler au tableau d'Etienne, ce qui m'a retardé énormément. Si donc vous pouvez m'envoyer vite vite la bordure qu'il a mise chez vous, vous me rendrez un très grand service. Les migraines petites & grandes sont venues m'assiéger ce mois de façon que j'ai eu a peine un quart de mon temps. Je vous assure que au physique comme au moral je suis en pleine démolition. Vous avez raison mon cher Rousseau la vie est bien triste & il y a bien peu d'endroits qui soient un lieu de refuge. On finit par comprendre ceux qui soupiraient après le lieu de rafraichissement, de lumière & de paix. On comprend aussi comment Dante a fait dire à certains de ses personnages pour désigner le temps qu'ils ont passé sur la terre : le temps de ma dette. Dites bien ceci à Mme Rousseau: c'est que je lui souhaite de tout mon cœur de se bien porter pour son propre compte puis qu'il y a un peu d'égoïsme de ma part dans ce souhait, en ce sens, que j'ai diablement besoin. D'être un peu houspillé & secoué quand j'irai à Paris un de ces jours, & qu'elle peut le faire mieux que personne. C'est que j'en éprouve un vrai besoin. Ma femme à l'air d'agir d'une façon plus de…, elle lui souhaite tout simplement de se porter aussi bien que…

Sensier me paraît furieux contre l'Exposition. Oui, il faudra tâcher d'y aller une fois que je serai à Paris. Je veux y aller en même temps que Sensier qui vient passer ici ces jours de Pâques. Je ne sais si nous partirons lundi soir ou mardi matin, ce sera comme il l'entendra bientôt mon cher Rousseau. J'ai fait la commission de coco[?] a…

Comme poignée de main,
J. F. Millet

Still Life Keywords Identified in Titles of Works Exhibited at the National Academy of Design, 1826–1900

The keywords listed here are either the plural or singular of a noun to avoid redundancy. In data tagging, both plural and singular versions of nouns were used.

acorns	chrysanthemum	hydrangea	primrose
alder	clematis	iris	pumpkin
anemone	clove	ivy	quince
apple	cod	jonquil	raspberry
apricot	coltsfoot	lacquer	rhododendrons
arbutus	columbine	laurel	rose
artichokes	cotton	lemon	salad
aster	cowslips	lilac	salmon
azalea	cranberry	lily	saucers
bamboo	crocus	loin	seaweed
bananas	daffodil	lotus	sedge
basin	dahlia	lucerne	seed
bean	daisy	mallow	spoon
beef	dandelion	maple	still life
beet	daphne	marguerites	strawberry
berries	egeria	melon	sumac
billiards	elm	moss	sunflower
blackberries	fern	mussel	sycamores
bloom	flagon	naiad	thistle
blossom	flora	narcissus	tobacco
boar	flower	nasturtium	tokay
bottle	fruit	oleander	tromp l'oeil
bough	fuchsias	olive	trout
bouquet	gentian	onion	tulip
brandy	geranium	orange	vase
briar	glades	orchid	vegele
buckwheat	gladiolus	peonies	verbenas
bud	goblet	pansies	vine
burgundy	gooseberries	pear	viola
bush	gorse	persimmon	violet
buttercups	grape	petunia	willow
butternut	ham	phlox	windfalls
cactus	hawthorn	pig	wineglass
calendula	hazel	pineapple	wisteria
camelia	heath	pipe	woodcock
card	herb	pitahaya	woodland
carnation	hibiscus	plum	woodruff
carrot	hollyhock	pomegranate	wrea
champagne	honeysuckle	poppies	
cherries	horn	posy	
chestnut	horseradish	prairie	

Further Information about Geographic Classifications of Royal Academy Data and Imperial Keywords

My inspiration for augmenting this dataset with geographic information was the Whiteley Index (see chapters 2 and 3 and appendix C). However, I did not have years to carefully classify works of art by their titles, as Whiteley did for his Salon index. Therefore, I worked with a programmer expert in Python—a language particularly well adapted to parsing text—to identify all nouns and adjectives that could possibly refer to geographic locations. More than 3,000 keywords or phrases were identified. I then manually went through and matched these with what was likely their present-day country. For example, a painting with "Bihar" in the title was classified as being in India, assuming that "Bihar" refers to Bihar State; a painting with "Warwickshire" in the title was categorized as being in England.

This process was not perfect. For example, certain common town names (especially those named for a saint) posed particular identification problems. When further context from the title made it impossible to definitively determine where a geographical site was located, the country was recorded as unidentified. Also, I had to translate older colonial place-names—and their various spellings—into information that could indicate which present-day country the location referred to. Some geographic identifiers, such as West Indies or East Indies, were difficult to ascribe to a single country without further contextual information in the title. Similarly, when there was insufficient context no country was identified.

Importantly, it was impossible to go through and systematically state whether or not a geographic site was being depicted in a work of contemporary landscape or a historical scene. It is difficult to say whether ruins of, for example, the Athenian Acropolis were depicted as they would have been experienced by a visitor in the nineteenth century or whether these were cited in the title as a backdrop to a historical political event. It is hard to know whether paintings with certain sites in their titles were history paintings, landscapes, or genre painting.

While more focused analyses in chapter 5 attempt to tease out the relationships between geography and different genres, this dataset is not yet as granular as the Whiteley Index. Finally, as with the Whiteley Index, there are inevitably some paintings of an imperial setting that are not clearly identified as such. Consider Turner's *Peace— Burial at Sea* (1842), which was exhibited at the Royal Academy annual exhibition in 1842. Showing artist David Wilkie's final burial just off the coast of the British territory of Gibraltar, shortly after his tour of the Middle East, could—arguably—be classed as an imperial painting. There is, however, no information in the title to identify it as such. These more general issues of title classification are discussed at length in chapters 2 and 3.

The keywords supporting figure 5.3 are, to a certain extent, aggregations of several words found in titles. Table G.1 shows these keywords. As a note: the Army and Navy categories *do not* include titles like Admiral and General. Instead, these appear in the breakdown of portraits presented in figure 5.17. As a whole, the classifications applied here should be viewed as a foundational step, but not a perfect product. Ideally, both I and future researchers will continue to build and refine this data.

TABLE G.1 Further Detail about Select Imperial Keywords That Appear in Figure 5.3

KEYWORD CATEGORY	KEYWORDS
"Army"	Battalion, Soldier, Army
"Navy"	Fleet, Navy, Armada, Sailor
"Battle"	Battle, Attack, Guns
"Arab" or "Muslim" [including alternate spellings]	Arab, Arabic, Mosque, Muslim, Moslem
"Jew" or "Jewish"	Jewish, Jew, Synagogue
"Slave" or "Slavery"	Slave, Slavery, Enslaved
"Hindu" [including alternate spellings]	Hindu, Hindoo
"Colony" and "Empire" [including adjectival and plural related words]	Colony, Protectorate, Dominion, Empire
"Cotton"	Cotton
"Coffee"	Coffee
"Tea"	Tea
"Sugar"	Sugar, Saccharine

Acknowledgments

◇◇◇

This book represents the culmination of almost a decade of work, beginning with my master's thesis in economic and social history at Oxford, through completing a doctoral dissertation that bridged art and economic history, and then ongoing work as I moved from a postdoctoral fellowship at the National Gallery of Art to my current position as assistant curator at the Isabella Stewart Gardner Museum. As this manuscript has grown and developed, I have grown and developed as a scholar—and many, *many* people along the way have contributed to this growth. I owe thanks to all of them.

First, thank you to my graduate advisors—Kevin O'Rourke, Michael Hatt, and Jane Garnett. Jane, my advisor at Wadham College, was not charged with being my direct academic supervisor at Oxford but rather served as an informal guide for a newly minted graduate student. She inadvertently set me on the path leading to this book when she pointed me to the Whiteley Index, which Dr. Jon Whiteley painstakingly assembled over more than a decade, as a potential resource for identifying landscape paintings at the Paris Salon. When I saw the index for the first time, I realized it was an invaluable data source that could easily be digitized. Without Jon's work, and his encouragement of my efforts, this book would not exist. He sadly passed away in spring 2020. I hope this use of his index is a credit to his memory as an accomplished scholar and generous mentor and colleague.

From that realization, this whole crazy adventure of creating a data-driven history of art began. Kevin, an economist and my formal academic advisor, was supportive of my interest in art historical subject matter, diligently read and gave valuable feedback on every chapter draft, and uncomplainingly wrote dozens of recommendation letters. Despite a very busy schedule, he was always attentive. I am grateful for his time and feedback. When I started my doctoral work at Oxford, it became clear to me and Kevin that I needed a cosupervisor who was an art historian. Based on a cold email and one meeting over coffee at the British Library, Michael generously volunteered to take on the position. He provided invaluable art historical perspective and helped me learn how to pitch my work in a way that would excite and not alienate my fellow art historians. Similarly, David Peters Corbett provided feedback in my viva (dissertation defense) that helped lay the groundwork for this book and its presentation to the art historical community. Avner Offer was not only a fantastic examiner but also a pleasure to talk to over tea at All Souls. His encouragement of my intellectual curiosity and enthusiasm for art were essential. My time at Oxford was partially supported by a research assistant role at the Institute for New Economic Thinking, where I worked with Doyne Farmer and François Lafond, both of whom were wonderful colleagues. The summers before and after my first year of graduate school, I had the privilege of working as an intern for Betsy Kornhauser in the American Wing at the Metropolitan Museum of Art. Her ongoing support both during my internship and in the years since has inspired me to continue to pursue art historical research and a museum career. She always saw my

interest in economic history as an asset to—rather than a distraction from—my art historical ambitions.

My gratitude to friends and fellow graduate students at Oxford for the fun I had and learning I was able to do there. Thank you to the Oswestrians Katia Mandaltsi, Marie Tidball, and Luke Rostill, and to my fellow economic historian Vellore Arthi. Thank you to the entire Economic and Social History Department for their support and feedback. Finally, Oxford gave me the opportunity to co-organize a wonderful conference—Genius for Sale!—in the spring of 2014, alongside Philip Bullock and Jonathan Paine. The conference affirmed that there is real interest in the intersection between arts and economics.

While I was working on my dissertation, I was fortunate to complete a series of predoctoral fellowships at the Smithsonian American Art Museum (SAAM), Winterthur Museum and Library, and the Frick's Center for the History of Collecting, as well as spend a semester as a visiting PhD scholar in Columbia University's Department of Art History and Archaeology. Each of these experiences provided the time and resources to think, write, present, and receive feedback. I am particularly grateful to Amelia Goerlitz and SAAM for taking a chance on my application at an early stage of my out-of-the-box dissertation. My time in residence alongside my fellow Americanists-in-training (particular shout-outs to Kirill Chunikhin, Juliet Sperling, and Ellen Macfarlane) gave me many opportunities to laugh, learn, and fret as a cohort. My time at SAAM also allowed me to meet and work with Senior Curator Eleanor Harvey, who reassured me that my work was worth continuing even when people did not understand it. She, more than anyone, has provided me with the most useful feedback about how to write and present in ways that are diplomatic and help art historians unfamiliar with quantitative analysis to connect with data-driven work. I am forever grateful for Eleanor's enduring confidence, guidance, and support.

At Winterthur and the Frick, I found supportive colleagues and friends who were always willing to let me use them as soundboards and guides. Thank you to Elizabeth Keslacy, Andrea Pappas, Amy Earls, Catharine Dann-Roeber, Samantha Deutch, Louisa Wood Ruby, and Ellen Prokop. It was a joy to spend a semester as a visiting student at my undergraduate institution. At Columbia, I am particularly grateful to Elizabeth Hutchinson—my senior thesis advisor and then sponsor as a graduate visitor—and Zoë Strother, who taught me about the importance of rigorous scholarship during my sophomore year of college. Thanks to Prof. Strother, I *always* check the footnotes of any work of scholarship that I am reading.

I benefited from two excellent postdoctoral opportunities that allowed me to continue working on this book. The first was a productive semester spent at the Université Libre de Bruxelles working with Kim Oosterlinck, a leader in economic studies of art. Kim was a supportive supervisor and is now an invaluable coauthor and colleague. The second was almost two years spent as an Andrew W. Mellon Postdoctoral Curatorial Fellow at the National Gallery of Art in Washington D.C., which was the perfect place to start an art historical career. Not only did I learn the ins and outs of being a curator, but I was fully supported by my colleagues and supervisors in my ongoing work on this book project. Thank you to my supervisor in the Department of Modern Prints and Drawings: Judith Brodie. In relation to this book project and many other endeavors, she is an interlocutor and mentor.

Additional thanks are due to my many Gallery colleagues who helped support my intellectual growth—and by extension this book—while I was in Washington. Thank you, Nancy Anderson, Jonathan Bober, Charlie Brock, Sarah Cash, Harry Cooper, Mary Lee Corlett, Kara Felt, Sarah Greenough, Amanda Hilliam, Rena Hoisington, Kim Jones, Frank Kelly, Shelley Langdale, Alex Libby, Steven Nelson, Carlotta Owens, Ali Peil, Kari Rayner, Charlie Ritchie, Jen Rokoski, Lynn Russell, Catherine Southwick,

Terence Washington, and Julia Vasquez. A particular thank-you to Elizabeth Cropper and Therese O'Malley, who, early in my tenure at the Gallery, invited me to present at the Center for Advanced Study in the Visual Arts' Wyeth Symposium in American Art. That talk became the fourth chapter of this book. Finally, Amy Hughes, a friend and assistant paper conservator at the Gallery, used her spare time to clean and photograph a Lilly Martin Spencer print that I had tracked down, purchased, and wanted to discuss in my book. (The only other example was in a historical society collection and poorly photographed.) Thank you, Amy, for making Spencer's work camera-ready as figure 4.12. The broader Washington community of scholars was also an invaluable resource to draw on as I wrote. I particularly want to thank Alan Wallach for his ongoing guidance. It was a pleasure to work in the same city as my friend and coauthor Nika Elder. Nika also helped me brainstorm the subtitle for this book—I am grateful for her titling skills.

When I moved to Boston, I had the good fortune of meeting and becoming friends with Sophie Lynford. An expert in the history of both British and American art, Sophie generously read an earlier version of this manuscript and provided essential edits. Chapter 5, in particular, was much improved because of her. The Isabella Stewart Gardner Museum has been the ideal place to bring this manuscript over the finish line. Thanks to my many colleagues for their patience and support of my work, both as a curator and as a scholar. In particular, I want to thank Peggy Fogelman, Nat Silver, Elizabeth Reluga, and the rest of the Collections department for fostering an environment of intellectual rigor while still enjoying a good laugh.

Several people have been essential to the nuts-and-bolts business of getting this book published. Myles Thompson at Columbia University Press read my initial book proposal as a favor. His enthusiasm for the book idea and guidance as to how I should shape my proposal and where I should send it were essential. His email to Peter Dougherty, former director and current editor at large at Princeton University Press, prompted my getting a meeting with arts and architecture editor Michelle Komie at the Annual Meeting of the College Art Association in 2018. Michelle's willingness to meet with me and her immediate enthusiasm for the project led me to Princeton. Since that first meeting, she has encouraged me to be ambitious in my writing. Her guidance has shaped the manuscript, and I am forever grateful to her and the rest of the excellent team at Princeton, including (but not limited to) Terri O'Prey, Kenneth Guay, and Kim Hastings. Thank you to Ashley Williams, whom I was lucky to meet during her graduate internship at the NGA. She fact-checked and copyedited the entire book before it was sent out for peer review. Her work and friendship have been essential. Thank you to my peer reviewers, whose comments and feedback helped make this book better and—to my happy surprise—recommended I make *bigger* claims for the book's contributions to art history rather than scale them back.

Last but certainly not least, I would like to thank my family for their enduring support. From my grandmother, Virginia Greenwald, who responded with an enthusiastic "Hot damn!" when I explained my master's thesis was combining statistics and art history, to my uncle, John Greenwald, who let me stay with him in Washington during my fellowship at SAAM. I have always felt supported and inspired by my entire extended family. My parents, Ava Seave and Bruce Greenwald, are the absolute best. My mother read every chapter of this book at least twice, offering excellent edits. For the year and a half that I was based back home in New York City, I met my father almost daily for writing sessions as I finished my dissertation and he completed his most recent book. My discussions with him helped me frame this book and understand how to best use data, economic theory, and econometrics in art history, and provided general comic relief. The only downside of finishing graduate school was that I could no longer participate in our informal coffee, croissant, and drafting

sessions. My husband, Hugues Le Bras, has tolerated my writing to meet deadlines on weekends and vacations while also helping me learn how to truly take time away and come back to a task refreshed. He is always willing to spend a dinner talking about whatever intellectual problem I am mulling over in relation to numbers and paintings, and his business and detail-oriented brain generates questions and approaches that I have totally overlooked. Above all, he is ambitious *for* me and always assumes that I will excel. His unrelenting confidence in me allows me to have confidence in myself. Without him I would be lost. Thank you.

Notes

◇◇◇

Chapter 1: What Is a Data-Driven History of Art?

1. Jules Prown, introduction to *Art as Evidence: Writings on Art and Material Culture* (New Haven: Yale University Press, 2001), 4. He states that he completed this work in 1964–65.

2. Jules Prown, "The Art Historian and the Computer: An Analysis of Copley's Patronage, 1753–1774," in *Art as Evidence: Writings on Art and Material Culture* (New Haven: Yale University Press, 2001), 36.

3. Prown, 39.

4. Prown, 51.

5. Prown, introduction to *Art as Evidence*, 4.

6. Prown, "The Art Historian and the Computer," 37, 51.

7. A version of this statement about the value of theory appears in Diana Seave Greenwald, "Used Cars and Canvases: Information Economics, Art History, and the Art Market," *American Art* 34, no. 2 (2019): 5–9.

8. Dominic Lusinchi, "'President' Landon and the 1936 Literary Digest Poll: Were Automobile and Telephone Owners to Blame?," *Social Science History* 36, no. 1 (2012): 23–54; Peverill Squire, "Why the 1936 Literary Digest Poll Failed," *Public Opinion Quarterly* 52, no. 1 (1988): 125–33.

9. Pierre Vaisse, "Reflexions sur la fin du Salon official," in *Ce Salon à quoi tout se ramène: Le Salon de peinture et de sculpture, 1791–1890*, ed. James Kearns and Pierre Vaisse (Bern: Peter Lang, 2011), 117.

10. Griselda Pollock, *Differencing the Canon: Feminist Desire and the Writing of Art's Histories* (London: Psychology Press, 1999), 10.

11. Quoted in Sylvia Nasar, *Grand Pursuit:*

The Story of Economic Genius (New York: Simon and Schuster, 2011), xiv.

12. Stephen Pollock, "Econometrics: An Historical Guide for the Uninitiated," *Interdisciplinary Science Reviews* 38, no. 2 (2013): 169, https://doi.org/10.1179/0308018813Z.00000000043.

13. Prown, "The Art Historian and the Computer," 49.

14. Lionel Robbins, *An Essay on the Nature and Significance of Economic Science* (London: Macmillan, 1932), 15.

15. Nasar, *Grand Pursuit*, 165–66.

16. An overview of research in behavioral economics is available in Daniel Kahneman, *Thinking, Fast and Slow* (New York: Farrar, Straus and Giroux, 2011). Kahneman, a psychologist, won the 2002 Nobel Prize in Economics along with economist Vernon L. Smith for work in behavioral economics.

17. A useful marker for the beginning of economists' sustained interest in the arts is the founding of the *Journal of Cultural Economics*, which published its first issue in 1977. See https://link.springer.com/journal/10824.

18. Notable examples of this kind of work include Filip Vermeylen, *Painting for the Market* (Turnhout: Brepols, 2003); Neil de Marchi and Hans J. van Miegroet, "Art, Value, and Market Practices in the Netherlands in the Seventeenth Century," *Art Bulletin* 76, no. 3 (1994): 451–64; Federico Etro, "The Economics of Renaissance Art," *Journal of Economic History* 78, no. 2 (2018): 500–538; Richard A. Goldthwaite, *Wealth and the Demand for Art in Italy, 1300–1600* (Baltimore: Johns Hopkins University Press, 1993); Guido Guerzoni, *Apollo and Vulcan: The Art Markets in Italy, 1400–1700* (East Lansing:

Michigan State University Press, 2011); Kim Oosterlinck, "Art as a Wartime Investment: Conspicuous Consumption and Discretion," *Economic Journal* 127, no. 607 (2017): 2665–2701; Kim Oosterlinck and Géraldine David, "War, Monetary Reforms and the Belgian Art Market, 1945–1951," *Financial History Review* 22, no. 2 (2015): 157–77.

19. John Michael Montias, *Artists and Artisans in Delft: A Socio-Economic Study of the Seventeenth Century* (Princeton: Princeton University Press, 1982); Montias, *Vermeer and His Milieu: A Web of Social History* (Princeton: Princeton University Press, 1989); Montias, "The Montias Database of 17th Century Dutch Art Inventories," *Frick Art Reference Library* (blog), accessed March 26, 2020, https://research.frick.org/montias.

20. Gerald Reitlinger, *The Economics of Taste: The Rise and Fall of Picture Prices, 1760–1960*, 3 vols. (London: Barrie and Rockliff, 1961); Guido Guerzoni, "Reflections on Historical Series of Art Prices: Reitlinger's Data Revisited," *Journal of Cultural Economics* 19, no. 3 (1995): 251–60; Bruno S. Frey and Reiner Eichenberger, "On the Return of Art Investment Return Analyses," *Journal of Cultural Economics* 19, no. 3 (1995): 207–20; William N. Goetzmann, Luc Renneboog, and Christophe Spaenjers, "Art and Money," *American Economic Review* 101, no. 3 (2011): 222–26; Luc Renneboog and Christophe Spaenjers, "Buying Beauty: On Prices and Returns in the Art Market," *Management Science* 59, no. 1 (2013): 36–53; Kim Oosterlinck, Géraldine David, and Ariane Szafarz, "Art Market Inefficiency," *Economics Letters* 121, no. 1 (2013): 23–25; Orley C. Ashenfelter and Kathryn Graddy, "Sale Rates and Price Movements in Art Auctions," *American Economic Review* 101, no. 3 (2011): 212–16; Orley C. Ashenfelter and Kathryn Graddy, "Art Auctions," in *A Handbook of Cultural Economics*, ed. Ruth Towse, 2nd ed. (Cheltenham, UK: Edward Elgar, 2011), 19–28; Christophe Spaenjers, William N. Goetzmann, and Elena Mamonova, "The Economics of Aesthetics and Record Prices for Art since 1701," *Explorations in Economic History* 57 (July 1, 2015): 79–94, https://doi.org/10.1016/j.eeh.2015.03.003.

21. Géraldine David, Christian Huemer, and Kim Oosterlinck, "Art Dealers' Strategy: The Case of Goupil, Boussod & Valadon from 1860 to 1914" (n.d.), http://som.yale.edu/sites/default/files/files/Oosterlinck%20paper.pdf; de Marchi and van Miegroet, "Art, Value, and Market Practices in the Netherlands in the Seventeenth Century"; Neil de Marchi and Hans J. van Miegroet, eds., *Mapping Markets for Paintings in Europe, 1450–1750* (Turnhout: Brepols, 2006); Thomas M. Bayer and John R. Page, *The Development of the Art Market in England: Money as Muse, 1730–1900* (London: Pickering and Chatto, 2011).

22. David W. Galenson, *Old Masters and Young Geniuses: The Two Life Cycles of Artistic Creativity* (Princeton: Princeton University Press, 2007).

23. Maximilian Schich et al., "A Network Framework of Cultural History," *Science* 345, no. 6196 (2014): 558–62.

24. Christiane Hellmanzik, "Location Matters: Estimating Cluster Premiums for Prominent Modern Artists," *European Economic Review* 54, no. 2 (2010): 199–218; John O'Hagan and Christiane Hellmanzik, "Clustering and Migration of Important Visual Artists: Broad Historical Evidence," *Historical Methods: A Journal of Quantitative and Interdisciplinary History* 41, no. 3 (2008): 121–36.

25. Gladys Engel Lang and Kurt Lang, "Recognition and Renown: The Survival of Artistic Reputation," *American Journal of Sociology* 94, no. 1 (1988): 79–109; Lang and Lang, *Etched in Memory: The Building and Survival of Artistic Reputation* (Chapel Hill: University of North Carolina Press, 1990).

26. Samuel P. Fraiberger et al., "Quantifying Reputation and Success in Art," *Science* 362, no. 6416 (2018): 825, https://doi.org/10.1126/science.aau7224.

27. Victor Ginsburgh, "Awards, Success and Aesthetic Quality in the Arts," *Journal of Economic Perspectives* 17, no. 2 (2003): 99–111; Victor Ginsburgh and Jan C. Van Ours, "Expert Opinion and Compensation: Evidence from a Musical Competition," *American Economic Review* 93, no. 1 (2003): 289–396.

28. Kathryn Graddy, "Taste Endures! The Rankings of Roger de Piles (†1709) and Three Centuries of Art Prices," *Journal of Economic History* 73, no. 3 (2013): 766–91. Notably, in these and similar studies, economists often use commercial information to judge the success of a cultural work. This follows a standard economic conceit that prices often reflect quality and true value. For visual arts, economists typically use publicly available auction results for price data. Of course, art historians can argue with the assumption that auction prices reflect the true quality of a painting. However, for the sake of this literature review, one must accept that this is the standard proxy for quality that economists use in their empirical work. With relation to quality, this proxy has been deployed to judge both how artists' behaviors affect their output and contemporaneous critics' ability to identify art that will be considered high quality for years, and even centuries, to come.

29. There are many excellent contributions in this edited volume; however, the most relevant for this book are James Cutting, "Mere Exposure, Reproduction, and the Impressionist Canon," in *Partisan Canons*, ed. Anna Bryzski (Durham: Duke University Press, 2007), 79–94; James Elkins, "Canon and Globalization in Art History," 55–78; and Robert Jensen, "Measuring Canons: Reflections on Innovation and the Nineteenth-Century Canon of European Art," 27–54.

30. David W. Galenson and Robert Jensen, "Careers and Canvases: The Rise of the Market for Modern Art in the Nineteenth Century," in *Current Issues in Nineteenth-Century Art* (Zwolle and Amsterdam: Waanders Publishers and Van Gogh Museum, 2007), 137–66; Robert Jensen, *Marketing Modernism in Fin-de-Siècle Europe* (Princeton: Princeton University Press, 1994).

31. David W. Galenson and Bruce A. Weinberg, "Creating Modern Art: The Changing Careers of Painters in France from Impressionism to Cubism," *American Economic Review* 91, no. 4 (2001): 1063–71; Galenson, *Old Masters and Young Geniuses*.

32. Agnès Penot, *La Maison Goupil: Galerie d'art internationale au XIXe siècle*

(Le Kremlin-Bicêtre: Mare & Martin, 2017); Penot, "The Perils and Perks of Trading Art Overseas: Goupil's New York Branch," *Nineteenth-Century Art Worldwide* 16, no. 1 (2017), https://www.19thc-artworldwide.org /spring17/penot-on-the-perils-and-perks -of-trading-art-overseas-goupils-new-york -branch; Penot, "The Goupil & Cie Stock Books: A Lesson on Gaining Prosperity through Networking," *Getty Research Journal*, no. 2 (2010): 177–82.

33. Léa Saint-Raymond, "How to Get Rich as an Artist: The Case of Félix Ziem— Evidence from His Account Book from 1850 through 1883," *Nineteenth-Century Art Worldwide* 15, no. 1 (2016), https://www .19thc-artworldwide.org/spring16/saint -raymond-on-how-to-get-rich-as-an -artist-felix-ziem; Félicie de Maupeou and Léa Saint-Raymond, "Les 'marchands de tableaux' dans le Bottin du commerce: Une approche globale du marché de l'art à Paris entre 1815 et 1955," *Artl@s Bulletin* 2, no. 2 (2013): Article 7, https://docs.lib.purdue.edu /artlas/vol2/iss2/7/; Saint-Raymond, "Le pari des enchères: Le lancement de nouveaux marchés artistiques à Paris entre les années 1830 et 1939" (Université de Paris–Nanterre, 2018).

34. Léa Saint-Raymond, "Revisiting Harrison and Cynthia White's Academic vs. Dealer-Critic System," *Arts* 8, no. 3 (2019): 96–113, https://doi.org/10.3390/arts8030096.

35. Pierre Bourdieu, *Distinction: A Social Critique of the Judgement of Taste*, trans. Richard Nice (Oxford: Routledge, 1984), xxv.

36. Bourdieu, xxv.

37. Bourdieu, 59.

38. Paul Dimaggio, "Cultural Entrepreneurship in Nineteenth-Century Boston: The Creation of an Organizational Base for High Culture in America," *Media, Culture and Society* 4, no. 1 (1982): 33–50. Bourdieu's work has been influential in the emerging field of the history of capitalism—see Sven Beckert, *The Monied Metropolis: New York City and the Consolidation of the American Bourgeoisie, 1850–1896* (London: Cambridge University Press, 2003). In sociology, many debates about cultural consumption and

social standing have—since the publication of Richard A. Peterson, "Understanding Audience Segmentation: From Elite and Mass to Omnivore and Univore," *Poetics* 21, no. 4 (1992): 243–58, https://doi.org/10.1016/0304-422X(92)90008-Q.—focused on cultural omnivores. For an introduction to this concept and debate, see Irmak Karademir Hazir and Alan Warde, "The Cultural Omnivore Thesis: Methodological Aspects of the Debate," in *Routledge International Handbook of the Sociology of Art and Culture*, ed. Laurie Hanquinet and Mike Savage (London: Routledge, 2015), 77–89; Bruno S. Frey, *Arts & Economics: Analysis & Cultural Policy* (Berlin: Springer, 2000); Oscar E. Vázquez, *Inventing the Art Collection: Patrons, Markets, and the State in Nineteenth-Century Spain* (University Park: Pennsylvania State University Press, 2001).

39. Arnold Hauser, *The Social History of Art* (London: Taylor and Francis, 2005), loc. 878 of 6423, Kindle.

40. For an extensive history of the social history of art and its impact on the field, see Andrew Hemingway, *Marxism and the History of Art: From William Morris to the New Left* (London: Pluto, 2006); Jonathan Harris, *The New Art History: A Critical Introduction* (London: Routledge, 2001).

41. Timothy J. Clark, *Image of the People: Gustave Courbet and the 1848 Revolution* (London: Thames and Hudson, 1973), 12.

42. Lillian B. Miller, *Patrons and Patriotism: The Encouragement of the Fine Arts in the United States, 1790–1860* (Chicago: University of Chicago Press, 1974); Alan Wallach, "Thomas Cole: Landscape and the Course of American Empire," in *Thomas Cole: Landscape into History*, ed. William H. Truettner and Alan Wallach (New Haven: Yale University Press, 1994), 23–111; Ann Bermingham, *Landscape and Ideology: The English Rustic Tradition, 1740–1860* (Berkeley: University of California Press, 1986); John Barrell, *The Dark Side of the Landscape: The Rural Poor in English Painting, 1730–1840* (Cambridge: Cambridge University Press, 1980).

43. André Dombrowski, *Cézanne, Murder and Modern Life* (Berkeley: University of California Press, 2013); Jennifer Roberts,

Transporting Visions: The Movement of Images in Early America (Berkeley: University of California Press, 2014); Tim Barringer, *Men at Work: Art and Labour in Victorian Britain* (New Haven: Yale University Press for the Paul Mellon Centre for Studies in British Art, 2005); Leo Costello, *J.M.W. Turner and the Subject of History* (Burlington: Ashgate, 2012); Andrew Hemingway, *Landscape Imagery and Urban Culture in Early Nineteenth-Century Britain* (Cambridge: Cambridge University Press, 1992).

44. Once again, for a discussion of these issues, see Harris, *The New Art History*; Hemingway, *Marxism and the History of Art*.

45. For a helpful overview of these debates and the field of digital art history, see Johanna Drucker, "Is There a 'Digital' Art History?," *Visual Resources* 29, no. 1–2 (2013): 5–13, https://doi.org/10.1080/01973762.2013.761106; Benjamin Zweig, "Forgotten Genealogies: Brief Reflections on the History of Digital Art History," *International Journal for Digital Art History*, no. 1 (2015): 39–49, https://doi.org/10.11588/dah.2015.1.21633.

46. For recent overviews of issues in digital art history, see Miriam Kienle, "Between Nodes and Edges: Possibilities and Limits of Network Analysis in Art History," *Artl@s Bulletin* 6, no. 3 (2017): Article 1, https://docs.lib.purdue.edu/artlas/vol6/iss3/1/; Susan Elizabeth Gagliardi and Joanna Gardner-Huggett, "Spatial Art History in the Digital Realm," *Historical Geography* 45 (2017): 17–36; Kimon Keramidas and Ellen Prokop, "Introduction: Re-Viewing Digital Technologies and Art History," *Journal of Interactive Technology and Pedagogy* 12 (2018), https://jitp.commons.gc.cuny.edu/category/issues/issue-twelve/.

47. Nuria Rodríguez-Ortega, "Digital Art History: The Questions That Need to Be Asked," *Visual Resources* 35, no. 1–2 (2019): 16.

48. Franco Moretti, *Graphs, Maps, Trees: Abstract Models for a Literary History* (New York: Verso, 2005); Matthew L. Jockers, *Macroanalysis: Digital Methods and Literary History* (Champagne-Urbana: University of Illinois Press, 2013).

49. For example, see Kim Gallon, "The Chicago Defender's Standing Dealers List,"

Black Press Research Collective (blog), accessed February 8, 2020, http://blackpressresearch collective.org/visualizing-the-black-press/.

50. Stephen Ramsay, *Reading Machines: Toward an Algorithmic Criticism*, Topics in the Digital Humanities (Urbana: University of Illinois Press, 2011).

51. Claire Bishop, "Against Digital Art History," *International Journal for Digital Art History*, no. 3 (2018): 123–31, https://doi.org /10.11588/dah.2018.3.49915. In the same issue of the *International Journal for Digital Art History*, Ulrich Pfisterer makes a linked but distinct argument about the risk of letting corporations like Google take the lead in digital art history projects. See Pfisterer, "Big Bang Art History," *International Journal for Digital Art History*, no. 3 (2018): 133–38, https://doi.org/10.11588/dah.2018.3.49916.

52. Willard McCarty, "Modeling the Actual, Simulating the Possible," in *The Shape of Data in the Digital Humanities: Modeling Texts and Text-Based Resources*, ed. Julia Flanders and Fotis Jannidis (London: Routledge, 2019), 264–84. The entire edited volume provides a broad overview of these questions and varying points of view.

53. Tara McPherson, *Feminist in a Software Lab: Difference and Design* (Cambridge, MA: Harvard University Press, 2018). The specific quote is on page 27; however, chapter 1, "Designing for Difference" (pp. 29–106), presents an extended consideration of these issues.

54. Pamela Fletcher et al., "Local/Global: Mapping Nineteenth-Century London's Art Market," *Nineteenth-Century Art Worldwide* 11, no. 3 (2012), http://www.19thc-artworld wide.org/autumn12/fletcher-helmreich -mapping-the-london-art-market, and Artl@s project, available at http://artlas.ens .fr/en/.

55. For example, see Matthew D. Lincoln, "Continuity and Disruption in European Networks of Print Production, 1550–1750," *Artl@s Bulletin* 6, no. 3 (2017): Article 2, https://docs.lib.purdue.edu/artlas/vol6/ iss3/2/.

56. Murtha Baca and Anne Helmreich, "Introducing Three Digital Art History Case Studies," *The Iris: Behind the Scenes at the Getty* (blog), February 15, 2017, http://blogs .getty.edu/iris/dah_baca_helmreich/#note1.

57. Paul B. Jaskot, "Digital Art History as the Social History of Art: Towards the Disciplinary Relevance of Digital Methods," *Visual Resources* 35, no. 1–2 (2019): 22, https://doi.org/10.1080/01973762.2019 .1553651.

58. Jaskot, 24.

59. Jaskot, 22.

60. For a comprehensive discussion of the issue of scale, see Schich et al., "A Network Framework of Cultural History."

61. Jaskot, "Digital Art History as the Social History of Art," 30.

62. Jaskot, 26.

63. For a discussion of the wide-ranging impact of cheaper printing technologies in the nineteenth century, see William St. Clair, *The Reading Nation in the Romantic Period* (Cambridge: Cambridge University Press, 2007); Richard D. Brown, *Knowledge Is Power: The Diffusion of Information in Early America* (Oxford: Oxford University Press, 1991).

64. For further reading about Degas's conservatism, anti-Semitism, and misogyny, see Maurice Braud, "Edgar Degas et l'affaire Dreyfus: Entre avant-garde et réaction," *Mil neuf cent: Revue d'histoire intellectuelle (Cahiers Georges Sorel)*, 1993, 107–12; Marilyn R. Brown, "'Miss La La's' Teeth: Reflections on Degas and 'Race,'" *Art Bulletin* 89, no. 4 (2007): 738–65; Eunice Lipton, *Looking into Degas: Uneasy Images of Women and Modern Life* (Berkeley: University of California Press, 1988).

65. Laura Bellelli wrote, "Living with Gennaro, whose detestable nature you know and who has no serious occupation, shall soon lead me to the grave." Quoted in Jean Sutherland Boggs, *Degas* (New York: Metropolitan Museum of Art, 1988), 81.

66. For information about the Degas family business in Louisiana, see Gail Feigenbaum et al., eds., *Degas and New Orleans: A French Impressionist in America* (New Orleans: New Orleans Museum of Art in conjunction with Ordrupgaard, 1999).

Chapter 2: The Historical Data of the Art World

1. If one searches online for the "Whiteley Index," results refer to an instrument for measuring hypochondriacal worries and beliefs. This database is distinct from the medical tool.

2. For an overview of the history of prints and their general popularity, see A. Hyatt Mayor, *Prints & People: A Social History of Printed Pictures* (New York: Metropolitan Museum of Art, 1971).

3. Under the ancien régime, the Académie des beaux-arts was called the Académie royale de peinture et de sculpture.

4. John Hagood, introduction to *Documenting the Salon: Paris Salon Catalogs, 1673-1945*, ed. John Hagood (Washington, DC: National Gallery of Art, 2016).

5. Specifically, 158,501 as counted in the digital transcription of Jon Whiteley, *The Subject Index to Paintings Exhibited at the Paris Salon, 1673-1881* (1993), Sackler Library, University of Oxford, and in *Catalogues of the Paris Salon, 1673 to 1881*, 60 vols., ed. H. W. Janson (New York: Garland, 1977). Note that throughout the book I rarely use the full sample of artworks and instead start the count either from 1740—when exhibitions became much more regular—or from 1830, which is the beginning of the time frame studied in chapter 3. The count of works from 1740 to 1881 is 136,346; the count of works from 1830 to 1881 is 114,455.

6. Whiteley also indexed drawings when they were included in the same exhibition and livret section as the paintings. See Jon Whiteley, introduction to *The Subject Index to Paintings Exhibited at the Paris Salon, 1673-1881*; *Catalogues of the Paris Salon, 1673 to 1881*.

7. The first version of *The Sower*, and the one shown at the 1850-1851 Salon, is in the Yamanashi Prefectural Museum of Art in Kofu, Japan. The Boston picture, shown here, was completed several months later and is very similar. I have featured the Boston picture because it is difficult to get an image of the Yamanashi painting for reproduction.

8. For discussions about the complex meanings and interpretative power of titles, see Greg Petersen, "Titles, Labels and Names: A House of Mirrors," *Journal of Aesthetic Education* 40, no. 2 (2006): 29-44; Jerrold Levinson, "Titles," *Journal of Aesthetics and Art Criticism* 4, no. 1 (1985): 29-39.

9. Whiteley, introduction to *The Subject Index to Paintings Exhibited at the Paris Salon, 1673-1881*. This short introduction is only available as a manuscript in the rare books stacks of the Sackler Library, University of Oxford. It is appended to volume 1 of the index.

10. For a description of the Impressionists' dealings with the Salon and Académie de beaux-arts, see John Rewald, *The History of Impressionism* (New York; Boston: Museum of Modern Art; Distributed by New York Graphic Society, 1987), 56-65, 106-7, 116-23; John Zarobell, "Paul Durand-Ruel and the Market for Modern Art, 1870-1873," in *Inventing Impressionism: Paul Durand-Ruel and the Modern Art Market*, ed. Sylvie Patry (London: National Gallery, 2015), 76-97.

11. Albert Boime, *The Academy and French Painting in the Nineteenth Century* (London: Phaidon, 1971), 3-4.

12. For a succinct overview of the structure of the Salon from the Revolution to the end of the nineteenth century, see Pierre Vaisse, introduction to *Ce Salon à quoi tout se ramène: Le Salon de peinture et de sculpture, 1791-1890*, ed. James Kearns and Pierre Vaisse (Bern: Peter Lang, 2011), 1-6.

13. Pierre Vaisse, "Reflexions sur la fin du Salon official," in *Ce Salon à quoi tout se ramène: Le Salon de peinture et de sculpture, 1791-1890*, ed. James Kearns and Pierre Vaisse (Bern: Peter Lang, 2011), 121-22.

14. Boime, *The Academy and French Painting in the Nineteenth Century*, 1-21; Patricia Mainardi, *The End of the Salon: Art and the State in the Early Third Republic* (Cambridge: Cambridge University Press, 2011), 15-20.

15. Boime, *The Academy and French Painting in the Nineteenth Century*, 4.

16. *Oxford Dictionary of Art and Artists*, 5th ed. (Oxford: Oxford University Press, 2015), s.v. "Salon des Refusés."

17. For an examination of how this system existed in Victorian England, see Pamela Fletcher and Anne Helmreich, "The Periodical and the Art Market: Investigating the 'Dealer-Critic System' in Victorian England," *Victorian Periodicals Review* 41, no. 4 (2008): 323–51. There has not been as specific an investigation of the dealer-critic system for the nineteenth-century United States. However, there have been a range of studies of American art criticism including but not limited to Wendy Jean Katz, *Humbug! The Politics of Art Criticism in New York City's Penny Press* (New York: Fordham University Press, 2020), and the essays in David B. Dearinger, ed., *Rave Reviews: American Art and Its Critics (1826–1925)* (New York: National Academy of Design, 2000).

18. Sylvie Patry, "Durand-Ruel and the Impressionists Solo Exhibitions of 1883," in *Inventing Impressionism: Paul Durand-Ruel and the Modern Art Market*, ed. Sylvie Patry (London: National Gallery, 2015), 98–119.

19. Kimberly A. Jones, "Paris Salons in the Nineteenth Century," in *Documenting the Salon: Paris Salon Catalogs, 1673–1945*, edited by John Hagood (Washington, DC: National Gallery of Art, 2016), 55–57.

20. Mainardi, *The End of the Salon*, 80–81.

21. Books that provide overviews and analyses of the instability and politics of the Salon, discussed in greater detail in chapter 3, include Patricia Mainardi, *Art and Politics of the Second Empire: The Universal Expositions of 1855 and 1867* (New Haven: Yale University Press, 1987); Mainardi, *The End of the Salon*; Boime, *The Academy and French Painting in the Nineteenth Century*.

22. Whiteley also created "super-categories" of paintings by genre, so it is possible to separate the total number of portraits from history paintings, landscapes, and other genres.

23. The scope of the data has been increased even further with the publication of *Salons et expositions de groupes, 1673–1914* (http://salons.musee-orsay.fr), published by the Institut national d'historie de l'art and the Musée d'Orsay. This searchable online database was created by transcribing the Salon livrets on which the Whiteley Index depend. Combining data from this additional source and the Whiteley Index creates a remarkably complete record of what was on display in the French art world during the long nineteenth century.

24. This data source was assembled from 2014 to 2016 for my doctoral research. For full information about the Historical American Art Exhibition Database, see Diana Seave Greenwald, "Painting by Numbers: Case Studies in the Economic History of Nineteenth-Century Landscape and Rural Genre Painting" (PhD diss., University of Oxford, 2018), https://ethos.bl.uk/Order Details.do?uin=uk.bl.ethos.757837.

25. The Getty Union List of Artist Names and other online resources were used to add birth and death dates for artists when these were not listed in the constituent index. Other online resources include Artnet, Grove Art, and Wikipedia. Getty database last accessed April 22, 2015, http://www.getty.edu/research/tools/vocabularies/ulan/.

26. Pennsylvania Academy of the Fine Arts, "Articles of Association, Dec. 26 1805," in *In the Service of Art: A Guide to the Archives of the Pennsylvania Academy of the Fine Arts*, ed. Cheryl Leibold (Philadelphia: Pennsylvania Academy of the Fine Arts, 2009), 11, https://www.pafa.org/sites/default/files/media-assets/GuidetoArchives_0.pdf.

27. Stephen May, "An Enduring Legacy: The Pennsylvania Academy of the Fine Arts, 1805–2005," in *Pennsylvania Academy of the Fine Arts, 1805–2005: 200 Years of Excellence*, ed. Mark. Hain and Alex Baker (Philadelphia: Pennsylvania Academy of the Fine Arts, 2005), 14.

28. May, 14.

29. Kenneth John Myers, "The Public Display of Art in New York City, 1664–1914," in *Rave Reviews: American Art and Its Critics (1826–1925)*, ed. David B. Dearinger (New York: National Academy of Design, 2000), 31–52.

30. Grischka Petri, "American Academy of Fine Arts," in *Grove Encyclopedia of American Art*, ed. Joan Marter (Oxford: Oxford University Press, 2011), https://doi.org/10.1093/gao/9781884446054.article.T2090109.

31. Theodore Sizer, "The American Academy of the Fine Arts," in *American Academy of Fine Arts and American Art-Union, 1816–1852*, ed. Mary Bartlett Cowdrey (New York: New-York Historical Society, 1953), 20–34.

32. For an overview of the Boston Athenaeum's early history, see David B. Dearinger, "Collecting Paintings and Sculpture for the Boston Athenaeum," in *Acquired Tastes: 200 Years of Collecting for the Boston Athenaeum* (Boston: Boston Athenaeum, 2006), 33–63. The NAD's focus on contemporary American art is described both in primary sources like Thomas Seir Cummings, *Historic Annals of the National Academy of Design, New York Drawing Association, Etc., with Occasional Dottings by the Way-Side, from 1825 to the Present Time* (Philadelphia: George W. Childs, 1865), and in secondary sources like Eliot Clark, *History of the National Academy of Design, 1825–1952* (New York: Columbia University Press, 1954).

33. Cummings, *Historic Annals of the National Academy of Design*, 84.

34. Greenwald, "Painting by Numbers," 94–97.

35. Hildie V. Kraus, "A Cultural History of the Mechanics' Institute of San Francisco, 1855–1920," *Library History* 23, no. 2 (2007): 115–16; John H. Wood, *Seventy-Five Years of History of the Mechanics' Institute of San Francisco* (San Francisco: Mechanics' Institute, 1930), 7–8; Raymond L. Wilson, "The First Art School in the West: The San Francisco Art Association California School of Design," *American Art Journal* 14, no. 1 (1982): 42–55.

36. For a full list of the wide range of exhibitions captured by this source, see James L. Yarnall et al., eds., *The National Museum of American Art's Index to American Art Exhibition Catalogs: From the Beginning through the 1876 Centennial Year*, 6 vols. (Washington, DC: National Museum of American Art, 1986).

37. Pennsylvania Academy of the Fine Arts, "Resolutions of [the] Committee of Arrangements and Inspection [for the Annual Exhibition], April 22, 1811," in *Selected Papers of Charles Wilson Peale and His Family*, vol. 3, ed. Lillian B. Miller (New Haven: Yale University Press, 1991), 89.

38. Anna Wells Rutledge, foreword to *The Annual Exhibition Record of the Pennsylvania Academy of the Fine Arts, 1807–1870*, ed. Peter Hastings Falk (Madison, CT: Soundview Press, 1988), 2–3.

39. Peter Hastings Falk, introduction to the revised edition of *The Annual Exhibition Record of the Pennsylvania Academy of the Fine Arts, 1807–1870*, ed. Peter Hastings Falk (Madison, CT: Soundview Press, 1988); Rutledge, foreword, 4.

40. Falk, introduction, x.

41. Peter Hastings Falk, ed., *The Annual Exhibition Record of the Pennsylvania Academy of the Fine Arts, 1876–1913* (Madison, CT: Soundview Press, 1989), 10.

42. This trend is also linked to the fact that by 1876—the first year recorded in the second volume of the *Annual Exhibition Record*—it was possible to clearly distinguish between the annual exhibitions and other PAFA shows. This means that post-1876 data are culled specifically from contemporary shows.

43. An overview of art dealing in the United States during this period is in Malcolm Goldstein, *Landscape with Figures: A History of Art Dealing in the United States* (Oxford: Oxford University Press, 2000), 3–93. For a focus on the early years of exhibition and art dealers in New York, see Carrie Rebora Barratt, "Mapping the Venues: New York City Art Exhibitions," in *Art and the Empire City: New York, 1825–1861* (New York: Metropolitan Museum of Art, 2000), 47–81.

44. The best-known examples of these pioneering dealers in the contemporary European market are Michael (Michel) Knoedler and Samuel P. Avery. Avery actually sold his impressive collection of American art at auction in 1867 in order to dedicate himself to selling European art. The primary source about Avery's American art collection is Henry H. Leeds & Co., *Catalogue of the Private Collection of Oil Paintings by American Artists Made by Samuel P. Avery* (New York: Henry H. Leeds & Co., 1867), https://archive.org/details/b1468922; a useful introduction to this topic is Madeline Fidell-Beaufort

and Jeanne K. Welcher, "Some Views of Art Buying in New York in the 1870s and 1880s," *Oxford Art Journal* 5, no. 1 (1982): 48–55. See Pamela Fletcher et al., "Local/Global: Mapping Nineteenth-Century London's Art Market," *Nineteenth-Century Art Worldwide* 11, no. 3 (2012), http://www.19thc-artworldwide .org/autumn12/fletcher-helmreich-mapping -the-london-art-market, for an overview of patterns of dealers' importing European art to the United States during the nineteenth century.

45. For an overview of Cowdrey's contributions, see the "Biographical Note" in "Cowdrey, Mary Bartlett, 1910–1974" (Newark, DE, January 22, 2010), Special Collections, University of Delaware, http:// www.lib.udel.edu/ud/spec/findaids/html /mss0556.html.

46. Mary Bartlett Cowdrey, introduction to *National Academy of Design Exhibition Record, 1826–1860*, vol. 1, ed. Mary Bartlett Cowdrey (New York: New-York Historical Society, 1943), xiv.

47. Cowdrey, xiv.

48. Robin Simon, "In Search of a Royal Academy," in *The Royal Academy of Arts: History and Collections*, ed. Robin Simon and Maryanne Stevens (London: Paul Mellon Centre for Studies in British Art and Yale University Press, 2018), 2–3.

49. For a basic description of the St. Martin's Lane Academy, see *Oxford Dictionary of Art and Artists*, 4th ed. (Oxford: Oxford University Press, 2009), s.v. "St Martin's Lane Academy." For a history of the origins of the Royal Academy, see Charles Saumarez Smith, *The Company of Artists: The Origins of the Royal Academy of Arts in London* (London: Modern Art Press in ass. with Bloomsbury, 2012), 21–30. There were fundamental differences between Hogarth's view of an art academy and the role envisioned by the founders of the Royal Academy. While I do not mean to downplay these differences, they are not directly relevant to an introduction to the Royal Academy and its data.

50. For a full description of this process, see Smith, *The Company of Artists*.

51. Maryanne Stevens, "A Closer Look: The Instrument of Foundation, 1768," in *The Royal Academy of Arts: History and Collections*, ed. Robin Simon and Maryanne Stevens (London: Paul Mellon Centre for Studies in British Art and Yale University Press, 2018), 12 and 16.

52. Mark Hallett, "1769: Catching Your Eye," in *The Royal Academy Summer Exhibition: A Chronicle, 1769–2018*, ed. Mark Hallett et al. (London: Paul Mellon Centre for Studies in British Art, 2018), https://chronicle250 .com/1769.

53. Stevens, "A Closer Look," 14–15. For an extensive study of the exhibition's life in its second home at Somerset House, see David H. Solkin, ed., *Art on the Line: The Royal Academy Exhibitions at Somerset House, 1780–1836* (New Haven: Published for the Paul Mellon Centre for Studies in British Art and the Courtauld Institute Gallery by Yale University Press, 2001).

54. "Instrument of Foundation" (London, December 10, 1768), Royal Academy of Arts, Official Archive, Royal Academy of Arts Archive, https://www.royalacademy .org.uk/art-artists/archive/instrument-of -foundation.

55. Stevens, "A Closer Look," 12–14. In addition to the Selection Committee, there was also a smaller Hanging Committee, often with just three members, that installed and arranged the show of all accepted artworks and could influence which works were most visible to the public.

56. "Art Made Now: Chronicling the Summer Exhibition," in *The Royal Academy Summer Exhibition: A Chronicle, 1769–2018*, ed. Mark Hallett et al. (London: Paul Mellon Centre for Studies in British Art, 2018), https://chronicle250.com/introduction.

57. "Art Made Now."

58. Hallett et al. shows the number of works exhibited on individual year-specific pages, e.g., https://chronicle250.com/1775.

59. Barbara Bryant, "1864: New Art Ascendant," in *The Royal Academy Summer Exhibition: A Chronicle, 1769–2018*, ed. Mark Hallett et al. (London: Paul Mellon Centre for Studies in British Art, 2018), https:// chronicle250.com/1864.

60. For another episode of calls for reform of the Royal Academy, see Morna

O'Neill, "1886: 'Can the Royal Academy Be Reformed?,'" in *The Royal Academy Summer Exhibition: A Chronicle, 1769–2018*, ed. Mark Hallett et al. (London: Paul Mellon Centre for Studies in British Art, 2018), https://chronicle250.com/1886.

61. John Barell, "Sir Joshua Reynolds and the Political Theory of Painting," *Oxford Art Journal* 9, no. 2 (1986): 39.

62. Peter Sawbridge, *A Little History of the Royal Academy* (London: Royal Academy of Arts, 2018), 29–35.

63. Sawbridge, 29.

64. Anthony Bailey, *Standing in the Sun: A Life of J.M.W. Turner* (London: Tate, 2013), 76–88, Kindle.

65. Thomas M. Bayer and John R. Page, *The Development of the Art Market in England: Money as Muse, 1730–1900* (London: Pickering and Chatto, 2011), 80–117.

66. Fletcher et al., "Local/Global: Mapping Nineteenth-Century London's Art Market"; Anne Helmreich, "The Goupil Gallery at the Intersection between London, Continent, and Empire," in *The Rise of the Modern Art Market in London, 1850–1939*, ed. Anne Helmreich and Pamela Fletcher (Manchester: Manchester University Press, 2011), 65–84; Pamela Fletcher, "Creating the French Gallery: Ernest Gambart and the Rise of the Commercial Art Gallery in Mid-Victorian London," *Nineteenth-Century Art Worldwide* 6, no. 1 (2007), http://www.19thc-artworldwide.org/spring07/143-creating-the-french-gallery-ernest-gambart-and-the-rise-of-the-commercial-art-gallery-in-mid-victorian-london.

67. See, in particular, Fletcher, "Creating the French Gallery." However, this is also touched on in Fletcher and Helmreich, "The Periodical and the Art Market." Finally, there are a series of case studies in Helmreich and Fletcher's *The Rise of the Modern Art Market in London, 1850–1939* (Manchester: Manchester University Press, 2011) that describe how artists, including avant-garde artists, moved between the Royal Academy and commercial art galleries: Malcom Warner, "Millais in the Marketplace: The Crisis of the Late 1850s," 216–36; Brenda Vix, "Branding the Vision: William Holman Hunt and the Victorian

Art Market," 237–56; Patricia de Montfort, "Negotiating a Reputation: J. M. Whistler, D. G. Rossetti, and the Art Market 1860–1900," 257–75.

68. Christopher Newall, *The Grosvenor Gallery Exhibitions: Change and Continuity in the Victorian World* (Cambridge: Cambridge University Press, 1995), 3.

69. Simon Fenwick, *The Enchanted River: 200 Years of the Royal Watercolour Society* (Bristol: Sansom & Company with Royal Watercolour Society, 2004), 15–22.

70. For information about Millais's biography and appointment as president of the Royal Academy, see *Oxford Dictionary of Art and Artists*, 4th ed. (Oxford: Oxford University Press, 2009), s.v. "Millais, Sir John Everett." For his exhibitions at the Grosvenor Gallery, see Newall, *The Grosvenor Gallery Exhibitions*, 104–5. And for a definition of the Pre-Raphaelites and their opposition to the Academy, see Tate, "Pre-Raphaelite," Tate Art Terms, accessed July 11, 2019, https://www.tate.org.uk/art/art-terms/p/pre-raphaelite.

71. Sawbridge, *A Little History of the Royal Academy*, 77–91.

72. One of the most vocal commentators on statistical economics and its links to real-world problems has been Deirdre McCloskey. See Stephen Thomas Ziliak and Deirdre N. McCloskey, *The Cult of Statistical Significance: How the Standard Error Costs Us Jobs, Justice, and Lives*, 2nd ed. (Ann Arbor: University of Michigan Press, 2014).

73. Gleaning has been a contested activity and right of the poor throughout history, hearkening back to biblical times. A landmark article that traces this history and the economic importance of gleaning is Peter King, "Customary Rights and Women's Earnings: The Importance of Gleaning to the Rural Labouring Poor, 1750–1850," *Economic History Review* 44, no. 3 (1991): 461–76, https://doi.org/10.2307/2597539. For a cultural history of the meaning of gleaning in a French setting, see Liana Vardi, "Construing the Harvest: Gleaners, Farmers, and Officials in Early Modern France," *American Historical Review* 98, no. 5 (1993): 1424–47, https://doi.org/10.2307/2167061.

Chapter 3: Between City and Country

1. Quoted in Robert L. Herbert, "City vs. Country: The Rural Image in French Painting from Millet to Gauguin," in *From Millet to Leger: Essays in Social Art History* (New Haven: Yale University Press, 2002), 35.

2. Timothy J. Clark, *Image of the People: Gustave Courbet and the 1848 Revolution* (London: Thames and Hudson, 1973), 9.

3. Eugen Weber, *Peasants into Frenchmen: The Modernization of Rural France, 1870–1914* (Palo Alto: Stanford University Press, 1976); Fernand Braudel, Ernest Labrousse, and Pierre Léon, *Histoire économique et sociale de la France: L'avènement de l'ère industrielle, 1789–années 1880*, vol. 3 (Paris: Presses Universitaires de France, 1976); Hugh Clout, *Agriculture in France on the Eve of the Railway Age* (Totowa, NJ: Barnes and Noble, 1980); Colin Heywood, *The Development of the French Economy, 1750–1914* (London: Palgrave Macmillan UK, 1992).

4. Scholars dispute the definition of "peasant"; however, I formulated my definition with particular reference to Teodor Shanin, "Peasantry: Delineation of a Sociological Concept and a Field of Study," *European Journal of Sociology* 12, no. 2 (1971): 289–300; and Michael Kearney, *Reconceptualizing the Peasantry* (Boulder: Westview Press, 1996).

5. For general information on this topic, see Roger Price, *The Economic Modernisation of France* (New York: John Wiley and Sons, 1975), 12 and 214; Laurence William Wylie, *Village in the Vaucluse*, 3rd ed. (Cambridge, MA: Harvard University Press, 1974); Harriet G. Rosenberg, *A Negotiated World: Three Centuries of Change in a French Alpine Community* (Toronto: University of Toronto Press, 1988); Roger Thabault, *Education and Change in a Village Community: Mazières-En-Gâtine 1848–1914*, trans. Peter Tregear (New York: Schocken Books, 1971); André Burguière, *Bretons de Plozevet* (Paris: Flammarion, Bibliothèque d'ethnologie historique, 1975).

6. Christopher Parsons and Neil McWilliam, "'Le Paysan de Paris': Alfred Sensier and the Myth of Rural France," *Oxford Art Journal* 6, no. 2 (1983): 43–47.

7. Robert L. Herbert, "Millet Reconsidered," *Art Institute of Chicago Museum Studies* 1 (1966): 46, https://doi.org/10.2307/4104371.

8. Herbert, "City vs. Country," 24.

9. Linda Nochlin, introduction to *The Politics of Vision* (London: Thames and Hudson, 1989), xv.

10. See note 22 in Herbert, "City vs. Country." The source material for this quote can only be traced to a nineteenth-century biography of Millet written by Alfred Sensier, a bureaucrat who doubled as Millet's patron and commercial agent. The underlying primary source, "an undated autobiography," is unlocated.

11. Timothy J. Clark, "The Conditions of Artistic Creation," in *Art History and Its Methods,* ed. Eric Fernie (London: Phaidon, 1995), 251.

12. Paul Duro, "Diderot and the Destination of Art," *Word & Image* 33, no. 2 (2017): 158–69, https://doi.org/10.1080/02666286.2017.1297658; Paul Duro, "Giving Up on History? Challenges to the Hierarchy of the Genres in Early Nineteenth-Century France," *Art History* 28, no. 5 (2005): 689–711.

13. Albert Boime, *The Academy and French Painting in the Nineteenth Century* (London: Phaidon, 1971), 1–21.

14. Boime, 1–21.

15. *Oxford Dictionary of Art and Artists*, 5th ed. (Oxford: Oxford University Press, 2015), s.v. "Valenciennes, Pierre-Henri De"; Peter Galassi, "The Nineteenth Century: Valenciennes to Corot," in *Claude to Corot: The Development of Landscape Painting in France*, ed. Alan Wintermute (New York: University of Washington Press and Colnaghi, 1990), 233.

16. Steven Adams, *The Barbizon School and the Origins of Impressionism* (London: Phaidon, 1994), 19–35.

17. Galassi, "The Nineteenth Century," 242.

18. André Parinaud, *Barbizon, the Origins of Impressionism* (Vaduz, Liechtenstein: Bonfini Press, 1994), 175–85.

19. Jean Bouret, *L'École de Barbizon et le paysage français au XIXe siècle* (Neuchâtel: Ides et Calendes, 1972), 91–101.

20. Richard R. Brettell and Caroline B. Brettell, *Painters and Peasants in the Nineteenth Century* (Geneva: Skira, 1983), 13–17; in

the Whiteley Index, there are at least a dozen copies of Robert's painting listed.

21. Although they exhibited at the Salon, neither Jeanron nor Leleux was educated at the École des beaux-arts.

22. Kimberly A. Jones, "Landscapes, Legends, Souvenirs, Fantasies: The Forest of Fontainebleau in the Nineteenth Century," in *In the Forest of Fontainebleau: Painters and Photographers from Corot to Monet*, ed. Kimberly A. Jones et al. (New Haven: Yale University Press, 2008), 9–12.

23. Simon Kelly, "Théodore Rousseau, His Patrons and Public" (PhD diss., University of Oxford, 1996), 28–30.

24. Adams, *The Barbizon School and the Origins of Impressionism*, 57–59; Bouret, *L'École de Barbizon et le paysage français au XIXe siècle*, 91–140.

25. The new state attempted to establish itself as a major patron of the arts, particularly with monumental public works celebrating the glory of France and its revolutions. The 1848 Salon had no jury; this had previously happened only once, in 1791. However, the open Salon did not last after professional artists complained about exhibiting alongside amateurs. The next three Salons transitioned to a jury system, where a general assembly of professional artists elected the jury, and a poll among the same general assembly determined the prizewinners. For more information about how this particularly affected images of rural and working-class people, see Raymond Grew, "Picturing the People: Images of the Lower Orders in Nineteenth-Century French Art," *Journal of Interdisciplinary History* 17 (1986): 227–31.

26. Bouret, *L'École de Barbizon et le paysage français au XIXe siècle*, 140–48.

27. The two primary contributors to this literature are Patricia Mainardi and Albert Boime. Mainardi believes the imperial administration was largely incompetent and settled on a policy of artistic eclecticism to avoid antagonizing any factions of the art world or the general public. See Mainardi, *Art and Politics of the Second Empire: The Universal Expositions of 1855 and 1867* (New Haven: Yale University Press, 1987), 66–96,

123–34. Boime characterizes the imperial administrators as using the fine arts and press censorship to create images of France that functioned as propaganda aimed at the public. According to Boime, rural genre and landscape painting were central to this propagandistic mission. See Boime, "The Second Empire's Official Realism," in *The European Realist Tradition*, ed. Gabriel P. Weisberg (Bloomington: Indiana University Press, 1982), 31–123.

28. For an extended discussion of the history of genre painting in the Second Empire, see Michaël Vottero, *La peinture de genre en France, après 1850* (Rennes: Presses Universitaires de Rennes, 2012); Alister Mill, "Artists at the unitary Salon during the July Monarchy," in *The Paris Fine Art Salon/Le Salon, 1791–1881*, ed. Alister Mill and James Kearns (Bern: Peter Lang, 2015), 152–53.

29. Mainardi, *Art and Politics of the Second Empire*, 151–74. Information about prizewinners from 1849 until the end of the Salon is available in the Salon catalogs; prize information before that date is harder to find. While Salon reviews in *L'Artiste* mentioned the winners, full lists were only intermittently published. Corot, Daubigny, Diaz, Millet, Rousseau, and the Barbizon affiliate Constant Troyon all won medals and became celebrity artists. Rosa Bonheur and Jules Breton—famous for his depictions of the peasants of his native Pas-de-Calais—won medals throughout the Second Empire.

30. Examples include "Millet," *L'Artiste*, no. 101 (1875): 113–15, https://gallica.bnf.fr/ark:/12148/bpt6k241389q/f1.image; Auguste Isnard, *Bon Papa Corot, Souvenir d'une excursion à Ville-d'Avray* (Paris: Alphones Lemerre, 1881); and in English, John W. Mollett, *The Painters of Barbizon: Millet, Rousseau, Diaz* (New York: Scribner and Welford, 1890).

31. Bonnie L. Grad and Timothy A. Riggs, *Visions of City and Country: Prints and Photographs of Nineteenth-Century France* (Worcester: Worcester Art Museum, 1982), 15–65.

32. Brettell and Brettell, *Painters and Peasants in the Nineteenth Century*, 29–74; Grad and Riggs, *Visions of City and Country*; Robert L. Herbert, *Peasants and "Primitivism": French Prints from Millet to Gauguin*

(South Hadley, MA: Mount Holyoke College Art Museum, 1995).

33. Herbert, *Peasants and "Primitivism,"* 11.

34. The specificity of the Salon Index subject headings allows paintings to be grouped into these categories. Millet's *Sower,* Bouguereau's *The Reaper* (1872), and Théodore Richard's *Woodcutters: Interior of the Forest* (1832) are examples of paintings categorized as "Work" in figure 3.5. Troyon's *Leaving for the Market* (1859) is tagged both as "Coming and Going" and as "Markets and Fairs," while Lhermitte's *Apple Market, Landernau, Finistère* (c. 1878) is tagged only as "Markets and Fairs." Demay's *La fête du village* (1834) is tagged as "Festivities and Relaxation." There is some double tagging—such as for Troyon's painting—but it is rare; fewer than 10 percent of the rural genre paintings have two or more tags.

35. Susan Carol Rogers, "Good to Think: The 'Peasant' in Contemporary France," *Anthropological Quarterly* 60, no. 2 (1987): 57, https://doi.org/10.2307/3317995; Brettell and Brettell, *Painters and Peasants in the Nineteenth Century,* 75–101.

36. Breton's painting is tagged both as "wheat" and as "benedictions, blessings, and holy water."

37. There were few images of industry; however, the universal exhibitions of 1855 and 1867 (both of which are referenced in the index) had fine arts and industrial components. See Mainardi, *Art and Politics of the Second Empire,* 123–34; Herbert, "City vs. Country," 44.

38. For an explanation of correlations, see Charles H. Feinstein and Mark Thomas, *Making History Count: A Primer in Quantitative Methods for Historians* (Cambridge: Cambridge University Press, 2002), 71–92, https://doi.org/10.1017/CBO9781139164832.

39. This correlation may be partly attributable to the shortened time series for agricultural employment—unlike for other variables—data is only available after 1855. After this date, both national rates of agricultural employment and the share of rural genre painting on display slowly but steadily declined.

40. For an explanation of bivariate and multivariate regression analysis, see Feinstein and Thomas, *Making History Count,* 93–114, 231–99.

41. For several useful and (relatively) succinct overviews of the economic history of the development of France, see François Crouzet, "The Historiography of French Economic Growth in the Nineteenth Century," *Economic History Review* 56, no. 2 (2003): 215–42, https://doi.org/10.1046/j.1468-0289.2003.00248.x; Hugh Clout, *The Land of France, 1815–1914* (London: Allen and Unwin, 1983); Paul Hohenberg, "Change in Rural France in the Period of Industrialization, 1830–1914," *Journal of Economic History* 32, no. 1 (1972): 219–40.

42. A painting is considered to be of a specified location when that location is mentioned in its title. For example, the painting *The Harvest of the Olives near Menton* (Whiteley Index number 1864–1401; no image found) is tagged as French and more specifically as set in Menton, Alpes-Maritime. Not all titles that include a geographic location refer to a place as specific as a town. Sometimes, only a country is mentioned, or the country is implied by an adjective in the title, such as Ernest Hébert's *Italian Shepherd* (Whiteley Index number 1849–1124; no image found). Of the paintings without a specified geographic location, it is difficult to know whether the audience saw the peasants depicted as French. The subjects may have been wearing recognizable regional dress, or French viewers may have assumed that any contemporary peasant depicted was a Frenchman or woman. Unfortunately, without an explicit location listed, one cannot know the audience's perception of a painting's geographical setting.

43. For reasons of statistical validity, these regressions use absolute numbers and include a variable for the size of the Salon in a given year instead of using the share of Salon painting as the dependent variable.

44. Nina Lübbren, *Rural Artists' Colonies in Europe, 1870–1910* (Manchester: Manchester University Press, 2001), 15–64.

45. Michael E. Porter, "Clusters and the New Economics of Competition," *Harvard Business Review* 76 (1998): 77–90.

46. Christiane Hellmanzik, "Location Matters: Estimating Cluster Premiums for Prominent Modern Artists," *European Economic Review* 54, no. 2 (2010): 199–218; Karol Jan Borowiecki and Diana Seave Greenwald, "Arts and Culture," in *Handbook of Cliometrics*, ed. Claude Diebolt and Michael Haupert, 2nd ed. (Berlin: Springer, 2019), 12–18.

47. Lübbren, *Rural Artists' Colonies in Europe, 1870–1910*, 146.

48. Lübbren, 2–3. One should note that Monet and other future Impressionists visited and briefly worked at these older colonies early in their career but later moved on to other communities. See Lübbren, 18 and 78.

49. Robert L. Herbert, *Monet on the Normandy Coast: Tourism and Painting, 1867–1886* (New Haven: Yale University Press, 1994), 87–89.

50. Susan Carol Rogers, "Which Heritage? Nature, Culture, and Identity in French Rural Tourism," *French Historical Studies* 25, no. 3 (2002): 475–503, https://doi.org/10.1215/00161071-25-3-475; Patrick Young, *Enacting Brittany: Tourism and Culture in Provincial France, 1871–1939* (Farnham: Ashgate, 2012).

51. Data measuring these incidents in France comes from Charles Tilly and David K. Jordan, "Strikes and Labor Activity in France, 1830–1960" (Inter-university Consortium for Political and Social Research [distributor], 2012), https://doi.org/10.3886/ICPSR08421.v2.

52. Griselda Pollock, *Millet* (London: Oresko Books, 1977), 8.

53. Pollock, 9.

54. Herbert, "Millet Reconsidered," 29–33.

55. Pollock, *Millet*, 9, 21–22.

56. Christopher Parsons, "Patrons and Collectors of Jean-François Millet between 1845 and 1875" (master's thesis, University of Oxford, 1980), 39; Pollock, *Millet*, 22.

57. Robert L. Herbert, "Millet Revisited— I," *Burlington Magazine* 104, no. 712 (1962): 295; Herbert, "Millet Reconsidered," 30–31.

58. Pollock, *Millet*, 22–23.

59. Bradley Fratello, "France Embraces Millet: The Intertwined Fates of 'The Gleaners' and 'The Angelus,'" *Art Bulletin* 85, no. 4 (2003): 685–701.

60. Quoted in Herbert, "Millet Reconsidered," 38.

61. These quotes are repeated in Alexandra Murphy, *Jean-François Millet, Drawn into the Light* (New Haven: Yale University Press, 1999); Parsons, "Patrons and Collectors of Jean-François Millet between 1845 and 1875"; Alfred Sensier, *Jean-François Millet, Peasant and Painter*, trans. Helena De Kay (Boston: J. R. Osgood and Company, 1881); Parsons and McWilliam, "'Le Paysan de Paris,'"; and Fratello, "France Embraces Millet."

62. Other institutions that hold letters written by Millet are the Fondation Custodia in Paris and the Getty Research Institute.

63. Musée du Louvre, Département des arts graphiques, "Inventaire du département des arts graphiques," accessed December 17, 2018, http://arts-graphiques.louvre.fr.

64. Web scraping is a process that allows one to capture information shown on a website and save it in a spreadsheet. Essentially, one uses a program to click through and look at each web page very quickly and copy the information into a digestible dataset. This process allows for all data publicly available on the web to be turned into data for analysis. For more information, see https://www.webharvy.com/articles/what-is-web-scraping.html.

65. A useful recent source about corpus analysis of texts and their relationship to geography is Ian Gregory et al., "Modeling Space in Historical Texts," in *The Shape of Data in the Digital Humanities: Modeling Texts and Text-Based Resources*, ed. Julia Flanders and Fotis Jannidis (London: Routledge, 2019), 133–49.

66. A description of the patronage and friendship between Rousseau and Millet is in Parsons, "Patrons and Collectors of Jean-François Millet between 1845 and 1875," 134.

67. Herbert's translation, which differs slightly from mine, below.

68. Jean-François Millet to Alfred Sensier, February 1851, Cote BSb12L9, Réserve des autographes, Cabinet des dessins, Musée du Louvre, Paris. Translation by Diana Seave Greenwald and Hugues Le Bras.

69. Parsons and McWilliam, "'Le Paysan de Paris,'" 38.

70. The clear exception to this is Parsons and McWilliam, 38–39. Parsons and McWilliam trace how Sensier cultivated a "Millet myth" around his rural birth and choice to live in Barbizon. Sensier felt this boosted Millet's appeal to the Second Empire public and also increased the monetary value of Millet's art—of which Sensier owned a considerable amount.

71. Jean-François Millet to Théodore Rousseau, April 1859, Cote BSb12L156, Réserve des autographes, Cabinet des dessins, Musée du Louvre, Paris. Translation by Diana Seave Greenwald and Hugues Le Bras.

72. Herbert, "City vs. Country," 42; Timothy J. Clark, *Farewell to an Idea: Episodes from a History of Modernism* (New Haven: Yale University Press, 1999), 55–137.

Chapter 4: Why Have There Been No Great Women Artists?

1. "Guerrilla Girls Archive," Getty Research Institute, accessed August 17, 2018, http://www.getty.edu/research/special _collections/notable/guerrilla_girls.html.

2. Kirsten Swinth, *Painting Professionals: Women Artists and the Development of Modern American Art, 1870–1930* (Chapel Hill: University of North Carolina Press, 2001); Laura R. Prieto, *At Home in the Studio: The Professionalization of Women Artists in America* (Cambridge, MA: Harvard University Press, 2001); Erica Hirshler, *A Studio of Her Own: Women Artists in Boston, 1870–1940* (Boston: Museum of Fine Arts, 2001); Melissa Dabakis, *A Sisterhood of Sculptors: American Artists in Nineteenth-Century Rome* (University Park: Pennsylvania State University Press, 2014).

3. Maura Reilly, "Taking the Measure of Sexism: Facts, Figures, and Fixes," *ARTnews* (blog), May 26, 2015, http://www.artnews .com/2015/05/26/taking-the-measure-of -sexism-facts-figures-and-fixes/; "Get the Facts | National Museum of Women in the Arts," accessed December 10, 2018, https:// nmwa.org/advocate/get-facts; Lily Le Brun, "Will Women Artists Ever Be Better Represented in Museums?," *Apollo Magazine*, March 2, 2015, https://www.apollo-magazine

.com/inquiry-wall-flowers-women-historical -art-collections/.

4. There is a vast literature about the definition of sex, gender, and the relationship between the two. Some of the most significant scholarly contributions that have explored this complexity are Ann Oakley, *Sex, Gender, and Society*, rev. ed. (London: Routledge, 2016); Thomas Laqueur, *Making Sex: Body and Gender from the Greeks to Freud* (Cambridge, MA: Harvard University Press, 1992); and Judith Butler, *Gender Trouble: Feminism and the Subversion of Identity*, 2nd ed. (London: Routledge, 1999).

5. For a sensitive discussion of intersectionality as experienced by a nineteenth-century woman artist, see Kirsten Pai Buick, *Child of the Fire: Mary Edmonia Lewis and the Problem of Art History's Black and Indian Subject* (Durham: Duke University Press, 2010).

6. Claudia Goldin, "The Quiet Revolution That Transformed Women's Employment, Education, and Family," *American Economic Association Papers and Proceedings* 96, no. 2 (May 2006): 4.

7. An overview of work in this area is provided in Marianne Bertrand, "The Glass Ceiling," Becker Friedman Institute Working Paper Series (Chicago: University of Chicago, June 2018).

8. For a comprehensive overview of legal forms of discrimination against married women, see Claudia Goldin, *Marriage Bars: Discrimination against Married Women Workers, 1920's to 1950's* (Cambridge, MA: National Bureau of Economic Research, 1988).

9. For an overview of workplace discrimination against women, see Faye J. Crosby, Margaret S. Stockdale, and S. Ann Ropp, eds., *Sex Discrimination in the Workplace: Multidisciplinary Perspectives* (London: Routledge, 2007).

10. This phenomenon has largely been examined with time diary data and interviews; these methodologies do not work particularly well in historical settings when surveys of these kinds did not exist. There is data available on unequal domestic burden for American women from the late twentieth century to the present. These empirical

findings have, in turn, lead to generalizations that unequal distribution of domestic labor has been a persistent pattern. See Phyllis Moen, *It's About Time* (Ithaca: Cornell University Press, 2003).

11. Claudia Goldin, "A Grand Gender Convergence: Its Last Chapter," *American Economic Review* 104, no. 4 (2014): 1091–1119.

12. Of course, the most famous early argument about a creative professional, particularly a woman writer, needing space and an opportunity to work undisturbed is Virginia Woolf, *A Room of One's Own* (London: Harcourt, 1929). As described below, women artists and histories of women artists report the importance of time in the studio as essential to their practice. However, social scientists are only beginning to specifically quantify the effects of factors like time, money, institutional support, and emotional well-being on creative output. Examples of forays into this research are surveyed in Karol Jan Borowiecki and Diana Seave Greenwald, "Arts and Culture," in *Handbook of Cliometrics*, ed. Claude Diebolt and Michael Haupert, 2nd ed. (Berlin: Springer, 2019).

13. An overview of art dealing in this period in the US can be found in Malcolm Goldstein, *Landscape with Figures: A History of Art Dealing in the United States* (Oxford: Oxford University Press, 2000), 3–93.

14. Lilly Martin Spencer to Angélique Martin, August 11, 1852, reel 131, no frame number, Lilly Martin Spencer Papers, 1828–1966, Archives of American Art, Smithsonian Institution, Washington, DC.

15. For an overview of the impact of this scholarship, see Jonathan Harris, *The New Art History: A Critical Introduction* (London: Routledge, 2001).

16. Linda Nochlin, "Why Have There Been No Great Women Artists?," in *Women, Art, and Power: And Other Essays* (New York: Harper and Row, 1989), 147.

17. Nochlin, 150.

18. Nochlin, 153.

19. For the social scientific definition, see "Economic Institutions," Econlib, accessed August 22, 2018, https://www.econlib.org/library/Topics/HighSchool/Economic Institutions.html.

20. For a useful review of the historiography of feminist art history, see Victoria Horne and Lara Perry, introduction to *Feminism and Art History Now: Radical Critiques of Theory and Practice* (London: I. B. Tauris, 2017), 1–23.

21. Swinth, *Painting Professionals*, 3. I should note that according to the source material for these numbers, the base number in 1870 was 418 and the number in 1890 was 10,923. See Janet M. Hooks, "Women's Occupations through Seven Decades" (Washington, DC: United States Department of Labor, 1947), https://fraser.stlouisfed.org/files/docs/publications/women/b0218_dolwb_1947.pdf. The figures appear on pages 168 and 208.

22. Swinth, *Painting Professionals*, 207–9.

23. Jean Gordon, "Early American Women Artists and the Social Context in Which They Worked," *American Quarterly* 30, no. 1 (1978): 54–69.

24. Gladys Engel Lang and Kurt Lang, *Etched in Memory: The Building and Survival of Artistic Reputation* (Chapel Hill: University of North Carolina Press, 1990), 1–15.

25. Margaret R. Laster and Chelsea Bruner, introduction to *New York: Art and Cultural Capital of the Gilded Age*, ed. Margaret R. Laster and Chelsea Bruner (New York: Routledge, 2018).

26. Pairing data from these linked institutions also eliminates the complicating factors of geography and local social networks that may create extra barriers to contemporary art production in one city being preserved in a museum in another city.

27. Grischka Petri, "American Academy of Fine Arts," in *Grove Encyclopedia of American Art*, ed. Joan Marter (Oxford: Oxford University Press, 2011), https://doi.org/10.1093/gao/9781884446054.article.T2090109; Theodore Sizer, "The American Academy of the Fine Arts," in *American Academy of Fine Arts and American Art-Union, 1816–1852*, ed. Mary Bartlett Cowdrey (New York: New-York Historical Society, 1953); Nancy Elizabeth Richards, "The American Academy of Fine Arts, 1802–1816: New York's First Art Academy" (master's thesis, University of Delaware, 1965).

28. Eliot Clark, *History of the National*

Academy of Design, 1825–1952 (New York: Columbia University Press, 1954), 12–15.

29. Clark, 16.

30. Thomas Seir Cummings, *Historic Annals of the National Academy of Design, New-York Drawing Association, Etc., with Occasional Dottings by the Way-Side, from 1825 to the Present Time* (Philadelphia: George W. Childs, 1865), 34.

31. Mary Bartlett Cowdrey, introduction to *National Academy of Design Exhibition Record, 1826–1860*, vol. 1, ed. Mary Bartlett Cowdrey (New York: New-York Historical Society, 1943), x–xii.

32. Clark, *History of the National Academy of Design*, 98–99.

33. Quoted in Clark, *History of the National Academy of Design*, 18.

34. Reproduced in Cummings, *Historic Annals of the National Academy of Design*, 196.

35. This institution was initially founded as the Apollo Association. The Apollo Gallery, the forerunner to the Apollo Association, was founded in New York City in 1838. The gallery was meant to be a space for artists to show their work for sale, but the venture was a financial failure. Apollo Gallery founder and artist James Herring subsequently formed the Apollo Association, which he modeled on art unions already operating in Europe. See Mary L. Natale, "The American Art-Union, 1839–51: A Reflection of National Identity" (master's thesis, Harvard University, 1993), 4–6. Membership for subscribers cost five dollars per year. This money would then be used to purchase artwork from living American artists. A committee of fifteen managers—none of whom could be artists—directed the purchases. At an annual end-of-year meeting, the purchased works would be distributed by lottery to members of the Association. The membership would also elect the next year's managers at that meeting. While artists could not be among the managers in charge of choosing the art, they could serve the institution in operational roles like secretary or treasurer. Finally, members were entitled to free entry to an annual exhibition of the works that would be distributed. Beginning in 1840, members also received at least one print of a work selected for distribution. "Constitution of the Apollo Association for the Promotion of Fine Arts in the United States," *Transactions of the Apollo Association for the Promotion of Fine Arts in the United States* (1839), 3–4.

36. Quoted in Cummings, *Historic Annals of the National Academy of Design*, 166.

37. Natale, "The American Art-Union," 230–52.

38. Clark notes that the "words 'Hanging Committee' first occur in the minutes of 1865 as distinguished from the former Committee on Arrangements." Clark, *History of the National Academy of Design*, 95. In fact, the term seems to have been first used in 1844, but the concept was not formalized until the 1860s. Cummings, *Historic Annals of the National Academy of Design*, 186.

39. Clark, *History of the National Academy of Design*, 95.

40. Almost immediately, artists began to chafe against the jury and other rules that were established to limit the submission of any works previously exhibited in New York City. The internal conflict reached a boiling point in 1877, when a splinter group of artists founded the Society of American Artists to challenge the dominance of the National Academy. The Hanging Committee was enlarged in 1882 to include five members and would go through various debated transformations into the 1890s. Clark, *History of the National Academy of Design*, 96–97, 100–102.

41. Prieto, *At Home in the Studio*, 13; Julie Graham, "American Women Artists' Groups: 1867–1930," *Woman's Art Journal* 1, no. 1 (1980): 7–12; "All National Academicians (1825–Present)," National Academy of Design, accessed August 27, 2018, https://www.nationalacademy.org/all-national-academicians/.

42. Prieto, *At Home in the Studio*, 26–27.

43. Prieto, 26–27.

44. Graham, "American Women Artists' Groups," 8.

45. Prieto, *At Home in the Studio*, 91.

46. Prieto, 42.

47. Prieto, 42–43.

48. Diana Seave Greenwald, "Colleague Collectors: A Statistical Analysis of Artists' Collecting Networks in Nineteenth-Century New York," *Nineteenth-Century Art Worldwide* 17, no. 1 (2018), https://www.19thc-art worldwide.org/spring18/greenwald-on -artists-collecting-networks-in-nineteenth -century-new-york.

49. Information communicated to me via email by the Century Association's archivist, Tim DeWerff. See DeWerff, "Women at the Century Association," November 2, 2018; John Gordon, "Twentieth Anniversary Celebration of Women Members" (transcript of a speech at Century Association, New York, October 27, 2009).

50. For another example of scholars in digital art history engaging with questions of women artists' exhibition practices and collectives, see Joanna P. Gardner-Huggett, "Women Artists' Salon of Chicago (1937–1953): Cultivating Careers and Art Collectors," *Artl@s Bulletin* 8, no. 1 (2019): Article 12, https://docs.lib.purdue.edu/artlas/vol8/iss1 /12.

51. Prieto, *At Home in the Studio*, 120–21; Jane Cunningham Croly, *Sorosis: Its Origin and History* (New York: J. J. Little & Co., 1886), https://link.gale.com/apps/doc/AQV TDI248914741/NCCO?u=columbiau&sid =NCCO&xid=3edef43b.

52. Prieto, *At Home in the Studio*, 123–24.

53. Prieto, 125–39.

54. Prieto, 138–43.

55. Calvin Tomkins, *Merchants and Masterpieces: The Story of the Metropolitan Museum of Art*, rev. ed. (New York: Henry Holt, 1989), 27–28.

56. Tomkins, 29.

57. The online tool I used to accomplish this is Markus Perl, Gender API (Gender -API.com, 2018).

58. For an overview of Hirst's career, see Martha M. Evans, *Claude Raguet Hirst: Transforming the American Still Life* (Columbus, OH: Columbus Museum of Art, 2004).

59. The program takes into account when a gender modifier is linked to the anonymous name, e.g., "A Lady Amateur."

60. In an exchange of emails in August 2018, I corresponded with Leela Outcalt to

receive "only fine arts" data. This meant excluding the large collections of furniture, vases, silver, and other items generally considered "decorative arts." However, this does *not* exclude graphic arts that may have been created in service of the design of a vase or lamp (i.e., "commercial material").

61. Prieto, *At Home in the Studio*, 26–28.

62. For a description of women's training and later integration into professional artistic life, see Prieto, 12–69. For a description of this pattern in other fields, see Bertrand, "The Glass Ceiling"; Goldin, "The Quiet Revolution That Transformed Women's Employment, Education, and Family."

63. Prieto, *At Home in the Studio*, 120–25.

64. Prieto, 179. For an overview of the different paths women took to formal training, see Swinth, *Painting Professionals*, 19–36.

65. The important point here is that the NAD represents a population of artists who are common in the Met's collection. Examples of artists in the American Wing who were also regular exhibitors at the NAD include Asher Durand, Sanford Gifford, Frederic Edwin Church, Thomas Moran, John Singer Sargent, Mary Cassatt, Daniel Huntington, John Frederick Kensett, and Winslow Homer.

66. The National Academy and other American academies imported, to a certain extent, the hierarchy of genres from Europe. This ranking of types of artwork placed history and landscape painting at the apex of artistic achievement and considered still life to be the "lowest" art form. For a description of the founding of the NAD and its links to European academies, see Clark, *History of the National Academy of Design, 1825–1952*, 3–41. For information about the genesis of the hierarchy of genres in France and its adoption at the Royal Academy, see Paul Duro, "Giving Up on History? Challenges to the Hierarchy of the Genres in Early Nineteenth-Century France," *Art History* 28, no. 5 (2005): 689–711; Sir Joshua Reynolds, *Discourses on Art*, ed. Robert R. Wark, new ed. (New Haven: Yale University Press, 1997).

67. The volatility of the percentage prior to 1860 is due to what is colloquially called a small denominator problem; so few works

were by women in the early years that any small absolute change translates to a huge percentage change. There is a chance the jury could have been more supportive of women artists creating still life rather than other genres; however, it is impossible to judge this selection effect because there is no data available about which works were submitted to the Academy but rejected.

68. Swinth mentions in passing this engagement with "diverse 'lesser' media"; see Swinth, *Painting Professionals*, 65–66.

69. Swinth, 74.

70. Swinth, 75.

71. Eleanor Jones Harvey, *The Painted Sketch: American Impressions from Nature, 1830–1880* (Dallas: Dallas Museum of Art, 1998), 25–61.

72. A description of the social barriers to women completing the necessary travel for landscape painting is in Prieto, *At Home in the Studio*, 59–63.

73. Prieto, 37.

74. Prieto, 60–61; Shannon Vittoria, "Nature and Nostalgia in the Art of Mary Nimmo Moran (1842–1899)" (PhD diss., City University of New York, 2016), 1–10, 147–54.

75. Wendy Greenhouse, "Daniel Huntington and the Ideal of Christian Art," *Winterthur Portfolio* 31, no. 2/3 (1996): 103.

76. Daniel Huntington to Benjamin Huntington, June 13, 1846, and Daniel Huntington to Channing Huntington, May 27, 1877, reel 4857, Huntington Family Papers, 1792–1901, Archives of American Art, Smithsonian Institution.

77. Daniel Huntington to Rev. Gurdon Huntington, May 30, 1875, reel 4857, Huntington Family Papers, 1792–1901, Archives of American Art, Smithsonian Institution.

78. Greenhouse, "Daniel Huntington and the Ideal of Christian Art," 108. Throughout his letters preserved at the Archives of American Art, Huntington describes what seems to be a happy coexistence with his wife.

79. Prieto, *At Home in the Studio*, 20–21.

80. For information about property rights, see Holly J. McCammon, Sandra C. Arch, and Erin M. Bergner, "A Radical Demand Effect: Early US Feminists and the Married

Women's Property Acts," *Social Science History* 38, no. 1–2 (2014): 221–50.

81. Quoted in Prieto, *At Home in the Studio,* 76.

82. An overview of the early years of the American art market is in Goldstein, *Landscape with Figures.* Carrie Rebora Barratt, "Mapping the Venues: New York City Art Exhibitions," in *Art and the Empire City: New York, 1825–1861* (New York: Metropolitan Museum of Art, 2000) discusses commercial galleries in New York City.

83. Jervis McEntee diary, October 19, 1876, reel D180, frame 144, Jervis McEntee Papers, 1796, 1848–1905, Archives of American Art, Smithsonian Institution.

84. For an explanation of how these spaces functioned, see Annette Blaugrund, *The Tenth Street Studio Building: Artist-Entrepreneurs from the Hudson River School to the American Impressionists* (Seattle: University of Washington Press, 1997). Blaugrund lists the resident artists from 1857 to 1895 on pp. 133–34. They are all men.

85. Blaugrund, 69–80; Joe Festa, "Requesting the Pleasure of Your Company: Artists' Receptions and the Tenth Street Studio Building's Legacy," *From the Stacks* (blog), December 17, 2014, http://blog.nyhistory.org/tenth-street-studio-building/.

86. Mary Mowll Mathews, *Mary Cassatt: A Life* (New York: Villard Books, 1994), 57–59.

87. Mathews, 3–61.

88. Dabakis, *A Sisterhood of Sculptors*, 9–10.

89. Dabakis, 28–35.

90. Robin Bolton-Smith and William H. Truettner, *Lilly Martin Spencer (1822–1902): The Joys of Sentiment* (Washington, DC: Smithsonian Institution Press, 1973), 11–12.

91. David Lubin, *Picturing a Nation: Art and Social Change in Nineteenth-Century America* (New Haven: Yale University Press, 1994), 166; Bolton-Smith and Truettner, *Lilly Martin Spencer,* 11.

92. Bolton-Smith and Truettner, *Lilly Martin Spencer,* 12.

93. Nick Fauchald, "The Father of American Sparkling Wine," *Wine Spectator,* June 28, 2004, https://www.winespectator.com/webfeature/show/id/The-Father-of-American-Sparkling-Wine_2133; Jochen

Wierich, "War Spirit at Home: Lilly Martin Spencer, Domestic Painting, and Artistic Hierarchy," *Winterthur Portfolio* 37, no. 1 (2002): 31.

94. Bolton-Smith and Truettner, *Lilly Martin Spencer*, 21.

95. Wendy Jean Katz, *Humbug! The Politics of Art Criticism in New York City's Penny Press* (New York: Fordham University Press, 2020); Elsie Freivogel, "Lilly Martin Spencer," *Archives of American Art Journal* 12, no. 4 (1972): 13. Note that Lillian Spencer Gates, a granddaughter of Lilly Martin Spencer and Benjamin Spencer, thought this characterization of her grandfather's occupation might have been inaccurate. Lillian Spencer Gates to Robin Bolton-Smith, July 22, 1973, Accession 97-004, National Museum of American Art, Curatorial Department, Exhibition Records, Smithsonian Institution Archives.

96. W. A. Adams to Lilly Martin Spencer, February 5, 1845, reel 131, no frame number, Lilly Martin Spencer Papers, 1828–1966, Archives of American Art, Smithsonian Institution, Washington, DC.

97. Bolton-Smith and Truettner, *Lilly Martin Spencer*, 28–63.

98. Freivogel, "Lilly Martin Spencer," 13; Bolton-Smith and Truettner, *Lilly Martin Spencer*, 24–25; Lubin, *Picturing a Nation*, 183–87.

99. April Masten, "'Shake Hands?' Lilly Martin Spencer and the Politics of Art," *American Quarterly* 56, no. 2 (2004): 358.

100. These points of view are presented in the limited literature dedicated to Spencer. Contributions include Freivogel, "Lilly Martin Spencer"; Bolton-Smith and Truettner, *Lilly Martin Spencer*; Wendy Jean Katz, "Lilly Martin Spencer and the Art of Refinement," *American Studies* 42, no. 1 (2001): 5–37; Wierich, "War Spirit at Home"; Wendy Jean Katz, *Regionalism and Reform: Art and Class Formation in Antebellum Cincinnati* (Columbus: Ohio State University Press, 2002), 27–85; Masten, "'Shake Hands?'."

101. Freivogel, "Lilly Martin Spencer," 9. I have lightly edited the typos and grammatical errors in Spencer's letters for the sake of clarity.

102. Transcribing all of Spencer's letters,

which are preserved on microfilm at the Archives of American Art, would be an exciting future project.

103. For examples of scholarship that engages in these debates, see Lubin, *Picturing a Nation*, 159–203; Masten, "'Shake Hands?'"; Wierich, "War Spirit at Home"; Katz, "Lilly Martin Spencer and the Art of Refinement."

104. Lilly Martin Spencer to Angélique Martin, June 5, 1850, reel 131, no frame number, Lilly Martin Spencer Papers, 1828–1966, Archives of American Art, Smithsonian Institution, Washington, DC.

105. Lilly Martin Spencer to Angélique and Gilles Martin, October 2, 1847, reel 131, no frame number, Lilly Martin Spencer Papers, 1828–1966, Archives of American Art, Smithsonian Institution, Washington, DC.

106. Lilly Martin Spencer to Angélique and Giles Martin, November 21, 1848, reel 131, no frame number, Lilly Martin Spencer Papers, 1828–1966, Archives of American Art, Smithsonian Institution, Washington, DC.

107. Spencer to Angélique Martin, June 5, 1850.

108. Lilly Martin Spencer to Angélique Martin, October 11, 1850, reel 131, no frame number, Lilly Martin Spencer Papers, 1828–1966, Archives of American Art, Smithsonian Institution, Washington, DC.

109. Eleanor Jones Harvey, "Tastes in Transitions: Gifford's Patrons," in *Hudson River School Visions: The Landscapes of Sanford Gifford*, ed. Kevin Avery (New Haven: Yale University Press, 2003), 79–89; Blaugrund, *The Tenth Street Studio Building*.

110. McEntee diary, May 3, 1878, reel D180, frame 200, Jervis McEntee Papers, 1796, 1848–1905, Archives of American Art, Smithsonian Institution, Washington, DC. Quoted in Kevin Michael Murphy, "Economics of Style: The Business Practices of American Artists and the Structure of the Market, 1850–1910" (PhD diss., University of California, Santa Barbara, 2005), 254–55.

111. For discussion of sales at the Century, see Murphy, "Economics of Style," 38–40; Greenwald, "Colleague Collectors."

112. Joseph S. Carels to Lilly Martin Spencer requesting her autograph, January 9, 1858, reel 131, no frame number, Lilly Martin Spencer Papers, 1828–1966, Archives of American Art, Smithsonian Institution, Washington, DC.

113. Letters describe these activities to Spencer's parents throughout her correspondence from the mid-1840s through the 1850s. See reel 131, no frame number, Lilly Martin Spencer Papers, 1828–1966, Archives of American Art, Smithsonian Institution, Washington, DC.

114. Laura Groves Napolitano, "Nurturing Change: Lilly Martin Spencer's Images of Children" (PhD diss., University of Maryland, 2008), 119–22.

115. Lilly Martin Spencer to Angélique Martin, September 10, 1856, reel 131, no frame number, Lilly Martin Spencer Papers, 1828–1966, Archives of American Art, Smithsonian Institution, Washington, DC.

116. Spencer to Angélique Martin, August 11, 1852.

117. Lilly Martin Spencer to Angélique and Giles Martin, December 29, 1859, reel 131, no frame number, Lilly Martin Spencer Papers, 1828–1966, Archives of American Art, Smithsonian Institution, Washington, DC.

118. Data was added about works that have since appeared in the Metropolitan Museum of Art and the National Gallery of Art.

119. Lubin, *Picturing a Nation*, 200–201.

120. Spencer to Angélique and Giles Martin, December 29, 1859.

121. Lilly Martin Spencer to Angélique and Giles Martin, March 7, 1857, reel 131, no frame number, Lilly Martin Spencer Papers, 1828–1966, Archives of American Art, Smithsonian Institution, Washington, DC.

122. Note that the images of animals are categorized as genre scenes.

123. This is calculated by taking the mean of the dimensions listed in the catalog and those added from works since located and now in public collections.

124. The specific breakdown of known works listed in Bolton-Smith and Truettner, *Lilly Martin Spencer*, is 78 oil paintings (16.1%), 111 works on paper including 81 individual sketchbook pages (23%), 294 medium unknown (60.9%).

125. Lilly Martin Spencer to Angélique Martin, June 28, 1858, reel 131, no frame number, Lilly Martin Spencer Papers, 1828–1966, Archives of American Art, Smithsonian Institution, Washington, DC.

126. Masten, "'Shake Hands?,'" 358; Lubin, *Picturing a Nation*, 187–89.

127. Wierich, "War Spirit at Home."

128. Alexander Nemerov, *The Body of Raphaelle Peale: Still Life and Selfhood, 1812–1824* (Berkeley: University of California Press, 2000); Mark Mitchell, *Art of American Still Life* (New Haven: Yale University Press, 2015).

129. Wierich, "War Spirit at Home," 23.

130. Artsy Editors, "You Can Be a Mother and Still Be a Successful Artist," *Artsy*, August 24, 2016, https://www.artsy.net/article/artsy-editorial-why-motherhood-won-t-hinder-your-career-as-an-artist.

131. Bourree Lam, "A Field Where Working Moms Aren't Punished," *The Atlantic*, July 13, 2016, https://www.theatlantic.com/business/archive/2016/07/arts-motherhood-penalty/491153/.

132. Anna Louie Sussman, "The Challenges Female Artists Face Mid-Career," *Artsy*, January 11, 2019, https://www.artsy.net/article/artsy-editorial-women-artists-survive-challenges-mid-career-stagnation.

133. Reilly, "Taking the Measure of Sexism."

134. Reilly.

135. Anna Louie Sussman and Kim Hart, "Do Women Dealers Represent More Women Artists?," *Artsy*, December 5, 2017, https://www.artsy.net/article/artsy-editorial-women-dealers-represent-women-artists-crunched-numbers.

136. This series is edited by Julia Halperin and is available at https://news.artnet.com/womens-place-in-the-art-world; examples of relevant articles include Rachel Corbett, "The Art World Is Considered a Progressive Place, But It Has a Big Blind Spot: Supporting Working Mothers," *ArtnetNews*, September 19, 2019, https://news.artnet.com/womens-place-in-the-art-world/maternity

-leave-parenthood-art-world-1613179; Bea-
triz Lozano, "Visualizing the Numbers: See
Infographics Tracing the Representation of
Women Artists in Museums and the Market,"
ArtnetNews, September 19, 2019, https://news
.artnet.com/womens-place-in-the-art-world
/visualizing-the-numbers-see-infographics
-1654084.

137. Woolf, *A Room of One's Own*, 2.

138. Woolf, 56.

139. Lenka Clayton, *Artist Residency in
Motherhood*, September 2012, conceptual
and digital artwork. Learn more about the
project at http://www.lenkaclayton.com.

Chapter 5: Implied But Not Shown

1. Angus Maddison, *The World Economy:
A Millennial Perspective*, Development Cen-
tre Seminars (Organization for Economic
Co-Operation and Development, 2001), 97.

2. Niall Ferguson, *Empire: How Britain
Made the Modern World* (New York: Penguin,
2003), xii.

3. Lawrence James, *The Rise and Fall of
the British Empire* (New York: St. Martin's,
1994), xiv.

4. David Lewis, "1914: An Indian Summer,"
in *The Royal Academy Summer Exhibition: A
Chronicle, 1769–2018*, ed. Mark Hallett et al.
(London: Paul Mellon Centre for Studies in
British Art, 2018), https://chronicle250.com
/1914.

5. A meditation on the use of digital
methods to grapple with the scale of difficult
topics is in Alberto Giordano, Anne Kelly
Knowles, and Tim Cole, "Geographies of the
Holocaust," in *Geographies of the Holocaust*,
ed. Alberto Giordano, Anne Kelly Knowles,
and Tim Cole (Bloomington: Indiana Univer-
sity Press, 2014), 1–17.

6. *Sir Joshua Reynolds's Discourses on Art*
(Chicago: A. C. McClurg, 1891), 53, https://
archive.org/details/sirjoshuareynold00
reynuoft.

7. Quoted in W. J. Thomas Mitchell, *What
Do Pictures Want?: The Lives and Loves of
Images* (Chicago: University of Chicago
Press, 2007), 145.

8. Sumathi Ramaswamy, "The Work of
Vision in the Age of European Empires," in
Empires of Vision: A Reader, ed. Martin Jay

and Sumathi Ramaswamy (Durham: Duke
University Press, 2014), 4.

9. Edward W. Saïd, *Orientalism* (New
York: Vintage Books, 2004) and *Culture
and Imperialism* (New York: Vintage Books,
1993); Gayatri Chakravorty Spivak, "Can the
Subaltern Speak? Revised Edition, from the
'History' Chapter of Critique of Postcolonial
Reason," in *Can the Subaltern Speak? Reflec-
tions on the History of an Idea*, ed. Rosalind
C. Morris (New York: Columbia University
Press, 2010), 21–78; Ramaswamy, "The Work
of Vision," 6–7.

10. Timothy Barringer, Geoffrey Quilley,
and Douglas Fordham, introduction to *Art
and the British Empire*, ed. Timothy Barrin-
ger, Geoffrey Quilley, and Douglas Fordham
(Manchester: Manchester University Press,
2007), 7.

11. Many works on art and empire have
enriched my understanding of this topic
but are not described or cited at length
here. A kernel of the idea for this chapter
developed in conversations with Rachel
Grace Newman after her presentation,
"Spectral Realms: William Berryman's
Revelatory Images of Nineteenth Century
Jamaica," at the National Gallery of Art in
fall 2018. Contributions to several edited
volumes helped me familiarize myself with
this topic; they include Catherine Hall, ed.,
*Cultures of Empire: Colonizers in Britain and
the Empire in the Nineteenth and Twentieth
Centuries—a Reader* (New York: Routledge,
2000); Julie F. Codell and Dianne Sachko
Macleod, eds., *Orientalism Transposed: The
Impact of the Colonies on British Culture*
(Aldershot: Ashgate, 1998); Martin Jay and
Sumathi Ramaswamy, eds., *Empires of Vision:
A Reader* (Durham: Duke University Press,
2014). I would also like to acknowledge
Nicholas Tromans, ed., *The Lure of the East:
British Orientalist Painting* (New Haven: Yale
University Press, 2008); Catherine Molineux,
*Faces of Perfect Ebony: Encountering Atlantic
Slavery in Imperial Britain* (Cambridge, MA:
Harvard University Press, 2012).

12. Beth Fowkes Tobin, *Picturing Imperial
Power: Colonial Subjects in Eighteenth-
Century British Painting* (Durham: Duke
University Press, 1999); Kay Dian Kriz,

Slavery, Sugar, and the Culture of Refinement: Picturing the British West Indies, 1700–1840 (New Haven: Yale University Press, 2008); Geoff Quilley, Empire to Nation: Art, History and the Visualization of Maritime Britain, 1768–1829 (New Haven: Published for the Paul Mellon Centre for Studies in British Art by Yale University Press, 2011); Natasha Eaton, Colour, Art and Empire: Visual Culture and the Nomadism of Representation (London: Bloomsbury Academic, 2013).

13. Tobin, Picturing Imperial Power, 6.

14. Tobin, 2.

15. Quilley, Empire to Nation, 11.

16. See Kriz, Slavery, Sugar, and the Culture of Refinement, 71–155. Chapters 3 and 4 particularly focus on this topic. Most recently, Douglas Fordham has published Aquatint Worlds: Travel, Print, and Empire (London: Yale University Press for the Paul Mellon Centre for Studies in British Art, 2019).

17. Tobin, Picturing Imperial Power, 13.

18. Tobin, 11.

19. Tobin, 10.

20. Kim Gallon, "The Chicago Defender's Standing Dealers List," Black Press Research Collective (blog), accessed February 8, 2020, http://blackpressresearchcollective.org /visualizing-the-black-press/; Joanna P. Gardner-Huggett, "Women Artists' Salon of Chicago (1937–1953): Cultivating Careers and Art Collectors," Artl@s Bulletin 8, no. 1 (2019): Article 12, https://docs.lib.purdue.edu/artlas /vol8/iss1/12.

21. Douglass C. North and Barry R. Weingast, "Constitutions and Commitment: The Evolution of Institutions Governing Public Choice in Seventeenth-Century England," Journal of Economic History 49, no. 4 (1989): 803–32.

22. Geoffrey M. Hodgson, "What Are Institutions?," Journal of Economic Issues 40, no. 1 (March 2006): 1–25.

23. Daron Acemoglu and James A. Robinson, Why Nations Fail: The Origins of Power, Prosperity, and Poverty (New York: Crown, 2012), 74–75. This book has more than 7,000 citations on Google Scholar as of May 2019.

24. For histories of the extension of the franchise, see John Hostettler and Brian P. Block, Voting in Britain: A History of the Parliamentary Franchise (Chichester: Barry Rose, 2001); Robert Saunders, Democracy and the Vote in British Politics, 1848–1867: The Making of the Second Reform Act (Farnham: Ashgate, 2011).

25. Acemoglu and Robinson, Why Nations Fail, 103.

26. For a work dedicated to the effects of institutions—and ideas about property rights, innovation, and inclusion—on the British economy during the eighteenth and nineteenth centuries, see Joel Mokyr, The Enlightened Economy: Britain and the Industrial Revolution, 1700–1850 (New Haven: Yale University Press, 2011).

27. For foundational works in this area of research, see Karl Marx, Capital: A Critique of Political Economy, vol. 1 (New York: Penguin, 1992), chapters 14 and 15; Edward Palmer Thompson, The Making of the English Working Class (London: Penguin, 2013). For more recent scholarship, see Marc W. Steinberg, England's Great Transformation: Law, Labor, and the Industrial Revolution (Chicago: University of Chicago Press, 2016); Jane Humphries, Childhood and Child Labour in the British Industrial Revolution (Cambridge: Cambridge University Press, 2010).

28. Kenneth Morgan, Slavery and the British Empire: From Africa to America (Oxford: Oxford University Press, 2008), 148–98.

29. Acemoglu and Robinson, Why Nations Fail, 76.

30. Acemoglu and Robinson, 81.

31. Acemoglu and Robinson, 75.

32. For a comprehensive overview of mercantilism, see Lars Magnusson, Mercantilism: The Shaping of an Economic Language (New York: Routledge, 1994). For a more concise summary of the British mercantilist approach, see Ashley Jackson, The British Empire: A Very Short Introduction (Oxford: Oxford University Press, 2013), 27.

33. For a general overview of center-periphery relationships, see Jackson, The British Empire, 27; Martin Lynn, "British Policy, Trade, and Informal Empire in the Mid-Nineteenth Century," in The Oxford History of the British Empire, vol. 3, The Nineteenth Century, ed. Andrew Porter (Oxford: Oxford University Press, 1999), https://doi

.org/10.1093/acprof:oso/9780198205654.003
.0006; Jeremy Black, *The British Seaborne Empire* (New Haven: Yale University Press, 2004). For an example of a more quantitative economic analysis of this relationship, see Olivier Accominotti et al., "Black Man's Burden, White Man's Welfare: Control, Devolution and Development in the British Empire, 1880–1914," *European Review of Economic History* 14, no. 1 (2010): 47–70, https://doi.org /10.1017/S1361491609990025.

34. For overviews of the spread of railroad around the world, see Patrick O'Brien, "Transport and Economic Development in Europe, 1789–1914," in *Railways and the Economic Development of Western Europe, 1830–1914* (London: Palgrave Macmillan UK, 1983), 1–27; Dan Bogart and Latika Chaudhary, "Railways in Colonial India: An Economic Achievement?," in *A New Economic History of Colonial India*, ed. Latika Chaudhary et al. (Abingdon-on-Thames: Routledge, 2015), 140–60; Elisabeth Köll, *Railroads and the Transformation of China*, Harvard Studies in Business History (Cambridge, MA: Harvard University Press, 2019), 4–9; Rémi Jedwab, Edward Kerby, and Alexander Moradi, "How Colonial Railroads Defined Africa's Economic Geography," in *The Long Economic and Political Shadow of History*, vol. 2, *Africa and Asia*, ed. Stelios Michalopulos and Elias Papaioannou (London: CEPR Press, 2017), 87–97; Jeremy Atack, "Historical Geographic Information Systems (GIS) Database of U.S. Railroads for 1826–1911," May 10, 2016, https://my.vanderbilt.edu/jeremyatack/data -downloads/.

35. For an introduction to the Grand Tour, see Christopher Hibbert, *The Grand Tour* (London: Thames Meuthuen, 1987). One artist who routinely went on sketching tours of Europe was J.M.W. Turner, who toured not only the UK but also Switzerland, France, and Italy several times. See David Blayney Brown, "Chronology," in *J.M.W. Turner: Sketchbooks, Drawings and Watercolours* (London: Tate, 2012), https://www.tate.org .uk/art/research-publications/jmw-turner /chronology-r1109229.

36. Jennifer Roberts, *Transporting Visions: The Movement of Images in Early America*

(Berkeley: University of California Press, 2014), 3.

37. For information about the importance of direct observation of landscape for British artists in this moment, see Andrew Hemingway, *Landscape Imagery and Urban Culture in Early Nineteenth-Century Britain* (Cambridge: Cambridge University Press, 1992), 1–148. Though it is primarily with reference to garden design, chapter 7, "John Ruskin and the Picturesque," in John Dixon Hunt, *Gardens and the Picturesque: Studies in the History of Landscape Architecture* (Cambridge, MA: MIT Press, 1992), 193–216, is also helpful.

38. John Ruskin, *Modern Painters*, vol. 1, *Of General Principles and Of Truth* (Sunnyside, UK: George Allen, 1888), 417.

39. There is a notable literature that engages with this focus on precision in British art, and particularly landscape. For further reading beyond the Hemingway cited above, see Stephen Daniels, *Fields of Vision: Landscape, Imagery and National Identity in England and the United States* (Cambridge: Polity Press, 1993); Charlotte Klonk, *Science and the Perception of Nature: British Landscape Art in the Late Eighteenth and Early Nineteenth Centuries* (New Haven: Yale University Press, 1996); K. Dian Kriz, *The Idea of the English Landscape Painter: Genius as Alibi in the Early Nineteenth Century* (New Haven: Yale University Press, 1997). In addition, as cited below, both John Barrell and Ann Bermingham address these issues in their social historical studies of British landscape painting.

40. Information about regular connections between the United Kingdom and Gibraltar is available in the opening pages of a series of English guidebooks for travelers in Spain: Richard Ford, *A Handbook for Travellers in Spain*, 3rd ed., 2 vols. (London: J. Murray, 1855), http://www.catalog.hathitrust.org /Record/011540929. There are more than eight editions of this guidebook, which was first published in the 1830s and continued to be reissued for roughly a century.

41. Nicholas Tromans, "Introduction: British Orientalist Painting," in *The Lure of the East: British Orientalist Painting*, ed. Nicholas

Tromans (New Haven: Yale University Press, 2008), 10.

42. Nicholas Tromans, *David Wilkie: The People's Painter* (Edinburgh: Edinburgh University Press, 2007), 156–215.

43. Tromans, "Introduction," 11.

44. For an overview of artists who traveled these routes, see the list in Tromans, *The Lure of the East.*

45. Tromans, "Introduction," 11.

46. The decade listed as "1770" is an aggregation of years 1769–1779, and "1910" is just 1910–1914, when the dataset ends. For all intervening decades, such as 1850, the years aggregated are 1850–1859, respectively.

47. Klas Rönnbäck, "Sweet Business: Quantifying the Value Added in the British Colonial Sugar Trade in the 18th Century," *Revista de historia económica/Journal of Iberian and Latin American Economic History* 32, no. 2 (2014): 223–45, https://doi.org/10.1017 /S0212610914000081. The specific figure of 5 percent appears on page 235.

48. Sarah Thomas, *Witnessing Slavery: Art and Travel in the Age of Abolition* (London: Yale University Press, 2019), 6–9, 125–61.

49. Actually, many enslaved laborers remained on the plantations of their enslavers until 1838, which marked the end of an apprenticeship system that had kept many enslaved people from being truly emancipated.

50. For a description of British efforts to find sources of cheap labor in Jamaica to replace enslaved labor, see Angela F. Murphy, "'This Foul Slavery-Reviving System': Irish Opposition to the Jamaica Emigration Scheme," *Slavery & Abolition* 37, no. 3 (2016): 578–98, https://doi.org/10.1080/0144039X .2016.1208914.

51. Thank you to Sophie Lynford for helping me understand how Australia's history affected this pattern of depiction. The settlement of Australia and how it appeared in art is addressed in Ian McLean, "The Expanded Field of the Picturesque: Contested Identities and Empire in *Sydney Cove* 1794," in *Art and the British Empire,* ed. Timothy Barringer, Geoffrey Quilley, and Douglas Fordham (Manchester: Manchester University Press,

2007), 23–37; Richard Neville, *A Rage for Curiosity: Visualising Australia 1788-1830* (Sydney: State Library NSW, 1997); Terry Smith, *Transformations in Australian Art: The Nineteenth Century—Landscape, Colony, Nation* (Sydney: Craftsman House, 2002).

52. Examples of Old Testament scenes include the discovery of Moses in the Nile; a common New Testament scene was the Holy Family's flight into Egypt.

53. Ivan David Kalmar, "Arabizing the Bible: Racial Supersessionism in Nineteenth-Cenutry Christian Art and Biblical Scholarship," in *Orientalism Revisited: Art, Land and Voyage,* ed. Ian Richard Netton (New York: Routledge, 2013), 176–86; Daniel Martin Varisco, "Orientalism and Bibliolatry: Framing the Holy Land in Nineteenth-Century Protestant Bible Customs Texts," in *Orientalism Revisited: Art, Land and Voyage,* ed. Ian Richard Netton (New York: Routledge, 2013), 187–204.

54. Khaled Fahmy, "The Era of Muhammad 'Ali Pasha, 1805-1848," in *Modern Egypt, from 1517 to the End of the Twentieth Century,* ed. M. W. Daly, vol. 2 of *The Cambridge History of Egypt* (Cambridge: Cambridge University Press, 1998), 139–46.

55. Tromans, "Introduction," 15.

56. Peninsular & Oriental Steam Navigation Company, archival catalog, Royal Museums Greenwich, accessed August 22, 2019, https://collections.rmg.co.uk/archive/objects /492010.html.

57. Hasan Ali Polat and Aytuğ Arslan, "The Rise of Popular Tourism in the Holy Land: Thomas Cook and John Mason Cook's Enterprise Skills That Shaped the Travel Industry," *Tourism Management* 75 (December 1, 2019): 231, https://doi.org/10.1016 /j.tourman.2019.05.003.

58. F. Robert Hunter, "Egypt under the Successors of Muhammad 'Ali," in *Modern Egypt, from 1517 to the End of the Twentieth Century,* ed. M. W. Daly, vol. 2 of *The Cambridge History of Egypt* (Cambridge: Cambridge University Press, 1998), 180–97.

59. M. W. Daly, "The British Occupation, 1882-1922," in *Modern Egypt, from 1517 to the End of the Twentieth Century,* ed. M. W. Daly, vol. 2 of *The Cambridge History of Egypt*

(Cambridge: Cambridge University Press, 1998), 239–51.

60. For a brief general overview of Orientalism in the fine arts, see Jennifer Meagher, "Orientalism in Nineteenth-Century Art," Heilbrunn Timeline of Art History, October 2004, https://www.metmuseum.org/toah/hd/euor/hd_euor.htm.

61. Emily M. Weeks, *Cultures Crossed: John Frederick Lewis and the Art of Orientalism* (New Haven: Yale University Press, 2014), 4–7.

62. *The Exhibition of the Royal Academy of Arts. The One Hundred and Eighth* (London: William Clowes and Sons, 1876), 13.

63. Weeks, *Cultures Crossed*, 70.

64. Weeks, 70–75. Weeks describes the ways in which Lewis cited information and illustrations from Edward William Lane's *An Account of the Manners and Customs of the Modern Egyptians*, first published in 1836, although Lewis seems to have worked with the 1860 edition.

65. For a discussion of the place of Egypt in Orientalist genre painting, see Tromans, "Introduction," 15–20; Nicholas Tromans, "Genre and Gender in Cairo and Constantinople," in *The Lure of the East: British Orientalist Painting*, ed. Nicholas Tromans (New Haven: Yale University Press, 2008), 78–99.

66. Quilley, *Empire to Nation*, 11.

67. The British Library, "Britain's Indian Empire," Timelines: Sources from History, accessed August 15, 2019, https://www.bl.uk/learning/timeline/item124187.html.

68. Jackson, *The British Empire*, 85.

69. "Queen Victoria Becomes Empress of India," Making Britain Discover How South Asians Shaped the Nation, 1870–1950, accessed August 22, 2019, http://www.open.ac.uk/researchprojects/makingbritain/content/queen-victoria-becomes-empress-india.

70. Andrew Pope, "British Steamshipping and the Indian Coastal Trade, 1870–1915," *Indian Economic & Social History Review* 32, no. 1 (1995): 1–21, https://doi.org/10.1177/001946469503200101; *Britannica Concise Encyclopedia* (Chicago: Britannica Digital Learning, 2017), s.v. "Suez Canal."

71. Maurice Shellim, *Oil Paintings of India and the East by Thomas Daniell, 1749–1840, and William Daniell, 1769–1837* (London: Inchcape & Co. in conjunction with Spink & Son, 1979), 14–15.

72. Shellim, 18.

73. The last work was shown under the name "The late W. Daniell, R.A."

74. Notably, Shellim published a follow-up to his first volume called *Additional Oil Paintings of India and the East by Thomas Daniell, RA, 1749–1840, and William Daniell, RA, 1769–1837* (London: Spink, 1988).

75. Shellim, *Oil Paintings of India and the East*, 15.

76. Edmund Burke, *A Philosophical Enquiry into the Origin of Our Ideas of the Sublime and the Beautiful* (New York: Oxford University Press, 2015); Immanuel Kant, *Critique of the Power of Judgment (The Cambridge Edition of the Works of Immanuel Kant)*, ed. Paul Gruyer, trans. Eric Matthews and Paul Gruyer (Cambridge: Cambridge University Press, 2000); Andrew Wilton, "The Sublime in the Old World and the New," in *American Sublime: Landscape Painting in the United States, 1820–1880*, ed. Tim Barringer and Andrew Wilton (Princeton: Princeton University Press, 2002), 11–37.

77. Wilton, "The Sublime in the Old World and the New," 13.

78. *The Exhibition of the Royal Academy. The Fifty-Fourth* (London: B. McMillan, 1822), 16.

79. Leslie Parris, "Malvern Hall, Warwickshire (1809)," in *The Tate Gallery Constable Collection* (London: Tate, 1981), https://www.tate.org.uk/art/artworks/constable-malvern-hall-warwickshire-n02653.

80. This efficient summary of Bermingham's work comes from Kim Ian Michasiw, "Nine Revisionist Theses on the Picturesque," *Representations*, no. 38 (Spring 1992): 78.

81. Ann Bermingham, *Landscape and Ideology: The English Rustic Tradition, 1740–1860* (Berkeley: University of California Press, 1986), 1.

82. Hemingway, *Landscape Imagery and Urban Culture*, particularly chapter 9; Daniels, *Fields of Vision*, 80–111, 200–42.

83. John Barrell, *The Dark Side of the Landscape: The Rural Poor in English Painting,*

1730–1840 (Cambridge: Cambridge University Press, 1980).

84. While not a complete literature review, important sources that address this topic include Robert C. Allen, *The British Industrial Revolution in Global Perspective* (Cambridge: Cambridge University Press, 2018); Mark Overton, *Agricultural Revolution in England: The Transformation of the Agrarian Economy, 1500–1850* (Cambridge: Cambridge University Press, 2010); Leigh Shaw-Taylor, "Parliamentary Enclosure and the Emergence of an English Agricultural Proletariat," *Journal of Economic History* 61, no. 3 (2001).

85. Gilpin quoted in Bermingham, *Landscape and Ideology*, 69–70.

86. For a more nuanced consideration of the different versions of the picturesque—particularly a useful comparison of picturesque seen while traveling and the picturesque that a landowner applies to his or her property—see Michasiw, "Nine Revisionist Theses on the Picturesque."

87. The most succinct summary of the different versions of the picturesque is in Michasiw.

88. Romita Ray, *Under the Banyan Tree: Relocating the Picturesque in British India* (New Haven: Yale University Press, 2013), 1–18, 53–96; Jill H. Casid, *Sowing Empire: Landscape and Colonization* (Minneapolis: University of Minnesota Press, 2005); Thomas, *Witnessing Slavery*, 125–61. Though it comes from literature, another notable contribution on the application of the picturesque to the British Empire comes from Karen O'Brien, "Imperial Georgic, 1660–1789," *The Country and the City Revisited: England and the Politics of Culture* 1550, no. 1850 (1999): 160–79. Finally, also worth noting is G.H.R. Tillotson, "The Indian Picturesque: Images of India in British Landscape Painting, 1780–1880," in *The Raj: India and the British, 1600–1948*, ed. Christopher A. Bayly (London: National Portrait Gallery, 1990), 141–229.

89. The most relevant parts of the book for this argument are chapters 1 and 2; see Casid, *Sowing Empire*, 1–94.

90. For a description of this event, see

Nani Gopal Chaudhuri, "The Rebellion in Hyderabad in 1857," *Proceedings of the Indian History Congress* 20 (1957): 286–92.

91. Grove Art Online, s.v. "Jones Family," by David Alexander and Paul Usherwood, January 1, 2003, https://doi.org/10.1093/gao /9781884446054.article.T045087.

92. Peter Harrington, "The Battle Paintings of George Jones, R.A. (1786–1869)," *Journal of the Society for Army Historical Research* 67, no. 272 (1989): 240.

93. Rosie Llewellyn-Jones, introduction to *Lucknow: City of Illusion*, ed. Rosie Llewellyn-Jones (London: Prestel, 2003), 15–17.

94. Llewellyn-Jones, 17–19.

95. Lydia Murdoch, "'Suppressed Grief': Mourning the Death of British Children and the Memory of the 1857 Indian Rebellion," *Journal of British Studies* 51, no. 2 (2012): 374–75.

96. Murdoch, 364.

97. For more information, Rudrangshu Mukherjee, *The Year of Blood: Essays on the Revolt of 1857* (Abingdon: Routledge, 2018). In particular, see the reprint of Mukherjee's 1990 essay from *Past & Present*: "'Satan Let Loose Upon Earth': The Kanpur Massacres in India in the Revolt of 1857," pp. 29–58.

98. *The Exhibition of the Royal Academy of Arts. The One Hundred and Eleventh* (London: William Clowes and Sons, 1879), 27.

99. For more information about Elizabeth Thompson Butler and this painting, see Catherine Wynne, "Elizabeth Butler's Literary and Artistic Landscapes," *Prose Studies* 31, no. 2 (2009): 126–40, https://doi.org/10.1080 /01440350903323553; Nathalie Saudo-Welby, "'[B]Eyond My Landscape Powers': Elizabeth Thompson Butler and the Politics of Landscape Painting," *Polysèmes*, December 20, 2019, https://doi.org/10.4000/polysemes.5533. For more information on Brydon in particular, see Ludwig W. Adamec, "Brydon, Dr. William (1811–1873)," in *Historical Dictionary of Afghanistan*, 4th ed., Historical Dictionaries of Asia, Oceania, and the Middle East (Lanham: Scarecrow Press, 2012), 88.

100. For more about these projects, see Robert Grant Irving, *Indian Summer: Lutyens, Baker, and Imperial Delhi* (New Haven: Yale University Press, 1981).

101. Northern Ireland and the Republic of Ireland are grouped together, which is why for this graph Ireland is presented as part of the British Isles and not a colony.

102. This category included more than just the *eight hundred* "portraits" of prized animals shown at the Royal Academy—such as the horses, hunting hounds, and other pets—I was able to identify from titles. I discovered this active subgenre when looking for the keyword "portrait" in the data. While the portrait of a person is often identified as "Portrait of…," it turns out that the titles of animal portraits also often start this way, so I had to distinguish human portraits from animal portraits. Of course, not only is the animal named in the title of an animal portrait, but the title often ends with the phrase "property of" and then names the owner of the animal.

103. For further information about the flourishing of genre painting after the 1850s, see Simon Poë, "From History to Genre," in *The Royal Academy of Arts: History and Collections*, ed. Robin Simon and Maryanne Stevens (London: Paul Mellon Centre for Studies in British Art and Yale University Press, 2018), 256–89.

104. Shearer West, *Portraiture* (Oxford: Oxford University Press, 2004), 81.

105. "Henry Fuseli RA (1741–1825)," RA Collection: People and Organisations, accessed August 26, 2019, https://www.royal academy.org.uk/art-artists/name/henry -fuseli-ra.

106. The full lecture and citation are also available in Henry Fuseli, "Lecture IV. Invention (Continued)," in *Lectures on Painting: By the Royal Academicians, Barry, Opie and Fuseli*, ed. Ralph Nicholson Wornum (London: H. G. Bohn, 1848), 449.

107. Acemoglu and Robinson, *Why Nations Fail*, 74.

108. Kim Oosterlinck and Diana Seave Greenwald, "The Changing Faces of the Paris Salon: Quantitative Analyses of Portraiture, 1740–1881," working paper.

109. E.g., Barringer, Quilley, and Fordham, introduction to *Art and the Empire*, 1.

110. Walker Art Gallery, "The Family of Sir William Young, Johann Zoffany,

1767–1769," accessed May 14, 2019, https:// artsandculture.google.com/asset/the-family -of-sir-william-young-johan-zoffany/WQFY dyTtjQvajA?hl=en.

111. Walker Art Gallery.

112. Barringer, Quilley, and Fordham, introduction to *Art and the Empire*, 1; Anthony Mullan, "A Web of Imperial Connections: Surveyors and Planters in Eighteenth-Century Dominica," *Terrae Incognitae* 48, no. 2 (2016): 198–202.

113. For discussions of this aristocratic flexibility, see David Cannadine, *Aspects of Aristocracy: Grandeur and Decline in Modern Britain* (New Haven: Yale University Press, 1994); Mark Rothery, "The Wealth of the English Landed Gentry, 1870–1935," *Agricultural History Review* 55, no. 2 (2007): 251–68.

114. For works dealing with these ephemeral media, some particularly helpful sources are Fordham, *Aquatint Worlds*; David Arnold, *The Tropics and the Traveling Gaze: India, Landscape, and Science, 1800–1856* (Seattle: University of Washington Press, 2006); Tapati Guha-Thakurta, "The Compulsions of Visual Representation in Colonial India," in *Traces of India*, ed. Maria Antonella Pelizzari (New Haven: Yale Center for British Art, 2004), 108–39; Vidya Dehejia, *India through the Lens: Photography 1840–1911* (Washington, DC: Freer Gallery of Art, 2000); Nicholas Thomas, *Entangled Objects: Exchange, Material Culture and Colonialism in the Pacific* (Cambridge, MA: Harvard University Press, 1991); James R. Ryan, *Picturing Empire: Photography and the Visualization of the British Empire* (Chicago: University of Chicago Press, 1997).

115. A potentially rich resource is G. W. Friend, *An Alphabetical List of Engravings Declared at the Office of the Printsellers' Association, London, Since Its Establishment in 1847 to the End of 1891* (London: Printsellers' Association, 1892). I discovered this resource too late for publication in this book but am currently digitizing it. Gillray's imperial caricatures are discussed in Kriz, *Slavery, Sugar, and the Culture of Refinement*, 6–7, 99–106, 113–15. An informal catalog raisonné of his work is available at Jim Sherry, "Gillray's Works: A Chronological Catalogue of His

Prints," *James Gillray: Caricaturist*, accessed August 29, 2019, http://www.james-gillray .org/catalog.html. There is an extensive appendix in Pheroza Godrej and Pauline Rohatgi, *Scenic Splendours: India through the Printed Image* (London: British Library, 1989), 147–61. Transcribing and digitizing those sources could create new datasets. Similarly, Fordham, *Aquatint Worlds,* includes tables (see pages 9 and 99) that could be helpful.

116. Outside of these two images, Leighton created an additional twenty scenes set in the modern-day region known as the Middle East and North Africa (MENA); see Leighton House Museum, "Paintings Inspired by the Middle East," Leighton and the Middle East, accessed September 5, 2019, https://www.rbkc.gov.uk/leightonarabhall /paintings.html.

117. For an overview of Leighton's career and preferred subject matter, see Christopher Newall, "Chronology 1830–1906," and Elizabeth Prettejohn, "The Classicism of Frederic Leighton," in *Frederic, Lord Leighton, 1830–1896: Painter and Sculptor of the Victorian Age*, ed. Margot Th. Brandlhuber and Michael Buhrs (London: Prestel, 2009), 10–31 and 32–77, respectively.

118. Leighton House Museum, "Origins of the Objects in the Arab Hall and Narcissus Hall," Leighton and the Middle East, accessed September 5, 2019, https:// www.rbkc.gov.uk/leightonarabhall/tour /collecting_map.html; Mary Roberts, "The Resistant Materiality of Frederic Leighton's Arab Hall," *British Art Studies*, no. 9 (August 2018), https://doi.org/10.17658/issn.2058-5462 /issue-09/mroberts.

Chapter 6: Conclusion

1. For these philosophers' contributions, see Francis Stephen Halliwell, *Plato's Republic 10: With an Introduction, Translation and Commentary*, Aris and Phillips Classical Texts (Liverpool: Liverpool University Press, 1988); Immanuel Kant, *Critique of the Power of Judgment (The Cambridge Edition of the Works of Immanuel Kant)*, ed. Paul Gruyer, trans. Eric Matthews and Paul Gruyer (Cambridge: Cambridge University Press, 2000); Robert Hullot-Kentor and Theodore Adorno,

Aesthetic Theory (Minneapolis: University of Minnesota Press, 1997).

2. David Hume, *Of the Standard of Taste* (1757), loc. 92 of 397, Kindle.

3. Hume, loc. 351 of 397.

4. Hume, loc. 148 of 397.

5. Hume, loc. 351 of 397.

6. Linda Nochlin, "Why Have There Been No Great Women Artists?" in *Women, Art, and Power: And Other Essays* (New York: Harper and Row, 1989); Griselda Pollock, *Differencing the Canon: Feminist Desire and the Writing of Art's Histories* (London: Psychology Press, 1999); Griselda Pollock, "Artists, Mythologies and Media—Genius, Madness and Art History," *Screen* 21, no. 3 (1980): 57–96, https://doi.org/10.1093/screen /21.3.57.

7. Anna Brzyski, "Introduction: Canons and Art History," in *Partisan Canons*, ed. Anna Bryzski (Durham: Duke University Press, 2007), 2.

8. Brzyski, 11–12.

9. Jules Prown, "The Art Historian and the Computer: An Analysis of Copley's Patronage, 1753–1774," in *Art as Evidence: Writings on Art and Material Culture* (New Haven: Yale University Press, 2001), 51.

10. A similar statement appears in the conclusion to Diana Seave Greenwald, "Colleague Collectors: A Statistical Analysis of Artists' Collecting Networks in Nineteenth-Century New York," *Nineteenth-Century Art Worldwide* 17, no. 1 (2018), https://www.19thc -artworldwide.org/spring18/greenwald-on -artists-collecting-networks-in-nineteenth -century-new-york.

Appendix B: A Brief Historiography of the Study of Jean-François Millet and the Relationship between City and Country in Nineteenth-Century French Rural Genre Painting

1. A more extensive historiography appears in chapter 4 of Diana Seave Greenwald, "Painting by Numbers: Case Studies in the Economic History of Nineteenth-Century Landscape and Rural Genre Painting" (PhD diss., University of Oxford, 2018), https://ethos.bl.uk/OrderDetails.do?uin=uk .bl.ethos.757837.

2. The importance of the exhibition catalog is described in Perry T. Rathbone, foreword to *Barbizon Revisited*, ed. Robert L. Herbert (Boston: Museum of Fine Arts, 1962). "This is the first important exhibition of the painters of Barbizon to be undertaken in contemporary times.... Likewise, this catalogue is only the second serious attempt in the twentieth century to appraise the whole achievement of the school."

3. Robert L. Herbert, *Barbizon Revisited* (Boston: Museum of Fine Arts, 1962), 64.

4. Herbert, 64.

5. Robert L. Herbert, "Millet Revisited—I," *Burlington Magazine* 104, n. 712 (1962): 294.

6. Herbert, 295–96.

7. Herbert, 295.

8. Herbert, 295.

9. Robert L. Herbert, "Millet Reconsidered," *Art Institute of Chicago Museum Studies* 1 (1966): 31.

10. Herbert, 37.

11. Herbert, 38.

12. Herbert, 46.

13. Robert L. Herbert, "City vs. Country: The Rural Image in French Painting from Millet to Gauguin," in *From Millet to Leger: Essays in Social Art History* (New Haven: Yale University Press, 2002), 24.

14. Herbert, 24.

15. Herbert, 35.

16. Linda Nochlin, *Realism*, new ed. (London: Penguin, 1991), 113.

17. Nochlin, 114.

18. Nochlin, nn. 60, 62, 64.

19. Nochlin, 108–11.

20. See Timothy J. Clark, *Image of the People: Gustave Courbet and the 1848 Revolution* (London: Thames and Hudson, 1973), 198, 200. The bibliographies of Clark's two books are identical.

21. Robert L. Herbert, "Goodbye to All That," *New York Review of Books*, November 4, 1999, https://www.nybooks.com/articles/1999/11/04/goodbye-to-all-that/.

22. Clark, *Image of the People*, 9–20.

23. Herbert, "Goodbye to All That."

24. Timothy J. Clark, *The Absolute Bourgeois: Artists and Politics in France, 1848–1851* (London: Thames and Hudson, 1973), 11.

25. The most explicit statement of this appears in the conclusion of Clark, *The Absolute Bourgeois*, 178.

26. Clark, *Image of the People*, 133.

27. Clark, 127–29.

28. Clark, 142.

29. Clark, 145.

30. Examples include Albert Boime, *Art in an Age of Civil Struggle, 1848–1871* (Chicago: University of Chicago Press, 2007); Griselda Pollock, *Millet* (London: Oresko Books, 1977); Madeleine Fidell-Beaufort, "Jules Breton in America: Collecting in the 19th Century," in *Jules Breton and the French Rural Tradition*, ed. Hollister Sturges (Omaha: Joslyn Art Museum and Arts Publisher, 1982), 51–62; Fidell-Beaufort, "Peasants, Painters and Purchases," in *The Peasant in French Nineteenth-Century Art*, ed. James Thompson (Dublin: Douglas Hyde Gallery, Trinity College, 1980), 45–78; Richard R. Brettell and Caroline B. Brettell, *Painters and Peasants in the Nineteenth Century* (Geneva: Skira, 1983); Simon Kelly, Maite van Dijk, Nienke Bakker, and Abigail Yoder (eds), *Millet and Modern Art: From Van Gogh to Dalí.* (New Haven: Yale University Press, 2019); Gabriel P. Weisberg, ed., *The European Realist Tradition* (Bloomington: Indiana University Press, 1982); Alexandra Murphy, *Jean-François Millet, Drawn into the Light* (New Haven: Yale University Press, 1999).

31. Frances Fowle and Richard Thomson, eds., *Soil and Stone: Impressionism, Urbanism, Environment,* Visual Arts Research Institute Edinburgh (Burlington: Ashgate, 2003).

32. Christopher Parsons and Neil McWilliam, "'Le Paysan de Paris': Alfred Sensier and the Myth of Rural France," *Oxford Art Journal* 6, no. 2 (1983): 54.

33. Bradley Fratello, "France Embraces Millet: The Intertwined Fates of 'The Gleaners' and 'The Angelus,'" *Art Bulletin* 85, no. 4 (2003): 685–701.

34. Nicholas Green, *The Spectacle of Nature: Landscape and Bourgeois Culture in Nineteenth Century France* (Manchester: Manchester University Press, 1990), 5.

35. Green, 226.

36. Green, 117.

37. Green, 118.

38. Robert L. Herbert, *Monet on the*

Normandy Coast: Tourism and Painting,
1867–1886 (New Haven: Yale University
Press, 1994).

Appendix D: Full Regression Tables, How
to Read Regression Tables, and Further
Discussion of Results

1. Charles H. Feinstein and Mark Thomas,
Making History Count: A Primer in Quanti-
tative Methods for Historians (Cambridge:
Cambridge University Press, 2002), 234.

2. Tests for statistical significance hinge
on disproving the "null hypothesis," that the
effect of a variable—or the descriptiveness of
a whole model—is *not* significantly different
from zero. There are certain quantitative
thresholds at which one can reject the null
hypothesis and conclude that an effect *is*
statistically significant. The F-test and t-test
are two of these kinds of thresholds. See
Feinstein and Thomas, 149–79, 269–73.

3. Much of this text is excerpted from
Diana Seave Greenwald, "Modernization
and Rural Imagery at the Paris Salon: An
Interdisciplinary Approach to the Economic
History of Art," *Economic History Review* 72,
no. 2 (2019): 531–67, https://doi.org/10.1111/ehr
.12695.

4. Travel price data from Guillaume
Daudin et al., "The Cultural Diffusion of the
Fertility Transition: Internal Migrations in
Nineteenth Century France," working paper,
http://eh.net/eha/wp-content/uploads/2013
/11/Daudinetal.pdf (accessed on December
14, 2017).

5. A major contribution to the consump-
tion of landscape painting during this period
was Baron Isidore Justin Séverin Taylor,
Voyages pittoresques et romantiques dans
l'ancienne France (1820–1878). Discussion of
this publication is beyond the scope of the
Whiteley Index and this chapter. However,
like landscape painting generally, it has been
subject to several demand-side explanations.

See, for example, Albert Boime, "The Second
Empire's Official Realism," in *The European*
Realist Tradition, ed. Gabriel P. Weisberg
(Bloomington: Indiana University Press,
1982), 161; Bonnie L. Grad and Timothy A.
Riggs, *Visions of City and Country: Prints and*
Photographs of Nineteenth-Century France
(Worcester: Worcester Art Museum, 1982),
15–91.

6. The regressions run here use the
standard xtreg panel regression command
in Stata. At the request of peer reviewers
for the *Economic History Review*, I also ran
regressions with xtregar command to further
control for autocorrelation. These results
were not appreciably different, and therefore
results presented in included tables are those
using xtreg.

7. Nina Lübbren, *Rural Artists' Colonies in*
Europe, 1870–1910 (Manchester: Manchester
University Press, 2001), 15–64.

8. Christiane Hellmanzik, "Location
Matters: Estimating Cluster Premiums for
Prominent Modern Artists," *European Eco-*
nomic Review 54, no. 2 (2010): 199–218.

9. Susan Carol Rogers, "Which Heritage?
Nature, Culture, and Identity in French
Rural Tourism," *French Historical Studies*
25, no. 3 (2002): 475–503, https://doi.org/10
.1215/00161071-25-3-475; Patrick Young,
Enacting Brittany: Tourism and Culture in
Provincial France, 1871–1939 (Farnham:
Ashgate, 2012).

10. Lübbren, *Rural Artists' Colonies in*
Europe, 1870–1910, 165–77.

11. Robert L. Herbert, *Monet on the Nor-*
mandy Coast: Tourism and Painting, 1867–1886
(New Haven: Yale University Press, 1994),
61–93.

12. Charles Tilly and David K. Jordan,
"Strikes and Labor Activity in France,
1830–1960" (Inter-university Consortium for
Political and Social Research [distributor],
2012), https://doi.org/10.3886/ICPSR08421.v2.

Bibliography

◇◇◇

Primary Sources

Catalogs of the Exhibitions of the Royal Academy, 1769 to 1914. https://www .royalacademy.org.uk/art-artists/search /exhibition-catalogues.

Catalogues of the Paris Salon, 1673 to 1881. 60 vols. Edited by H. W. Janson. New York: Garland, 1977.

Clayton, Ellen Creathorne. *English Female Artists.* Vol. 1. 2 vols. London: Tinsley Brothers, 1876.

"Constitution of the Apollo Association for the Promotion of Fine Arts in the United States." *Transactions of the Apollo Association for the Promotion of Fine Arts in the United States,* 1839.

Croly, Jane Cunningham. *Sorosis: Its Origin and History.* New York: J. J. Little & Co., 1886.

Cummings, Thomas Seir. *Historic Annals of the National Academy of Design, New York Drawing Association, Etc., with Occasional Dottings by the Way-Side, from 1825 to the Present Time.* Philadelphia: George W. Childs, 1865.

Ellet, E. F. *Women Artists in All Ages and Countries. By Mrs. Ellet.* London: R. Bentley, 1859.

Friend, G. W. *An Alphabetical List of Engravings Declared at the Office of the Printsellers' Association, London, since Its Establishment in 1847 to the End of 1891.* London: Printsellers' Association, 1892.

Fuseli, Henry. "Lecture IV. Invention (Continued)." In *Lectures on Painting: By the Royal Academicians, Barry, Opie and Fuseli,* edited by Ralph Nicholson Wornum, 435–59. London: H. G. Bohn, 1848.

Henry H. Leeds & Co. *Catalogue of the Private Collection of Oil Paintings by American Artists Made by Samuel P. Avery.* New York: Henry H. Leeds & Co., 1867. https://archive.org/details/b1468922.

Huntington Family Papers, 1792–1901. Archives of American Art, Smithsonian Institution, Washington, DC.

"Instrument of Foundation." London, December 10, 1768. Royal Academy of Arts, Official Archive. Royal Academy of Arts Archive. https://www.royalacademy .org.uk/art-artists/archive/instrument -of-foundation.

McEntee, Jervis. Papers, 1796, 1848–1905. Archives of American Art, Smithsonian Institution, Washington, DC.

"Millet." *L'Artiste,* no. 101 (1875): 113–15. https://gallica.bnf.fr/ark:/12148/bpt6k 241389q/f1.image.

Millet, Jean-François. "Jean-François Millet to Alfred Sensier, February 1851," February 1851. Cote BSb12L9. Réserve des autographes, Cabinet des dessins, Musée du Louvre, Paris.

———. "Jean-François Millet to Théodore Rousseau, April 1859," April 1859. Cote BSb12L156. Réserve des autographes, Cabinet des dessins, Musée du Louvre, Paris.

Pennsylvania Academy of the Fine Arts. "Articles of Association, Dec. 26 1805." In *In the Service of Art: A Guide to the Archives of the Pennsylvania Academy of the Fine Arts,* edited by Cheryl Leibold. Philadelphia: Pennsylvania Academy of the Fine Arts, 2009. https://www.pafa.org /sites/default/files/media-assets/Guide toArchives_0.pdf.

———. "Resolutions of [the] Committee of Arrangements and Inspection [for the Annual Exhibition], April 22, 1811."

Reproduced in *Selected Papers of Charles Wilson Peale and His Family*, vol. 3, edited by Lillian B. Miller. New Haven: Yale University Press, 1991.

Reynolds, Joshua. *Sir Joshua Reynolds's Discourses on Art.* Chicago: A. C. McClurg, 1891. https://archive.org/details/sirjoshua reynold00reynuoft. New edition, edited by Robert R. Wark. New Haven: Yale University Press, 1997.

Royal Academy of Arts. *The Exhibition of the Royal Academy. The Fifty-Fourth.* London: B. McMillan, 1822.

———. *The Exhibition of the Royal Academy of Arts. The One Hundred and Eighth.* London: William Clowes and Sons, 1876.

———. *The Exhibition of the Royal Academy of Arts. The One Hundred and Eleventh.* London: William Clowes and Sons, 1879.

Ruskin, John. *Modern Painters.* Vol. 1, *Of General Principles and Of Truth.* Sunnyside, UK: George Allen, 1888.

Sensier, Alfred. *Jean-François Millet, Peasant and Painter.* Translated by Helena De Kay. Boston: J. R. Osgood and Company, 1881.

Spencer, Lilly Martin. Papers, 1828–1966. Archives of American Art, Smithsonian Institution, Washington, DC.

Secondary Sources

Accominotti, Olivier, Marc Flandeau, Riad Rezzik, and Frédéric Zumer. "Black Man's Burden, White Man's Welfare: Control, Devolution and Development in the British Empire, 1880–1914." *European Review of Economic History* 14, no. 1 (2010): 47–70. https://doi.org/10.1017/S136149160999 0025.

Acemoglu, Daron, and James A. Robinson. *Why Nations Fail: The Origins of Power, Prosperity, and Poverty.* New York: Crown, 2012.

Adams, Steven. *The Barbizon School and the Origins of Impressionism.* London: Phaidon, 1994.

Allen, Robert C. *The British Industrial Revolution in Global Perspective.* Cambridge: Cambridge University Press, 2018.

Alpers, Svetlana. *Rembrandt's Enterprise: The Studio and the Market.* Chicago: University of Chicago Press, 1988.

Arnold, David. *The Tropics and the Traveling Gaze: India, Landscape, and Science, 1800–1856.* Seattle: University of Washington Press, 2006.

Ashenfelter, Orley C., and Kathryn Graddy. "Art Auctions." In *A Handbook of Cultural Economics*, edited by Ruth Towse, 2nd ed., 19–28. Cheltenham, UK: Edward Elgar, 2011.

———. "Sale Rates and Price Movements in Art Auctions." *American Economic Review* 101, no. 3 (2011): 212–16.

Atack, Jeremy. "Historical Geographic Information Systems (GIS) Database of U.S. Railroads for 1826–1911," May 10, 2016. https://my.vanderbilt.edu/jeremyatack /data-downloads/.

Baca, Murtha, and Anne Helmreich. "Introducing Three Digital Art History Case Studies." *The Iris: Behind the Scenes at the Getty* (blog), February 15, 2017. http:// blogs.getty.edu/iris/dah_baca_helmreich /#note1.

Bailey, Anthony. *Standing in the Sun: A Life of J.M.W. Turner.* London: Tate, 2013. Kindle.

Bailey, Martha. "'Momma's Got the Pill': How Anthony Comstock and Griswold v. Connecticut Shaped US Childbearing." *American Economic Review* 100, no. 1 (2010): 98–129.

Barell, John. "Sir Joshua Reynolds and the Political Theory of Painting." *Oxford Art Journal* 9, no. 2 (1986): 36–41.

Barratt, Carrie Rebora. "Mapping the Venues: New York City Art Exhibitions." In *Art and the Empire City: New York, 1825–1861*, 47–81. New York: Metropolitan Museum of Art, 2000.

Barrell, John. *The Dark Side of the Landscape: The Rural Poor in English Painting, 1730–1840.* Cambridge: Cambridge University Press, 1980.

Barringer, Tim. *Men at Work: Art and Labour in Victorian Britain.* New Haven: Yale University Press for the Paul Mellon Centre for Studies in British Art, 2005.

Barringer, Timothy, Geoffrey Quilley, and Douglas Fordham. Introduction to *Art and the British Empire*, edited by Timothy Barringer, Geoffrey Quilley, and Douglas

Fordham, 1–19. Manchester: Manchester University Press, 2007.

Bayer, Thomas M., and John R. Page. *The Development of the Art Market in England: Money as Muse, 1730–1900*. London: Pickering and Chatto, 2011.

Beckert, Sven. *The Monied Metropolis: New York City and the Consolidation of the American Bourgeoisie, 1850–1896*. London: Cambridge University Press, 2003.

Bermingham, Ann. *Landscape and Ideology: The English Rustic Tradition, 1740–1860*. Berkeley: University of California Press, 1986.

Bertrand, Marianne. "The Glass Ceiling." Becker Friedman Institute Working Paper Series. Chicago: University of Chicago, June 2018.

Bishop, Claire. "Against Digital Art History." *International Journal for Digital Art History*, no. 3 (2018): 123–31. https://doi.org/10.11588/dah.2018.3.49915.

Black, Jeremy. *The British Seaborne Empire*. New Haven: Yale University Press, 2004.

Blaugrund, Annette. *The Tenth Street Studio Building: Artist-Entrepreneurs from the Hudson River School to the American Impressionists*. Seattle: University of Washington Press, 1997.

Bogart, Dan, and Latika Chaudhary. "Railways in Colonial India: An Economic Achievement?" In *A New Economic History of Colonial India*, edited by Latika Chaudhary, Bishnupriya Gupta, Tirthankar Roy, and Anand V. Swamy, 140–60. Abingdon-on-Thames: Routledge, 2015.

Boggs, Jean Sutherland. *Degas*. New York: Metropolitan Museum of Art, 1988.

Boime, Albert. *The Academy and French Painting in the Nineteenth Century*. London: Phaidon, 1971.

———. *Art in an Age of Civil Struggle, 1848–1871*. Chicago: University of Chicago Press, 2007.

———. "The Second Empire's Official Realism." In *The European Realist Tradition*, edited by Gabriel P. Weisberg, 31–123. Bloomington: Indiana University Press, 1982.

Bolton-Smith, Robin, and William H. Truettner. *Lilly Martin Spencer (1822–1902): The Joys of Sentiment*. Washington, DC: Smithsonian Institution Press, 1973.

Borowiecki, Karol. "Geographic Clustering and Productivity: An Instrumental Variable Approach for Classical Composers." *Journal of Urban Economics* 73, no. 1 (2013): 94–110.

Borowiecki, Karol Jan, and Diana Seave Greenwald. "Arts and Culture." In *Handbook of Cliometrics*, edited by Claude Diebolt and Michael Haupert, 2nd ed., 1–24. Berlin: Springer, 2019.

Bourdieu, Pierre. *Distinction: A Social Critique of the Judgement of Taste*. Translated by Richard Nice. Oxford: Routledge, 1984.

Bouret, Jean. *L'École de Barbizon et le paysage français au XIXe siècle*. Neuchâtel: Ides et Calendes, 1972.

Braud, Maurice. "Edgar Degas et l'affaire Dreyfus: Entre avant-garde et réaction." *Mil neuf cent: Revue d'histoire intellectuelle (Cahiers Georges Sorel)*, 1993, 107–12.

Braudel, Fernand, Ernest Labrousse, and Pierre Léon. *Histoire économique et sociale de la France: L'avènement de l'ère industrielle, 1789–années 1880*. Vol. 3. Paris: Presses Universitaires de France, 1976.

Brettell, Richard R., and Caroline B. Brettell. *Painters and Peasants in the Nineteenth Century*. Geneva: Skira, 1983.

Brown, David Blayney. "Chronology." In *J.M.W. Turner: Sketchbooks, Drawings and Watercolours*. London: Tate, 2012. https://www.tate.org.uk/art/research-publications/jmw-turner/chronology-r1109229.

Brown, Marilyn R. "'Miss La La's' Teeth: Reflections on Degas and 'Race.'" *Art Bulletin* 89, no. 4 (2007): 738–65.

Brown, Richard D. *Knowledge Is Power: The Diffusion of Information in Early America*. Oxford: Oxford University Press, 1991.

Bryant, Barbara. "1864: New Art Ascendant." In *The Royal Academy Summer Exhibition: A Chronicle, 1769–2018*, edited by Mark Hallett, Sarah Victoria Turner, Jessica Feather, Baillie Card, Tom Scutt, and Maisoon Rehani. London: Paul Mellon Centre for Studies in British Art, 2018. https://chronicle250.com/1864.

Brzyski, Anna. "Introduction: Canons and Art History." In *Partisan Canons*, edited by Anna Bryzski, 1–26. Durham: Duke University Press, 2007.

Buick, Kirsten Pai. *Child of the Fire: Mary Edmonia Lewis and the Problem of Art History's Black and Indian Subject*. Durham: Duke University Press, 2010.

Burguière, André. *Bretons de Plozevet*. Paris: Flammarion, Bibliothèque d'ethnologie historique, 1975.

Burke, Edmund. *A Philosophical Enquiry into the Origin of Our Ideas of the Sublime and the Beautiful*. New York: Oxford University Press, 2015.

Butler, Judith. *Gender Trouble: Feminism and the Subversion of Identity*. 2nd ed. London: Routledge, 1999.

Cannadine, David. *Aspects of Aristocracy: Grandeur and Decline in Modern Britain*. New Haven: Yale University Press, 1994.

Casid, Jill H. *Sowing Empire: Landscape and Colonization*. Minneapolis: University of Minnesota Press, 2005.

Chaudhuri, Nani Gopal. "The Rebellion in Hyderabad in 1857." *Proceedings of the Indian History Congress* 20 (1957): 286–92.

Clark, Eliot. *History of the National Academy of Design, 1825–1952*. New York: Columbia University Press, 1954.

Clark, Timothy J. *The Absolute Bourgeois: Artists and Politics in France, 1848–1851*. London: Thames and Hudson, 1973.

———. "The Conditions of Artistic Creation." In *Art History and Its Methods*, edited by Eric Fernie, 245–53. London: Phaidon, 1995.

———. *Farewell to an Idea: Episodes from a History of Modernism*. New Haven: Yale University Press, 1999.

———. *Image of the People: Gustave Courbet and the 1848 Revolution*. London: Thames and Hudson, 1973.

Clout, Hugh. *Agriculture in France on the Eve of the Railway Age*. Totowa, NJ: Barnes and Noble or Croom Helm, London, 1980.

———. *The Land of France, 1815–1914*. London: Allen and Unwin, 1983.

Codell, Julie F., and Dianne Sachko Macleod, eds. *Orientalism Transposed: The Impact of the Colonies on British Culture*. Aldershot: Ashgate, 1998.

Corbett, Rachel. "The Art World Is Considered a Progressive Place, But It Has a Big Blind Spot: Supporting Working Mothers." *ArtnetNews*, September 19, 2019. https://news.artnet.com/womens -place-in-the-art-world/maternity-leave -parenthood-art-world-1613179.

Costello, Leo. *J.M.W. Turner and the Subject of History* Burlington: Ashgate, 2012.

Cowdrey, Mary Bartlett, ed. *American Academy of Fine Arts and American Art-Union, 1816–1852*. New York: New-York Historical Society, 1953.

———, ed. *National Academy of Design Exhibition Record, 1826–1860*, 2 vols. New York: New-York Historical Society, 1943.

Crosby, Faye J., Margaret S. Stockdale, and S. Ann Ropp, eds. *Sex Discrimination in the Workplace: Multidisciplinary Perspectives*. London: Routledge, 2007.

Crouzet, François. "The Historiography of French Economic Growth in the Nineteenth Century." *Economic History Review* 56, no. 2 (2003): 215–42. https://doi.org/10 .1046/j.1468-0289.2003.00248.x.

Cutting, James. "Mere Exposure, Reproduction, and the Impressionist Canon." In *Partisan Canons*, edited by Anna Bryzski, 79–94. Durham: Duke University Press, 2007.

Dabakis, Melissa. *A Sisterhood of Sculptors: American Artists in Nineteenth-Century Rome*. University Park: Pennsylvania State University Press, 2014.

Daly, M. W. "The British Occupation, 1882–1922." In *Modern Egypt, from 1517 to the End of the Twentieth Century*, edited by M. W. Daly, 239–51. Vol. 2 of *The Cambridge History of Egypt*. Cambridge: Cambridge University Press, 1998.

Daniels, Stephen. *Fields of Vision: Landscape, Imagery and National Identity in England and the United States*. Cambridge: Polity Press, 1993.

David, Géraldine, Christian Huemer, and Kim Oosterlinck. "Art Dealers' Strategy: The Case of Goupil, Boussod & Valadon from 1860 to 1914," n.d. http://som.yale

.edu/sites/default/files/files/Oosterlinck%20paper.pdf.

De Marchi, Neil, and Hans J. van Miegroet. "Art, Value, and Market Practices in the Netherlands in the Seventeenth Century." *Art Bulletin* 76, no. 3 (1994): 451–64.

———, eds. *Mapping Markets for Paintings in Europe 1450–1750*. Turnhout: Brepols, 2006.

de Maupeou, Félicie, and Léa Saint-Raymond. "Les 'marchands de tableaux' dans le Bottin du commerce: Une approche globale du marché de l'art à Paris entre 1815 et 1955." *Artl@s Bulletin* 2, no. 2 (2013): Article 7. https://docs.lib.purdue.edu/artlas/vol2/iss2/7/.

Dearinger, David B. "Collecting Paintings and Sculpture for the Boston Athenaeum." In *Acquired Tastes: 200 Years of Collecting for the Boston Athenaeum*, 33–63. Boston: Boston Athenaeum, 2006.

———, ed. *Rave Reviews: American Art and Its Critics (1826—1925)*. New York: National Academy of Design, 2000.

Dehejia, Vidya. *India through the Lens: Photography 1840–1911*. Washington, DC: Freer Gallery of Art, 2000.

Dimaggio, Paul. "Classification in Art." *American Sociological Review* 52, no. 4 (1987): 440–55.

———. "Cultural Entrepreneurship in Nineteenth-Century Boston: The Creation of an Organizational Base for High Culture in America." *Media, Culture and Society* 4, no. 1 (1982): 33–50.

———. "Culture and Cognition." *Annual Review of Sociology* 23, no. 1 (1997): 263–87.

Dombrowski, André. *Cézanne, Murder and Modern Life*. Berkeley: University of California Press, 2013.

Drucker, Johanna. "Is There a 'Digital' Art History?" *Visual Resources* 29, no. 1–2 (2013): 5–13. https://doi.org/10.1080/01973762.2013.761106.

Dupeux, Georges. *Atlas historique de l'urbanisation de la France*. Paris: Editions du Centre national de la recherche scientifique, 1981.

Duro, Paul. "Diderot and the Destination of Art." *Word & Image* 33, no. 2 (2017): 158–69. https://doi.org/10.1080/02666286.2017.1297658.

———. "Giving Up on History? Challenges to the Hierarchy of Genres in Early Nineteenth Century France." *Art History* 28, no. 5 (2005): 689–711.

Eaton, Natasha. *Colour, Art and Empire: Visual Culture and the Nomadism of Representation*. London: Bloomsbury Academic, 2013.

Elkins, James. "Canon and Globalization in Art History." In *Partisan Canons*, edited by Anna Bryzski, 55–78. Durham: Duke University Press, 2007.

Etro, Federico. "The Economics of Renaissance Art." *Journal of Economic History* 78, no. 2 (2018): 500–538.

Evans, Martha M. *Claude Raguet Hirst: Transforming the American Still Life*. Columbus, OH: Columbus Museum of Art, 2004.

Fahmy, Khaled. "The Era of Muhammad 'Ali Pasha, 1805–1848." In *Modern Egypt, from 1517 to the End of the Twentieth Century*, edited by M. W. Daly, 139–79. Vol. 2 of *The Cambridge History of Egypt*. Cambridge: Cambridge University Press, 1998.

Falk, Peter Hastings, ed. *The Annual Exhibition Record of the Pennsylvania Academy of the Fine Arts, 1807–1870*. Madison, CT: Soundview Press, 1988.

——— ed. *The Annual Exhibition Record of the Pennsylvania Academy of the Fine Arts, 1876–1913*. Madison, CT: Soundview Press, 1989.

Feigenbaum, Gail, Jean Sutherland Boggs, Christopher E. G. Benfey, and Marilyn R. Brown, eds. *Degas and New Orleans: A French Impressionist in America*. New Orleans: New Orleans Museum of Art in conjunction with Ordrupgaard, 1999.

Feinstein, Charles H., and Mark Thomas. *Making History Count: A Primer in Quantitative Methods for Historians*. Cambridge: Cambridge University Press, 2002. https://doi.org/10.1017/CBO9781139164832.

Fenwick, Simon. *The Enchanted River: 200 Years of the Royal Watercolour Society*. Bristol: Sansom & Company with Royal Watercolour Society, 2004.

Ferguson, Niall. *Empire: How Britain Made the Modern World.* New York: Penguin, 2003.

Festa, Joe. Requesting the Pleasure of Your Company: Artists' Receptions and the Tenth Street Studio Building's Legacy," *From the Stacks* (blog), December 17, 2014, http://blog.nyhistory.org/tenth-street -studio-building.

Fidell-Beaufort, Madeline. "Jules Breton in America: Collecting in the 19th Century." In *Jules Breton and the French Rural Tradition*, edited by Hollister Sturges, 51–62. Omaha: Joslyn Art Museum and Arts Publisher, 1982.

———. "Peasants, Painters and Purchases." In *The Peasant in French Nineteenth-Century Art*, edited by James Thompson, 45–78. Dublin: Douglas Hyde Gallery, Trinity College, 1980.

Fidell-Beaufort, Madeline, and Jeanne K. Welcher. "Some Views of Art Buying in New York in the 1870s and 1880s." *Oxford Art Journal* 5, no. 1 (1982): 48–55.

Fletcher, Pamela. "Creating the French Gallery: Ernest Gambart and the Rise of the Commercial Art Gallery in Mid-Victorian London." *Nineteenth-Century Art Worldwide* 6, no. 1 (2007). http://www.19thc -artworldwide.org/spring07/143-creating -the-french-gallery-ernest-gambart-and -the-rise-of-the-commercial-art-gallery -in-mid-victorian-london.

Fletcher, Pamela, and Anne Helmreich. "The Periodical and the Art Market: Investigating the 'Dealer-Critic System' in Victorian England." *Victorian Periodicals Review* 41, no. 4 (2008): 323–51.

Fletcher, Pamela, Anne Helmreich, David Israel, and Seth Erickson. "Local/Global: Mapping Nineteenth-Century London's Art Market." *Nineteenth-Century Art Worldwide* 11, no. 3 (2012). http://www .19thc-artworldwide.org/autumn12 /fletcher-helmreich-mapping-the -london-art-market.

Ford, Richard. *A Handbook for Travellers in Spain.* 3rd ed. 2 vols. London: J. Murray, 1855. https://babel.hathitrust.org/cgi /pt?id=hvd.hnnxuj&view=1up&seq=5.

Fordham, Douglas. *Aquatint Worlds: Travel, Print, and Empire, 1770-1820.* London: Yale University Press for the Paul Mellon Centre for Studies in British Art, 2019.

Fowle, Frances, and Richard Thomson, eds. *Soil and Stone: Impressionism, Urbanism, Environment.* Visual Arts Research Institute Edinburgh. Burlington: Ashgate, 2003.

Fraiberger, Samuel P., Roberta Sinatra, Magnus Resch, Christoph Riedl, and Albert-László Barabási. "Quantifying Reputation and Success in Art." *Science* 362, no. 6416 (2018): 825. https://doi.org/10.1126/science .aau7224.

Fratello, Bradley. "France Embraces Millet: The Intertwined Fates of 'The Gleaners' and 'The Angelus.'" *Art Bulletin* 85, no. 4 (2003): 685–701.

Freivogel, Elsie. "Lilly Martin Spencer." *Archives of American Art Journal* 12, no. 4 (1972): 9–14.

Frey, Bruno S. *Arts & Economics: Analysis & Cultural Policy.* Berlin: Springer, 2000.

Frey, Bruno S., and Reiner Eichenberger. "On the Return of Art Investment Return Analyses." *Journal of Cultural Economics* 19, no. 3 (1995): 207–20.

Gagliardi, Susan Elizabeth, and Joanna Gardner-Huggett. "Spatial Art History in the Digital Realm." *Historical Geography* 45 (2017): 17–36.

Galassi, Peter. "The Nineteenth Century: Valenciennes to Corot." In *Claude to Corot: The Development of Landscape Painting in France*, edited by Alan Wintermute, 233–49. New York: University of Washington Press and Colnaghi, 1990.

Galenson, David W. *Old Masters and Young Geniuses: The Two Life Cycles of Artistic Creativity.* Princeton: Princeton University Press, 2007.

Galenson, David W., and Robert Jensen. "Careers and Canvases: The Rise of the Market for Modern Art in the Nineteenth Century." In *Current Issues in Nineteenth-Century Art*, 137–66. Zwolle and Amsterdam: Waanders Publishers and Van Gogh Museum, 2007.

Galenson, David W., and Bruce A. Weinberg.

"Creating Modern Art: The Changing Careers of Painters in France from Impressionism to Cubism." *American Economic Review* 91, no. 4 (2001): 1063–71.

Gallon, Kim. "The Chicago Defender's Standing Dealers List." *Black Press Research Collective* (blog). Accessed February 8, 2020. http://blackpressresearch collective.org/visualizing-the-black -press/.

Gardner-Huggett, Joanna P. "Women Artists' Salon of Chicago (1937–1953): Cultivating Careers and Art Collectors." *Artl@s Bulletin* 8, no. 1 (2019): Article 12. https://docs .lib.purdue.edu/artlas/vol8/iss1/12.

Ginsburgh, Victor. "Awards, Success and Aesthetic Quality in the Arts." *Journal of Economic Perspectives* 17, no. 2 (2003): 99–111.

———, ed. *Handbook of the Economics of Art and Culture*. 2 vols. Amsterdam: Elsevier, 2006.

Ginsburgh, Victor, and Jan C. Van Ours. "Expert Opinion and Compensation: Evidence from a Musical Competition." *American Economic Review* 93, no. 1 (2003): 289–396.

Giordano, Alberto, Anne Kelly Knowles, and Tim Cole, eds. *Geographies of the Holocaust*. Bloomington: Indiana University Press, 2014.

Godrej, Pheroza, and Pauline Rohatgi. *Scenic Splendours: India through the Printed Image*. London: British Library, 1989.

Goetzmann, William N., Luc Renneboog, and Christophe Spaenjers. "Art and Money." *American Economic Review* 101, no. 3 (2011): 222–26.

Goldin, Claudia. "A Grand Gender Convergence: Its Last Chapter." *American Economic Review* 104, no. 4 (2014): 1091–1119.

———. *Marriage Bars: Discrimination against Married Women Workers, 1920's to 1950's*. Cambridge, MA: National Bureau of Economic Research, 1988.

———. "The Quiet Revolution That Transformed Women's Employment, Education, and Family." *American Economic Association Papers and Proceedings* 96, no. 2 (May 2006): 1–20.

Goldstein, Malcolm. *Landscape with Figures: A History of Art Dealing in the United States*. Oxford: Oxford University Press, 2000.

Goldthwaite, Richard A. *Wealth and the Demand for Art in Italy, 1300–1600*. Baltimore: Johns Hopkins University Press, 1993.

Gordon, Jean. "Early American Women Artists and the Social Context in Which They Worked." *American Quarterly* 30, no. 1 (1978): 54–69.

Gordon, John. "Twentieth Anniversary Celebration of Women Members." Transcript of a speech at Century Association, New York, October 27, 2009.

Grad, Bonnie L., and Timothy A. Riggs. *Visions of City and Country: Prints and Photographs of Nineteenth-Century France*. Worcester: Worcester Art Museum, 1982.

Graddy, Kathryn. "Taste Endures! The Rankings of Roger de Piles (†1709) and Three Centuries of Art Prices." *Journal of Economic History* 73, no. 3 (2013): 766–91.

Graham, Julie. "American Women Artists' Groups: 1867–1930." *Woman's Art Journal* 1, no. 1 (1980): 7–12.

Green, Nicholas. *The Spectacle of Nature: Landscape and Bourgeois Culture in Nineteenth Century France*. Manchester: Manchester University Press, 1990.

Greenhouse, Wendy. "Daniel Huntington and the Ideal of Christian Art." *Winterthur Portfolio* 31, no. 2/3 (1996): 103–40.

Greenwald, Diana Seave. "Colleague Collectors: A Statistical Analysis of Artists' Collecting Networks in Nineteenth-Century New York." *Nineteenth-Century Art Worldwide* 17, no. 1 (2018). https://www.19thc -artworldwide.org/spring18/greenwald -on-artists-collecting-networks-in -nineteenth-century-new-york.

———. "Modernization and Rural Imagery at the Paris Salon: An Interdisciplinary Approach to the Economic History of Art." *Economic History Review* 72, no. 2 (2019): 531–67. https://doi.org/10.1111/ehr .12695.

———. "Painting by Numbers: Case Studies in the Economic History of

Nineteenth-Century Landscape and Rural Genre Painting." PhD diss., University of Oxford, 2018. https://ethos.bl.uk/Order Details.do?uin=uk.bl.ethos.757837.

——. "Used Cars and Canvases: Information Economics, Art History, and the Art Market." *American Art* 34, no. 2 (2019).

Gregory, Ian, Christopher Donaldson, Andrew Hardie, and Paul Rayson. "Modeling Space in Historical Texts." In *The Shape of Data in the Digital Humanities: Modeling Texts and Text-Based Resources*, edited by Julia Flanders and Fotis Jannidis, 133–49. London: Routledge, 2019.

Grew, Raymond. "Picturing the People: Images of the Lower Orders in Nineteenth-Century French Art." *Journal of Interdisciplinary History* 17 (1986): 203–31.

Griffiths, Harriet. "The Jury of the Paris Fine Arts Salon, 1831–1852." PhD diss., University of Exeter, 2013.

Guerzoni, Guido. *Apollo and Vulcan: The Art Markets in Italy, 1400–1700*. East Lansing: Michigan State University Press, 2011.

——. "Reflections on Historical Series of Art Prices: Reitlinger's Data Revisited." *Journal of Cultural Economics* 19, no. 3 (1995): 251–60.

Guha-Thakurta, Tapati. "The Compulsions of Visual Representation in Colonial India." In *Traces of India*, edited by Maria Antonella Pelizzari, 108–39. New Haven: Yale Center for British Art, 2004.

Hagood, John, ed. *Documenting the Salon: Paris Salon Catalogs, 1673–1945*. Washington, DC: National Gallery of Art, 2016.

Hain, Mark, and Alex Baker. *Pennsylvania Academy of the Fine Arts, 1805–2005: 200 Years of Excellence*. Philadelphia: Pennsylvania Academy of the Fine Arts, 2005.

Hall, Catherine, ed. *Cultures of Empire: Colonizers in Britain and the Empire in the Nineteenth and Twentieth Centuries—a Reader*. New York: Routledge, 2000.

Hallett, Mark. "1769: Catching Your Eye." In *The Royal Academy Summer Exhibition: A Chronicle, 1769–2018*, edited by Mark Hallett, Sarah Victoria Turner, Jessica Feather, Baillie Card, Tom Scutt, and Maisoon Rehani. London: Paul Mellon Centre for Studies in British Art, 2018. https://chronicle250.com/1769.

Hallett, Mark, Sarah Victoria Turner, Jessica Feather, Baillie Card, Tom Scutt, and Maisoon Rehani, eds. *The Royal Academy Summer Exhibition: A Chronicle, 1769–2018*. London: Paul Mellon Centre for Studies in British Art, 2018. https://chronicle250.com.

Halliwell, Francis Stephen. *Plato's Republic 10: With an Introduction, Translation and Commentary*. Aris and Phillips Classical Texts. Liverpool: Liverpool University Press, 1988.

Halteman, Ellen, ed. *Nineteenth-Century San Francisco Art Exhibition Catalogues: A Descriptive Checklist and Index*. Davis: Library Associates, University of California, 1981.

——, ed. *Publications in California Art No. 7: Exhibition Record of the San Francisco Art Association, 1872–1915; Mechanics' Institute, 1857–1899; California State Agricultural Society, 1856–1902*. Los Angeles: Dustin Publications, 2000.

Harrington, Peter. "The Battle Paintings of George Jones, R.A. (1786–1869)." *Journal of the Society for Army Historical Research* 67, no. 272 (1989): 239–52.

Harris, Jonathan. *The New Art History: A Critical Introduction*. London: Routledge, 2001.

Harvey, Eleanor Jones. *The Painted Sketch: American Impressions from Nature, 1830–1880*. Dallas: Dallas Museum of Art, 1998.

——. "Tastes in Transitions: Gifford's Patrons." In *Hudson River School Visions: The Landscapes of Sanford Gifford*, edited by Kevin Avery, 75–89. New Haven: Yale University Press, 2003.

Hauser, Arnold. *The Social History of Art*. London: Taylor and Francis, 2005. Kindle.

Hazir, Irmak Karademir, and Alan Warde. "The Cultural Omnivore Thesis: Methodological Aspects of the Debate." In *Routledge International Handbook of the Sociology of Art and Culture*, edited by Laurie Hanquinet and Mike Savage, 77–89. London: Routledge, 2015.

Hellmanzik, Christiane. "Location Matters:

Estimating Cluster Premiums for Prominent Modern Artists." *European Economic Review* 54, no. 2 (2010): 199–218.

Helmreich, Anne. "The Goupil Gallery at the Intersection between London, Continent, and Empire." In *The Rise of the Modern Art Market in London, 1850–1939*, edited by Anne Helmreich and Pamela Fletcher, 65–84. Manchester: Manchester University Press, 2011.

Hemingway, Andrew. *Landscape Imagery and Urban Culture in Early Nineteenth-Century Britain.* Cambridge: Cambridge University Press, 1992.

———. *Marxism and the History of Art: From William Morris to the New Left.* London: Pluto, 2006.

Herbert, Robert L. *Barbizon Revisited.* Boston: Museum of Fine Arts, 1962.

———. "City vs. Country: The Rural Image in French Painting from Millet to Gauguin." In *From Millet to Leger: Essays in Social Art History*, 23–48. New Haven: Yale University Press, 2002.

———. "Goodbye to All That." *New York Review of Books*, November 4, 1999, https://www.nybooks.com/articles/1999 /11/04/goodbye-to-all-that/.

———. "Millet Reconsidered." *Art Institute of Chicago Museum Studies* 1 (1966): 29–65. https://doi.org/10.2307/4104371.

———. "Millet Revisited—I." *Burlington Magazine* 104, no. 712 (1962): 294–305.

———. "Millet Revisited—II." *Burlington Magazine* 104, no. 714 (1962): 377–85.

———. *Monet on the Normandy Coast: Tourism and Painting, 1867–1886.* New Haven: Yale University Press, 1994.

———. *Peasants and "Primitivism": French Prints from Millet to Gauguin.* South Hadley, MA: Mount Holyoke College Art Museum, 1995.

Heywood, Colin. *The Development of the French Economy, 1750–1914.* London: Palgrave Macmillan UK, 1992.

Hibbert, Christopher. *The Grand Tour.* London: Thames Meuthuen, 1987.

Hirshler, Erica. *A Studio of Her Own: Women Artists in Boston 1870–1940.* Boston: Museum of Fine Arts, 2001.

Hodgson, Geoffrey M. "What Are Institutions?" *Journal of Economic Issues* 40, no. 1 (2006): 1–25.

Hohenberg, Paul. "Change in Rural France in the Period of Industrialization, 1830–1914." *Journal of Economic History* 32, no. 1 (1972): 219–40.

Hooks, Janet M. "Women's Occupations through Seven Decades." Washington, DC: United States Department of Labor, 1947. https://fraser.stlouisfed.org/files /docs/publications/women/b0218_dolwb _1947.pdf.

Horne, Victoria, and Lara Perry. Introduction to *Feminism and Art History Now: Radical Critiques of Theory and Practice*, 1–23. London: I. B. Tauris, 2017.

Horowitz, Noah. *Art of the Deal: Contemporary Art in A Global Financial Market.* Princeton: Princeton University Press, 2011.

Hostettler, John., and Brian P. Block. *Voting in Britain: A History of the Parliamentary Franchise.* Chichester: Barry Rose, 2001.

Hullot-Kentor, Robert, and Theodore Adorno. *Aesthetic Theory.* Minneapolis: University of Minnesota Press, 1997.

Hume, David. *Of the Standard of Taste.* 1757. Kindle.

Humphries, Jane. *Childhood and Child Labour in the British Industrial Revolution.* Cambridge: Cambridge University Press, 2010.

Hunt, John Dixon. "John Ruskin and the Picturesque." In *Gardens and the Picturesque: Studies in the History of Landscape Architecture*, 193–216. Cambridge, MA: MIT Press, 1992.

Hunter, F. Robert. "Egypt under the Successors of Muhammad 'Ali." In *Modern Egypt, from 1517 to the End of the Twentieth Century*, edited by M. W. Daly, 180–97. Vol. 2 of *The Cambridge History of Egypt.* Cambridge: Cambridge University Press, 1998.

Irving, Robert Grant. *Indian Summer: Lutyens, Baker, and Imperial Delhi.* New Haven: Yale University Press, 1981.

Isnard, Auguste. *Bon Papa Corot, Souvenir d'une excursion à Ville-d'Avray.* Paris: Alphones Lemerre, 1881.

Jackson, Ashley. *The British Empire: A Very*

Short Introduction. Oxford: Oxford University Press, 2013.

James, Lawrence. *The Rise and Fall of the British Empire.* New York: St. Martin's, 1994.

Jaskot, Paul B. "Digital Art History as the Social History of Art: Towards the Disciplinary Relevance of Digital Methods." *Visual Resources* 35, no. 1–2 (2019): 21–33. https://doi.org/10.1080/01973762.2019 .1553651.

Jay, Martin, and Sumathi Ramaswamy, eds. *Empires of Vision: A Reader.* Durham: Duke University Press, 2014.

Jedwab, Rémi, Edward Kerby, and Alexander Moradi. "How Colonial Railroads Defined Africa's Economic Geography." In *The Long Economic and Political Shadow of History.* Vol. 2, *Africa and Asia,* edited by Stelios Michalopulos and Elias Papaioannou, 87–97. London: CEPR Press, 2017.

Jensen, Robert. *Marketing Modernism in Fin-de-Siècle Europe.* Princeton: Princeton University Press, 1994.

———. "Measuring Canons: Reflections on Innovation and the Nineteenth-Century Canon of European Art." In *Partisan Canons,* edited by Anna Bryzski, 27–54. Durham: Duke University Press, 2007.

Jockers, Matthew L. *Macroanalysis: Digital Methods and Literary History.* Champagne-Urbana: University of Illinois Press, 2013.

Jones, Kimberly A. "Landscapes, Legends, Souvenirs, Fantasies: The Forest of Fontainebleau in the Nineteenth Century." In *In the Forest of Fontainebleau: Painters and Photographers from Corot to Monet,* edited by Kimberly A. Jones, Simon Kelly, Sarah Kennel, and Helga Aurisch, 2–27. New Haven: Yale University Press, 2008.

———. "Paris Salons in the Nineteenth Century." In *Documenting the Salon: Paris Salon Catalogs, 1673–1945,* edited by John Hagood, 55–65. Washington, DC: National Gallery of Art, 2016.

Kahneman, Daniel. *Thinking, Fast and Slow.* New York: Farrar, Straus and Giroux, 2011.

Kalmar, Ivan David. "Arabizing the Bible: Racial Supersessionism in Nineteenth-Cenutry Christian Art and Biblical Scholarship." In *Orientalism Revisited: Art, Land and Voyage,* edited by Ian Richard Netton, 176–86. New York: Routledge, 2013.

Kant, Immanuel. *Critique of the Power of Judgment (The Cambridge Edition of the Works of Immanuel Kant).* Edited by Paul Gruyer. Translated by Eric Matthews and Paul Gruyer. Cambridge: Cambridge University Press, 2000.

Katz, Wendy Jean. *Humbug! The Politics of Art Criticism in New York City's Penny Press.* New York: Fordham University Press, 2020.

———. "Lilly Martin Spencer and the Art of Refinement." *American Studies* 42, no. 1 (2001): 5–37.

———. *Regionalism and Reform: Art and Class Formation in Antebellum Cincinnati.* Columbus: Ohio State University Press, 2002.

Kearney, Michael. *Reconceptualizing the Peasantry.* Boulder: Westview Press, 1996.

Kelly, Elish, and John O'Hagan. "Geographic Clustering of Economic Activity: The Case of Prominent Western Visual Artists." *Journal of Cultural Economics* 31, no. 2 (2007): 109–28.

Kelly, Simon. "Théodore Rousseau, His Patrons and Public." PhD diss., University of Oxford, 1996.

Kelly, Simon, Maite van Dijk, Nienke Bakker, and Abigail Yoder, eds. *Millet and Modern Art: From Van Gogh to Dalí.* New Haven: Yale University Press, 2019.

Keramidas, Kimon, and Ellen Prokop. "Introduction: Re-Viewing Digital Technologies and Art History." *Journal of Interactive Technology and Pedagogy* 12 (2018). https://jitp.commons.gc.cuny.edu /category/issues/issue-twelve/.

Kienle, Miriam. "Between Nodes and Edges: Possibilities and Limits of Network Analysis in Art History." *Artl@s Bulletin* 6, no. 3 (2017): Article 1. https://docs.lib .purdue.edu/artlas/vol6/iss3/1/.

King, Peter. "Customary Rights and Women's Earnings: The Importance of Gleaning to the Rural Labouring Poor, 1750–1850." *Economic History Review* 44, no. 3 (1991): 461–76. https://doi.org/10.2307/2597539.

Klonk, Charlotte. *Science and the Perception of Nature: British Landscape Art in the Late*

Eighteenth and Early Nineteenth Centuries.
New Haven: Yale University Press, 1996.

Köll, Elisabeth. *Railroads and the Transformation of China.* Harvard Studies in Business History. Cambridge, MA: Harvard University Press, 2019.

Kraus, Hildie V. "A Cultural History of the Mechanics' Institute of San Francisco, 1855–1920." *Library History* 23, no. 2 (2007): 115–16.

Kriz, Kay Dian. *The Idea of the English Landscape Painter: Genius as Alibi in the Early Nineteenth Century.* New Haven: Yale University Press, 1997.

———. *Slavery, Sugar, and the Culture of Refinement: Picturing the British West Indies, 1700–1840.* New Haven: Yale University Press, 2008.

Lam, Bourree. "A Field Where Working Moms Aren't Punished." *The Atlantic,* July 13, 2016. https://www.theatlantic .com/business/archive/2016/07/arts -motherhood-penalty/491153/.

Lang, Gladys Engel, and Kurt Lang. *Etched in Memory: The Building and Survival of Artistic Reputation.* Chapel Hill: University of North Carolina Press, 1990.

———. "Recognition and Renown: The Survival of Artistic Reputation." *American Journal of Sociology* 94, no. 1 (1988): 79–109.

Laqueur, Thomas. *Making Sex: Body and Gender from the Greeks to Freud.* Cambridge, MA: Harvard University Press, 1992.

Laster, Margaret R., and Chelsea Bruner. Introduction to *New York: Art and Cultural Capital of the Gilded Age*, edited by Margaret R. Laster and Chelsea Bruner. New York: Routledge, 2018.

Le Brun, Lily. "Will Women Artists Ever Be Better Represented in Museums?" *Apollo Magazine*, March 2, 2015. https:// www.apollo-magazine.com/inquiry -wall-flowers-women-historical-art -collections/.

Lehning, James R. *Peasant and French: Cultural Contact in Rural France during the Nineteenth Century.* Cambridge: Cambridge University Press, 1995.

Levinson, Jerrold. "Titles." *Journal of Aesthetics and Art Criticism* 4, no. 1 (1985): 29–39.

Lewis, David. "1914: An Indian Summer." In *The Royal Academy Summer Exhibition: A Chronicle, 1769–2018*, edited by Mark Hallett, Sarah Victoria Turner, Jessica Feather, Baillie Card, Tom Scutt, and Maisoon Rehani. London: Paul Mellon Centre for Studies in British Art, 2018. https://chronicle250.com/1914.

Lincoln, Matthew D. "Continuity and Disruption in European Networks of Print Production, 1550–1750." *Artl@s Bulletin* 6, no. 3 (2017): Article 2. https://docs.lib .purdue.edu/artlas/vol6/iss3/2/.

Lipton, Eunice. *Looking into Degas: Uneasy Images of Women and Modern Life.* Berkeley: University of California Press, 1988.

Llewellyn-Jones, Rosie, ed. *Lucknow: City of Illusion.* London: Prestel, 2003.

Lozano, Beatriz. "Visualizing the Numbers: See Infographics Tracing the Representation of Women Artists in Museums and the Market." *ArtnetNews*, September 19, 2019. https://news.artnet.com/womens -place-in-the-art-world/visualizing-the -numbers-see-infographics-1654084.

Lübbren, Nina. *Rural Artists' Colonies in Europe, 1870–1910.* Manchester: Manchester University Press, 2001.

Lubin, David. *Picturing a Nation: Art and Social Change in Nineteenth-Century America.* New Haven: Yale University Press, 1994.

Lusinchi, Dominic. "'President' Landon and the 1936 Literary Digest Poll: Were Automobile and Telephone Owners to Blame?" *Social Science History* 36, no. 1 (2012): 23–54.

Lynn, Martin. "British Policy, Trade, and Informal Empire in the Mid-Nineteenth Century." In *The Oxford History of the British Empire*, vol. 3, *The Nineteenth Century*, edited by Andrew Porter. Oxford: Oxford University Press, 1999. https://doi .org/10.1093/acprof:oso/9780198205654 .003.0006.

Maddison, Angus. "The World Economy: A Millennial Perspective." Development Centre Seminars. Organization for Economic Co-Operation and Development, 2001.

Magnusson, Lars. *Mercantilism: The Shaping of an Economic Language*. New York: Routledge, 1994.

Mainardi, Patricia. *Art and Politics of the Second Empire: The Universal Expositions of 1855 and 1867*. New Haven: Yale University Press, 1987.

———. *The End of the Salon: Art and the State in the Early Third Republic*. Cambridge: Cambridge University Press, 2011.

Marx, Karl. *Capital: A Critique of Political Economy*. Vol. 1. New York: Penguin, 1992.

Masten, April. "'Shake Hands?' Lilly Martin Spencer and the Politics of Art." *American Quarterly* 56, no. 2 (2004): 348–94.

Mathews, Mary Mowll. *Mary Cassatt: A Life*. New York: Villard Books, 1994.

May, Stephen. "An Enduring Legacy: The Pennsylvania Academy of the Fine Arts, 1805–2005." In *Pennsylvania Academy of the Fine Arts, 1805–2005: 200 Years of Excellence*, edited by Mark Hain and Alex Baker, 10–27. Philadelphia: Pennsylvania Academy of the Fine Arts, 2005.

Mayor, A. Hyatt. *Prints & People: A Social History of Printed Pictures*. New York: Metropolitan Museum of Art, 1971.

McCammon, Holly J., Sandra C. Arch, and Erin M. Bergner. "A Radical Demand Effect: Early US Feminists and the Married Women's Property Acts." *Social Science History* 38, no. 1–2 (2014): 221–50.

McCarty, Willard. "Modeling the Actual, Simulating the Possible." In *The Shape of Data in the Digital Humanities: Modeling Texts and Text-Based Resources*, edited by Julia Flanders and Fotis Jannidis, 264–84. London: Routledge, 2019.

McLean, Ian. "The Expanded Field of the Picturesque: Contested Identities and Empire in *Sydney Cove* 1794." In *Art and the British Empire*, edited by Timothy Barringer, Geoffrey Quilley, and Douglas Fordham, 23–37. Manchester: Manchester University Press, 2007.

McPherson, Tara. *Feminist in a Software Lab: Difference and Design*. Cambridge, MA: Harvard University Press, 2018.

Michasiw, Kim Ian. "Nine Revisionist Theses on the Picturesque." *Representations*, no. 38 (Spring 1992): 76–100.

Mill, Alister. "Artists at the Salon during the July Monarchy." In *The Paris Fine Art Salon/Le Salon, 1791–1881*, edited by Alister Mill and James Kearns, 137–80. Bern: Peter Lang, 2015.

Miller, Lillian B. *Patrons and Patriotism: The Encouragement of the Fine Arts in the United States, 1790–1860*. Chicago: University of Chicago Press, 1974.

Mitchell, Mark. *Art of American Still Life*. New Haven: Yale University Press, 2015.

Mitchell, W. J. Thomas. *What Do Pictures Want?: The Lives and Loves of Images*. Chicago: University of Chicago Press, 2007.

Moen, Phyllis. *It's About Time: Couples and Careers*. Ithaca: Cornell University Press, 2003.

Mokyr, Joel. *The Enlightened Economy: Britain and the Industrial Revolution, 1700–1850*. New Haven: Yale University Press, 2011.

Molineux, Catherine. *Faces of Perfect Ebony: Encountering Atlantic Slavery in Imperial Britain*. Cambridge, MA: Harvard University Press, 2012.

Mollett, John W. *The Painters of Barbizon: Millet, Rousseau, Diaz*. New York: Scribner and Welford, 1890.

Montfort, Patricia de. "Negotiating a Reputation: J. M. Whistler, D. G. Rossetti, and the Art Market 1860–1900." In *The Rise of the Modern Art Market in London, 1850–1939*, edited by Anne Helmreich and Pamela Fletcher, 257–75. Manchester: Manchester University Press, 2011.

Montias, John Michael. *Artists and Artisans in Delft: A Socio-Economic Study of the Seventeenth Century*. Princeton: Princeton University Press, 1982.

———. "The Montias Database of 17th Century Dutch Art Inventories." *Frick Art Reference Library* (blog). Accessed March 26, 2020. https://research.frick.org/montias.

———. *Vermeer and His Milieu: A Web of Social History*. Princeton: Princeton University Press, 1989.

Moretti, Franco. *Graphs, Maps, Trees: Abstract Models for a Literary History*. New York: Verso, 2005.

Morgan, Kenneth. *Slavery and the British Empire: From Africa to America*. Oxford: Oxford University Press, 2008.

Mukherjee, Rudrangshu. *The Year of Blood: Essays on the Revolt of 1857*. Abingdon: Routledge, 2018.

Mullan, Anthony. "A Web of Imperial Connections: Surveyors and Planters in Eighteenth-Century Dominica." *Terrae Incognitae* 48, no. 2 (2016): 183–205.

Murdoch, Lydia. "'Suppressed Grief': Mourning the Death of British Children and the Memory of the 1857 Indian Rebellion." *Journal of British Studies* 51, no. 2 (2012): 364–92.

Murphy, Alexandra. *Jean-François Millet, Drawn into the Light*. New Haven: Yale University Press, 1999.

Murphy, Angela F. "'This Foul Slavery-Reviving System': Irish Opposition to the Jamaica Emigration Scheme." *Slavery & Abolition* 37, no. 3 (2016): 578–98. https://doi.org/10.1080/0144039X.2016.1208914.

Murphy, Kevin Michael. "Economics of Style: The Business Practices of American Artists and the Structure of the Market, 1850–1910." PhD diss., University of California, Santa Barbara, 2005.

Myers, Kenneth John. "The Public Display of Art in New York City, 1664–1914." In *Rave Reviews: American Art and Its Critics (1826–1925)*, edited by David B. Dearinger, 31–52. New York: National Academy of Design, 2000.

Napolitano, Laura Groves. "Nurturing Change: Lilly Martin Spencer's Images of Children." PhD diss., University of Maryland, 2008.

Nasar, Sylvia. *Grand Pursuit: The Story of Economic Genius*. New York: Simon and Schuster, 2011.

Natale, Mary L. "The American Art-Union, 1839–51: A Reflection of National Identity." Master's thesis, Harvard University, 1993.

Naylor, Maria, ed. *National Academy of Design Exhibition Record, 1861–1900*. New York: Kennedy, 1973.

Nemerov, Alexander. *The Body of Raphaelle Peale: Still Life and Selfhood, 1812–1824*.

Berkeley: University of California Press, 2000.

Neville, Richard. *A Rage for Curiosity: Visualising Australia 1788–1830*. Sydney: State Library NSW, 1997.

Newall, Christopher. "Chronology 1830–1906." In *Frederic, Lord Leighton, 1830–1896: Painter and Sculptor of the Victorian Age*, edited by Margot Th. Brandlhuber and Michael Buhrs, 10–31. London: Prestel, 2009.

———. *The Grosvenor Gallery Exhibitions: Change and Continuity in the Victorian World*. Cambridge: Cambridge University Press, 1995.

Nochlin, Linda. Introduction to *The Politics of Vision*. London: Thames and Hudson, 1989.

———. *Realism*. New ed. London: Penguin, 1991.

———. "Why Have There Been No Great Women Artists?" In *Women, Art, and Power: And Other Essays*, 145–78. New York: Harper and Row, 1989.

North, Douglass C., and Barry R. Weingast. "Constitutions and Commitment: The Evolution of Institutions Governing Public Choice in Seventeenth-Century England." *Journal of Economic History* 49, no. 4 (1989): 803–32.

Oakley, Ann. *Sex, Gender, and Society*. Rev. ed. London: Routledge, 2016.

O'Brien, Karen. "Imperial Georgic, 1660–1789." *The Country and the City Revisited: England and the Politics of Culture 1550*, no. 1850 (1999): 160–79.

O'Brien, Patrick. "Transport and Economic Development in Europe, 1789–1914." In *Railways and the Economic Development of Western Europe, 1830–1914*, 1–27. London: Palgrave Macmillan UK, 1983.

O'Brien, Patrick, and Caglar Keyder. *Economic Growth in Britain and France, 1780–1914*. London: George Allen and Unwin, 1978.

O'Hagan, John, and Christiane Hellmanzik. "Clustering and Migration of Important Visual Artists: Broad Historical Evidence." *Historical Methods: A Journal of Quantitative and Interdisciplinary History* 41, no. 3 (2008): 121–36.

O'Neill, Morna. "1886: 'Can the Royal Academy Be Reformed?'" In *The Royal Academy Summer Exhibition: A Chronicle, 1769–2018*, edited by Mark Hallett, Sarah Victoria Turner, Jessica Feather, Baillie Card, Tom Scutt, and Maisoon Rehani. London: Paul Mellon Centre for Studies in British Art, 2018. https://chronicle250 .com/1886.

Oosterlinck, Kim. "Art as a Wartime Invest-ment: Conspicuous Consumption and Discretion." *Economic Journal* 127, no. 607 (2017): 2665–2701.

Oosterlinck, Kim, and Géraldine David. "War, Monetary Reforms and the Belgian Art Market, 1945–1951." *Financial History Review* 22, no. 2 (2015): 157–77.

Oosterlinck, Kim, Géraldine David, and Ariane Szafarz. "Art Market Inefficiency." *Economics Letters* 121, no. 1 (2013): 23–25.

Overton, Mark. *Agricultural Revolution in England: The Transformation of the Agrarian Economy, 1500–1850.* Cambridge: Cambridge University Press, 2010.

Parinaud, André. *Barbizon, the Origins of Impressionism.* Vaduz, Liechtenstein: Bonfini Press, 1994.

Parris, Leslie. "Malvern Hall, Warwickshire (1809)." In *The Tate Gallery Constable Collection.* London: Tate, 1981. https:// www.tate.org.uk/art/artworks/constable -malvern-hall-warwickshire-n02653.

Parsons, Christopher. "Patrons and Collec-tors of Jean-François Millet between 1845 and 1875." Master's thesis, University of Oxford, 1980.

Parsons, Christopher, and Neil McWilliam. "'Le Paysan de Paris': Alfred Sensier and the Myth of Rural France." *Oxford Art Journal* 6, no. 2 (1983): 38–58.

Patry, Sylvie. "Durand-Ruel and the Impres-sionists Solo Exhibitions of 1883." In *Inventing Impressionism: Paul Durand-Ruel and the Modern Art Market*, edited by Sylvie Patry 98–119. London: National Gallery, 2015.

Penot, Agnès. "The Goupil & Cie Stock Books: A Lesson on Gaining Prosperity through Networking." *Getty Research Journal*, no. 2 (2010): 177–82.

———. *La Maison Goupil: Galerie d'art internationale au XIXe siècle.* Le Kremlin-Bicêtre: Mare & Martin, 2017.

———. "The Perils and Perks of Trading Art Overseas: Goupil's New York Branch." *Nineteenth-Century Art Worldwide* 16, no. 1 (2017). https://www.19thc-artworldwide .org/spring17/penot-on-the-perils-and -perks-of-trading-art-overseas-goupils -new-york-branch.

Perkins Jr., Robert F., and William J. Gavin III, eds. *The Boston Athenaeum Art Exhi-bition Index, 1827–1874.* Boston: Library of the Boston Athenaeum, 1980.

Petersen, Greg. "Titles, Labels and Names: A House of Mirrors." *Journal of Aesthetic Education* 40, no. 2 (2006): 29–44.

Peterson, Richard A. "Understanding Audience Segmentation: From Elite and Mass to Omnivore and Univore." *Poetics* 21, no. 4 (1992): 243–58. https://doi.org/10 .1016/0304-422X(92)90008-Q.

Petri, Grischka. "American Academy of Fine Arts." In *Grove Encyclopedia of Ameri-can Art*, edited by Joan Marter. Oxford: Oxford University Press, 2011. https://doi .org/10.1093/gao/9781884446054.article .T2090109.

Pfisterer, Ulrich. "Big Bang Art History." *International Journal for Digital Art His-tory*, no. 3 (2018): 133–38. https://doi.org /10.11588/dah.2018.3.49916.

Poë, Simon. "From History to Genre." In *The Royal Academy of Arts: History and Collections*, edited by Robin Simon and Maryanne Stevens, 256–89. London: Paul Mellon Centre for Studies in British Art and Yale University Press, 2018.

Polat, Hasan Ali, and Aytuğ Arslan. "The Rise of Popular Tourism in the Holy Land: Thomas Cook and John Mason Cook's Enterprise Skills That Shaped the Travel Industry." *Tourism Management* 75 (December 1, 2019): 231–44. https://doi.org /10.1016/j.tourman.2019.05.003.

Pollock, Griselda. "Artists, Mythologies and Media—Genius, Madness and Art His-tory." *Screen* 21, no. 3 (1980): 57–96. https:// doi.org/10.1093/screen/21.3.57.

———. *Differencing the Canon: Feminist Desire and the Writing of Art's Histories.* London: Psychology Press, 1999.

———. *Millet*. London: Oresko Books, 1977.

Pollock, Stephen. "Econometrics: An Historical Guide for the Uninitiated." *Interdisciplinary Science Reviews* 38, no. 2 (2013): 169–86. https://doi.org/10.1179 /0308018813Z.00000000043.

Pope, Andrew. "British Steamshipping and the Indian Coastal Trade, 1870–1915." *Indian Economic & Social History Review* 32, no. 1 (1995): 1–21. https://doi.org/10.1177 /001946469503200101.

Porter, Michael E. "Clusters and the New Economics of Competition." *Harvard Business Review* 76 (1998): 77–90.

Prettejohn, Elizabeth. "The Classicism of Frederic Leighton." In *Frederic, Lord Leighton, 1830–1896: Painter and Sculptor of the Victorian Age*, edited by Margot Th. Brandlhuber and Michael Buhrs, 32–77. London: Prestel, 2009.

Price, Roger. *The Economic Modernisation of France*. New York: John Wiley and Sons, 1975.

Prieto, Laura R. *At Home in the Studio: The Professionalization of Women Artists in America*. Cambridge, MA: Harvard University Press, 2001.

Prown, Jules. "The Art Historian and the Computer: An Analysis of Copley's Patronage, 1753–1774." In *Art as Evidence: Writings on Art and Material Culture*. New Haven: Yale University Press, 2001.

———. Introduction to *Art as Evidence: Writings on Art and Material Culture*. New Haven: Yale University Press, 2001.

Quilley, Geoff. *Empire to Nation: Art, History and the Visualization of Maritime Britain, 1768–1829*. New Haven: Published for the Paul Mellon Centre for Studies in British Art by Yale University Press, 2011.

Ramaswamy, Sumathi. "The Work of Vision in the Age of European Empires." In *Empires of Vision: A Reader*, edited by Martin Jay and Sumathi Ramaswamy, 1–22. Durham: Duke University Press, 2014.

Ramsay, Stephen. *Reading Machines: Toward an Algorithmic Criticism*. Topics in the Digital Humanities. Urbana: University of Illinois Press, 2011.

Rathbone, Perry T. Foreword to *Barbizon Revisited*, edited by Robert L. Herbert, 10–13. Boston: Museum of Fine Arts, 1962.

Ray, Romita. *Under the Banyan Tree: Relocating the Picturesque in British India*. New Haven: Yale University Press, 2013.

Reilly, Maura. "Taking the Measure of Sexism: Facts, Figures, and Fixes." *ARTnews* (blog), May 26, 2015. http://www.artnews .com/2015/05/26/taking-the-measure-of -sexism-facts-figures-and-fixes/.

Reitlinger, Gerald. *The Economics of Taste: The Rise and Fall of Picture Prices, 1760–1960*. 3 vols. London: Barrie and Rockliff, 1961.

Renneboog, Luc, and Christophe Spaenjers. "Buying Beauty: On Prices and Returns in the Art Market." *Management Science* 59, no. 1 (2013): 36–53.

Reverdy, Anne. *L'École de Barbizon: L'évolution du prix des tableaux de 1850 à 1960*. Paris: Mouton, 1973.

Rewald, John. *The History of Impressionism*. New York; Boston: Museum of Modern Art; Distributed by New York Graphic Society, 1987.

Richards, Nancy Elizabeth. "The American Academy of Fine Arts, 1802–1816: New York's First Art Academy." Master's thesis, University of Delaware, 1965.

Robbins, Lionel. *An Essay on the Nature and Significance of Economic Science*. London: Macmillan, 1932.

Roberts, Jennifer. *Transporting Visions: The Movement of Images in Early America*. Berkeley: University of California Press, 2014.

Roberts, Mary. *Istanbul Exchanges: Ottomans, Orientalists, and Nineteenth-Century Visual Culture*. Oakland: University of California Press, 2015.

———. "The Resistant Materiality of Frederic Leighton's Arab Hall." *British Art Studies*, no. 9 (August 2018). https:// doi.org/10.17658/issn.2058-5462/issue -09/mroberts.

Rodríguez-Ortega, Nuria. "Digital Art History: The Questions That Need to Be Asked." *Visual Resources* 35, no. 1–2 (2019): 6–20.

Rogers, Susan Carol. "Good to Think: The 'Peasant' in Contemporary France."

Anthropological Quarterly 60, no. 2 (1987): 56–63. https://doi.org/10.2307/3317995.

———. "Which Heritage? Nature, Culture, and Identity in French Rural Tourism." *French Historical Studies* 25, no. 3 (2002): 475–503. https://doi.org/10.1215/00161071-25-3-475.

Rönnbäck, Klas. "Sweet Business: Quantifying the Value Added in the British Colonial Sugar Trade in the 18th Century." *Revista de Historia Económica / Journal of Iberian and Latin American Economic History* 32, no. 2 (2014): 223–45. https://doi.org/10.1017/S0212610914000081.

Rosenberg, Harriet G. *A Negotiated World: Three Centuries of Change in a French Alpine Community.* Toronto: University of Toronto Press, 1988.

Rothery, Mark. "The Wealth of the English Landed Gentry, 1870–1935." *Agricultural History Review* 55, no. 2 (2007): 251–68.

Rutledge, Anna Wells. Foreword to *The Annual Exhibition Record of the Pennsylvania Academy of the Fine Arts, 1807–1870*, edited by Peter Hastings Falk, 1–5. Madison, CT: Soundview Press, 1988.

Ryan, James R. *Picturing Empire: Photography and the Visualization of the British Empire.* Chicago: University of Chicago Press, 1997.

Saïd, Edward W. *Culture and Imperialism.* New York: Vintage Books, 1993.

———. *Orientalism.* New York: Vintage Books, 2004.

Saint-Raymond, Léa. "How to Get Rich as an Artist: The Case of Félix Ziem—Evidence from His Account Book from 1850 through 1883." *Nineteenth-Century Art Worldwide* 15, no. 1 (2016). https://www.19thc-artworldwide.org/spring16/saint-raymond-on-how-to-get-rich-as-an-artist-felix-ziem.

———. "Le pari des enchères: Le lancement de nouveaux marchés artistiques à Paris entre les années 1830 et 1939." Université de Paris-Nanterre, 2018.

———. "Revisiting Harrison and Cynthia White's Academic vs. Dealer-Critic System." *Arts* 8, no. 3 (2019): 96–113. https://doi.org/10.3390/arts8030096.

Saudo-Welby, Nathalie. "'[B]Eyond My Landscape Powers': Elizabeth Thompson Butler and the Politics of Landscape Painting." *Polysèmes*, December 20, 2019. https://doi.org/10.4000/polysemes.5533.

Saunders, Robert. *Democracy and the Vote in British Politics, 1848–1867: The Making of the Second Reform Act.* Farnham: Ashgate, 2011.

Sawbridge, Peter. *A Little History of the Royal Academy.* London: Royal Academy of Arts, 2018.

Schich, Maximilian, Chaoming Song, Yong-Yeol Ahn, Alexander Mirsky, Mauro Martino, Albert-László Barabási, and Dirk Helbing. "A Network Framework of Cultural History." *Science* 345, no. 6196 (2014): 558–62.

Shanin, Teodor. "Peasantry: Delineation of a Sociological Concept and a Field of Study." *European Journal of Sociology* 12, no. 2 (1971): 289–300.

Shaw-Taylor, Leigh. "Parliamentary Enclosure and the Emergence of an English Agricultural Proletariat." *Journal of Economic History* 61, no. 3 (2001): 640–62.

Shellim, Maurice. *Additional Oil Paintings of India and the East by Thomas Daniell, RA, 1749–1840, and William Daniell, RA, 1769–1837.* London: Spink, 1988.

———. *Oil Paintings of India and the East by Thomas Daniell, 1749–1840, and William Daniell, 1769–1837.* London: Inchcape & Co. in conjunction with Spink & Son, 1979.

Simon, Robin. "In Search of a Royal Academy." In *The Royal Academy of Arts: History and Collections*, edited by Robin Simon and Maryanne Stevens, 2–11. London: Paul Mellon Centre for Studies in British Art and Yale University Press, 2018.

Sizer, Theodore. "The American Academy of the Fine Arts." In *American Academy of Fine Arts and American Art-Union, 1816–1852*, edited by Mary Bartlett Cowdrey, 20–34. New York: New-York Historical Society, 1953.

Smith, Charles Saumarez. *The Company of Artists: The Origins of the Royal Academy of Arts in London.* London: Modern Art Press in association with Bloomsbury, 2012.

Smith, Terry. *Transformations in Australian Art: The Nineteenth Century—Landscape, Colony, Nation.* Sydney: Craftsman House, 2002.

Solkin, David H., ed. *Art on the Line: The Royal Academy Exhibitions at Somerset House, 1780–1836.* New Haven: Published for the Paul Mellon Centre for Studies in British Art and the Courtauld Institute Gallery by Yale University Press, 2001.

Spaenjers, Christophe, William N. Goetzmann, and Elena Mamonova. "The Economics of Aesthetics and Record Prices for Art since 1701." *Explorations in Economic History* 57 (July 1, 2015): 79–94. https://doi.org/10.1016/j.eeh.2015.03.003.

Spivak, Gayatri Chakravorty. "Can the Subaltern Speak? Revised Edition, from the 'History' Chapter of Critique of Postcolonial Reason." In *Can the Subaltern Speak? Reflections on the History of an Idea,* edited by Rosalind C. Morris, 21–78. New York: Columbia University Press, 2010.

Squire, Peverill. "Why the 1936 Literary Digest Poll Failed." *Public Opinion Quarterly* 52, no. 1 (1988): 125–33.

St. Clair, William. *The Reading Nation in the Romantic Period.* Cambridge: Cambridge University Press, 2007.

Steinberg, Marc W. *England's Great Transformation: Law, Labor, and the Industrial Revolution.* Chicago: University of Chicago Press, 2016.

Stevens, Maryanne. "A Closer Look: The Instrument of Foundation, 1768." In *The Royal Academy of Arts: History and Collections,* edited by Robin Simon and Maryanne Stevens, 12–15. London: Paul Mellon Centre for Studies in British Art and Yale University Press, 2018.

Sturges, Hollister. *Jules Breton and the French Rural Tradition.* Omaha: Joslyn Art Museum and Arts Publisher, 1982.

Swinth, Kirsten. *Painting Professionals: Women Artists and the Development of Modern American Art, 1870–1930.* Chapel Hill: University of North Carolina Press, 2001.

Thabault, Roger. *Education and Change in a Village Community: Mazières-En-Gâtine*

1848–1914. Translated by Peter Tregear. New York: Schocken Books, 1971.

Thomas, Nicholas. *Entangled Objects: Exchange, Material Culture and Colonialism in the Pacific.* Cambridge, MA: Harvard University Press, 1991.

Thomas, Sarah. *Witnessing Slavery: Art and Travel in the Age of Abolition.* London: Yale University Press, 2019.

Thompson, Edward Palmer. *The Making of the English Working Class.* London: Penguin, 2013.

Tillotson, G.H.R. "The Indian Picturesque: Images of India in British Landscape Painting, 1780–1880." In *The Raj: India and the British, 1600–1948,* edited by Christopher A. Bayly, 141–229. London: National Portrait Gallery, 1990.

Tilly, Charles, and David K. Jordan. "Strikes and Labor Activity in France, 1830–1960." Inter-university Consortium for Political and Social Research (distributor), 2012. https://doi.org/10.3886/ICPSR08421.v2.

Tobin, Beth Fowkes. *Picturing Imperial Power: Colonial Subjects in Eighteenth-Century British Painting.* Durham: Duke University Press, 1999.

Tomkins, Calvin. *Merchants and Masterpieces: The Story of the Metropolitan Museum of Art.* Rev. ed. New York: Henry Holt, 1989.

Tromans, Nicholas. *David Wilkie: The People's Painter.* Edinburgh: Edinburgh University Press, 2007.

———. "Genre and Gender in Cairo and Constantinople." In *The Lure of the East: British Orientalist Painting,* edited by Nicholas Tromans, 78–99. New Haven: Yale University Press, 2008.

———. "Introduction: British Orientalist Painting." In *The Lure of the East: British Orientalist Painting,* edited by Nicholas Tromans, 10–21. New Haven: Yale University Press, 2008.

———, ed. *The Lure of the East: British Orientalist Painting.* New Haven: Yale University Press, 2008.

Vaisse, Pierre. Introduction to *Ce Salon à quoi tout se ramène: Le Salon de peinture et de sculpture, 1791–1890,* edited by James

Kearns and Pierre Vaisse, 1–6. Bern: Peter Lang, 2011.

———. "Reflexions sur la fin du Salon officiel." In *Ce Salon à quoi tout se ramène: Le Salon de peinture et de sculpture, 1791–1890*, edited by James Kearns and Pierre Vaisse, 117–38. Bern: Peter Lang, 2011.

Vardi, Liana. "Construing the Harvest: Gleaners, Farmers, and Officials in Early Modern France." *American Historical Review* 98, no. 5 (1993): 1424–47. https://doi.org/10.2307/2167061.

Varisco, Daniel Martin. "Orientalism and Bibliolatry: Framing the Holy Land in Nineteenth-Century Protestant Bible Customs Texts." In *Orientalism Revisited: Art, Land and Voyage*, edited by Ian Richard Netton, 187–204. New York: Routledge, 2013.

Vasari, Giorgio, Betty Burroughs, and Jonathan Foster. *Vasari's Lives of the Artists: The Classic Biographical Work on the Greatest Architects, Sculptors and Painters of the Italian Renaissance.* New York: Simon and Schuster, 1973.

Vázquez, Oscar E. *Inventing the Art Collection: Patrons, Markets, and the State in Nineteenth-Century Spain.* University Park: Pennsylvania State University Press, 2001.

Velthuis, Olav. *Talking Prices: Symbolic Meanings of Prices on the Market for Contemporary Art.* Princeton: Princeton University Press, 2007.

Vermeylen, Filip. *Painting for the Market.* Turnhout: Brepols, 2003.

Vittoria, Shannon. "Nature and Nostalgia in the Art of Mary Nimmo Moran (1842–1899)." PhD diss., City University of New York, 2016.

Vix, Brenda. "Branding the Vision: William Holman Hunt and the Victorian Art Market." In *The Rise of the Modern Art Market in London, 1850–1939*, edited by Anne Helmreich and Pamela Fletcher, 237–56. Manchester: Manchester University Press, 2011.

Vottero, Michaël. *La peinture de genre en France, après 1850.* Rennes: Presses Universitaires de Rennes, 2012.

Wallach, Alan. "Thomas Cole: Landscape and the Course of American Empire." In *Thomas Cole: Landscape into History*, edited by William H. Truettner and Alan Wallach, 23–111. New Haven: Yale University Press, 1994.

Warner, Malcom. "Millais in the Marketplace: The Crisis of the Late 1850s." In *The Rise of the Modern Art Market in London, 1850–1939*, edited by Anne Helmreich and Pamela Fletcher, 216–36. Manchester: Manchester University Press, 2011.

Weber, Eugen. *Peasants into Frenchmen: The Modernization of Rural France, 1870–1914.* Palo Alto: Stanford University Press, 1976.

Weeks, Emily M. *Cultures Crossed: John Frederick Lewis and the Art of Orientalism.* New Haven: Yale University Press, 2014.

Weisberg, Gabriel P., ed. *The European Realist Tradition.* Bloomington: Indiana University Press, 1982.

West, Shearer. *Portraiture.* Oxford: Oxford University Press, 2004.

White, Harrison C., and Cynthia A. White. *Canvases and Careers: Institutional Change in the French Painting World.* 1965. Chicago: University of Chicago Press, 1993.

Whiteley, Jon. Introduction to *The Subject Index to Paintings Exhibited at the Paris Salon, 1673–1881.* Oxford, 1993. Sackler Library, University of Oxford.

Wierich, Jochen. "War Spirit at Home: Lilly Martin Spencer, Domestic Painting, and Artistic Hierarchy." *Winterthur Portfolio* 37, no. 1 (2002): 23–42.

Wilson, Raymond L. "The First Art School in the West: The San Francisco Art Association California School of Design." *American Art Journal* 14, no. 1 (1982): 42–55.

Wilton, Andrew. "The Sublime in the Old World and the New." In *American Sublime: Landscape Painting in the United States, 1820–1880*, edited by Tim Barringer and Andrew Wilton, 11–37. Princeton: Princeton University Press, 2002.

Wood, John H. *Seventy-Five Years of History of the Mechanics' Institute of San Francisco.* San Francisco: Mechanics' Institute, 1930.

Woolf, Virginia. *A Room of One's Own.* London: Harcourt, 1929.

Wylie, Laurence William. *Village in the*

Vaucluse. 3rd ed. Cambridge, MA: Harvard University Press, 1974.

Wynne, Catherine. "Elizabeth Butler's Literary and Artistic Landscapes." *Prose Studies* 31, no. 2 (2009): 126–40. https://doi.org/10.1080/01440350903323553.

Yarnall, James L., William H. Gerdts, Katharine Fox Stewart, and Catherine Hoove Voorsanger, eds. *The National Museum of American Art's Index to American Art Exhibition Catalogs: From the Beginning through the 1876 Centennial Year*, 6 vols. Washington, DC: National Museum of American Art, 1986.

Young, Patrick. *Enacting Brittany: Tourism and Culture in Provincial France, 1871–1939.* Farnham: Ashgate, 2012.

Zarobell, John. "Paul Durand-Ruel and the Market for Modern Art, 1870–1873." In *Inventing Impressionism: Paul Durand-Ruel and the Modern Art Market*, edited by Sylvie Patry, 76–97. London: National Gallery, 2015.

Ziliak, Stephen Thomas, and Deirdre N. McCloskey. *The Cult of Statistical Significance: How the Standard Error Costs Us Jobs, Justice, and Lives.* 2nd ed. Ann Arbor: University of Michigan Press, 2014.

Zweig, Benjamin. "Forgotten Genealogies: Brief Reflections on the History of Digital Art History." *International Journal for Digital Art History*, no. 1 (2015): 39–49. https://doi.org/10.11588/dah.2015.1.21633.

Index

◇◇◇

Bold numbers indicate illustrations, charts, graphs, and tables.

A

Académie des beaux-arts (Academy of Fine Arts), 14–15, 26, 56–58, 75–76

Acemoglu, Daron, 124–126

Adams, W. A., 103

aesthetics (philosophy of art), 137, 153

After Dinner at Ornans (Courbet), 58

aggregation of data, 2, 10, 18, 49, 131, 156

Aitchison, George, 152

Allston, Washington, 103

American Academy of Fine Arts, 39, 91–92

American Academy of Fine Arts and American Art-Union, 1816–1852 (Cowdrey), **36–37**, 39

American Art-Union, 92, 106, 200n35

An Artist Residency in Motherhood (Clayton), 114

The Angelus (Millet), 76

Annual Exhibition, Royal Academy. *See* Summer Exhibition, Royal Academy

Annual Exhibition Record of Pennsylvania Academy of the Fine Arts 1807–1870 (Falk), **36–37**, 40

Annual Exhibition Record of Pennsylvania Academy of the Fine Arts 1876–1913 (Falk), **36–37**

Antique capitals, from sketches at Alexandria, by Col. Turner (Cotes), 133–134

Apollo Association, 200n35

Aquatint Worlds: Travel, Print and Empire (Fordham), 137

Arab Hall, Leighton House Museum, 151–152, **152**

architecture: architects as academy members or exhibition jurors, **33**, 44, 48; architectural subjects in paintings, 134–135, **135**, 137–140, **139**; exhibition of architectural models or designs, 45, 91, **118**; and imperialism, 116, 146; Leighton House, The Arab Hall, 151–152, **152**

archives, digital, 20

Armstead, Henry Hugh, 143

Arrival of the Harvesters in the Swamp of Pontins (Robert), 57

Art and the British Empire (Quilley and Fordham), 121

artist colonies, 12, 13; and artists as entrepreneurs, 15; Barbizon, 57–58; and "clustering," 13–14, 71; cost of living and, 55, 71, 169; and depiction of geographical locations, 70–71; and legacy effect, 73; transportation and, 55, 71–72, **72–73**, 82–83; women artists and, 102

Artl@s exhibition mapping, 19, 123

Artsy, 113

A Sisterhood of Sculptors (Dabakis), 90

At Home in the Studio (Prieto), 90, 93, 100

auction catalogs as data source, 13

awards: data sources on prizewinners, 58; and exhibition privileges, 25, 26, 58; juries and, 25–26, 29–30, 58; Paris Salon and, **24**, 24–25, 29, 31, 195n29; Pennsylvania Academy of the Fine and, 40–41; percentage awarded to rural genre paintings, 58–59, **59**; and reputation, 14

B

Barrell, John, 17, 82, 140–142

Barringer, Tim, 17

Bastien-Lepage, Jules, 59

Bayer, Thomas, 13

Beckert, Sven, 16

behavioral economics, 10–11

The Bellelli Family (Degas), **8**, 22

Bermingham, Ann, 17, 140–141

D

Dabakis, Melissa, 90

Daniell, Thomas, 136–137, **138**, 146, 151; *Ruins of the Naurattan, Sasaram, Bihar* by, 141–142, **142**

Daniell, William, 136–137, **138**, 151

data: aggregation and loss of individuality, 21, 49–51; analysis of (*See* regression analysis); compilation of, 157–158; and mediation, 54; and sample bias, 4, 5–9, 10, 25–26, 30, 49, 55, 60, 154–156; sources of (*See* data sources); transcription of, 6, 21, 42–43, 115–116, 154–155, 157–158; web-scraping and collection of, 77, 96, 197n64; website to access datasets, 157

data-driven art history: controversies over and criticism of, 18–20; and cultural contributions of marginalized makers, 123; and econometrics, 10–11, 15, 20, 54, 64, 68–69, 156; as field, 18–21; and "loss of the object," 21, 49–51, 156; and lost or obscure works, 123, 154–155; and mediation, 54–55; Nineteenth century art as ideal subject for, 20–22; and scale, 23; as supplement to rather than replacement for qualitative art history, 21, 49–51, 90, 112–113, 156; and visualization of trends or relationships, 18, 26, 31, 34, 155, 158

data sources, 23–25; accuracy of, 42–43; auction catalogs as, 13; catalogues raisonnés, 23; compilation and access to, 157–158; exhibition catalogs, 6; exhibition checklists, 23; gallery exhibition records, 19, **37**; Royal Academy Exhibition Database, 25, 115; and transcription, 42–43. *See also* Historical American Art Exhibition Database (HAAExD); Whiteley Index

Daubigny, Charles-François, 58–59

David, Géraldine, 13

dealers: commercial art dealers in U.S., 41; and commercial infrastructure, 48; dealer-critic system, 14–15, 30–31; and import/export art market, 48

decentralization of art market, 15

decorative arts, 95

Degas, Edgar, 6–7, 20–22; *The Bellini Family* by, **8**, 22

Denon, Vivant, 33

dependent variables, 10–11, **66**, 68–70, 75, 156

The Development of the Art Market in England (Bayer & Page), 13

Diaz de la Peña, Narcisse-Virgile, 58–59

Differencing the Cannon (Pollock), 7, 17

digital humanities, 4, 12, 18, 123. *See also* data-driven art history

Dimaggio, Paul, 16

"distant reading," 18

Distinction: A Social Critique of the Judgment of Taste (Bourdieu), 16

Dombrowski, André, 17

Dossin, Catherine, 19

Do Women Have to Be Naked to Get into the Met. Museum? (Guerrilla Girls), **85**

dummy variables, use of, **73**, 167, 168, 169

Dupré, Jules, 58

Durand, Asher, 92

Durand-Ruel, Paul, 15, 31

E

Eaton, Natasha, 121

École des beaux-arts, 44, 56–58

econometrics, 10–11, 15, 54, 64, 68–69, 156. *See also* regression analysis

economics, as discipline, 3

Ellet, Elizabeth Fries, 89, 106

Empire to Nation (Quilley), 121–122, 135

empiricism, and art history methodology, 17–18

enclosure, 140–141

England, as region of study, 3. *See also* British Empire

English Female Artists (Clayton), 89

entrepreneurs, artists as, 163; and alternative venues for exhibition, 46–48; business subjects in Millet's letters, 77–83, **78**; women artists and demands of marketing, 88

Etched in Memory (Lang and Lang), 14, 90–91

exhibition catalogs as data sources, 6

exhibition rules. *See* rules, exhibition

experimental artists, 13, 48

explanatory variables, 10–11, 68–69, **72**, 72–75, 156

extractive institutions, 124–127, 147–148

F

Falk, Peter Hastings, **36**

The Family of Sir William Young (Zoffany), 149–150, **150**

Fanon, Frantz, 123
feminist criticism, 7–9, 20
Ferry, Jules, 31
Fisher, Irving, 11
Fletcher, Pamela, 198
Fordham, Douglas, 121, 137
Fraiberger, Samuel, 14
France, as region of study, 3; dealer-critic
 market system in, 14–15
Fruits of Temptation (Spencer), **109**, 109–110
Fuseli, Henry, 148

G

Gainsborough, Thomas, 46, 129, 140
Gala, Wanda, 113
Galenson, David, 13
galleries, 39–40; entrepreneurial artists and
 exhibition in private, 28–30, 48, 95–96,
 200n35; exhibition records as data source,
 19, **37**; female owned, 114; women artists
 and, 86, 95–96, 113–114
Gallon, Kim, 18, 123
Gautier, Théophile, 15
Gavin, William J., III, **36**
gender, 3, 7, 86, 154; of makers and keywords,
 94–97; as variable for analysis, 94–95. *See
 also* women artists
"genius": and biographical approach to art
 history, 89; canons and, 153–154; and
 gender, class, or ethnic bias, 154; and lost
 or obscure works as *not* genius, 154; and
 sample bias, 7, 55; and standards of taste,
 153–154
geographic locations: analysis and tagging
 process, 178; digital art history and, 19,
 123; of French landscape / rural genre
 paintings, 69–70; and imperial keywords,
 152; in Millet's letters, 77; and Royal
 Academy and colonial settings, 131–136,
 132, **135**; Royal Academy Summer Exhi-
 bition and colonial settings, 9, 12, **117**,
 118, 122, 178; Royal Academy Summer
 Exhibition and images of the metropole,
 12, 116, **117**, 123, 131, 146; in scope of
 research, 3; title-based assumptions
 about, 116
Gerdts, William H., **36**
Gillray, James, 151
Gilpin, William, 137
Ginsburgh, Victor, 14

The Gleaners (Millet), 49–51, **50**
Goldin, Claudia, 87, 113
Gordon, Jean, 90
Graddy, Kathryn, 14
Graves, Algernon, 45–46
Green, Nicholas, 53–54, 162–164
Grosvenor Gallery, 48
Guerrilla Girls collective, 85

H

Hall, Ann, 92, 96
Halteman, Ellen, **36**
hanging committees, 43, 46, 92, 200n38,
 200n40
Hauser, Arnold, 16–17
Heim, François-Joseph, *Charles X Distribut-
 ing Awards* by, **25**
Hellmanzik, Christiane, 13
Helmrich, Anne, 19
Hemingway, Andrew, 17, 140
Herbert, Robert, 17, 53–54, 59–60, 64,
 159–164
hierarchy of genres, 46, 56–57, 88, 122; and
 decorative arts, 95; women artists and,
 101
Hirst, Claude (Claudine) Raguet, 90–91
Historical American Art Exhibition Data-
 base (HAAExD), 25, 35–43; accuracy of,
 42–43; compilation of, 41–42; original
 purpose of, 25; scope of, 43–44; source
 material of, 25; sources collected in, 25,
 36–37
history paintings, 45, 46, 56–58, 88, 103, 118,
 178
Hodges, William, 136
Hogarth, William, 44
homo economicus, 11–12
Huemer, Christian, 13
Huet, Paul, 58–59
Hume, David, 153
Huntington, Daniel, 100–101
hypotheses, role in quantitative art history,
 10

I

Image of the People (Clark), 17
imperial imagery, 3, 22; absence or erasure
 of, 119–120, 127, 146–147; the Daniells and,
 136–137, **138**, 141–142, 146, 151; demand for,
 137; depictions of named countries shown

at Royal Academy, **117**; failure or defeat and, 143–145, **144**, **145**; identification of colonial locations, 116–118, 127, 178; imperial visual culture, 18, 115; and inclusive/extractive institutional regimes, 119–122, 125–127, 140–141, 147–148, 151; keywords associated with, 118–119, **119**, 178, **179**; and military subjects, 118, 122, 134, 136, 143–146; and the picturesque, 129, 136–143; as rarely displayed in the metropole, 9, 12; and transportation, 127–131; and Zoffany's portrait of *The Family of Sir William Young*, 149–150

Impressionists, 59; and dealer-critic system, 30–31; exclusion from Paris Salon, 14, 28–29; and independent exhibition, 28–29; and landscapes, 73

inclusive institutions, 124–127, 147–148

independent variables, **66**

An Indian Girl (Rood), 143

individuality, quantitative analysis and loss of the object, 21, 49–51, 156

industrialization, 18, 22, 55, 75, 125; and artistic production, 56; and exhibition of landscape and genre paintings, 55–56, 60–61; industrial subjects in paintings, 64, **83**, 84, 165, 166; and labor, 125; Millet and, 52, 160; and peasant as subject of art, 53–54; and rural genre paintings, 84

institutions, 12; academic affiliation and, 94; and artists' colonies or clusters, 14; and cultural economy, 16; economic development and, 124–125; inclusive *vs.* extractive economic, 119–122, 125–127, 140–141, 147–148, 151; institutional records as data, 6, 25; politics and stability of, 31–34, **32**–**33**, 123–124; property rights and inclusive economic, 123–126, 140–141, 147; and social stability, 120, 151; United States and art, 35–38. *See also* specific i.e. Metropolitan Museum

Interior of the Grand Mosque, Damascus (Leighton), 151

irrationality, 11–12

J

Jacques, Charles, 80, 81

James, Lawrence, 115

Jaskot, Paul, 19–21

Jeanron, Philippe-Auguste, 57

Jensen, Robert, 15

Jockers, Matthew, 18–19

Jones, George: *Cawnpore, the Passage of the Ganges*, 143, 145–146; *Lucknow*, 143–144, **144**

Joyeux-Prunel, Béatrice, 19

juries: and awards or prizes, 25–26, 29–30, 58; constitution of, 25, 29, 30, 57; control exercised by, 25–26; and dealer-critic system, 15, 30–31; and demand, 168; and fairness, 46; and landscape or rural genres, 57; and marginalization of nonacademic artists, 46; and marginalization of women artists, 92; National Academy of Design, 91, 93; Paris Salon exhibition and, 25, 29–30, **33**, 57; politics and, 31–33, 70, **72**–**73**; Royal Academy, 44–46, 115; unjuried exhibitions, 46, 92–93, 195n25

K

Kent, William, 137

keywords: accuracy and precision of Whiteley Index subject tags, 27–28, 34; and analysis of letters, 76–77, **78**, 104; and gender of makers, 94–97; and geographical locations, 118, 152, 178; and imperial imagery, 118–119, **119**, 178–**179**; and still life paintings, 88, 91–93, 94, 96–97, 177; as subject headings, 26–27; *vs.* titles as descriptors, 27–28

Kriz, Kay Dian, 121

L

labor: activism and strikes, **66**–**67**, **68**, 70, **72**–**73**, 161, 169, 170, **171**–**174**; economics, 198–199n10; industrialization and exploitation of, 125; slave, 125; women and labor market dynamics, 86–88

Ladies Art Association, 93

The landing of the British army in Egypt (Pocock), 133–134

Landscape and Ideology (Bermingham), 140–141

landscape paintings: colonial locations depicted in, 129–130; demand for, 88; and direct observation, 88, 129, 137; and enclosure, 140; geographical tags and identifiable locations in, 69–70, **70**; historical overview of French, 56–60; and historical subjects, 57; Impressionists and, 73;

landscape paintings (cont.):
 included with rural genre paintings for
 analysis, 55; as more frequent than rural
 genre paintings, 60–61, **61**; number exhib-
 ited, 60–61, **61**; as percentage of Paris
 Salon exhibited paintings, **62**; and pic-
 turesque aesthetic, 120, 129, 136–143, 146;
 socioeconomic change and, 157; and time
 as theme, 141; transportation and, 55–56,
 74, 129–131; women artists and, 100–101
Lang, Gladys Engel, 14, 90–91
Lang, Kurt, 14, 90–91
Leighton, Frederick, Lord, 151–152
Leleux, Adolphe, 57
letters, keyword analysis of: of Lilly Martin
 Spencer, 104; of Millet, 76, **78**
Lilly Martin Spencer: The Joys of Sentiment
 (1973 Exhibition Catalog), 106
Lincoln, Matthew, 19
Lives of the Artists (Vasari), 9, 89, 153–154
Longworth, Nicholas, 103
lost or obscure works, 5–6, 34, 43–44, 143;
 data-driven art history and inclusion
 of, 123, 153–155; as *not* genius, 153–154;
 women artists and, 89, 94–95, 108
Lübbren, Nina, 71–72
Lucknow (Jones), 143–144, **144**
The Lure of the East (Tromans), 130–131

M
macroanalysis, 18
Malvern Hall, Warwickshire (1809) (Constable),
 138–140, **139**
Malvern Hall, Warwickshire (1820–1821) (Con-
 stable), 138–140, **139**
Marchi, Neil de, 13
marginalization: decentering datasets to
 correct for, 123; and exclusion of colonial
 subjects, 119–120; of Impressionists by
 Paris Salon, 59; and innovation, 73; and
 underrepresentation in Museum collec-
 tions, 85–86
maritime imagery, 122, 133–136
Marshall, Alfred, 10
Marxian art history, 17, 20, 140–141, 159
McCarty, Willard, 19
McPherson, Tara, 19
Mechanics' Institute (San Francisco), 39
media, artistic: exhibitions devoted to,
 48; and imperial imagery, 122–123; in

Metropolitan Museum American Wing
 collections, 98, **99**; subject matter linked
 to, 9; time constraint and, 98–99; works
 on paper, 9, 26, 35, 59, 98–99, 109, 122–123
mediation, 54–55
mercantilism, 126
Metropolitan Museum of Art, 40, 41, 85,
 86, 88, 102; gender of artists represented
 in American Wing of, **97**; institutional
 history of, 94; and National Academy
 of Design, 91, 94; still life paintings in
 collection of, 96–98, **97**, **98**; women artists
 represented in collections of, 85–86, 94,
 97
Michallon, Achille, 57
military subjects: and imperial imagery, 118;
 portraits of, **149**
Miller, Lillian B., 17
Millet, Jean-François, 7; and agent Alfred
 Sensier, 53 (*See also* Millet letters,
 Moreau-Nélaton collection); and attention
 of art historians, 6–7, 53–54; and Barbizon
 artists, 58–59, 76, 77, 79–81; biography
 and early career, 75–76; *The Gleaners*
 by, 49–51, **50**, 52; and industrialization/
 urban life, 52–54, 56; letters of (*See* Millet
 letters, Moreau-Nélaton collection);
 and Paris Salon exhibition, 58, 76; and
 "peasant painter" reputation, 53, 76, 79,
 81, 159–160; prints and works on paper by,
 59; quantitative analysis of letters, 55–56;
 and rural genre paintings, 49–55, **50**, 76,
 81; and sample bias, 55; *The Sower* by, 27,
 28, 52, 58, 76; on urban Paris, 52, 76; *The
 Winnower* by, 76
Millet letters, Moreau-Nélaton collection,
 55–56; business affairs, 77, **78**; as data
 source, 76–77; geographic locations men-
 tioned in, 77, **78**; keywords and analysis of,
 76, **78**; Paris in, 77
miniatures, 92, 98–100, **99**, 101
modernization, 55, 83
Modern Painters (Ruskin), 129
Montias, John Michael, 13
Moran, Mary Ninno, 100
Moretti, Franco, 18
multivariate regression analysis, 68–69
Murtha, Baca, 19
Museum of Fine Arts, Boston, 41
mythological themes, 53, 79–80

N

Nakazawa, Natalia, 113

Napoleon III (Charles-Louis Napoléon Bonaparte), 58

National Academy of Design Exhibition Record: 1826–1860 (Cowdrey), **36–37**, 41–42, **43**, **44**, 94; *1861–1900* (Naylor), **36–37**, 94

National Academy of Design (NAD), 39; classes for women, 95–96; and education of women artists, 92–93, **93**; exhibition rules, 91–92; institutional history of, 91–92; and juries, 91, 93; and Metropolitan Museum, 91, 94; still life keywords in titles of works exhibited at, 88, 91–93, 94, 177; and women artists, 91–100, **97**

Naylor, Maria, **36–37**

The New York Times, front page, July 8, 1863, **110**, **112**

Nineteenth-Century San Francisco Art Exhibition Catalogues (Halteman), **36–37**

Nochlin, Linda, 17, 53–55, 154; *Realism*, 161; "Why Have There Been No Great Women Artists?," 89–90

North, Douglass, 123–125, 148

The Nut Gatherers (Bouguereau), **8**

O

"Of the Standard of Taste" (Hume), 153

O'Hagan, John, 13

Old Masters and Young Geniuses (Galenson), 13

Oosterlinck, Kim, 13

Orientalism, 116, 118, 121, 130, 133–135, 151

Orientalism (Said), 121

P

Page, John, 13

Painting Professionals (Swinth), 90

panel regressions, **66**, 69, 169

Paris Salon, 14; Academy of Fine Arts and institution of, 29; awards and prize system of, 29–30, 31, 195n29; composition of juries, 31; and exhibition as right, 30; exhibition data for, 23, **24**; Impressionists rejected by, 15, 30; juries of, 25, 29–30, **33**, 57; jury abolished, 30, 33, 57, 58; and landscape paintings, 57; and national politics, 31–32; number of paintings exhibited, 34; number of rural genre and landscape paintings exhibited, 60–61, **61**; number of works exhibited, 26; as political institution, 26, 30; politics and jury policies of, 31–33; and rural genre paintings, 49, 55–59; rural genre paintings exhibited at, 55; visibility of works at, 25; Whiteley Index of exhibition livrets (*see* Whiteley Index)

Partisan Canons (Brzyski), 14, 154

pastorals, 57, 61–63, **62**, 84

Paul Mellon Centre for British Art, 45

Peace—Burial at Sea (Turner), **130**, 130–131, 134, 178

peasants, as subject: industrialization and, 53–54; Millet on choice to paint, 79, 81; in pastoral *vs.* rural genre paintings, 56–57; in prints, 59–60; and work, 161

The Peasants of Flagey Returning from the Fair (Courbet), 52, 58

Pennsylvania Academy of the Fine Arts (PAFA), 37, 38–41, 96; women admitted as students to, 92; women artists and, 92–93, **93**

Penot, Agnès, 15

the picturesque, 136–143, 146–147

Picturing Imperial Power (Tobin), 121–123

Piles, Roger de, 14

Pissarro, Camille: *The River Oise near Pontoise*, 82, **83**

Pocock, Nicholas, 133–134

political polling and sample bias, 5

Pollock, Griselda, 7, 17, 53, 90, 154, 162

portraits: of animals, 211n102; and hierarchy of genres, 56, 88; identity and portraiture, 147–148; inclusion and flourishing of portraiture, 120, 147–150, **149**; military, 118, 143, **149**, 178; politics and exhibition of, 26, 31–34, **35**; Prown's quantitative art history and, 1–2, 10; of rulers or monarchs, 147–148, **149**; social makeup of subjects, 148, **149**; Spencer's self-portrait, 103, **104**, 111; time required for, 88, 100–101; women artists and, 100–101; Zoffany's *The Family of Sir William Young*, 149–150

Portraiture (West), 147–148

price data, 13, 14, 71, 168, 186n28

Prieto, Laura, 90, 93, 100

prints. *See* works on paper

property rights, 123–126, 140–141, 147

Prown, Jules, 1–2, 4, 10, 156

Publications in California Art No. 7 (Halteman), **36–37**

Turner, J. M. W., 46–47; *Peace—Burial at Sea* by, 130–131, 134, 178
Turquet, Edmond, 31

U

Union League Club, 93, 94, 105–106
United States, as region of study, 3
urbanization, 22, 55; and labor, **68**; migration and clustering of artists, 13–14; Millet's condemnation of, 52; and rural genre painting, 54–55

V

Valenciennes, Pierre-Henri de, 57
van Miegroet, Hans, 13
variables, 156; and correlation, 64–68; dependent, 10–11, **66**, 68–70, 75, 156; dummy, **73**, 167, 168, 169; gender, 94–95; independent, **66**; and multivariate regression analysis, 68–69; and regression analysis, 10–11, 68; selection of socioeconomic, 54–55; testing identified socioeconomic, 60, 64
Vasari, Giorgio, 9, 89, 153–154
Vázquez, Oscar, 16
visualization of trends or relationships, and data-driven art history, 31, 34, 155, 158

W

Wallach, Alan, 17
The War Spirit at Home (Spencer), 109–111, **110**
watercolors, 48, **99**, 100; women and production of, 88, 100, 101, 103
web-scraping, 77, 96, 197n64
Weingast, Barry, 123–125, 148
West, Shearer, 147–148
Whistler, James Abbot McNeill, 48
White, Cynthia, 2–3, 14–16, 23, 30–31
White, Harrison, 2–3, 14–16, 23, 30–31
Whiteley, Jon: and key terms and categories, 165, 190n22; and precision of categorization, 26–28, 31–32; and process of indexing, 26–28
Whiteley Index keywords: as data source, 157; family genre painting tags, 166; industrial genre painting tags, 167; and landscape paintings as separate category, 165; and limited information about rural genre painting, 63–64; religious genre painting tags, 166; rural genre

painting tags, 165; scope and precision of, 27–28
Whiteley Index to Paris Salon Paintings: content of, 30, 34; as database source, 34–35; keyword tagging in (*See* Whiteley Index keywords); and lost or obscure works, 34; original purpose of, 25, 26; process of compilation, 41–42; Salon des Refusés in, 30; scope and detail of, 34; source material of, 25, 26–27, 34
"Why Have There Been No Great Women Artists?" (Nochlin), 89–90
Why Nations Fail (Acemoglu and Robinson), 124–126
Wilkie, David, 130
The Winnower (Millet), 76
Woman's Building, 1893 World's Columbia Exhibition, 93–94
Woman's Pavilion, 1876 Centennial Exhibition, 93–94
women artists, 17, 22; access to academic training in art, 96–97; and artists colonies or clustering, 102; and art training at institutions, 92–93; biographical approach to, 89; career trajectories of, 86–87; and commercial dealers and galleries, 113–114; curators and marginalization of, 92; decorative arts produced by, 95; exhibition opportunities for, 93–94; expatriate success of, 101–102; identification of works by, 94–95; juries and marginalization of, 86; and labor market dynamics, 86–88, 100–103; and market access, 101–102, 113–114; marriage as threat to career, 103–104; medium and genre of works by, 100–103, 108; motherhood and, 113–114; and National Academy of Design, 91–100; and quantitative approach, 89–91; and scale of works, 88, 98, 108; and still life paintings, 96–98, **97**, **98**; and studio space, 101, 108; and subject choice, 109–111; supply of and demand for works by, 86; and time constraints, 87–88, 100–103, 108, 113–114; as underrepresented in museum collections, 85–86, 102–103; and watercolors, 88, 100, 101, 103. *See also* Spencer, Angelique Marie "Lilly" Martin
Women Artists in All Ages and Countries (Ellet), 89, 106
The Women's Life Class (Stephens), **93**

Women's National Art Association, 93

"Women's Place in the Art World" *(artnet-News)*, 114

Woolf, Virginia, 114

works on paper (books, prints, etc.), 35, 59, 98–99, 109; and British imperial culture, 9, 26, 122–123; as omitted from data sources, 26, 59–60

Y

Yarnall, James L., **36**

"You Can Be a Mother and Still Be a Successful Artist," 113

Z

Zoffany, Johannes, 149–150